Why Does Michelangelo Matter?

Why Does Michelangelo Matter?

A Historian's Questions about the Visual Arts

Theodore K. Rabb

The Society for the Promotion of Science and Scholarship
Palo Alto, California

The Society for the Promotion of Science and Scholarship
Palo Alto, California

©2018 The Society for the Promotion of Science and Scholarship, Inc.

The Society for the Promotion of Science and Scholarship is a nonprofit organization established for the purposes of scholarly publishing, to benefit both academics and the general public. It has special interests in European and British studies.

This publication is made possible in part from the Barr Ferree Foundation Fund for Publications, Department of Art and Archaeology, Princeton University.

The essays and reviews in this book—all slightly revised—first appeared in the following publications, which have graciously agreed to their inclusion in this volume: *The Art Newspaper*, *Commentary*, *Fundación Amigos del Museo del Prado*, *The Journal of Interdisciplinary History*, *The Los Angeles Times*, and *The Times Literary Supplement*. For the two essays from *The New York Times* permissions fees have been paid.

Printed in the United States of America.

ISBN cloth: 978-0-930664-31-2
ISBN paper: 978-0-930664-32-9

Library of Congress Cataloging-in-Publication Data available on request.

For Tamar

per sempre

Contents

List of Illustrations
(Illustrations follow p. 169)

There is room here for only ten illustrations, but works that are mentioned are almost always to be seen through Google Images. Titles can vary, though, especially in translation. Thus, Le Nain's *Argument over a Card Game* becomes *Quarrel over a Card Game* in Google.

1. Michelangelo Buonarotti, *The Fall of Phaethon* (1533), ink drawing, British Museum. © The Trustees of the British Museum. All rights reserved.

2. Peter Paul Rubens, *Peace and War* (1629), oil painting, the National Gallery, London. Art Resource, NY.

3. Jan Van Eyck, *The Arnolfini Marriage* (1434), oil painting, the National Gallery, London. Art Resource, NY.

4. Otto Dix, *The Skat Players* (1920), oil painting and collage, reproduced by kind permission of Staatliche Museen zu Berlin, Nazionalgalerie: acquired by the Association of the Friends of the Nationalgalerie, with aid from Ingeborg and Günter Milich. Bpk/Jörg P. Anders.

5. Pieter Bruegel the Elder, *Massacre of the Innocents* (1565–7), oil painting, The Royal Collection, England. By permission of Royal Collection Trust/© Her Majesty Queen Elizabeth II 2016.

6. Hans Holbein the Younger, *The Ambassadors* (1533), oil painting, the National Gallery, London. Art Resource, NY.

7. Rembrandt van Rijn, *St. Bartholomew* (1661), oil painting. By kind permission of the Getty Museum, Los Angeles.

Preface

In recent years waves of fashionable subjects, theories, and "turns" of attention have swept over the work of historians, yet the enduring rock on which all historical research relies is evidence. It is often the case that useful materials are scarce, and endless ingenuity has been applied to fill the gaps—which is all the more reason to cherish those sets of easily accessible sources that are available. The essays that follow deal with one such set, which, considering its easy accessibility and the window it offers into the past, is insufficiently used: the evidence of the fine arts.

Studying images has not been a standard weapon in the historian's armory. The exceptions, such as Jacob Burckhardt, have been applauded for their insights, but not much imitated. In recent decades, however, attitudes have begun to shift, and there has been increasing concern to include the creations of artists in the attempt to understand the society of a particular period. A notable example is a recent work that seeks to link two subjects that have long remained elusive and little studied: animals and individual identity in early modern times. This is a lavishly illustrated volume, and at one point, in order to document the absence of sunshine in the labyrinth at the Sun King's Versailles, a picture of a hedge is used to show that its height cast the adjacent area in permanent shadow. In other words, without the image the argument could not have been made.[1]

This may be a tiny example, but it is indicative of an attention to the visual which has begun to infuse the writing of history. There is a long way to go, and some of the essays that follow suggest how limited the adjustment has been. Nevertheless, the very existence of these essays confirms the recognition that has been gained: that historians, too, have a stake in understanding the visual arts. We may not focus as much on issues of style or form, and our interests may diverge from those of the professional art historian. But there can be no question that images have

become essential evidence in the exploration of the past.

*

The essay that gives this book its title opens the proceedings for two reasons: it touches on the history of taste, a subject that invites the attention of both disciplines; and it emphasizes how large are the questions that the response to art—even to a small drawing—can provoke. The book is then divided into eight specific topics, organized by subject matter and geographic areas. Here a few essays are joined by reviews of exhibitions and books—the majority of the pieces—that explore the relevance of the arts to the work of the historian. It is also worth noting that, although the contents were published during a span of over forty years, from 1973 to 2016—which accounts for the occasional minor repetitions—the steady increase in per annum listings may well reflect the growing interaction between the two disciplines.

Part 1 looks at the general issue of the advantages the historian gains by regarding art as essential evidence, and also at some of the problems. In addition to my first review, in the early 1970's, of books that emphasized how useful the interaction could be, three specific examples are explored. The first is a study of the sugar trade that reveals the relevance of this perspective in economic and material history; the second serves the same purpose in the history of peace and war; and the third suggests the worlds that a single painting can open. To end the section two essays investigate the limits on this interaction between disciplines. The starting point is an attempt, by Peter Burke, to lay out ground rules for the use of images. Taking these seriously has consequences that are explored in an essay that questions easy assumptions about their impact. Here issues of meaning and response suggest how difficult it can be to illuminate history through art.

In Part 2 the focus is on a favorite entryway into the arts for the historian: the portrait. This is a standard prop for the biographer, and it has also served to fix in the mind the facial features of individuals, and the clothing and general appearance of the people of different periods and places. As will be clear from these reviews, however, it is not just obvious features of a person or an age that can be gleaned from portraits. When closely examined, they offer unique insights into larger cultural and social issues.

Another topic that requires the historian to grapple with the arts is patronage, especially when it leads a patron to assemble a collection. Why does this happen? What does it tell us about the collector or the times?

These are some of the questions that are addressed in Part 3. Here we see what can be learned from one particular strand in the works that were bought by the British royal family over the centuries. We can learn, too, from the activities and heritage of individual monarchs, such as Charles I of England, the Emperor Rudolf II, and Philip IV of Spain. No less suggestive are interests in particular kinds of creativity, such as drawings and prints. And the tastes of a perceptive individual like Cassiano del Pozzo or Helen Clay Frick can tell us much about the outlook of an age. In all these cases, however, the revelations are the most telling when the art that is collected takes center stage.

Each of the final five parts deals with a particular geographic area within Europe: the German-speaking region, the Netherlands, Spain, Italy, and Venice. In part, these essays explore what is distinctive about the work created in different places. This is a perennial historical question, closely linked to the many attempts to define what is particular to a given area: what holds its people together and gives them a recognizable identity. Even small, adjacent territories like Flanders and the Low Countries go their own ways, and it is revealing to see how they part company. Equally important, though, is the cross-cultural interaction, which is especially notable in the case of the Flemings, whose influence is visible in both Spain and Italy.

Throughout these essays, the constant drumbeat is the importance to the historian of understanding the images that were characteristic of a place or time. At the very least, they offer a layer of evidence without which the story of the past remains incomplete.

Theodore K. Rabb
September 2017
Princeton, NJ

Why Does Michelangelo Matter?

A First Question: Why Does Michelangelo Matter?

The recent exhibition in London entitled *Michelangelo Drawings: Closer to the Master* enjoyed the largest advance sale the British Museum had ever known. For a mere 90 drawings—hard to see unless one got quite close, which was not easy in the crowds—the venerable Museum attracted more than 150,000 visitors in six months. To prevent the jostling from bursting all bounds, entry was limited, but so great was the demand that, for the first time in its 250-year history, the Museum remained open until midnight on Saturdays.

The critics were rapturous. "Nothing short of a religious experience," intoned the often curmudgeonly Brian Sewell in the *Evening Standard*. "It will take your breath away again and again," said the *Sunday Times*, while other papers offered encomia like "unmissable," "astonishing," "absolutely magic," and "truly staggering." Much as he liked to be praised, even the gruff artist himself might have been taken aback.

A few weeks after seeing the show, I was in Rome, where more people seemed to be standing in front of Michelangelo's *Pietà* than in the whole of the rest of St. Peter's. When I ventured to the Sistine Chapel—assured that this was a quiet time before the crowds came for Holy Week—the slow-moving line, three-deep, started so far away that it took an hour to reach the entrance, and once inside it was barely possible to move. This was a cold and rainy late-winter morning, but the chapel was hot and humid from the press of visitors. Most had given up trying to look at the ceiling: it was just too difficult to keep focused amid the swiveling shoulders and elbows. A few paid passing attention to the masterpieces by Perugino, Botticelli, Ghirlandaio, and others that graced the walls, but just about everyone was looking at Michelangelo's gigantic *Last Judgement*.

How many had braved the discomfort for that brief moment with the master? The Sistine Chapel, built to what were assumed to be the dimen-

sions of Solomon's Temple, covers an area of 5,700 square feet. Without trying to estimate exact numbers, I could see no area where visitors had more than six square feet to themselves, and some had less. In other words, there were at least a thousand people in the chapel that off-season morning—one part of a steady stream that flowed all day. My guess is that in one week, perhaps in one day, more people came to see Michelangelo's work for themselves than in the entire first century after the chapel was completed.

Why? What is it, in this age of hype and empty celebrity, that makes the name of Michelangelo so magnetic? One can perhaps understand the draw when the Impressionists or van Gogh take over a museum. These are the prophets of a modern sensibility: lyrical, colorful, and yet with an edge of experimentation and a tinge of revolt. Michelangelo, by contrast, is remote, often deliberately unapproachable, cerebral, hard on himself (and all around him), and devoted to values, both aesthetic and spiritual, that are now long gone.

Nor has he always ranked so high. To contemporaries, it is true, he was "Il divino." And he was the only living person included by Giorgio Vasari in his collection of biographies of the stars of the Renaissance, *Lives of the Artists*, a book which became a milestone in the study of art history. Vasari regarded Michelangelo as the summit of what had been a brilliantly creative age. As he put it, after the achievements of Giotto and his followers in the three diverse fields of painting, sculpture, and architecture,

> the great Ruler of Heaven looked down and, seeing these vain and fruitless efforts and the presumptuous opinion of man more removed from truth than light from darkness, resolved, in order to rid him of these errors, to send to earth a genius universal in each art.

For Vasari, Michelangelo's transcendent abilities in all three fields required the coinage of an entirely new term, "genius." No other word could describe how he towered over all his contemporaries. Yet that verdict did not last.

For Bernini, the dominant figure in sculpture and architecture a century after Michelangelo's death, his great predecessor still represented the standard against which his own work had to be measured. But just fifty years later, the critics and leaders of taste of Enlightenment Europe were less impressed. Unlike Titian, who has never been out of favor among collectors and connoisseurs, Michelangelo was not highly regarded in the eighteenth century. In the Age of Reason, of self-assurance and relaxation, Michelangelo seemed too tormented, too unfulfilled, too emotional. The

serenity of Raphael, the pastoral qualities of the Dutch masters, the re-
straint of a Claude or a Poussin—those were the qualities that won the
highest admiration.

The turnaround that followed during the nineteenth century was as
remarkable as the previous decline. This has not been much studied,
though in an excellent book, published in 1998 by a Danish scholar, Lene
Ostermark-Johansen, English taste serves as a case study in how the
change came about.[1] She pointed to a number of influences and shifts in
sensibility, but argued that the transformation derived primarily from the
new aesthetic of Romanticism. Great art, according to the Romantics,
flowed from emotion and expressiveness. Both were embodied by Mi-
chelangelo. Who else conveyed so potently the struggles, the independ-
ence, the originality, and the power that were the mark of the artist's call-
ing? In his combination of classical style with personal idealism, he was
the equivalent in the visual arts of Beethoven in music. For the nineteenth
century, these were the twin titans of the proud but forceful creative im-
pulse, the exemplars of what it meant to *be* an artist.

But today? We share the values neither of the sixteenth nor the nine-
teenth century. We may appreciate, but we do not feel, the religious pas-
sion that drove Michelangelo repeatedly to draw scenes of the crucifixion,
and to write anguished poetry on this theme. Decades after the death of
Savonarola, the artist said he could still hear that fiery preacher's thunder-
ing voice—an indication of the fear of heavenly judgment that is hardly as
central to Western consciousness in the twenty-first century. Nor, in this
post-Freudian age, are we much taken with notions of divine sparks, su-
perhuman energies, or the inspiration that Vasari had in mind when he
coined the term "genius."

Might it simply be the force of public relations and the promotion of
tourism that make the Accademia in Florence—home of the *David* and
figures of agonized slaves—or the *Pietà* and the Sistine Chapel in Rome
essential stopping-points for visitors? If so, then why the rush to see the
drawings at the British Museum? These, after all, are the most elusive and
personal of an artist's works. Rarely finished, they do not offer the coher-
ence or the compelling vision of a completed sculpture or painting. There
is neither the texture of stone nor the full color of paint to draw the eye.
One could even argue that most of these quick jottings, generally experi-
mental, and produced in order to solve specific problems rather than to
make artistic statements, are as much technical as aesthetic ventures.

The case is even stronger for Michelangelo's rival Leonardo, who left a

vastly larger body of work in his drawings (some of which have become as familiar as his paintings) than in any other medium. By contrast, Michelangelo, obsessively secretive about his ideas and intentions, burned the bulk of his drawings; we are left with some 600 out of a lifetime's production that may have exceeded 10,000. And yet, those drawings still exert, as the British Museum exhibition illustrated, a potent appeal. Could it be that, even more than the attention-grabbing *Moses* or *The Creation of Adam*, they give us a keener insight into the nature of Michelangelo's art?

As one moved from drawing to drawing at the London show, the immediate and overwhelming impression was of a state of constant and acute restlessness. Michelangelo boasted that, although he created thousands of figures, he had never repeated himself; nowhere is this boast more triumphantly demonstrated than in his drawings. There are a few calm, finished portraits—masterpieces in the elegant exploration of physiognomy and character. But the overwhelming majority were not meant to be completed. They were for the artist's own use, and (as in the case of Leonardo) their inventiveness is dazzling. The questing, the search for a new or an ideal form, never ceased.

A perfect instance is one of the British Museum drawings—not by any means the most famous, but absolutely symptomatic of the artist's irrepressible creativity. It depicts the scene from Ovid where Apollo's son, Phaethon, having persuaded his father to allow him to drive the chariot that each day takes the sun through the heavens, loses control. To prevent the world from being burned, Jupiter hurls one of his lightning bolts to send Phaethon and his chariot crashing to earth. Youth, horses, and chariot end up in the Po river, while Phaethon's three sisters and a relative, witnessing the disaster, are transformed into poplar trees and a swan. It is a scene riddled with problems of presentation: horses, chariot, and Phaethon himself, all turned every which way as they hurtle downward; Jupiter and his thunderbolts; the observers in mid-transformation; and the stately river Po (*Illustration 1*).

But that is exactly the challenge that Michelangelo relished. In the sky, in motion as he hurls his thunderbolt, is the small but powerful Jupiter. Below him, falling helter-skelter, are the central, contorted figures in the drama, Phaethon and his horses. Although their bodies are in bizarre positions, they do not seem unnatural: Michelangelo has imagined them as real living beings falling from a great height. Finally, at ground level, we see the sisters turning into trees, the nascent swan in the distance, and, calmly observing it all, Neptune, symbolizing the Po.

It is as if we are witnessing a burst of ideas tumbling onto the paper before us, yet somehow it all hangs together. And having tossed off the sketch, Michelangelo sent it to the young nobleman Tomasso de' Cavalieri, of whom he was inordinately fond, adding a note at the foot of the sheet: "If this sketch does not please you, say so . . . in time for me to do another tomorrow evening." The promise that he could quickly reinvent the composition was typical of the artist. Eventually the sketch led to a formal presentation drawing, but it is in the stylus-and-black-chalk "first draft" that we see the vitality and élan that help define Michelangelo.

Equally telling were the video screens set up in the exhibition at the British Museum. They showed how individual drawings, such as God's hand in *The Creation of Adam*, fitted into the final work of art. The videos helped one understand how the different elements in the first sketches— seen in varied sizes and from different angles—slowly blended together as Michelangelo attacked and re-attacked individual problems until the whole took shape. The process was not uncommon among the artists of his age, but there is always a sharpness of touch, a fascination with the hard matter of reality, and a ceaseless quest for the ideal form that is his alone.

The endless and urgent ingenuity is, surely, one of the secrets of Michelangelo's allure. Working alone—unlike his most famous contemporaries, he did not set up a large studio full of assistants, but took on just a few pupils—chalk or pen in hand, he confronted his small pieces of paper day after day, always to magnificent effect. The brooding figure at the front of *The School of Athens*, reputedly Raphael's portrait of Michelangelo, sums up this image of the fierce and lonely explorer, driven by unstoppable inventiveness. It is what sets him apart.

But that is not all. There is also an unmistakable sense of command, an instinctive expression of power. This is not just a matter of personal determination, a demand for attention emanating from the artist himself. It is a potency and vigor that radiate from all of Michelangelo's creations, especially his human figures. The Sistine Adam may not yet have life, but the strength latent in every one of his muscles and limbs is already daunting. The young David in the Accademia, supposedly overmatched by Goliath, staring into the distance, is about to unleash a massive burst of power that tautens his every sinew. He may represent, as has been said, the Renaissance ideal of the contemplative conjoined with the active life, but there is no question, as one looks at his oversized right hand, which of the two ideals dominates. Even the slaves struggling to emerge from their unfinished marble, nearby in the Accademia, pay tribute to the force of

their physicality. So, too, does the dead Christ of the *Pietà*, far too large to be so easily balanced on his mother's lap.

It is this celebration of the human body, and the strength inherent in its every movement, that again distinguishes Michelangelo's art. No other artist so unerringly and consistently gives his figures the aura of almost unconscious immensity. In *The Last Judgement*, power flows naturally from the avenging Jesus at the center of the fresco. But it pours no less natural-ly from all the saints who surround him, as it does from the figures con-demned to eternal punishment. In fact, both heaven and hell seem popu-lated by the top graduates of body-building programs. St. Peter clutching his keys is a massive figure. St. Bartholomew, holding his flayed skin, on which Michelangelo has portrayed his own agonized face, suggests colos-sal strength. Even the muscles in the arm of St. Catherine of Alexandria seem ready for strenuous action.

Of course, it would be as frivolous to suggest that Michelangelo's popularity is linked to the contemporary world's obsession with fitness as it would be to see him as a lodestar for current discussions of homoeroti-cism. Yet his delight in the human body—more exuberant than that of any other Old Master—is not irrelevant. It is difficult to name any lumi-nary of the Western cultural tradition who was more closely attuned to the grace as well as the weight of our fleshly appearance, of our sheer joy in being alive. Michelangelo's art focuses on us, and we face the world in our most resplendent physical guise.

To the inventiveness, the power, and the relish of humanity must be added one complicating element. Ever the explorer, Michelangelo may have sought perfection, but it could not be achieved. One could imagine a representation of the story of Phaethon, but getting it down on paper was—however extraordinary—just the beginning. There was no way of solving all the problems the subject posed. Hence the offer to start again from scratch. This was not so much a recognition of human fallibility as an embrace of the duty constantly to do better. Thus, when a relic from antiquity, the *Laocoön*, was unearthed in Rome in 1506, Michelangelo was one of the artists who went to the site to sketch the new discovery, but unlike the others he grappled for years with the new ways to depict the body and capture strong emotions that the ancient sculpture inspired. The unattainability of perfection requires its unending pursuit.

To us, Michelangelo's work could not be bettered, but he himself was never satisfied. To be sure, he bristled when criticized, and in many of his thousands of letters he complained about critics and patrons alike. He was

nothing if not proud. But the relentless experimentation reveals a traveler who rarely felt he had arrived. Again and again, even his officially "completed" projects awaited further work. The only major section of the tomb of Julius II that was finished was the *Moses*; the slaves and captives remain embedded in marble.

If restlessness, the drive to perfection, and the love of humanity (combined with a poor opinion of most individuals —he would not have been a pleasant dinner companion) are qualities that identify Michelangelo, there remains another characteristic that may seem paradoxical: an instinctive sense of relaxation and composure that tempers the vigor. Thus the power of his figures nearly always remains latent, as if it were holding back or biding its time. Even Jupiter, as he flings his thunderbolt at Phaethon, seems barely to exert himself. Nor is there any hint of struggle as Phaethon submits to his free fall. Meanwhile, down below, Neptune is the very essence of quiet strength. Though muscled and formidable, he leans placidly on an elbow and watches unmoved as chariot and bodies plunge towards earth. If it seems impossible for Michelangelo to create a feeble or puny figure, the vibrant dynamism of his bodies is nevertheless held in check. They have an unruffled quality, as if to show that potential is all. It is this calm, as unmistakable as their inherent strength, that catches the eye.

This relaxation seems unusual only because, to Michelangelo, many appealing human attributes were of little interest. He left no room for gentleness. Even his babies are tough. Nor was there any place for sweetness or romance. What drew him to antiquity were not the heartwarming moments, such as the love of Orpheus for Eurydice, but rather the agonies, epitomized by Phaethon. Even his architectural designs have an austerity and an edge that ensure they are never merely decorative. Michelangelo does not allow us simply to sit back and enjoy what he has done. The questions are too urgent, the ideals too elusive, the problems never fully solved.

One could see the effect the artist had by looking at the crowd in the Sistine Chapel that wintry morning. Staring at the damned souls just above eye level in *The Last Judgement*, they were coming to terms, not with a scene of joy or delight, but with an unblinking look at the very nature of human existence. They may not have shared Michelangelo's assumption that existence is subject to the implacable judgment of heaven, or that their lives are shaped by the story that began on the ceiling above them and ends with the scene in front of them. But they could not avoid con-

fronting the implications of that huge, swirling fresco. Magnificent though we humans are, we always fall short. We may address our problems, but they can never fully be solved. Because the ideal is so close, however, the search must never stop. More than any other artist, Michelangelo makes us probe and think. And that is why he continues to matter.

Part One

The Historian and the Art Historian

1

What Links Historians and Art Historians?

It is a measure of how much is still to be done in developing the techniques of architectural (and art) history that buildings are inadequately used as source material by other kinds of historian, and when they are used the evidence is often misunderstood, to the detriment of history. If any justification were needed for the study of architectural history it could be that the evidence for many other forms of historical study is incomplete without the study of architectural evidence at a comparable level of scholarship.

Allsopp's strictures, intended for historians of art and architecture whose standards he considers inadequate, could be applied with equal force to historians. Interchange is a two-way affair, and if students of art and architecture have been little interested in broader social developments, historians have been no less negligent in ignoring a precious fund of evidence. As Allsopp points out, historians always seem to prefer the written statements of the past to artifacts or expressions of creativity. In so doing, as this brief, polemical, provocative book reveals, they miss unmatchable opportunities for insights into the mentality of ages very different from our own.

Allsopp has little time for elaboration, for in hardly more than 100 well-illustrated pages he takes us from Herodotus and Stonehenge to the present. But perceptive and stimulating suggestions appear on almost every page. Anyone who doubts the effectiveness of architectural evidence needs but look at the picture of Durham, juxtaposing modern government offices with the Norman cathedral and castle—"the expression of power in different ages," as Allsopp puts it. Or one can contrast the pictures of the front and back of elegant London Georgian houses, which "show a concept of architecture which was like a man wearing evening dress, of impeccable black and white at the front, and nothing but rags at

the back." This reveals the social conspiracy whereby "the gentry never went to the back door and it did not matter what the servants saw."

There are all too few art historians who take so broad a view of their subject, and many will doubtless wince at the barbs Allsopp sprays about him with abandon. In the meantime, though, what are historians to do? Should they stand on the sidelines and wait for a new generation of art historians, all the while continuing to shrug off the responsibility for considering paintings or buildings as evidence? The answer is surely "no." The task is not easy, but they must make a conscious effort to use materials which can often give a priceless insight into the way people felt, as opposed to the way they wrote or thought.

In 1966, the issues were laid out clearly and forcefully by John Hale, who condemned both historians and art historians for their isolation.[1] He held out little hope for improvement, but he did think that scholars might wish to address themselves to such questions as: What did people feel about nature? How were artists recruited, and what was the pattern of patronage? And how did styles emerge? On the whole, his pessimism has been justified, for very little has appeared since 1966 to suggest that historians are taking art more seriously: it continues to be the subject reserved for the poorly-attended undergraduate lecture on the day following Thanksgiving.

Yet historians must surely take an active role. They cannot wait for art historians to provide ready-made answers. They must be prepared to take whatever materials they can find, even if published for very different purposes, such as stylistic exegesis, and bend them to their own uses. As cases in point, the six books (besides Allsopp's) under consideration here offer good examples of the materials available to the historian who is alert to the potentialities of painting as evidence. None is concerned primarily with the broader problems that interest the historian, but then only one work in recent years has created a unique view of an entire historical era on the basis of its art—Millard Meiss' *Painting in Florence and Siena after the Black Death*. One can hardly hold up this splendid book as a standard, because few eras, certainly not the ones covered here, faced as shattering a disaster as the Black Death. It is conceivable that a book like Meiss' can be written only about a period completely overshadowed by a cataclysmic event, and it could be argued that the impact of the Black Death has never been equaled. Given the less dramatic material, and the different aims, what can these books offer the historian?

One observation must be made immediately. Like the vast majority of

works on art history, each of these deals with just one man, not with a
movement or an era. This focus also sets them apart from Meiss' book,
but by no means necessarily reduces their significance. Biography is one
of the oldest and most effective of historical forms, and in the hands of a
master, the study of a single figure can tell us more than seemingly broad-
based undertakings. One of the greatest masters of the last generation
was undoubtedly Panofsky. By looking at Michelangelo, he could uncover
new levels of meaning in the relationship between Neoplatonism and
Christianity; through Suger, the twelfth century came to life; Dürer re-
flected all sides of the Northern Renaissance; a page from Vasari revealed
the Italian Renaissance's sense of history; and a painting by Poussin
showed how views of death changed between Virgil and the Romantics. It
is not surprising that one of his disciples could devote an entire book to a
single painting by Rembrandt, using his subject to investigate popular no-
tions of science, Amsterdam society, the history of anatomy, and similar
far-flung topics.[2] For Panofsky, and those who follow his example, art is a
means of entering the mind of an age. Indeed, in his last work, *Problems in
Titian*, Panofsky specifically reproved, with a delightful quotation from
Henry James, those who would separate style from the context and pur-
pose of an artist's vision.[3]

At one level, *Problems in Titian* is, of course, a technical piece of scholar-
ship, concerned with such matters as attribution, provenance, and the rise
and fall of various influences. Similarly, there are exercises in the classic
forms of historical scholarship, notably an admirably argued and docu-
mented effort to establish the date of Titian's birth. But the book is also
much more. In his determination to unravel Titian's mental processes,
Panofsky delves into such diverse topics as the Catholic doctrine of the
redemptive power of the Virgin, the different interpretations of the Sa-
lome story, the personality of Charles V, the symbolism of clocks and
mirrors, and the hierarchy of different forms of love. Nobody interested
in the "mind" of the sixteenth century should fail to read this book. Al-
though Panofsky's purpose may have been only to explicate Titian's mean-
ing, he describes important areas of contemporary thought in order to do
so. And he uses the perspective of the art historian to disclose what oth-
erwise might remain hidden. Who else, for example, would have dared to
call Philip II "as fond of erotica as he was devout"? To whom among the
long and distinguished succession of historians of Philip's Spain would
such a startling revelation have seemed possible? Panofsky seems to re-
gard it as perfectly natural, and his point is amply proved by the pictures

that Philip ordered.

If this study of Titian suggests that historians have much to learn from art historians, regardless of the latter's intentions, it also implies that historians must have a commitment to such material in the first place. They must come to see painting, sculpture, architecture, and music, too, as vital expressions of a period's feelings. They must seek out this rich and suggestive evidence, and use it as a part of their work, not as something distinct and implicitly less significant. And they may realize that by looking at an artist's work, they can come to appreciate those feelings of an age that go beyond thoughts or words. Even Panofsky, for all his verbal facility, can only say that the Munich portrait of Charles V conveys "in a mysterious way" an impression of "majesty." One has to see the picture to sense how the sixteenth century felt the glory of an emperor who ruled half of Europe.

The prescription to take art seriously does not necessarily include the admonition that historians train as art historians. It suffices that they be able to read such work intelligently, and to use all the available evidence when working on historical problems. Yet it is surely not beyond the mere historian to question even so towering a figure as Panofsky. In the work at hand, for example, one can suggest that, even in terms of art criticism alone, there is an important omission and a mistake in the treatment of Titian's *Presentation of the Virgin*. The omission is the obvious dependence of the composition on the treatment of this same subject by another Venetian, Carpaccio, who painted it for the Scuola degli Albanese in Venice during Titian's youth. The mistake is Panofsky's emphasis on the fact that the old Jewish woman depicted in the foreground is selling eggs, a food which he regards as significant because it has no place in the Jewish ritual and therefore represents unenlightened Judaism. On the contrary: The one time in the year when eggs must be eaten is at the "Seder" meal on the eve of Passover, a possible reference to that Seder which proved to be Christ's Last Supper.

In a very different vein are White's two volumes on the seventeenth-century masters, Rembrandt and Rubens. These are scholarly works, but are clearly aimed at the general reader rather than the specialist. Unlike the "coffee-table" art book, however, the emphasis is on the text, not the plates. White is an urbane and persuasive guide, who uses his illustrations to inform the reader, not to dazzle. There is little attempt to solve problems of analysis; his purpose is to present the artist and the world he moved in. Panofsky provided a scintillating biography of Titian at the

start of his book, but this was clearly intended to set the context for the details that followed. For White, the biography itself is the end.

The writing is admirably free of unnecessary jargon. White is so careful in this regard that not once, for example, is there a reference to "chiaroscuro," a term which seems almost inevitable whenever Rembrandt, its greatest practitioner, is discussed. And there is considerable evidence of research into the general historical background. It is true that a historian might not wish to state that the Reformation burst forth in the Low Countries when Charles V died—it was still far too small a movement in 1558—or might hesitate to say that in the Jordaan district of Amsterdam "no questions were asked. Everyone went his own way, totally absorbed in the struggle for existence." But these are minor lapses. Not only does White have a real command of the history of the period, but he uses the artists to cast light on seventeenth-century Europe.

With Rubens he has the easier task. The Fleming was a courtier and diplomat as well as a painter; his life is richly documented; and he traveled to every major capital of Western Europe. Rembrandt, by contrast, remained outside public life, probably never left his beloved Holland, and appears in few and uninformative documents of the period. It must be said that, partly because of this, the Rembrandt book is the less successful of the two. To make up for his lack of information, White takes us in great detail on the walks Rembrandt must have taken to draw his many landscapes around Amsterdam. The larger significance is not apparent, and one wishes there were more effort to deal with the enduring qualities of the Dutchman's art: the humanity, the interest in ordinary people, the deep religious feeling. His reflections of Dutch life, and the contrast between his work and that of most of his contemporaries, are other subjects that would have placed him more firmly in his background. The depiction of the character, by contrast, is White's principal triumph, achieved with minimal evidence but with a convincing and subtle blending of the few available materials. As a result, however, the historian will find this to be primarily a useful introduction to Rembrandt, rather than a source of special insights into the period.

The biography of Rubens, on the other hand, illuminates much of European society at the same time as it presents a finely etched portrayal of his personality and an appreciation of his work. We are given a sense of how an artist was trained for his profession, of court life, of patterns of patronage, of a painter's image of Italy, of diplomacy, and of the variety among the courts of Europe. The politics of the first decades of the sev-

enteenth century are seen from a new angle, approached by a man who regarded kings and princes as both clients and negotiators. We see the "political animals who infested" London so much more clearly because of the contrast with Rubens, who was one of them and yet above them. Here White again shows admirable restraint with technical terms. The word "baroque" is rarely invoked to help us understand Rubens, and yet the instinct for grandeur, massiveness, and exaggeration that he shared with his contemporaries is strikingly and forcefully conveyed. In sum, this is a book that anyone interested in the seventeenth century should make sure to read. The result will be an understanding of how, through the eyes of a painter, new dimensions can be added to the study of history.

Both Panofsky and White are unusual practitioners of their discipline in that they are interested in more than art alone. They display a familiarity with political and intellectual currents which brings their readers to an appreciation of more than the paintings and drawings of a single figure. But such breadth of vision is all too rare among art historians. More representative is *Velázquez' Work and World*, by López-Rey, one of the leading interpreters of the Spanish master. This book shares with White's work little more than the mention of "World" in the title, a word whose different meaning soon becomes apparent as one searches in vain for insights into Spanish court life, royal patronage, the training of an artist, or even the contrast between the artist in Seville and the artist in Madrid.

But it would be a mistake to assume that *Velázquez' Work and World* is of no help to the historian. Works like this, technical and aimed at narrow scholarly interests, merely require more effort. Whereas Panofsky and White teach their lessons themselves, the other, less helpful, kind of art history demands that historians develop their own expertise, so as not to miss the potential rewards. Thus, reading between López-Rey's lines can lead to an enriched appreciation of such diverse features of seventeenth-century life as the continuing dominance of Italy in cultural affairs, the hazards of court appointments, the Spanish monarchy's view of itself, and the impact of international developments on the mentality of observers in Madrid. If historians have to dig for these valuable insights, that is exactly what they must be prepared to do.

It is not enough to pay obeisance to Velázquez' greatness or to outline his career. One has to ask such questions as: Is the *Surrender of Breda* an antiwar picture? Why is Mars painted as a totally exhausted soldier for the Royal Hunting Lodge? And why pick for another painting at the Lodge the subject of Menippus, the ancient philosopher known only for being a

Cynic? Questions such as these reveal the painter's interpretations and reflections of his time. They not only bring him to life, but also place him in a context that is essential if we are to appreciate the aims of his work. It is the blending of the skills of the historian and the art historian that leads to a mutual broadening of horizons.

The same expansion of understandings is available from the handsomely produced English translation of Georg Christoph Lichtenberg's description of Hogarth's *Marriage à la Mode* series. First published in 1798, the book offers one of the fullest explications of the six engravings. It was written by an Anglophile German with considerable intellectual attainments in many fields, from astronomy to linguistics, and with extraordinarily acute powers of observation. Apart from underlining the pointed morals which Hogarth was drawing, however, Lichtenberg confined himself to a detailed discussion of the content of the pictures—essentially placing the facts before us.

Yet the works can also be perceived as invaluable evidence of the social customs and outlook of eighteenth-century Englishmen. Hogarth's jaundiced view of all of his characters—whether they be the reckless aristocrat, the avaricious merchant, or the opportunistic lawyer—leaves nobody unscathed. But through his eyes we also see the preoccupations of different classes and the customs they enjoyed to while away their time. The public "bath," auction mania, and the fashionable soirée, complete with hairdresser and Italian castrato, come to life with an immediacy that cannot be found in any other source. Art reveals how people spent their days; it takes us beyond the notable events into private behavior. Some artists conveyed this more consistently than others, and Hogarth is so remarkable precisely because he devoted himself to social commentary. But that means one cannot write about him without also describing the era in which he lived. When Coley recounts Hogarth's career and aims in a brief introduction to *Marriage à la Mode* in this volume, he quickly becomes involved in various features of eighteenth-century England: the standards of taste among bourgeoisie and aristocracy, the changing forms of patronage, the admiration for French culture, the economic status of the artist, and the employment of art as propaganda—all essential Hogarthian themes.

With such a subject, a more ambitious author can weave an entire social and cultural history of eighteenth-century England. And that is what Hogarth's life inspires in Paulson's two magisterial volumes. They brilliantly achieve, through the study of a single artist, the blending of art, history,

and general culture that must stand as an exemplar for future work. In pursuit of Hogarth, Paulson takes us to Walpole's Parliament; to Tristram Shandy; to Garrick, Fielding, Addison, and Steele; to society's strolling places and hospital routines; to popular songs, black magic, and newspapers. It is a dazzling journey through Augustan London, illuminated by an erudition which, although lightly carried, establishes irrefutably the interdependence of social, political, literary, and artistic themes. The richness of Hogarth's creativity and life has at last received its due.

It may be that a biography of Hogarth has special advantages; that the subject lends itself to such treatment because, in contrast to most artists, he took the role of social and political commentator with unusual seriousness. Bruegel in the sixteenth century, Daumier in the nineteenth, and the caricaturists of the last two hundred years may be in the same company, but they still occupy only a small corner in the history of art. Most painters speak to eternal verities and, like Rembrandt, are not interested in sardonic interpretations of their contemporaries' way of life. Public figures like Rubens and Velázquez give us some insight into their time, but only because of the nature of their position and patronage. And they, too, were exceptional. Thus, if artists can be fitted into three categories according to their interest in commenting explicitly on their own age, one might well find the social-minded (e.g., Hogarth) to be the least common, the public figures (e.g., Rubens) more common, and the personal (e.g., Rembrandt) the most common. It is also apparent that some ages put more of themselves into their art than other. The great medium of expression in the Renaissance was paint, and to some extent this was still true in the sixteenth, seventeenth, and eighteenth centuries. But painting in the twentieth century no longer seems as central as those other visual arts, films and television.

A further complication is the old question of representativeness. What can one figure, however talented, tell us about a whole period? Obviously, a single genius cannot be taken to stand for an entire generation, or even for a literate elite. But there is no doubt that an artist can distill the experiences of an age, and can sum up and clarify what is otherwise elusive and confused. Moreover, the forces that shape an aesthetic must be powerful if they are to move someone who is deeply committed to the articulation of feelings both personal and common (since the audience has to be in mind along with the individual's own concerns). The choice of subject and the mode of expression must surely reflect broader issues, for it would be nihilistic to argue that they are governed solely by whim, par-

ticularly since artists never stand alone: they are always part of some movement or style, whether as originator, participant, or heir. The case is only strengthened when entire bodies of artists, such as the seventeenth-century Dutch painters, focus attention on the societies in which they lived.

Considerations such as these, emerging from an attempt to assess the place of art in history, serve to underline how much still has to be done before genuine integration takes place. Most of the comments remain at the level of hypothesis, but if the situation is to change, the impetus must come from the historian. A Panofsky is a rare phenomenon, and even he had highly specialized interests. Major historical subjects like the economics of painting, the purposes of patronage, or the sociology of artists may long remain peripheral even to the most broadly gauged art historian. And the application of the findings of anthropology and psychology—for example, in explaining how and why certain styles or world-views are adopted—is clearly of little interest. It is up to historians, therefore, not only to undertake the research into subjects they need to know more thoroughly, but also to develop some of the aesthetic sensibilities of the art critic. Without the latter, they will have to leave untouched the vast areas of art history that have not attracted a Panofsky or a White. If this is, indeed, what the future holds, then there can be no justification for revising Hale's gloomy prognosis. But if, instead, historians stop ignoring art whenever a good guide is not available, and determine to use even a work like López-Rey's to gain the unique insights that a painter's evidence provides, then there is every likelihood that a vital new dimension will be added to the study of the past.

2

What Role for Art in the History of the Sugar Trade?

The Sugar Trade is the handiwork of more than forty scholars, designers, and illustrators, not to mention the dozen members of the committees under whose auspices it was produced. With well over 300 handsomely produced illustrations; nearly 600 large, glossy pages; and a hefty slip-case—the book might seem on first glance to be another lavish coffee-table ornament, more notable for its pictures than its text. Though it could have used the images more productively, as we will see, this first impression is far from the case. Strum, the principal author, has written an extraordinarily wide-ranging assessment of the many ramifications of the sugar trade that connected Brazil, Portugal, and the Netherlands in the early-seventeenth century. The one question that arises as one encounters the various methods by which Strum brings his story to life is whether the illustrations are deployed to the best effect.

The basic narrative is straightforward and not unfamiliar. From modest beginnings in the mid-sixteenth century, Brazil became, within fifty years, the world's chief source of sugar. Ever-increasing production not only made fortunes for the Portuguese and the Dutch who were involved in its refinement, transportation, and sale, but it also changed eating habits and tastes. Sugar had entered the market as an elite luxury, sought after as a decoration and as a component of meat, fish, and vegetable dishes; wider availability eventually gave it a new prominence in what we would call desserts—fruit, cakes, and various kinds of sweets.

To tell this story, Strum has to draw on analytical methods that range from the chemistry and biology of preservation to numismatics and even the history of trades (as confectioners became independent of bakers). The wealth of issues raised by the production, refinement, commerce, and consumption of sugar seems endless in this telling, as is the application of tools from many disciplines that help explain the creation and impact of

so broadly consumed a commodity. Thus, Strum offers chapters on inter-
national diplomacy and warfare, because they affected deliveries; on the
perils of maritime navigation, which affected transport; and on such issues
as forms of credit and shifts in attitude—all of which affected the ways in
which sugar came to be an essential presence in the lives of people of eve-
ry class and rank.

Such breadth of coverage is familiar from recent work in material histo-
ry, especially in the study of foodstuffs. What sets Strum's book apart is,
in his own words, his "significant research into images." The lavish illus-
trations, in other words, are not just a device for enlivening an otherwise
sober account in order to appeal to a broader readership; they are integral
to Strum's argument. The works of art, the maps, and the other types of
visual evidence, instead of being merely decorative, are a means of analyz-
ing sugar's ever-widening role in society. Unlike previous attempts to inte-
grate such evidence into historical research, Strum's aim is not to decode
the pictures in order to expose currents of thought but to present them as
evidence that will help us to detect basic shifts in daily existence.

It seems appropriate to focus on this particular weapon in Strum's ar-
mory, since he emphasizes it as a distinctive element in his enterprise.
What emerges, moreover, is revealing: we come to see how stimulating
this concern can be, as well as how its effectiveness can be limited.

The most striking of the many illustrations in the book comes near the
beginning—Tomás Hiepes' *Table with Sweets* of 1624. Hiepes was a Span-
ish artist who specialized in *bodegónes*, the still-lifes that were a new and
favorite genre during this period. They often showed food, but this par-
ticular scene is notable, not so much for the pastries and icing that are its
main subject but for the pieces of sugar cane that reveal the source of the
treats. The painting is almost a tribute to a new industry and the tastes
that it made possible. There could hardly be more vivid testimony to the
role that sugar had assumed in the lives of Europeans.

Nonetheless, although the picture is a wonderful addition to the book,
promising a powerful means of understanding the place of sugar in seven-
teenth-century society, the larger interpretive possibilities are left unex-
plored. In fact, the painting does not once appear to have been mentioned
in the text. As a result, it ends up serving exactly the same function as the
illustrations in a coffee-table book; it decorates and enhances but does
nothing to advance the argument. As it turns out, this is how Strum treats
nearly all of the many paintings and objects that are reproduced in his
book. His "significant research into images" amounts to an impressive

collection of colorful adjuncts to his narrative, but prompts no analysis of the materials he has assembled.

In the wake of such studies as Brown and Elliott's investigation of the building and adornment of the Buen Retiro in Madrid as a window into the policies of the Count-Duke of Olivares and Philip IV, historians surely have an obligation to treat images as more than attractive accompaniments to their research.[1] They need to see what light those images cast on the findings themselves. The implications of the Hiepes painting are relatively easy to suggest, but they deserve to be included in the account of the growing popularity and availability of sugared desserts. The art historian's basic apparatus—if not the support, size, and location of a painting, at least the medium—should serve as a model in the identification of a work. And the analytical demands of explicating an image deserve no less attention than the effort to understand credit exchanges or the process of sugar refinement.

A few examples suggest the opportunities that Strum could have pursued. For a start, although his attention to charts and maps—crucial elements in understanding both how sailors operated and how the world was perceived—is commendable, the differences between these two renderings of reality should not be ignored. The charts that are reproduced in *The Sugar Trade* are all relevant, but they receive none of the analysis that would have indicated how mariners actually used them, what they were required to contain, and why they were indispensable guides in a voyage. Strum simply tells us what they are and no more. Nor does he draw any contrast between charts and decorative maps, which were usually regarded as informative ornaments that could adorn a wall—as in such seventeenth-century paintings as Johannes Vermeer's *Portrait of the Artist in His Studio* (c. 1666). As a result, the reader would never know that the lovely world map and the fine example of *Leo Belgicus* (the cartographical depiction of the Netherlands as a lion) served a purpose quite distinct from the mariners' charts. Yet the divide between ornamentation and practicality, which underlies the entire topic of the rise of sugar, would have been particularly appropriate to expound.

The book also has an abundance of city scenes and portraits, beautifully reproduced, but again for only limited purposes. In order to set the stage for his story, Strum lays out the major political developments of the time, concentrating on the Iberian Peninsula, on warfare, on empire building in the New World, and on the role of the Dutch during these decades. This is useful background, but the potential information hidden in his pictures

of busy city streets and squares, and in portraits of some of the *dramatis personae*, is left largely untouched. What, for instance, is an African doing at the very front of the magnificent view of Lisbon that is the first double-spread illustration in the book? If, as Philip II himself noted, the city was full of slaves, what is this one doing with a sword at his side? Similarly, why not probe a little into the splendid full-page paintings of an Amsterdam businessman or a Dutch admiral? Why not explain the businessman's coat of arms, or the medallion that the admiral wears? The chance to encourage readers to look closely, to use images as evidence, is lost. Another double-spread reproduction, Alonso Sanchez Coello's *Banquet of Monarchs* (c. 1599), at which nothing sugared is visible, seems to provide no more than an opportunity to list all the dignitaries who were present, many of them with no connection to the sugar trade.

The benefits of closer examination are manifest in one of the most striking of the illustrations in *The Sugar Trade*—a full-page portrait of a woman standing behind a counter, selling small sugarloaves. All we are told is that she is a Glasgow shopkeeper of the eighteenth century. Scotland is not mentioned in the chapter that follows, and a few hundred pages later, in the list of credits, Strum informs us only that the artist is anonymous and that the picture is in Glasgow. Yet one feature of the painting catches the eye immediately—the necklace that the woman wears. Hanging from it as a charm is, of all things, an anchor. This visual detail, which strongly underlines one of the book's themes—linking trade, travel by sea, and the mariner with sugar consumption—remains unremarked. Whether one of the woman's relatives was a sailor (she is wearing no rings that might suggest a husband), or the artist made the connection on his own, we may never know. Yet such evidence, uniquely available through the close examination of an image, is precisely what this otherwise exemplary interdisciplinary study overlooks.

In one case, Strum does unpack the meaning of a picture—*The Milch Cow*, an English cartoon now in the Rijksmuseum. Thanks to the caption in the cartoon, Strum is able to identify the various protagonists and the message that they convey. Even in this instance, however, he misses the implications of the cartoon being an English picture, and he does not indicate why the caption's identification of William the Silent's "purse" as a "pail" is changed to "pocket" and "bucket." Despite the many insights that Strum provides, we miss the attention that he might have paid to the possibilities offered by images.

This criticism is not intended to lessen the appreciation for the wealth of apt illustrations in the book. There has never been such a gathering of relevant objects, from sugar bowls to coin presses, nor such a collection of informative depictions of the stages whereby sugar made its way into European mouths, from harvesting and refineries to shops and tables. The range of sources is exemplary, encompassing manuscripts, prints, tiles, shop signs, coins, and other artifacts, as well as paintings. It may seem churlish to ask for more, but when the foundations have been laid for an interdisciplinary endeavor that embraces not only politics, the sciences, and economics but also the arts, one is entitled to expect that the illustrations Strum has included will receive analyses commensurate with the detailed investigations he conducts in these other fields.

Can an Exhibition Illuminate Peace as Well as War?

It is easy to think of war in terms of its images—arrays of soldiers as they appear in depictions from ancient Assyria to the present; rows of the dead in Matthew Brady's photographs; early flickering films of troops surging out of their trenches in 1916. Equally, it is hard to imagine a moviegoer who has not been engulfed by the mayhem, whether hand-to-hand combat in antiquity or explosions and devastation in modern times. Far more difficult is the task of envisaging peace.

Yet that is precisely what was attempted by the exhibition mounted in Westphalia in 1998 to commemorate the 350th anniversary of the treaties that take their name from that region of modern Germany. The Peace of Westphalia ended what Europeans long regarded—until the twentieth century set new levels of inhumanity and carnage—as the most brutal war in history, the Thirty Years' War. And the conflict deserved its reputation. Appalling in its deliberate assaults on civilian life, it began mainly as a bitter religious struggle, but gradually became a naked search for power among increasingly aggressive states, even as it ravaged much of today's Germany.

Yet the unmistakable consequence of all the slaughter was a reaction to the horrors by contemporaries that changed assumptions and attitudes beyond recall—a reorientation that propelled Europe toward the modern age. It is clear, for instance, that the revulsion at the bloodshed and depravity associated with soldiers prompted the establishment of tighter military discipline: stricter organization, more formal training, and the isolation of troops in barracks. And civilian and battle casualties fell dramatically during the century that

followed. For this reason alone, 1648 would be a major landmark, like 1066 or 1789, but its main claim to fame is that the peace treaties hammered out in that year not only proved to be entirely new kinds of diplomatic agreements but also created a system of international relations that survived until World War II.

To celebrate these treaties, a vast exhibition was mounted in three sites in Münster and Osnabrück, the Westphalian cities where the negotiators spent much of the 1640s and where they finally signed their accords. The exhibition, sponsored by the Council of Europe and made up of some 1,500 items, opened on October 24 1998 with ceremonies that featured the combatants' descendants in the persons of ten kings and queens; eleven other heads of state, including Vaclav Havel; and a prince and a grand duke. To put it all into context, however, the displays looked back to the war and its origins. They suggested how Europe's political, military, and artistic cultures were transformed by the ravages of a seemingly endless war, and they did not shrink from a chilling look at Nazi interpretations of the peace.

For the historical background to the war, one started in the Dominican church in Osnabrück, where paintings, printed broadsides, and sculptures documented the vicious confessional conflicts among Roman Catholics, Lutherans, and Calvinists. Virulent propaganda, however, rarely inspires great art. Thus *The Ship of the Church*, attributed to the Catholic Jacob Loef, carries revered biblical figures, including Jesus crucified on a mast. More to the point, the ship is followed by a dozen or so little men, who are identified as Luther, Hus, and other heretics. Fully clothed, waist-deep in the water, and vainly brandishing weapons, they seem more absurd than serious in their threat to the Church. From the Protestant camp a crude anonymous painting shows a monk making love to a nun, their union blessed with tiny monster-children. They are surrounded by symbols of lust, and presided over by a benign, red-nosed pope.

In this setting, surrounded by liturgical artifacts and church scenes that demonstrate the differences among the faiths, it was startling to find an authentic masterpiece, Bernini's bust of Pope Urban VIII. Deep in contemplation, the shrewd and cultured pontiff, dressed in an exquisitely detailed cape and hat, seemed almost

out of place amidst the products of fierce confessional strife, especially since he became an advocate of peace and compromise in the 1630s. Yet the sculpture did have a clear purpose: to remind us of the dignity of the faiths. We saw it, too, in the images of church buildings, which, together with the Bernini, offered an essential contrast to the omnipresence of rivalry and hatred.

For artifacts of the war itself, one had but to travel a few hundred yards, to Osnabrück's main museum. Here masterpieces were more common, in the portraits of the main protagonists—notably a gleaming canvas (remarkable even in the company of Velázquez and Rubens) by van Dyck of the Spanish general Ambrogio Spínola, whose intelligence shines through an awkward pose in full armor and ruff. Though he did not inspire particularly memorable paintings, the most vivid personality was the Swedish King, Gustavus Adolphus, the Lion of the North, who saved the Protestant cause as he swept through Germany until killed in battle. Though painters never did justice to his commanding presence, a monumental bronze bust by Hans von der Putt suggests his charismatic power, as does a vicious sword that he probably wielded with murderous accuracy, and his drawing of a battle plan that reflects his mastery of the art of war.

This exhibition was largely focused on the leaders who kept the war going for so many years. As a result, the scenes of fighting, the townscapes, the portraits, and the broadsides all served to underline the steady decline of the religious passions that had prompted the war. We thus saw one of the major shifts of the age, as politics, territorial ambition, and the quest for loot became driving forces for the combatants. Velázquez' *Surrender of Breda*, perhaps the greatest work the conflict inspired, could not be lent by the Prado, but it adorned the catalog, showing the Catholic general Spínola gently comforting his Calvinist Dutch opponent. Here we confront the dwindling pleasures of victory, even over religious antagonists. And the Dutch response after they recaptured Breda, Hendrick de Meyer's *The Withdrawal of the Spanish Garrison*, is a calm country scene, surveyed by a peasant and his dog, with covered wagons quietly passing by on a fine autumn day. Yet we must not mistake hope for reality. Despite the longing for peace, the final conference had to be split—for seven years—between Protestant Osnabrück and

Catholic Münster, and Pope Innocent X denounced the treaties as "invalid, iniquitous, damnable, inane" for their concessions to Protestants. Luckily, the Pope's fulminations were ignored.

It is also worth noting that the Osnabrück show ended in the stark new wing of the museum normally devoted to the art of the Holocaust victim Friedrich Nussbaum. It surveyed later reactions to the war and drew particular attention to the Nazi response. In the 1930s and early 1940s, Westphalia was compared to Versailles—the treaties by which France had crushed German hopes, but which now were to be overturned. The xenophobia and arrogance reminded one of the new fanaticisms and hatreds that replaced religious passions in national affairs.

The war itself remained the focus in the Münster Landesmuseum, half an hour by train from Osnabrück (but a day's ride in the 1640s). Here, in the largest of the Westphalia exhibitions, 35 rooms were devoted to different themes of the conflict. We again saw the major protagonists, but now in masterful representations: two popes in busts by Bernini, the leaders of Spain in austere full-length portraits by Velázquez, the Dutch leader in a robust van Dyck, a charming Christina of Sweden by Bourdon, a corpulent and disheveled Christian of Denmark by Karel van Mander, and half a dozen stiff princely figures. The one blaze of color in this self-consciously stoic gathering was Cardinal Richelieu, resplendent in his robes in a full-length painting by Philippe de Champagne.

This was the public and dignified face of war. Very different was the experience of anonymous participants and victims. Harrowing glimpses were provided of widespread atrocities, plague, and hunger. A cart and coffin that have survived from the 1620s brought home the effects of plague. Other gruesome images included a finely polished ivory by Leonard Kern of a man eating a human leg, and vicious scenes of civilians tortured by soldiers.

Yet it was these realities that prompted another fundamental change that the war brought about: the creation of a more comprehensive, formal international system that Europe's powers hoped would control the horrors in future. This is where the peace negotiations came to the fore, and their depiction became central to the exhibitions. How were they to be shown?

First on view were the aristocratic faces of the dozens of negoti-

ators, together with the elegantly sealed documents they signed. Looking at them, one realized that only their persistence—remaining in this corner of Europe for seven dreary years so as to resolve all the issues—enabled the peace congresses to curb (for a while) the unrestrained aggression made possible by gunpowder and the new ambitions of territorial states. These statesmen redrew the map of Europe, and in so doing they revolutionized diplomacy.

How does an exhibition bring that achievement to life? First, by showing some of the maps they drew. The establishment of boundaries—rendered precise in the maps—was the key achievement in settling the war's disputes. Never before had such a concerted effort been made to define the individual states that made up Europe. And then there was a painting, also without precedent. Gerard ter Borch was present, working for the Spaniards, at the decisive moment when peace was concluded: the signing ceremony in Münster. The scene comes to life when one crosses the Cathedral Square to the City Hall where it took place, in a room that still looks as it did in 1648. But the painting, too—including a self-portrait by ter Borch—is a numinous reminder of the transformation of politics and warfare that the treaties brought into being.

No less potent was the evidence of the war's impact on the artistic sensibilities of the age. This was one of the great periods of European art, and its most sensitive practitioners recoiled from the slaughter and desolation they saw. Jacques Callot's grim series on the *Miseries of War* sets the tone; less obviously, Mathieu Le Nain's haunting version of a genre scene, *Argument Over a Card Game*, took on layers of meaning as one noticed the competing symbols of military and civilian life, the readiness to spill blood, and the somber, exhausted faces of the soldiers. Even more poignant were a pair of bleak paintings by Georges de La Tour: *John the Baptist in the Desert* and *Job and his Wife*. Driven from his native Lorraine by the conflict, de La Tour showed John in depressed solitude, and the gaunt figure of Job staring blankly as his wife told him, "Curse God and die." One saw these paintings differently in the context of an agonizing, all-consuming war.

That artists embodied their generation's most urgent pleas for peace was abundantly clear in Velázquez' *Breda* and in Rubens' design for the entry into Antwerp of the Cardinal-Infante Ferdinand,

the new ruler of the southern Netherlands. And the final room in Münster, centered on Rubens' lush *Peace and War*, made the case for peace unmistakably (*Illustration 2*). The sunny, fruitful world of Peace dominates the painting, while in the background Minerva pushes Mars away into the dark world of furies and war. Mars looks over his shoulder in amazement at the pleasures of Peace, organized for the benefit of two young girls (as it happens, portraits of the children of one of Rubens' friends, a personal touch that indicates the strength of the artist's feelings).

Even when there was no political message, though, the very agenda of art, which hitherto had so often celebrated the glory of war and its heroes, began to change. A quiet landscape by Claude Lorrain that hung amid cavalry engagements and sorties gave a foretaste of what was to come. The emotion and drama of the Baroque were about to give way to the more formal and restrained aesthetic of Classicism and Rococo, and it may not be too much to suggest that the experience of thirty years of brutality helped encourage that shift in sensibilities.

The catalog for this rich and multifaceted exhibition is a handsome hardback, modestly priced, beautifully illustrated and flawed only in its skimpy index. It gives a sense of what the exhibition offered: a stirring encounter with one of the most creative as well as violent ages in European history, illuminated by art both great and ordinary. Above all, though, it demonstrated that images, so often a means to evoke war, can be just as telling in capturing the need for, and the achievement of, peace.

Can a Single Painting Open Windows into History?

Carola Hicks' book is essentially a love letter to a painting. Like many a love letter, it has a melancholy air—in this case because it was written just before the author died, and had to be completed and seen through the press by her husband. But the strength of the passion for one of Britain's favorite works of art is unmistakable, especially when this academic art historian scolds her colleagues for "untangling its meaning, rather than just enjoying it." Inevitably, in the course of more than 200 pages, Hicks invests what she calls *The Arnolfini Portrait* with a great deal of meaning, and explains at some length what Jan van Eyck was trying to do when he painted it. Even as she dismisses alternative interpretations, however, she keeps reminding us of the exquisite mastery and the profound influence exhibited by this little wooden panel, measuring less than two feet by three (*Illustration 3*).

There are two main themes that Hicks pursues. First, going much further than predecessors like Craig Harbison, she delves into the material world that is reflected in the many objects in the painting. If you want to know what the "dagging" of a fabric requires, how "crown glass" is made, or what was involved when the *huchiers* made a *banc à perche*, this is the book for you. There is an affectionate re-creation of the crafts and the rare and fine goods that were available to a couple as rich as the Arnolfini, established as they were at the upper levels of the social hierarchy. To make these descriptions as concrete as she can, Hicks situates them firmly in context, explaining what was available in Bruges, the city where the picture was produced. Thus we discover the source of the fur that lines the woman's underdress (*pured minever* or *lettice* from local squirrels) and the quite different fur (pine marten from Russia or Scandinavia) that is visible around the man's gown. The portrait becomes a cornucopia of

earthly delights—costly stuffs and sumptuous things, brought from far and near.

The second major theme is provenance. As Hicks points out, one of the remarkable features of the panel is its pedigree, for we have a good idea of who owned it, and where it was, from the day it was finished in 1434 down to our own times. Its history is not without adventure, and certainly hazardous moments, as it traveled over land and sea, escaped burning, and even survived a battle and disposition by soldiers after the fighting ended. This history Hicks recounts with aplomb, together with sketches of the owners and tales of the negotiations as the painting changed hands.

The one owner who gets less than his due is Philip II of Spain, whose interests are described in terms merely of his piety and his Habsburg inheritance. But the nudes the king commissioned from Titian, and the many other examples of his tastes, mark him as probably the most discriminating connoisseur to have owned the van Eyck. The Spanish devotion to Netherlandish art, moreover, long predated any political or dynastic interest. Philip's great-grandfather, John II, was already a collector in the 1400s, as were other patrons who sought goods from the north at the Medina del Campo fairs. There are over a thousand Flemish pictures in the Prado, and many examples of Hispano-Flemish architecture from the fifteenth century. Those connections alone should have precluded this verdict on Spaniards in a sentence about Hieronymus Bosch: "The artist's combination of grotesquerie with medieval Christian symbolism, his way of blending sensuality with pain, and the surreal conjunction of fantastic and microscopically accurate landscape epitomized the distinctive Spanish character and the fanatic power of Spanish religion."

The two themes (physical objects and provenance) provide the backbone of the book, and generate a lively narrative that brings one from fifteenth-century Flanders to the present. The only difficulty is that Hicks decided to interweave the two themes. Thus a chapter on the painting's furniture comes between chapters on two successive owners, Marguerite of Austria and Marie of Hungary. And the jumping back and forth continues to the end of the nineteenth century. A chapter entitled "The Dog" divides even the period after 1842, when the van Eyck found the home it has kept ever since, in the National Gallery in London. The effect is to interrupt the flow, to cause threads to be lost, and to blur the overall narrative as attention switches from one kind of analysis to another.

It is only in the last two chapters that Hicks takes up the question of what the painting is about. Her emphasis on the material goods in the Arnolfini room makes clear her own focus: that this is a celebration of the wealth and possessions of a prominent merchant. As for other interpretations, she suggests that the spate of scholarly quests for symbolic or other meanings have led to "many misunderstandings," and she pays them little notice beyond an indication of some of their shortcomings. It is fair enough to argue that a superb experience is in store for anyone who stands in front of the panel and revels in its mastery of color, of light, and of detail. Yet an overall assessment of the artist's aims, beyond the depiction of everyday objects, would surely have enhanced the pleasure of the general reader for whom this book is written.

That is not to say that Hicks herself eschews the wider references the painting implies. She explains the presence of the oranges, for instance, by citing the contemporary theory that they were "Adam's apples," and possibly the fruit on the tree of knowledge in the Garden of Eden. Repeatedly, too, she notes the analogies in the picture to the attributes of the Virgin Mary, one of van Eyck's favorite subjects. But she firmly resists the notion, first put forward in the 1930s, in a famous article by Erwin Panofsky, that there might be an underlying theme that animates the array of unusual details in the panel. For Panofsky it was the sacrament of marriage, evidenced by a multitude of objects, from the figure of St. Margaret, patron saint of childbirth, carved on the bedpost, to the couple's hand-holding and the single lit candle (a feature of the marriage ceremony) in the candelabrum. Though some of the connections were challenged, the two pages that Panofsky devoted to the painting twenty years later, in his *Early Netherlandish Painting*, still manage to give van Eyck a purpose that elevates the immediate celebration of a rich man and his possessions.

Hicks hesitates to offer any such broad understanding. Yet one has to wonder whether her insistence that a bed was a feature of presentation rooms (which is how she describes the Arnolfini chamber) might not be tempered by a recognition that its appearance was a feature of scenes in presentation rooms that celebrated a marriage. Along similar lines, she describes Arnolfini's raised hand as a greeting to the two visitors reflected in the concave mirror, even though his palm is directed at his wife, which is far more likely to mean that the gesture is directed as a salutation or blessing to her (emphasizing the connection between them) rather than to the visitors. And Hicks seems deliberately to avoid mentioning the symbolisms that were common in the art of the day: the dog as a token of

fidelity, or the discarded shoes that marked a holy place (echoing God's command to Moses at the burning bush).

Although arguments over specific references—such as whether the woman is pregnant—may never be resolved, there seems little doubt that this is a painting about a sanctified relationship, and not simply a portrait of a couple. That perception not only aids understanding, but also enriches the enjoyment of van Eyck's achievement. How vivid it all seems, and yet how powerful is the basic message about the sacrament of marriage.

Hicks abjures this approach to the painting, focusing instead, in her concluding pages, on the impact it has had on the arts since going on public display in 1842. This is a masterly account, ranging from the Pre-Raphaelites to Tracey Emin, and encompassing advertising, cartoons, and souvenirs as well as more serious endeavors. It is here, however, that one becomes aware of how poorly Hicks has been served by the book's illustrations. In the early chapters, they are small, dark, and largely unhelpful. It is almost impossible, for instance, to read the inscription in the portrait of Marie of Hungary. A section of color reproductions is better, but still too small to help with details. Because the text lacks cross-references, one is disappointed when, stirred by a vivid description of an *hommage* to van Eyck by David Hockney in his *Mr and Mrs Clark and Percy*, one turns to the color illustrations for illumination, only to find a painting by Benjamin Sullivan that is deemed beguiling but is otherwise not explored.

The shortcomings of the illustrations are especially regrettable in that they could have done much to help Hicks make her points. Again and again, the arguments would have been easier to follow if there had been sizeable reproductions of the details in the painting, let alone of other van Eycks that bear on her subject—the Berlin portrait of Arnolfini, the various portrayals of the Virgin (notably with Chancellor Rolin), and details from the Ghent altarpiece, all of which figure in the analysis. Even without such assistance, however, the book, beautifully written, is a splendid testament to the intelligence, attention to detail, depth of research, and down-to-earth vision of a first-rate scholar.

How Should Historians Use Images?

Nearly twenty years have passed since *The Journal of Interdisciplinary History* sponsored a conference on the interactions between historians and art historians. The papers that were given at that time appeared in a special issue in 1986, and two years later were published as *Art and History* by Cambridge University Press. If this interdisciplinary effort then seemed in its infancy, despite such notable forebears as Jacob Burckhardt and Erwin Panofsky, it has in the intervening decades grown in range, sophistication, and achievement, and may now be said to be approaching maturity.

One measure of that advance is Peter Burke's new book. Only a field that has accumulated a broad variety of results could prompt a historian to consider its operating mechanisms. Burke's basic set of questions—how does the use of images for historical analysis work, and when (from the perspective of the historian) is it likely to be successful and/or effective?—could not have been explored in such richness or detail if a proliferating enterprise had not supplied him with so many instances, both cautionary and exemplary. It is suggestive that his bibliography of some 300 items is dominated by publications from the 1980s onward.

Burke investigates both the types and the contexts of the images historians use. He embraces just about every kind of evidence that has been available, mainly since the Renaissance in the West, though he does venture into other periods and cultures. If he has a special fondness for his own early modern period in Europe, he also has much to say about other times and places, and in so doing he touches upon a huge range of artefacts: crucifixes, sculptures, the Bayeux Tapestry, mosaics, buildings, furniture, paintings, drawings, films, and photography. To everything he brings a keen eye and a cautious stance. A photograph of Rio in the 1860s, for instance, he finds suggestive because a tiny detail shows a man wearing a hat but no shoes—an indication of dress code that Burke ac-

cepts only because it is so unimportant a part of the picture, and therefore unlikely to have been posed.

As this example demonstrates, Burke is constantly on the look-out for the danger of over-interpretation. Who is showing what, and why? And, more difficult, how can it be understood? By repeatedly asking these questions, he tries to construct a set of defenses that will protect the historian from easy conclusions or superficial observation. Indeed, he comes to the subject with the assumption that images are now so easily available, and scholars are so readily tempted to use them to make connections otherwise unavailable, that the most important immediate task is to temper enthusiasm and ensure that pitfalls are avoided. This admirable stance is especially timely, in that it offers an astute and instructive counter to the enthusiastic relaxing of standards of evidence that images, so vivid and direct, can inspire.

*

Very early on, having acknowledged their power, Burke emphasizes that "the testimony of images raises many awkward problems." He then surveys various genres that illustrate his themes: portraits, the use of iconography, depictions of the sacred, expressions of power and protest, revelations of social forms, the treatment of the "other," and narratives. Throughout, he keeps our attention on context, on the identity of the creator of the image, and on hidden purpose.

Warning against taking portraits too literally, for instance, he suggests that they be regarded "as a record of what the sociologist Erving Goffman has described as 'the presentation of self,' a process in which artist and sitter generally colluded." To de-emphasize the specificity of such images, Burke points out the power of convention; thus, depictions of the kings of France echoed the classic pose of Hyacinthe Rigaud's 1701 painting of Louis XIV even as late as Louis Hersent's presentation of Louis Philippe in 1831. The key here is the position of the legs in the portrait of the Sun King, which is still visible in the 1830s, implying that the convention had a power that transcended the physiognomy and costume of the monarch himself. What Burke does not note is that his point could be extended yet further back. As the illustrations indicate, the position of Louis XIV's legs derived, in turn, from one of the most famous royal portraits of the 1630s: Anthony van Dyck's *Le Roi à la Chasse*, a painting that was itself a revolution in image-making, showing a king without regalia, robes, or armor. Not even astride his horse, Charles is stripped of the classic indicators of rank, and yet to Rigaud he remains the model of roy-

alty. The need to disentangle these strands, even in so well-documented a form of image-making as royal portraiture, indicates the subtleties and complexities that need to be mastered before such evidence is put to the historian's use.

Where messages are more ambiguous, as Burke notes, yet greater care is required. We need to know what people *saw* in iconographic details, in religious polemic, or in evocations of power or protest. Even scenes that seem self-evidently useful for the social historian, such as the familiar rooms or courtyards in Dutch art, may show more than meets the eye. To the extent that details and incidents may have been meant to serve moral purposes, as has been argued by a number of scholars, their usefulness for documenting daily life may be limited. Even a group of Louis Le Nain peasants may say more about the appearance of Christ at the Supper at Emmaus than it does about French rural life in the 1640s.

Intent is repeatedly crucial in Burke's account. If Pieter Bruegel the Elder's *Peasant Wedding* is a work of satire rather than description, he asks, does it still speak straightforwardly about customs and behavior? About costume, maybe, but about peasant manners? And the bizarre "third leg" of the tray-carrier in the picture (an oddity not on Burke's list) merely adds to the confusion. On the other hand, while the self-consciously "eyewitness style" of Gerard ter Borch's painting of the moment when the Peace of Münster was ratified in 1648—whose purpose ter Borch underlined by inserting a self-portrait (an unmentioned detail that strengthens Burke's claim for the picture)—removes ambiguity of intent, it also brings into play the conventions of what Burke calls "eyewitness rhetoric," which has its own way of coloring the evidence that it provides.

In other words, caution is the watchword, even when context and purpose are well documented. The one place the caution seems slightly overplayed is in the chapter on visual narratives: subjects where the values of the artist are often deliberately on display. The brief paragraph on ter Borch could have been expanded, and the evidence of painters expressing anti-war views is both earlier and broader than Burke acknowledges. Battles without heroes and unheroic scenes of soldiers' lives were genres before the mid-seventeenth century, and attacks on the horrors of combat had produced masterpieces long before Goya or the Crimean War.

Still, to err on the side of modesty is to achieve an unusual quality in a field that too often has succumbed to excessive enthusiasms for a newfound toy. Burke eschews direct criticism of such failings, though he does make a thoughtful and cogent case for believing that the structuralists and

post-modernists have been unable to undermine the fundamental value of Panofskyan iconography. Indeed, going somewhat against the grain, he gives Erwin Panofsky higher marks as a guide to pictorial meaning than has been fashionable in recent years. He suggests more emphasis on social context than iconography usually allows, but in this respect, too, Burke seems to strike exactly the right balance.[1]

As one might expect, the book is informatively illustrated, and marred by few typos. There are a couple of slips: Frankenstein was the doctor, not the monster; and the Callot siege prints were segments of a huge scene rather than a real series. One could also have wished for a more elaborate section on films, increasingly the visual evidence of choice in classrooms.

The differences among commercial films, documentaries, and docudramas require more elucidation than they receive here, and the range of reference needs to be broadened to such neglected masterpieces as the 1963 *I Compagni* ("The Organizer"), with its extraordinary performance by Marcello Mastroianni of a nineteenth-century Italian union organizer. Even a blockbuster like James Clavell's 1970 *The Last Valley*, an epic starring Michael Caine and Omar Sharif that may now be deservedly forgotten, has its uses for the historian of the Thirty Years' War and of German witchcraft. It certainly would yield more useful information, keeping Burke's recommendations in mind, than the still-visible 1933 Greta Garbo vehicle set in this era, *Queen Christina*. And the passing mention of Andrzej Wajda's 1958 *Ashes and Diamonds* merely whets the appetite for a nuanced assessment of the rapidly growing filmography on the Holocaust. What Burke's brief comments on film stimulate, in other words, is a wish for the kind of extended analysis and commentary that his book lavishes on non-moving images.

That one can ask for more is a testament to the sanity and analytic insight Burke has brought to the subject. The care and concern for evidence that he advocates is an admirable corrective to some recent flights of "reception theory" and similar attempts to attribute an innate (but unproven) power to images. Much of the recent discussion of princely propaganda in early modern Europe, for example, blithely ignores the need to demonstrate (preferably through first-hand testimony) the impact of a particular creation or representation on the body of people who saw it; even more inconclusive has been the discussion of how these viewers responded, especially in an age when iconography could be so complicated as to defy comprehension even among learned humanists. The request for docu-

mentation of the effects or meanings that audiences supposedly felt or took from works of art can be too lightly ignored, and in some cases has been dismissed in *ad hominem* fashion.[2]

To remind us so cogently, by contrast, that evidence is central to the enterprise, and that the historian's own standards of proof must always be brought to bear, is a notable accomplishment. Although he resists calling it a handbook, Burke's *Eyewitnessing* deserves to become essential reading for the next generation of interdisciplinary historians who turn to visual images for both teaching and research.

6

Who Understood Renaissance Art?

It has become something of a fashion in recent work on Renaissance and early modern Europe to see visual images as essential and effective weapons of political propaganda—vital components of the rise of the state. Roy Strong and his disciples have unraveled elaborate advocacies of peace at Charles I's court; Rubens has been treated as an apostle of power; glorifications of the Habsburg and Valois dynasties have been deciphered in their collections, buildings, and ceremonies; and monarchs and state-builders have emerged as manipulators of the arts almost on a par with the spin doctors of modern television campaigns.

Given the insistence on the deliberate purpose of a ruler's patronage, one has to wonder why Ferdinand II, Grand Duke of Tuscany, had an agent buy Lely's heroic portrait of Oliver Cromwell hot off the easel in August 1654. After all, to the house of Medici, Cromwell was a revolutionary who had assaulted aristocratic privilege, murdered Charles I, and exiled Henrietta Maria, Ferdinand's own cousin. That the Grand Duke hung the picture alongside his van Dyck and Rubens portraits of Charles I, Henrietta Maria, and Charles' favorite, the Duke of Buckingham, seems to make a mockery of the current emphasis on the political purposes that maintained princely patronage of the arts.

Images could certainly enhance stature and power, when the message was simple. St. Mark's lion, for example, could assert the power of Venice unmistakably at the center of cities from Bergamo to Corfu. But this kind of meaning and impact seems to have dissolved as soon as complexity appeared, whether in the iconography of private collections, like Rudolf II's Kunstkammer, or in elaborately decorated palaces and ornate official entries into cities.

There is no question that monarchs of the seventeenth century owned huge collections, and that ownership on this grand scale made a statement about royal magnificence. The sheer numbers were often astounding. Queen Christina, for instance, had 750 paintings in 1652, and they were but a small part of an inventory that encompassed over 40,000 items, ranging from timepieces to classical marbles.

But the enhancement of prestige was not necessarily the prime aim of the omnivorousness; it was often a by-product of other ambitions. As accumulated by Christina and her fellow rulers, the collections were, in essence, much larger equivalents of the *studioli* that had been created by Federigo da Montefeltro and Isabella d'Este. Such decorated rooms were for the private delectation of their owners and their circles; they were expressions of taste, intelligence, learning, and patronage, but other than their general confirmation of the wealth and beneficence of the patron, they could make specific political points (such as Federigo's combination of arms and letters) only to a few initiates. Even the extravagance of an entire building like the Gonzagas' Palazzo Te revealed the prince primarily as *homo ludens*, not as *homo politicus*.

The great monarchs of the age of absolutism—especially Philip IV in Spain, Charles I in England, and Louis XIV in France—may have been moved by a similar impulse, but they indulged in a gigantism that would have astounded Federigo or Isabella. The huge collections also required the construction of special settings and these were certainly more public than the Italian *studioli*. Christina's art chamber in Stockholm was succeeded by a famous gallery of Titians and Veroneses in the Palazzo Riario in Rome. Philip had the Buen Retiro and Velázquez; Charles had the Banqueting House, Rubens and van Dyck; and Louis XIV had not only the Italian masters in the Louvre's Galerie de Diane but also the largest palace in Europe, Versailles.

That the extravagance impressed visitors cannot be doubted. But there is no indication that this particular form of display was essential to a crown's prestige. Louis's father, Louis XIII, for example, was indifferent to art, yet lost no stature on that account. The accumulations that filled the palaces, in other words, testified above all to their owners' shared aesthetic interests, a commitment which prompted them to use art to demonstrate goodwill toward one another. Hence the magnificent equestrian portrait of herself, on a Bucephalus-like horse, that Christina commissioned Bourdon to paint as a gift for Philip IV. There is no doubt that

the love of the arts enriched Western culture beyond measure; it is less clear whether it also carried an *understood* political meaning, beyond its implicit confirmation of the wealth and ostentation of princely patrons.

One way that such meaning has been uncovered in recent years has been through analysis of the allegorical intent of the paintings these rulers owned or commissioned. Allegory, as a centuries-old device, was of course a standard means of masking deeper purpose. In the case of Christina, for example, Arne Danielsson's erudite researches have revealed an obsession with Alexander the Great in her portraits and her life. By its nature, however, as Danielsson emphasizes, allegory has a large element of secrecy. When the Bourdon portrait arrived in Madrid, therefore, how many of the points Danielsson has extracted from the work did Philip IV in fact understand? It is significant that the original plan was for Bourdon (despite his Huguenot background) to accompany the picture to Madrid—doubtless to interpret it for Philip. In the event, a storm intervened, and the picture arrived at its destination without its explicator. From its appearance alone, in the absence of the painter, what could the King have made of the portrait's layers of meaning? Given the failure of contemporaries to identify the story of Bacchus founding Spain that lay behind one of Philip's most famous paintings, Velázquez' *Los Borrachos*, it seems highly improbable that any part of Christina's more obscure iconographic scheme would have been understood in Madrid.

Philip could relish Christina's gift, nevertheless, as a thing of beauty which appealed to the touch of *homo ludens* that softened even the sober Habsburgs. It was a quality that had made his grandfather, Philip II, a lover of gardens, the founder of an elegant library, and a passionate admirer of Titian. Like most early modern rulers, they learned from the princely courts of Italy and from each other. The dour appearance of the Spanish court masked its role in shaping, first, the eccentric tastes of young Rudolf II before he went to Prague, and then, fifty years later, the budding appreciation of the delights of art in the future Charles I of England.

One view of this torrent of patronage, represented by Antoine Schnapper, is that although it served as "a suitable adornment" for a great court, it lent a monarch prestige "only in a vague, indefinite way." Schnapper admits that great buildings could "signal the grandeur and intelligence of princes," but this message, he believes, could never be specific. Other scholars have claimed more: that, for instance, even a hermetic Kunstkammer could transmit a symbolism of order, hierarchy, and power

to the initiates who grasped its references. None of these scholarly investigations, however, has paid much attention to audience or reception. Nothing in the evidence suggests that public displays could convey (beyond a tiny group of *cognoscenti*) more than a prince's personal splendor or exuberance.

If few found it strange that four pagan horses dominated the portal of St. Mark's Basilica in Venice, or that in the nearby *terra firma* farmhouses were made to look like Greek temples, one cannot put too much store by the content of visual images. Yet the claim for a distinctive political use of art is very weak, if images merely reflect a monarch's grandeur, or gain precision solely in iconography so arcane that it requires a Scaligerian education to unravel. This brings us to the heart of the issue, which has to do not just with individual reactions at the highest level—i.e., whether Philip IV was impressed or left in the dark by the classical and personal allusions in Christina's portrait. It has, instead, to do with the force of art as propaganda in a wider arena. This is a subject that has spawned a small scholarly industry, though its recent contributors have exercised little of the restraint of the pioneers in the field.

The first master of the genre, Jacob Burckhardt, may have referred both to the state and to war as works of art, but he did not, in that part of his masterpiece, treat festivals and the arts as instruments of politics or power. Rather, he examined them solely as a means of understanding social norms and the personalities of individual rulers. And he made sure to point out the contemporary skepticism about their meaning and impact. Thus Francesco Sforza rejected a triumphal chariot, because "such things were monarchical superstitions." And Alfonso V refused to wear a laurel wreath during a grand entry into Naples that Burckhardt described as "a strange mixture of antique, allegorical, and purely comic elements." There was "simply no end to the mythological charioteering," he wrote, and he mischievously proclaimed his wonder that "funerals were not also treated in the same way."

Burckhardt regarded speeches and processions, together with the Carnival, as entertainments. To look too closely at their esoteric symbolism was to give them a weight, he suggested, that they could not bear. Similarly, Erwin Panofsky and Aby Warburg used their decoding of iconography to explain what an artist intended, not what an audience (beyond the most learned) was likely to have recognized. And the erudition that Frances Yates brought to bear on the Valois Tapestries provided ample evidence

of the way Catherine de Medici's family regarded itself, but did not imply that these gorgeous creations influenced anyone else. When Yates asked how the feckless Anjou could have fooled someone as shrewd as William of Orange, she answered by citing qualities of character and family connections, not artistic propaganda. The scholars who followed these masters have not been so restrained, as they argue for the specific role of images of Apollo or Mars in enhancing princely prestige.

This is not to ignore, or to take anything but seriously, Richelieu's distress at Louis XIII's indifference to the arts; the programs of cultural control that he launched, despite his sovereign's lack of interest; the relentless glorification that Olivares undertook; or the references to its "massive irrelevance" to the fortunes of the Spanish monarchy.

The elaborate processions and festivals, like the huge buildings, certainly made a statement about princely grandiosity in the public arena. One could not fail to be awed by the massive palaces that dominated the centers of Ferrara, Urbino, Mantua, and Venice. To the extent that, in larger states, less emphasis was placed on this form of assertiveness—the Escorial was well outside Madrid, Versailles outside Paris, and Hampton Court outside London—there were dazzling parades and displays to transmit public messages.

Decoding some of these events was not difficult. In Bellini's Corpus Christi procession, all the major corporations of Venice pass before us, in carefully regulated order, yet united by religious devotion. The hierarchy and structure of the city are straightforwardly reflected and reinforced. But the message was harder to convey when it became more complicated.

Take what may well have been the most stunning city "entry" of the seventeenth century—when Ferdinand of Austria came into Antwerp in 1635. That a military hero, the brother of Philip IV, was taking over as governor of the Netherlands was reason enough for splendor. That he was making his formal appearance in the home town of Rubens made it certain that the brilliance would be directed by the most learned as well as exuberant artist of the day. And Rubens outdid himself, as we know from a volume of engravings and descriptions presented to Ferdinand seven years later, which recorded for posterity the arches and tableaux he had designed.

We have no record of the new governor's reaction, either to the entry or to the explications offered in the book. It does not seem likely, however, that the message got through, because if it had, he would probably

have been offended. For the central display, the temple of Janus, showed his predecessor, the Archduchess Isabella, opposing harpies who were trying to keep war going in the Netherlands. Ferdinand's fame was as a soldier, the general who had defeated Sweden's Protestants at Nördlingen, and he had a mandate to continue the battle against the Dutch Protestants. One cannot imagine that he would have taken kindly to the tableau's urgent pleas for peace, or to the more detailed explanation of the Netherlands' wartime sufferings that appeared in the presentation volume. But Rubens and his colleagues were probably safe, because the book, though explicit, was so full of learned disquisitions about the temple, and quotations from the likes of Hesiod and Petronius in both Greek and Latin, that it was probably beyond Ferdinand's comprehension. Even if he recognized the attributes of Janus, could he have identified Tisiphone or Hyginus?

That Rubens knew exactly how difficult it was to decipher such references is suggested by his need to write a letter identifying the characters and symbols in his painting *The Horrors of War* to his fellow painter Justus Sustermans, who was himself no mean authority on classical antiquity. Sustermans doubtless remembered the extraordinary Giulio Romano frescoes in the Palazzo Te that he had seen during a visit to Mantua, but he must have been astounded by what he now read. For he would have discovered that Romano's playful and salacious images of Venus and Mars had become models for the central figures in a forceful anti-war statement. Rubens had transformed a lovers' quarrel into a cry for peace, a plea that even so learned an artist as Sustermans might not have been able to follow without the clarifications the letter provided.

If a Sustermans could have trouble understanding Rubens, what about the hordes of Antwerpians who turned out for Ferdinand's grand entry? How many of them could have made out the inscriptions, high above their heads, let alone understood the Latin? They may have been amused by an arch topped by a grotto, a dragon, and huge coins, or by agricultural tools and sheaves of wheat on the aforementioned temple of Janus. But how many understood, on seeing farm implements on one side of the temple, that they represented the opposite, the fruits of peace, of the spears and weapons of war on the other side? And would anyone have recognized Pax from her caduceus? Rubens may have been trying to transmit a powerful political message, but there is no reason to believe that it was received.

What mattered on these occasions was the brilliant spectacle. And this was true not just for ordinary townsfolk. One of the most cultivated diplomats of the age, Sir Dudley Carleton, described a regatta of 1613 in honor of Luigi d'Este as "a horse-race of boats, well furnished . . . with certain large boats of ten oars, which were gilded and painted and the rowers all in liveries . . . it was the best entertainment I saw since I came to Venice." Isabella d'Este dismissed the famous ceremony of Venice's wedding with the sea as tiring and boring, and learned spectators missed the meaning of decorations at Henri III's entry into Rouen and Christina's into Rome.

As for the average onlooker, one can easily imagine the reaction of most Swabians to the bizarre ornamentation on the Duke of Württemberg's costume in a 1603 procession. They may have known enough not to laugh openly, but it hardly contributed to the seriousness of the occasion that the outfit prompted speculation as to whether the farrago of decorations was Turkish, Muscovite, or Pontifical, none of which was a compliment.

And it was easy to miscalculate the reaction, because the public also had reasons not to appreciate lavish expenditures or spectacles. The Romans of 1651, furious at a tax the Pope had imposed on bread, were unmoved by Bernini's new Four Rivers fountain in the Piazza Navona. One critic said that papal extravagance had fashioned the stones of the fountain out of bread; others cried "Pane, non fontane!"

Buildings, collections, works of art and cavalcades may have been choreographed to convey elaborate political meanings, but there is no evidence that their audience (except for a few learned insiders) recognized, let alone understood, their intentions. It is a strange paradox, and it makes one wonder whether anyone at all, even their creators, regarded these iconographic programs as more than shows of learning, homages to antiquity, or *jeux d'esprit*.

If they did indeed serve a wider political function, then surely the one group of contemporaries who made it their business to investigate the components of political authority would have recognized the role of the arts in government: the great political theorists of early modern Europe, who were transforming the conception of the state and redefining the nature of power. Yet none of them paid attention to the visual arts.

Contemporaries certainly admired the way that Elizabeth I used her progresses for self-promotion, and it is suggestive that she regulated her

portraits to avoid unflattering depictions. The negative potential of pictures had been appreciated at least since the broadside wars that followed Luther's break with Rome. But recognition of the negative effects of visual propaganda did not imply equal force for positive effects. Political theorists did pay attention to the power of speech, even of universities. The power of visual images, however, remained the province of art theorists like Vasari, not political commentators.

And yet, if any age should have displayed the influence of the arts, it is this one, when absolutist forms were coalescing; when court formality and ritual were being elaborated in ways never before attempted; when public display was breaking all previous restraint; when the dominant style, the Baroque, was permeated by the quest for grandiosity; and when some of the most learned and emotion-laden artists in Western history were serving all these goals. What we have found, however, are messages that were so complex they could be unraveled only by a learned few; enjoyment rather than awe or analysis; and intentions that seem to have had little to do with the responses they inspired.

The decoding of meanings in recent scholarship is fascinating as an enterprise in art history or intellectual history. But the literature does not demonstrate the political effectiveness of the arts beyond the general truism that magnificence was accepted as an attribute of princes. If a seventeenth-century monarch wished to assert or enhance his authority, he had much more direct means of doing so, as the *dragonnades* demonstrated. Accordingly, we need to recognize that marvelous manipulations of images and forms may offer insights into the genius of an artist, a scholar, or a patron, but not into the workings of political propaganda.

The collector or builder was driven in the first instance by aesthetic enjoyment and ambition. If something fine also contributed to one's prestige or self-esteem, all the better. But the political message was rarely the main purpose, which is why the purchase of the Lely Cromwell, rather than seeming paradoxical, made eminent good sense.

One of the finest portrait painters of the generation after van Dyck was the Netherlander who, like van Dyck, settled in England. Naturally, therefore, those great collectors, the Medici, had to have a superb example of his work. It is possible that they regarded the Lely as an example of a peculiar genre, the portrait of an enemy. But this would not have included rebels, and there is no hint, in the instructions to their agent, of anything but a desire to secure, right away, a handsome likeness of the newly de-

clared Lord Protector. The political implications of the painting apparent-
ly carried no weight at all When the Lely arrived, therefore, the Medici
could display it proudly in their collection, where it remains to this day,
conveying by its mere presence the severe limits on the political uses of
art in early modern times.

Part Two

The Portrait

1

Why Are Portraits Important?

Rather like the status of biography among historians, the portrait is not always ranked at the highest level of artistic achievements. Although such enterprises have attracted outstanding talents—Ranke wrote biography, Titian excelled in portraiture—and the difficulty of capturing a person is acknowledged, they have often been considered less challenging than larger themes. For artists the pinnacle supposedly requires expressions of faith, scenes from mythology or history, or breaks with tradition. To this day, terms like "landscapist," "still-life specialist," or "portrait artist" have a slightly supercilious tinge.

Yet the portrait retains a potent appeal. And three exhibitions during the past year exposed how short-sighted are doubts about its stature as a test of mastery and a unique window into the culture of the past. The principal case was made by two related shows and their catalogs: *El retrato del Renacimiento* at the Prado and *Renaissance Faces* at the National Gallery in London. The Madrid effort was the more comprehensive: it not only provided five essays beyond the four it shared with London, but it also translated the entire catalog into English (though in tiny type). And its display of 126 items was over 25 percent larger than London's. As a result, it was able to make a more extensive and persuasive case for the ever-broadening importance of the portrait during the Renaissance.

It was in the 1400s that the depiction of the individual as an end in itself became a permanent part of the Western artist's repertoire. The first two illustrations in the Prado catalog, a Memling and a Piero della Francesca, signal not only the simultaneous emergence of the form across Europe, but also some of its multiple purposes. Piero's Malatesta was a famous prince seeking to glorify himself, but Memling's subject, a young man holding a coin from Nero's time, was probably a collector of classical antiquities who was anything but famous. Right from the start, we have

the portrait as propaganda or as object of emulation, and the portrait as family memento, laden with symbols (Memling's bay leaves and palm tree may be significant) to convey identity, a message, or a moral point.

The Prado volume defines Renaissance broadly, all the way to Rubens, which is not inappropriate, since he and his pupil van Dyck brought to culmination the development of the genre over the previous two centuries. Although there is only one example of the supreme effort of glorification, the equestrian portrait (Titian's Charles V), which was to be a favorite for both Rubens and van Dyck, the recruitment of artists for political propaganda is amply demonstrated and elegantly summarized in an essay on the court by the editor of the Prado volume, Miguel Falomir. Engraved portraits, which could be widely distributed, were especially useful for this purpose, though they also served to spread the fame of writers and artists—a theme that was a focus in Madrid.

The genre may have seemed new during the Renaissance, but like so much in that period the inspiration came from antiquity. This was the model to be emulated, after a long hiatus, and in medals and in depictions of princes the homage was unmistakable. Nor was it unimportant that Memling's young man should have been holding a coin from the reign of Nero. But very soon artists went beyond their original inspiration, and the uses to which their work was put began to proliferate. This is a subject admirably surveyed by Jennifer Fletcher in an essay marred only by her condescending dismissal of Panofsky's breakthrough reading of van Eyck's Arnolfini portrait as "simplistic." Whether to serve as ideals, as entertainment, as means of self-improvement, as cautionary tales, or as explorations of beauty (both spiritual and physical), portraits fulfilled just about every artistic goal, and the variety of ways they were displayed reflected this multiplicity of purpose.

The sheer variety soon prompted concerns. As is noted in the commentary on Moroni's calm and beautifully observed portrait of a tailor, the sharp-tongued Pietro Aretino, panegyrist of Titian's high-society subjects, had already complained that "even tailors and vintners are given life by painters." In other words, only stimuli to virtue or high-minded memories were worthy of the classical prototypes. But artists felt no such restraint. They might embellish the features of their patrons—a telling juxtaposition by Falomir of a Sebastiano del Piombo drawing and a Titian canvas suggests how Charles V's strange appearance was "improved" for official paintings—but their wish to explore life in all its forms meant that the humble, the disheveled, and the ugly also made their way into portraiture.

By the time Bernini flourished in the mid-seventeenth century (the subject of the third exhibition, *Bernini and the Birth of Baroque Portrait Sculpture*, at the Getty Museum, 2008), all of these practices had become familiar. Rome's dominant sculptor and architect, also at home with pen and chalk, could draw a devastating portrait of Innocent XI looking like a "ghostly grasshopper" with "impressively grotesque features"—as two of the editors, Bacchi and Hess, put it in their perceptive catalog essay. But when there was an official portrait to be fashioned out of marble, the irreverence was gone. Instead, one saw the astonishing life-like character studies that, as the catalog makes clear, set Bernini apart from predecessors and contemporaries.

Throughout the Renaissance, painters had struggled to suggest—through mirrors and other devices—that their portraits could stand comparison with the three-dimensionality of sculptors (a few of whose works were visible in Madrid and London). But painters could use color and background for effects unavailable to the sculptor. Bernini, by contrast, had to transcend the constraints of marble. Though there were just eighteen of his busts amidst the more than fifty items in the exhibition (other works were reproduced in the catalog), they were enough to make the case for his unique ability to capture texture and character. One has but to look at the vivid portrayal of Costanza Bonarelli, a married lady for whom Bernini developed a passion, to see why Wittkower called it a "speaking likeness." She looks past us in mild surprise, lips slightly open, with every hair and every fold of her dress captured for eternity. We can recognize why Bernini kept the sculpture for himself, even as we acknowledge that its powerful evocation of humanity and personality places portraiture at the very summit of the creative arts.

2

What Do Portraits Accomplish?

It may be that portraits can be dismissed as the least demanding of artistic genres—telling simple stories, with little originality, and incapable of evoking profound thought or deep emotion. But if Protagoras' statement that man is the measure of all things still resonates across three millennia, it is small wonder that portraiture remains one of the chief preoccupations of artists, scholars, curators, and audiences alike.

The strength of that continuing interest has been reflected, in recent years, by a boom in exhibitions devoted to the fifteenth- and sixteenth-century portrait in Europe. Three major shows were mounted between 2008 and 2011 at leading museums in London, Munich, Vienna, Berlin, and New York, and the sumptuous catalogs they generated allow one to take a closer look at the appeal and significance of the quest to capture and display the human form.

At least the periodization is no mystery. As all the catalogs make clear, these were the centuries when the portrait, largely neglected since antiquity, became a central preoccupation of Western art. To Jacob Burckhardt, who looms over these pages, this development was a prime justification for one of his central conclusions, that the Renaissance was responsible for the "discovery of man." There were a number of forces at work in this shift: the attempt to imitate the ancients, whose profiles adorned coins and medals; a growing interest in the natural world; a preoccupation with earthly fame that had long been subdued; changing patterns of patronage and taste; and the rise of new social norms that were distilled in Baldassare Castiglione's famous book, *The Courtier* (1527). Though none of the essays in these volumes probes very far into such issues, all agree about the result: that during the 1400s the demand for portraits began to multiply throughout Europe.

Poring through the hundreds of painting, engravings, drawings, medals, and sculptures reproduced in the catalogs, one immediately perceives

what the scholarly essays emphasize: the broad variety of purposes for which portraits were made. From the earliest days, there were pious donors who wanted to be included in religious scenes; there were rulers and warriors who wanted to have themselves and their families shown in all their magnificence; there were individuals (usually wealthy) who sought to have their features recorded either straightforwardly or for symbolic purposes; there were occasions, such as weddings, that were marked by depictions of the participants; there were famous individuals whom contemporaries wanted to memorialize; there were loved ones whose images were made as keepsakes or remembrances; there were artists who wanted to capture themselves and their relatives; and over all these enterprises hovered the desire to perpetuate for posterity the fleeting lives of the present.

These different purposes are discussed at some length in the catalog essays, using the abundant evidence from both patrons and artists to document the varieties within the genre. The result is a fascinating traversal of some of the most memorable faces in Western art, accompanied by meticulous explanations of the symbols that accompany many of the sitters, the origins of the commissions, and the reception the works received. Yet the emphases differ widely. The London volume, the earliest to be published, focuses on the different purposes the works served: remembrance, friendship, family, and so forth. The New York volume examines the different settings in Italy where they were produced, finding distinct qualities in Florence, at princely courts, and in Venice. And the German volume, with many more pictures than the other two, aims for a comprehensive understanding, not only of its principal artists—Dürer, Cranach, and Holbein—but also of the different media that were used, ranging from paint to metalwork.

One theme that regularly preoccupies the authors is the issue of likeness. Again and again, commentators at the time were looking for—and found—a vividness and a truth that went beyond the real person in the picture. As Pietro Aretino put it, when describing a painting by Titian:

> Observe the flesh-tints so beautifully painted that they . . . seem to be warm and to pulsate with the very essence of life. I will say nothing of the crimson of the garment nor of its lining of lynx, for in comparison real crimson and real lynx seem painted, whereas these seem real.

The belief in the inanimate brought to life was even, in one case, literally put into effect. As both of the Italian volumes relate (for some degree of

overlap among these books is unavoidable), when Domenico Ghirlandaio painted his famous double portrait of a grandfather and grandson, now in the Louvre, we know from a sketch that the old man had recently died. For the panel painting, however, the grandfather once again appeared amongst the living.

Especially when pondering the question of whether an image could capture character as well as likeness—which was strongly encouraged—those who discussed portraits grappled with the question of the unpaintable. How could an artist convey the essence of a person? How could the invisible be made visible? Erasmus, for one, had no doubt that Dürer could scale that mountain, even in his drawings and prints. As he put it in his eulogy for the recently deceased master:

> Above all, he can draw the things that are impossible to draw: . . . feelings, attitudes, the mind revealed by the carriage of the body, almost the voice itself. All this he can do just with lines in the right place, and those lines all black! And so alive is it to the eye that if you were to add colour you would spoil the effect.

It is difficult to square praise like that with the notion that the portrait was less demanding than other artistic genres.

A basic issue that these volumes pose is the difference between Mediterranean and northern lands. One has but to open to any illustration to see the contrast in feeling and even intensity that distinguishes Flemish, Italian, and German portraits. Occasionally, as in Dürer's Italianate ventures, the lines blur, and the borrowings are manifold. Nevertheless, there is a crispness and an unsmiling toughness north of the Alps that becomes softened and lightened as one enters Italy. Even in Raphael's remarkable double portrait of Andrea Navagero and Agostino Beazzano, where the artist adopted different styles for the two faces, the hard edge that a Fleming or a German would have brought to the work remains absent. And children, too, display the contrast, as a comparison of Ghirlandaio's grandchild with Seisenegger's two-year-old archduchess Eleonore reveals. To seek to identify the sources and elements of these differences would be to explore the nature of traditions, both artistic and geographic—a task that lies outside the scope of these erudite catalogs, but remains a hugely promising means of linking the arts to the social, political, and economic setting in which they were created. And portraiture, with its clear boundaries of subject matter and approach, would be an ideal arena for such research.

If one jumps ahead another century, moreover, one can see how essential the portrait had become as a means of expression across a broad spectrum of themes. In an exhibition of seventeenth-century Dutch drawings at the Morgan Library, for instance, an entire section was labeled "portraits." Its juxtaposition of sober burghers, sleeping women, peasant vignettes, and humble craftsmen evoked an entire society, and was a highlight of the show (though the catalog, organized chronologically by artist, could not drive the point home). Across the North Sea, meanwhile, Rubens was fashioning a dazzling ceiling in London's Banqueting House that was, in essence, an elaborate portrait of King James I. As Gregory Martin cogently argues in his *Rubens in London*, it had become possible, through the representation of a monarch, to promote an entire "philosophy of kingship." What had begun, at least to some degree, as an exercise in vanity—not a topic much discussed in these pages—had become one of the West's most powerful and flexible forms of artistic expression.

3

How Do Van Dyck and Other Portraitists Reveal Changing Values?

Throughout history, the leaders of society have sought to embody specific ideals of demeanor, appearance, and behavior that they and their communities accept as exemplary. In Homer, Odysseus and Achilles, despite many differences, share one essential quality: the warrior's fearlessness. Although this particular ideal was to change, especially as a result of the rise of Christianity, its influence remained central in Western society until, in the Renaissance and the early modern period, a sea change in the concept of the noble man reduced the emphasis on the warrior and elevated the softer qualities of the gentleman. In our postmodern age, the latter term, too, may have lost its meaning as a standard for conduct, but if so, it was the previous sea change that made possible our current situation, when the very notion of social ideals has become as elusive as the quantum.

Even in the devout Middle Ages, the basic attribute of the Homeric ideal survived; the bravery of the soldier was fundamental to male nobility. Thus Roland, Charlemagne, Richard I, and the pious Louis IX were all crusaders and men of war. Odo looms large in the Bayeux Tapestry, not because he was that city's bishop, but because he fought at William's right hand at Hastings. In the famous tripartite division of those who fought, those who prayed, and those who worked, it was the first group that led society, that felt entitled to the wealth and the distinction that were the rewards for courage on the battlefield. A lord might be illiterate, but his sword and armor established his worth. Surviving for more than 2,000 years following the composition of the *Iliad* and the *Odyssey*, this vision became one of the most enduring determinants of social hierarchy in Western history.

In Renaissance Italy, the first cracks began to appear. Chastened by the new values promoted by the humanists, fifteenth-century patricians began

to set themselves apart from their inferiors not simply by their valor, but by their patronage of the arts and the elegance of their taste. The old ideal did not die: in a famous portrait, Federigo da Montefeltro sits in a chair, reading a book even while dressed in armor. But one of Federigo's protegés, Baldassare Castiglione, laid out the program for the future of gentility in one of the most influential books of the age, *The Courtier*. Although he accepted the continuing importance of arms, Castiglione placed an emphasis on manners and refinement which set the tone for the future. Exposed since the 1490s as incapable of defending their homeland from the invasions of barbarian Frenchmen and Spaniards, the Italians readily embraced the finer qualities described by Castiglione as the marks of the aristocrat, and gradually the rest of Europe followed suit.

For the next 100 years, the two definitions of the gentleman continued to coexist: sculpted and painted portraits of princes and aristocrats, shown in courtly dignity and finery, stood alongside the military figures, in armor and on horseback, who were the embodiments of heroic virtue. Titian depicted the Emperor Charles V in both modes, and Rubens and Velázquez remained masters of the equestrian as well as the indoors scene. But the tide was running against the former. Although in public sculpture it remained the standard way to represent princes and generals, in paint the last masterpieces of the genre, before it was briefly revived by David for Napoleon, date from the 1630s, when the horrors of the Thirty Years' War shifted opinion decisively against the military as the fount of virtue.

The time was ripe, therefore, for a master who could bring to exemplary height both the forms and the feelings that might express the new tradition of aristocratic portraiture. And that master was at hand in the person of Anthony van Dyck, who proved to be perfectly endowed by talent and temperament to capture the new needs of his clients. In meeting the challenge at this decisive moment, he gave direction to his metier for centuries to come, and in so doing shaped the history not only of Western art but also of social attitudes. Though we may have retreated from the Castiglionian definition of the gentleman, we have to acknowledge van Dyck, the painter who brought that definition to visual life, as a seminal influence on the ideals of manners and breeding in the modern world.

The future Sir Anthony was born in Antwerp in March 1599. His father was a cloth and silk merchant, but on both sides of the family there were artistic antecedents, and, at the age of ten, he was apprenticed to one of the leading painters in the city, Hendrick van Balen, known for his altarpieces and religious scenes. But he did not remain with van Balen long,

for the dominant artist in Antwerp (and indeed in all of northern Europe) was Peter Paul Rubens, who soon became both his teacher and the presiding influence in his formative years.

At the splendid Royal Academy exhibition mounted to commemorate the 400th anniversary of van Dyck's birth, the first picture we encounter is the earliest by his hand known to have survived: a delicate self-portrait done at the age of fourteen or fifteen. It is a bravura performance, which asserts the young prodigy's astonishing mastery and hints at the achievements to come. Within a year or so, he had his own studio and began to produce the stream of religious subjects that was to occupy him throughout his life. If we had none but these saints and biblical scenes, and his occasional ventures into classical and literary stories, van Dyck would be recognized as one of the leading figures of Baroque art, in a league with the great Italian depicters of Christian and mythological imagery such as Guido Reni, Guercino, and Pietro da Cortona. A somber *Ecce Homo*; the 1630 *Samson and Delilah*, suffused with reproach, yearning and regret; and a voluptuous *Cupid and Psyche*—all glowingly on show in this exhibition— testify to the power, psychological insight, and color that van Dyck brought to these themes. And yet, accomplished though he is, he is overshadowed, in this subject matter, by his teacher Rubens, and on such grounds alone he probably would not have achieved his unique place among the many masters of the seventeenth century, or have become the center of so many major exhibitions in recent years—at the National Gallery in Washington, in Genoa, in Antwerp, and now in London. It may be that this work would not put him into the company of those Richard Spear (in the *TLS* of July 9) has called seventeenth-century "superstars," but when one moves on from the religious and literary themes, one comes to the van Dyck who set a distinctive stamp on Western art.

At about the time the eighteen-year-old van Dyck registered as a master of the painters' guild in Antwerp, he began to produce the formal portraits that were to make his fortune. A number of examples in the exhibition from these early years follow traditional forms and also suggest the influence of Rubens; but around 1620, when he first visited London, the young man was beginning to come into his own. A head of Cornelis van der Geest, a leading Antwerp merchant and patron, captures the sitter's personality with a piercing and compelling force we have not previously seen, and a portrait of the Earl of Arundel, the most distinguished connoisseur and collector in England, is a portent of the individual style to come. Arundel, sitting in a brilliant red chair in front of darkly opulent

drapery, with a vague landscape glimpsed in the distance, reflects the growing influence of Venetian painting (especially Titian) which van Dyck was soon to absorb directly, during a long stay in Italy.

The years that van Dyck spent in Genoa, Rome, Palermo, and Venice throughout much of the 1620s marked the emergence of the great portrait specialist. In a lush self-portrait painted in Rome, we encounter the richness, the directness, and the perception that were to be van Dyck's hallmarks. Here, too, we notice the unnaturally long, tapered fingers that became a feature of his subjects. If these newly Castiglionian aristocrats were to be distinguished from their social inferiors by any one physical characteristic, it had to be their hands. The bearing, the coiffure, the clothes, and the setting might proclaim the man, but only the soft hands, unmarred by the blemishes of manual labor, confirmed the genuine article. That van Dyck exaggerated this feature deliberately can be surmised from the 1629 portraits of the Antwerp painter Jan de Wael and his wife. Jan, his gentility signified by the gloves he holds, extends one of his fine, elongated fingers; but Gertrude, in subservient pose, holds a fur with a hand that has been thickened and hardened by years of toil.

There could be no mistaking the status of the Italians whom van Dyck painted. The members of the great Genoese families such as the Cattaneo or the Lomellini radiate their grandeur, even if they are no more than four, or in one case two, years old. The three Balbi boys are clearly children, but their stares and their poses already have the hauteur of the aristocrat. And the adults, whether an unnamed Genoese lady with her son or the Duke of Savoy in armor, display their relaxed elegance (not to mention their tapered fingers) without a hint of self-consciousness.

Yet it was not until he came to England, where he spent most of his last nine years, from 1632 to 1641, that van Dyck established the standard for princely portraiture that was to be imitated in countless examples thereafter. Sadly, the exhibition *A Royal Image*, which documented this influence and formed part of the Antwerp celebration earlier this year, did not travel to London; nevertheless, the very fame of the paintings he completed during his English period testifies to their importance. This was when Charles I and Henrietta Maria became the most recognizable royal couple in English (and possibly European) history; and when the "van Dyck beard" achieved its prominence not only on the kingly visage but also on the faces of England's earls—not to mention the glamorous artist himself.

Ironically, though, the self-portrait and the late *Cupid and Psyche* are among the few paintings from the artist's last decade (he was forty-two when he died) that show flashes of the exuberance which shone forth, even amid melancholy, from van Dyck in his teens and twenties. For this was the decisive period in the triumph of the refined Castiglionian aristocratic image. Van Dyck did still depict great men in heroic mode, in armor and on horseback. But among painters the equestrian pose was clearly on its last legs, for all its chivalric heritage and a lineage descending from Marcus Aurelius via Donatello, Verrocchio, and Titian. Its last powerful exponents, Rubens, Velázquez, and van Dyck, gave the genre a final flourish in the 1630s; thereafter, its vitality was gone. The irony inherent in Rubens depicting Charles' father, the pacifist James I, as an armored hero on the Banqueting House ceiling could not be sustained for long. Van Dyck did twice turn Charles I into a fairly convincing armed rider (neither painting is in the exhibition, though both are in London); but the portrayal of *A Prince of Savoy* at the Royal Academy is almost comic. Shown in classic position, with his horse held in a difficult manoeuver—rearing backwards, with front legs held high—Prince Tommaso Francesco looks sideways at the viewer with a nervous glance that belies the confidence of the pose. Even the standing portraits of armored men have a touch of irony; one senses that van Dyck's old patron Arundel was a man of culture rather than war, while the elegant Palatine princes, though they were to have sad involvements in military affairs, seem to carry their resplendent armor as if it were fancy dress. Yet, in the previous century, Titian had been able to show Philip II in this guise, despite his perennial absence from the battlefield, without a hint of irony.

Far more convincing in the 1630s, and the true wave of the future, were the striking pictures of the pampered inhabitants of a lavish courtly world. Venetia, Lady Digby, harrowingly shown on her deathbed, was soon thereafter commemorated in an allegorical scene of ornate splendor. Warwick, despite his naval command, has his armor at his feet and is swathed in luminous orange. Danby, sword and battle scar notwithstanding, is almost a study in silks. Because of the general opulence, it is hard to draw a line between mere courtiers and the King and Queen themselves. The dim crown and scepter on a table, in the double portrait from the Czech Republic, give their identity away, although the symbolism of the leaves that the Queen is holding remains clouded. If, as seems plausible from Charles' gesture, he is reaching for the olive branch in his wife's left hand, then this picture affirms the shift that had taken place in the ideal of

nobility, by emphasizing the quest for that new princely virtue, peace. And in van Dyck's most famous image of Charles—the Louvre's *Le Roi à la Chasse*, which is conspicuously absent from the Royal Academy—the King could be any fine gentleman, in elegant outfit, with hat and cane, resting while off his horse in the quiet countryside. That this was the pose that Hyacinthe Rigaud was to echo, half a century later, in the most famous portrait of Louis XIV, indicates how completely the new style of portraiture (and with it, the new image of majesty) had been formed by van Dyck.

The most telling reflection of the change in aristocratic values is the marvelous double portrait of two cousins of the King, Lords John and Bernard Stuart. Here, personifying disdain, stand two spoiled young men. Conceit oozes from them, and one even points to himself as if to emphasize the egoism. In their high boots, lace and brilliant silks, with their flowing hair and peach-like complexions, they are the very models of the newly modern courtier.

Elegance, refinement and a sense of superiority are now the touchstones of the gentleman; he no longer needs to display his martial valor, and even the sword that marks his social status is barely visible. In fact, both of these Stuarts were to die in battle in the Civil War, but looking at them one almost wishes the Castiglionian transformation were not so complete. A touch of military spirit would have made them seem less contrived. Yet the portrait reminds us again, both of van Dyck's genius in capturing and fashioning a new definition of gentility, and of the reasons for the modern egalitarian reaction that has made that definition obsolete. Above all, we can see that the standards he set in the purposes of aristocratic portraiture made van Dyck more than just one of many masters of seventeenth-century art.

4

What Do German Portraits of the 1920s Tell Us?

Germany between the World Wars is the pivot around which the history of the twentieth century turns, and it is the first half of that period, leading towards catastrophe, that is the subject of an extraordinary exhibition at the Metropolitan Museum, *Glitter and Doom*. Laid out before us is the fevered cultural and social exploration that swept German cities to a degree not seen anywhere else in Europe at the time. As Sabine Rewald, curator of the exhibition, points out, the misery and turmoil of a defeated nation did not prevent these years from becoming an age of "creative ferment ... [and] innovative accomplishments . . . unparalleled elsewhere." If the pessimistic probing of the human psyche in Mann, Rilke, and Remarque captured an era that, on the one hand sought to escape its memories and deprivations, but on the other faced them with an unrelenting eye, the same was also true in the visual arts. And nowhere was the enterprise more caustically, more profoundly explored than by the group of artists known as the Verists, who made the portrait the focus of their work.

To go through this exhibition was to endure an assault on the senses. The Metropolitan even warned, in a wall label at the entrance to the show, that the images could be disturbing to children. One's assumption has to be that they were disturbing to all. On both the occasions I went I felt compelled, as I emerged, to visit an exhibition elsewhere at the Metropolitan full of Cézannes and van Goghs in order to cleanse my palate, to restore some sense of equilibrium by reminding myself of the role of art as a creator of beauty.

For there was no quest for beauty in the Verist portraits. Instead, they were a means of examining a society ravaged by war, by profiteers, by desperate attempts at glamour, and by a moral decline that merely reflected an oppressive world of self-doubt, empty pleasures, and gloom. The

exhibition's title, *Glitter and Doom*, captures the atmosphere perfectly. Even the self-portraits intensify the darkened tone. Max Beckmann, cigar stub in hand, put himself on canvas twice, in 1919 and 1923. In both pictures he stares fixedly, almost aggressively—in the first, as the embodiment of decadence; in the second, as a surly bully. Three years later, Otto Dix had himself standing at an easel, frowning suspiciously at the viewer. And Gert Wollheim shows himself as grim, terrified, and wild. Like the subjects they painted, these artists themselves had no joy, not even simple straightforwardness, to offer.

There were 100 pictures in the show, and it was hard to choose one over another as exemplars of their unremitting capacity to depress and shock. From Dix, the dominant brooding presence in the show, there are drawings showing war veterans horribly disfigured by grenades, and prostitutes of singular repulsiveness. His colleague Christian Schad, represented here mainly by portraits of unutterably sad denizens of café society, including a resplendent transvestite, was drawn to those who seemed unable to express a hopeful normality. A portrait of two performers becomes, by implication, a display of freaks. There is a black woman, an outsider in this society who was known for dancing with a snake; and, towering above her, undressed so that his disfiguration dominates the picture, is a man who was famous for having been born with an upside-down rib cage, and was called "the winged one."

One might have thought that George Grosz would be the star of the show. And yet his devastating political commentaries, which skewer authority, self-satisfaction, and wealth at every turn, are here just one part of the scenery. Seen in context, they become a recognizable dimension of the Verists' commentary on the decadence and misery of 1920s Germany. And for sheer horror, they do not come close to the ghastliness of the most disturbing picture in the exhibition: Dix's three card players who, in an exaggeration of three veterans he had seen, share two normal eyes, one leg, and a hand (*Illustration 4*).

What was most remarkable about the exhibition, however, was not the accusatory satire and the chilling exposure of the underbelly of a society that had lost its moorings. It was the way these artists portrayed their own friends and colleagues. How anyone would have been willing to sit for Dix, Beckmann, Schad, Grosz, or their lesser-known colleagues Meidner, Schlichter, and Scholz, defies belief. Brecht emerges relatively unscathed, although with a sneer on his lips; Kokoschka, as the catalog notes (fairly kindly), appears as "a somewhat retarded man of the woods." But these

are minor exposures. Dix made his friend the doctor and art dealer Hans Koch look like a torturer, with a fixed stare and a sinister smile. He turned the homosexual jeweler Karl Krall into a wasp-waisted emblem of affectation. One is not too surprised to learn that neither man kept his portrait long. Wherever one turned, especially if there was a photograph in the catalog for comparison, one could see that these were not people who turned out well when put on canvas or paper. If they looked strange in any way, they were seized upon; but even if not, they were fodder for a jaundiced view of the world.

There has never been anything like it in the long history of portraiture, either before or since. Hitherto, the portrait had served, first, as an accolade to the rich and powerful, and then as a means of exploring the nature of humanity. Now, however, for a little more than a decade, the depiction of the human figure became a potent weapon of social criticism. There have certainly been great artists who have assailed the failings of mankind: one has but to think of Bruegel or Goya. Yet the use of the portrait to this end, and not just by a single artist, but by a coherent group, is unique to Germany in the 1920s.

For the historian the most telling lesson of the exhibition is that the humiliation and self-laceration distilled into these portraits can last only so long. It was inevitable that German society would eventually pursue new ambitions, a renewed sense of purpose. The grim outcome of that quest we know only too well, and it was reflected in the fate of most of these artists who, together with their subjects, fled their native land when the Nazis came to power. For all the tragedy that they reflected and to some degree intensified, however, one has to retain one's admiration for their demonstration of one unyielding truth: that even the often dismissed genre of the portrait has the power to shape a culture and define a historical moment.

Part Three

The World of the Collector

1

What Was the Audience for Prints?

Among the many transformations brought about by the invention of printing, one stands out in the history of art: it made possible the cheap reproduction of multiple copies of pictures. Whether as woodcuts or as engravings, images could now circulate easily across large distances. And this breakthrough happened at the very moment when it filled an urgent need, during the Renaissance.

While opinions about the origins and meaning of the Renaissance may vary, one feature is unmistakable: the period's passion for antiquity. This was clear from the outset, when Petrarch in 1350 addressed a letter to the Roman historian Livy that said: "I would wish, either that I had been born in your age, or you in ours. I should thank you, though, that you have so often caused me to forget present evils and have transported me to happi- er times." It remained true over 150 years later, when Machiavelli, in re- tirement, put on his finest clothes so that he could imagine dining with heroes from antiquity. Like Petrarch, he regarded the Romans as the only models of virtue worthy of imitation—a belief that persisted well into the seventeenth century.

Prints became essential to this story when Petrarch's call for a return to antiquity captured the imagination of Florence's intellectual leadership, then the princely courts of Italy, and in particular the artists who were among the chief ornaments of the age. Beginning with a visit to Rome by the Florentines Donatello and Brunelleschi around 1409, the buildings and other relics of the ancient world inspired a revolution in imagery as well as thought.

In this familiar story, prints were to play a crucial role. For how else, in an age of tortuous communications, could artists gain access to the achievements of antiquity that they sought to imitate? Few of them could travel to Rome, and personal contact and scarce manuscripts could hardly

meet their needs. The answer, if they were to see for themselves the mas-
terpieces of antiquity, was the print. What is telling, though, as all this new
information flooded through Europe, is what printmakers chose to depict
from the ancient world.

That is the subject that the exhibition *Revivals, Reveries and Reconstructions:
Images of Antiquity in Prints from 1500 to 1800*, at the Philadelphia Museum
of Art, sought to document in 2000. Through 93 prints and 16 illustrated
books, the show revealed the role played by great masters and obscure
engravers alike in the dissemination of the ancient prototypes that were
essential to Renaissance and Baroque art. The story these prints told,
however, was not only about the intensifying engagement with antiquity,
but also about a shifting purpose that opened a window into the world of
the collector.

The importance of antiquity was established very early during the Re-
naissance. In the 1480s, for instance, Andrea Mantegna painted nine huge
works that reconstructed in meticulous detail a triumphal procession of
Julius Caesar. Reproduced by contemporary engravers, the paintings be-
came widely accessible, and they remained in demand 120 years later,
when Andrea Andreani produced a woodcut version (the opening exhibit
in Philadelphia). By then, most of the great names of European art had
absorbed Petrarch's message, and the close interest continued into the
mid- and late-eighteenth century, when prints by Tiepolo, Fragonard, Pi-
ranesi, and Angelica Kauffman were still depicting buildings, characters
from Ovid's stories, and other subjects that remained fundamental means
of representing ancient Rome.

Yet it was not just the advocacy by Petrarch and his followers, the hu-
manists, that shaped the interests of artists. A repeated stimulus was the
sensational discovery of ancient artifacts, from the *Laocoön* in 1506 to
Pompeii in 1748. The *Laocoön*, uncovered in Rome, was immediately rec-
ognized because it had been described by Pliny. Artists were apparently
drawing the statue even as it was being taken out of the ground, but its
fame throughout Europe was the work of printmakers. Within a few years
it had been caricatured as a group of monkeys by Titian (possibly to sati-
rize the excessive imitation of antique works), and by the 1540s that cari-
cature itself had been reproduced in a woodcut.

Perhaps because of their ability to survive underground unscathed,
sculptures were a favorite subject for the printmakers. It was also easy to
see them in the Belvedere Court, now a dismal parking lot but then the
first public museum since antiquity, opened by Julius II soon after the

start of his pontificate in 1503. The Belvedere's first installation, and its star attraction, was a recently discovered statue of Apollo, which instantly became a touchstone of ideal male beauty.

To see that influence one need only look at the figure of Adam in Albrecht Dürer's 1504 engraving *Adam and Eve*, which, though Dürer never visited Rome, was clearly inspired by the *Apollo*. Other residents of the Belvedere whom the printmakers celebrated—a powerful torso, a recumbent *River God*, a statue of the comely youth Antinous—attracted similar attention from artists as different as Salvator Rosa, Nicolas Poussin, and William Hogarth.

Symptomatic of this absorption in antiquity was the career of the Dutch master engraver Hendrick Goltzius. He visited Rome in 1590, where he became so preoccupied with ancient sculpture that neither an outbreak of plague nor its dreadful accompaniment—the stench of rotting corpses piled up near the statuary he was copying—kept him from his work. After he returned home, he engraved three of his drawings, and the two in the exhibition show the artist looking up at the *Apollo* and at another recent discovery: a huge statue of Hercules that had been found in 1556. Taken by the powerful Farnese family, the *Hercules* became an essential sight for visitors to Rome. By 1590 it was so familiar that Goltzius could show it from the rear and know that it would be instantly recognizable.

Ancient buildings were less numerous than sculptures, but they, too, became common currency throughout Europe. Though he never left his native land, the Dutchman Jan van de Velde put a recognizable Temple of the Sybil from Tivoli in one of his landscapes. And despite the disfigurement of the actual Pantheon by two bell towers and a new wing, Hubert Robert could show it as it had been in antiquity.

The printmakers also copied inscriptions and reliefs, and a fascinating section of the Philadelphia exhibition documented the appeal of funerary monuments—notably antique tombs such as Rome's pyramid of Gaius Cestius. The reliefs became sources for pastoral scenes, for battles, arms and triumphs, and for stories about gods, myths and ancient heroes. The breadth of the subject matter the engravers derived from arches, columns, and other relics helped create the basic vocabulary of Renaissance and Baroque painting, architecture, and sculpture.

In the early eighteenth century, the basic impulse behind the collection of prints began to change. Artists still looked to their predecessors for inspiration and purpose, and wanted access to the images they needed; but

increasingly there was another reason for collecting engravings. They had long been recognized—at least since the generation of Dürer—as significant works of art in their own right. Gradually, this became their main appeal, and in the eighteenth century their value to the rich collector transformed the enterprise.

A decisive figure here was Piranesi, who, though etching Roman remains, was not doing so in order to evoke the shapes and structures that could inspire fellow artists. Instead, like Canaletto in Venice, he was feeding a market eager for views of the places tourists had visited or wanted to see. His workshop became a center for the restoration and sale of antiquities, and the clearest testimony to the change in outlook was the pair of etchings he produced in 1769 of an elegantly decorated marble vase that had just been discovered at Hadrian's villa in Tivoli. Its fruits and putti, lovingly reproduced, were intended not to enlarge the store of Roman images, but to advertise the value of the vase to potential buyers. The collector of prints—their audience—had become the connoisseur, not other artists.

For Mantegna or Poussin, the commercialization of Rome's inspiring images might have seemed sacrilegious. No more were the printmakers helping feed the passion for antiquity. Nothing found at Pompeii was to be as famous as the *Laocoön*, the *Apollo*, or the *Hercules*. Convinced by the Scientific Revolution that they had progressed beyond their forebears, Europeans no longer looked so urgently to Greece or Rome for the forms and substance of artistic creativity.

The change in European culture was almost palpable, and the Philadelphia exhibition, though unassuming in scope and intention (as were many of the devotees of the black-and-white, unglamorous print), demonstrated not only the role of humble etcher and engraver in the ascendancy of the antique but also their creation of a new collectible art form, the print.

2

Why the Interest in Piero della Francesca?

The selected bibliography in the catalog for the exhibition *Piero della Francesca in America* runs to more than 250 items, an indication of the fascination that Piero has exercised since his "rediscovery" in the nineteenth century. One of the reasons for the attention is that he poses so many puzzles: Why do almost all of his faces display such an enigmatic lack of expression? Why is it often so difficult to explicate a painting (notably his *Flagellation*)? How does his involvement with mathematics relate to his art? These issues have preoccupied scholars for generations, but a topic that has not received detailed treatment until this exhibition is the particular appeal he has held for Americans. There are more Pieros in the United States than anywhere else outside Italy, and that convergence gave the Frick Collection, with the largest of the American holdings, the occasion for this investigation.

In addition to Helen Clay Frick, the principal players in the story are Isabella Stewart Gardner and Robert Sterling Clark, though Bernard Berenson and Lord Duveen are never far away. Thanks to their enthusiasms, we can now ponder an assemblage of five of the six American Pieros (the Gardner *Hercules* does not travel), plus a related St. Augustine from Lisbon. The result is to make possible a consideration, both visual and scholarly, of what it was that drew the great collectors of the early twentieth century to the man from Borgo San Sepolcro.

Rarity and inaccessibility were major motivators, though one must also emphasize, especially in the case of Helen Clay Frick, an aesthetic instinct. Unlike Robert Sterling Clark, she really did love Piero's work. Moreover, her close study of Old Masters, and her belief in their educative value—manifested in her remarkable donation of superb, full-scale copies to the University of Pittsburgh—set her apart as a collector. A priceless photograph of her in front of Orvieto's spectacular cathedral, accompanied by

her Cicerone, the Giotto scholar Mason Perkins, suggests how deter-
minedly her engagement with the arts of Italy led her to become the
greatest Piero collector of the day.

Yet the contributors to the catalog cannot resist taking on a puzzle. All
of the paintings in the show, with the exception of the Clark Museum's
Virgin, were intended as elements of an altarpiece, now long gone, in the
church of Sant'Agostino in Borgo. What did it look like? There is no way
of knowing, but there are clues, and these become the basis of an elegant,
plausible reconstruction that is one of the features of the exhibition. Large
gaps may remain, and the documentation across half a millennium may be
sparse, but scholarly ingenuity and dedication are abundant. That they
have been devoted at such length to these few works is the surest sign of
the continuing magnetism that derives from the serenity, grace, and deli-
cacy of the art of Piero della Francesca.

3

What Can Drawings Tell Us?

There is much that we owe Renaissance Italy, but even Jacob Burckhardt, its most enthusiastic advocate, did not cite what a group of exhibitions in London and New York in early 2010 have made unmistakable—the creation of drawing as a major art form. From Fra Angelico to Bronzino, and on to the Carracci, artists used pencil, pen, and chalk not only to work out their most cherished ideas but also to connect to their audience with an immediacy and a sense of closeness that have no equal. Paintings and sculptures may achieve unique effects, but they establish a distance between artist and viewer that drawings dissolve. It is no wonder that the latter have appealed to collectors, and as a result have survived in such large numbers.

The riches on display at the Morgan Library, the Metropolitan Museum, the Courtauld Gallery, and the British Museum, tempt one to call Spring 2010 the season of the Italian drawing. Except for the Morgan, which showed works from its holdings under the rubric *Rome after Raphael*, all the organizers have produced sumptuous catalogs that reinforced the uniqueness of their subject through learned essays on context, meaning, and provenance. Though the absence of an index in the Courtauld volume is regrettable, all three books are exemplary in presentation and scholarship. And the Morgan wall labels alone convey the adventure students of drawings embark on as they seek to unravel purpose and origins. Here, in some eighty works, one can follow a succession of talents as they struggled with the weighty heritage of Raphael and Michelangelo, forging the new styles of Mannerism and Baroque, and creating new kinds of subject matter, such as Giuseppe Cesari's fetching child who turns to the artist while holding its mother's hand.

For the scholar, though, intent and attribution remain perennial problems. In the Courtauld show, these issues are relatively limited but still

vexing. The centerpiece is one of the gallery's great treasures, Michelange-
lo's *Dream*, a beautifully rendered but strangely esoteric composition that
Panofsky linked to Platonic and Christian ideas of love, but which has
eluded definitive interpretation. Stephanie Buck seeks, with some success,
to link it to other presentation drawings Michelangelo made for his be-
loved Tommaso de' Cavalieri, and these, notably the haunting *Fall of
Phaehon*, are the focus of the catalog. And yet, however famous these
drawings were (amongst the many copies made of *The Dream*, for instance,
the one by Clovio is at the Morgan), their aims, in subject matter and
presentation, remain fiercely contested. The alternatives are judiciously
laid out in the catalog, but firm conclusions about the artist's intent (and
in some cases even his authorship) remain out of reach.

The trouble is that drawings are rarely signed, and unless they can be
linked directly to other works (a gift not often given) their lightness of
touch can complicate opinions about style and attribution. The British
Museum avoids the problem by offering over a hundred masterpieces,
mainly from its collection, that have solid provenance. These drawings
make an overwhelming case for the power of the form. Whether it is an
old man captured by Signorelli or Vivarini, or a young girl evoked by Ti-
tian, people come to life before one's eyes with a vividness and distinc-
tiveness that the more distancing art of painting never achieves. One has
a sense of the artist, just inches away from the vellum or the paper, mak-
ing tiny adjustments, adding a line or two here and there, right before
one's eyes.

Here we have the whole range the form encouraged: magnificent
presentation drawings, such as Mantegna's beautifully finished and elabo-
rate *Virtus Combusta*; Verrochio's preparatory drawing of an angel's face,
pricked, and ready for transfer to his *Baptism*; Pollaiuolo's experiments
with hands in different positions for a *John the Baptist*; and Leonardo's
quick observations of a cat in varied poses. The variety, encompassing
moods from grandiose ambition to personal delight, is breathtaking. And
repeatedly the artist himself seems to emerge from the scene. To see the
changes Carpaccio made between the pen and oil versions of his *St. Au-
gustine* is almost like standing at his shoulder as he decided, for example, to
substitute a dog for an ermine, or to surround the saint's desk with books.

In scholarly terms, though, the principal achievement in these volumes
is the restoration of Agnolo Bronzino to his proper place as a master
draftsman. The precision and the unadorned directness of his drawings
have even led one critic (Souren Melikian) to suggest that they were more

compelling than his paintings. In fact, though, the comprehensive illustrations of Bronzino's oils and tapestries at the end of the catalog remind one that, for elegance and the vibrant use of color, he had few equals. The experience of the drawings is simply different, a medium where Bronzino could convey pathos, intimacy, charm, yearning, grace, or power in just a few strokes. His sharp observations of detail, his easy control of line and shading, and his subtle suggestions of character make it remarkable that this is the first ever show devoted to his drawings. The main problem has been attribution. Nevertheless, despite the lack of consensus among experts, and the modest willingness of the authors of the catalog to accept "attributed to" in a number of cases, a strong case is made for the oeuvre as they define it. Their success in lending new stature to a famous sixteenth-century Italian artist is no mean achievement.

The scholarly intricacies aside, it is heartening to see drawings receiving such attention from these major museums. The form may lack the glamor of painting or sculpture, but it deserves this attention, because it allows the viewer a unique glimpse of the moment of creation when an artist brings his ideas into reality. Especially in the quick sketches and the tiny details, rather than in the fully realized presentation works, these sheets help one understand how it was that the Italians of these centuries were able to transform the nature of the visual arts.

How Is the Emperor Charles V to Be Assessed?

The story that begins with the Roman Emperor Augustus, and then trac-
es, through constantly changing fortunes, the dream of a single Emperor
who dominates all of Europe, comes to an end 1,500 years later, with the
Holy Roman Emperor Charles V. It was an ideal of astonishing durability,
particularly since none who pursued it came close to making it real. Even
its last exemplar, Charles, who proved also to be the first who could claim
to rule an empire on which the sun never set, recognized the futility of the
ambition, and in his final years split his domains, and thus the vision of
universality itself, into two separate units.

 It is entirely appropriate, therefore, that the reign of this pivotal figure
in European history should be marked with the major exhibition, *Carolus:*
Charles Quint 1500–1558, on view in Ghent, whence it moves on to Bonn
and Madrid. The locales may suggest the diversity of the places associated
with Charles' rule, but the connections are ambiguous at best. Bonn was a
minor German city, and Madrid an obscure village, in the early sixteenth
century; as for Ghent, though it was the site of his birth in 1500, it has
always hated its famous son. The organizers of the exhibition have in fact
been careful to say that they are commemorating, not celebrating, Charles,
the ruler who suppressed Ghent's ancient liberties and destroyed the city's
centuries-old tradition of independence. Indeed, as a run-up to the exhibi-
tion, a group of the local citizenry has emblazoned on the last remaining
wall of the palace in which Charles was born the names of the Ghent
burghers whom he executed for trying to resist his oppressive regime.

 It is easy to see Charles as a symbol of European unity. Traveling cease-
lessly across the Continent, well versed in more of its newly distinct lan-
guages than any of his predecessors or successors—he is said to have re-
marked that he spoke Spanish to God, French to men, Italian to women,
and German (or Dutch) to his horse—he seems an international figure.

Which makes it all the more surprising that there has been so little new scholarship on his virtually Continent-wide regime during the past half-century, despite the accelerating drive towards European unity. To his last major biographer, Karl Brandi, writing more than sixty years ago, he was a tragic figure, devout and with a high sense of mission, but ultimately unable to hold together his scattered dominions. Recent views have been less favorable, as his arrogance and cruelties have been identified; yet his importance is inescapable, and the range of his influence undeniable, as this thoughtful and scholarly exhibition makes clear.

Comprising more than 300 works of art, armor, documents, maps, books, medals, instruments and such items as the cot in which Charles was reputedly born, the display in Ghent seeks to capture the many worlds the Emperor bestrode, while hinting at the dazzling creativity of those who adorned his age. In four successive sections we see the expanding circles of his presence, from Ghent itself, on to the Netherlands at large, then to Europe as a whole, and finally to the Americas. In each arena we see the Emperor's stamp—on his repression of Ghent, on his consolidation of authority over the Netherlands, on his embrace of territories that stretched from Hungary to Portugal, and on the fabulous wealth pouring in from the New World. His was the ubiquitous face of the age, reproduced in paint, line, tapestry, wood, and metal. For all the rivals we see here, notably Henry VIII of England and François I of France, this was unmistakably the age of Charles V.

And its problems were his, too. Portraits of Luther, Calvin and Pope Paul III remind us of the ruinous consequences of the religious disputes that erupted in Charles' reign, which he proved powerless, despite military success, to subdue. One of the most chilling items on view is a copy of Erasmus' *Institutio Principis Christiani*, the famous treatise of moral advice for a Christian prince, issued in 1516 with the future emperor in mind. Slashing across the pages to which it has been opened are the heavily inked deletions of the censors. Even the greatest intellectual ornament of Charles' age had to succumb to the destructive passions of the day, and there is no doubt that the authoritarian emperor would have approved. That he was also the dedicatee of one of the other publishing monuments of the reign, Andreas Vesalius' lavishly illustrated landmark of anatomy, *De Humani Corporis Fabrica*, seems to have made no impression. The intellectual transformations that were under way in his realm—the spread of humanism, the Reformation, the Scientific Revolution—were as often as not resisted or ignored by this deeply conservative figure. He may have

regretted that his assertion of power led to the sack of Rome by his troops in 1527, but what mattered was the defense of traditional values: arranging to have Pope Clement crown him (the last such event in a line that went back to Charlemagne), crushing Lutheran rebels in Germany, or launching a crusade against infidel Muslims in North Africa.

In one area alone, Charles was at the vanguard of his times: his patronage of the arts. Anyone who visits the Alhambra in Granada will be awed by the stunning though unfinished palace that he built next door as a kind of demonstration of Christian triumph over Islam. And in other media, too, he had a keen eye for the finest talents of the time—in metal and sculpture, the Leoni family; in tapestry, the huge propagandistic hangings that accompanied him wherever he went, but sadly not on display in Ghent; and, in painting, such masters as Dürer and Titian. The wonderful silverpoint of a lion that Dürer produced during a visit to Ghent is one of the first images in the exhibition, and it is an immediate reminder of the glories of the age. And yet, though the artist's journey to the city was prompted, early in the Emperor's reign, by his hope that Charles would continue the pension that his grandfather and predecessor, Maximilian, had paid—it was in fact renewed for two more years—there is no record of any commissions from the new patron.

Charles' favorite portraitist, instead, was the Venetian Titian, for whom he was said to have picked up a fallen brush—in emulation of Alexander the Great's similar gesture for Apelles. Although the spectacular model of an armored horse and rider that Titian used for his equestrian portrait of Charles at the Battle of Mühlberg is in the exhibition, the painting itself appears only in a small copy. But there is a splendid *Christ* that the Emperor owned, and also, in fascinating juxtaposition, the Seisenegger portrait of the Emperor with his dog, alongside Titian's reworking of the composition. Here, at one glance, is revealed the difference between the workmanlike and the masterful, and it is worth the visit to Ghent merely to see how Titian transformed Seisenegger's composition, straightforward and flat, into a powerful presence that breathes dignity and feeling.

There are other fine depictions of the people of the age, but it takes Titian to give us a glimpse of the full vibrancy of Charles' reign. The excellent catalog, available in French, German and Spanish, provides a series of essays that set the scene, plus detailed provenances for the works on display. But this publication, too, puts the emphasis on political and intellectual, not artistic achievement. This is a commemoration, in other words, that will satisfy the scholar and the historian rather than those who

seek to experience one of the formative periods of Western art. For the latter, one needs to go to Venice, to the current exhibition at the Palazzo Grassi, *Renaissance Venice and the North*, which is a cornucopia of the out-pouring of genius in sixteenth-century Europe. But for context one needs to start in Ghent.

What Can We Learn from a Kunstkammer Collector?

The Emperor Rudolf II would have loved the book under review—*Rudolf II and Prague*, an 800-page explication and catalog of a series of exhibitions held in 1997. Among the treasures here displayed are objects as varied as a jasper vase; a sandstone gargoyle; a pair of silk slippers with cork soles; an antelope horn in a silver-gilt half Seychelles-nut; a fire-gilded brass torquetum (a revolving measuring instrument); a boxwood and brass alto horn; a steel, leather, and silver Turkish battle-axe; and dozens of medals, sculptures, engravings, drawings, and paintings. To modern tastes, items in the last four categories might qualify as works of art, while the rest would be set apart under such headings as the decorative arts. For Rudolf, however, they would all have been exemplars of the beauties and wonders of the world, to be assembled, avidly and comprehensively, in the city that he made his imperial capital, Prague.

Fittingly, it was Prague itself that arranged this agglomeration so as to pay tribute to Rudolf, the most remarkable patron in its long history. And the gargantuan scale, not to mention the variety, accurately reflected the omnivorousness of the honoree. So enormous was the assemblage that eighteen separate venues were needed to show it all, from May to September, and still some of the exhibits, such as "Postal Services during the Time of Rudolf II," had to be left out of the catalog, notwithstanding its nearly 1,200 entries and 120 contributors.

Like its central subject, *Rudolf II and Prague* roams all over the place, and only occasionally gives hints of coherent purpose. Nearly four hundred pages are given over to thirty introductory essays, divided very roughly between discussions of the imperial court and explorations of the urban society in which it was located. But it is almost impossible to discern either connecting themes or uniform goals in essays that range from a chronology of the feud between Rudolf and his brother Matthias, by Her-

bert Haupt, to a monographic investigation of Roelandt Savery's depiction of waterfalls, by Joaneath Spicer; a discussion of the larger aims of royal portraiture, by Lars Olof Larsson; and a detailed description of the work of individual glass-makers, bell-casters, embroiderers and other craftsmen, by Jana Kybalov.

There are attempts to impose some kind of structure on the aesthetics and productivity of Rudolf's Prague. Thomas DaCosta Kaufmann, for example, responds to what he calls the absence of "one set of forms which is characteristically Rudolfine," by positing a system underlying the choices of styles that he calls "stylistics": a combination of humanist learning, Dutch Mannerism and Italian exemplars in an intellectualized and classically inspired "poetics" of painting. And the effect of confessional dispute is a consistent theme, whether in Jaroslav Pánek's treatment of the Bohemian nobility or in Ivana Cornejova's history of education in Prague.

Nevertheless, the principal impression that is conveyed, by the essays, by the catalog entries, and by the hundreds of illustrations, is of a kaleidoscopic outburst of creativity, unrestrained by system, structure, or shared aspirations. Prague's Golden Age is thus rather different from other famous golden ages, such as those of Athens, Florence, Elizabethan England, or the Spain of Philip II, III, and IV. In these other cases, there is a certain outlook, a distinctive set of masterpieces, and a recognizable progression in literature and the arts. In the century that this book covers (the authors take the story from the 1550s to the 1640s), only the first of these distinguishing marks, a specific outlook, is discernible.

That outlook, which combined an open-hearted acceptance of talent, whatever its source, with an ardent desire to embrace as many of the world's wonders as possible, was fundamental to Rudolf II's own tastes as a collector, which expanded rapidly after he left the austere Spanish court where he was raised, and settled in Prague. Moreover, his enthusiasms came to epitomize the arts of a century in which his thirty-six-year reign as emperor (1576–1612) was by far the longest. Herein lies the justification both for the exhibition and for the flurry of recent research on which it rests. But the many pages of description and illustration still leave one wondering how these Rudolfine interests came to take the form they did, and why, for example, the painter Anton Stevens was still producing a quintessentially mannerist *St. Sebastian* in the 1650s, when the rest of Europe was already into the last stages of the Baroque.

Some possible answers can be gleaned from the essays, though they are

on the whole less analytical than the scholarly contributions to the previous major traversal of this subject, the exhibition *Prag um 1600* of 1988. Yet it is because of the longer chronological span that the first glimmerings of the Golden Age become visible in the reign of Ferdinand I, Rudolf's grandfather. In a magisterial survey that opens the catalog, Eliška Fučikova, the curatorial director of the exhibition, emphasizes Ferdinand's wide-ranging interests, from architecture and botany to numismatics and zoology, as setting the tone for the collector's instincts of his successors. It may have been Rudolf who made the Kunstkammer—the accumulation of objects, wonders and works of art—the heart of the collecting enterprise, but it was his grandfather who put together the first Kunstkammer in the 1550s. This was in Vienna, but Ferdinand also gave a major impetus to the explosion of building and decoration that was to transform Prague into a worthy capital city over the next half-century. Born in Spain, brought up in the Netherlands, resident in Vienna and Prague in his later years, and enamored of Italian and humanist culture, Ferdinand established eclecticism at the heart of imperial Habsburg aesthetics.

His interests were sustained by his son, the Emperor Maximilian II, in whose reign another unique feature of the Prague scene came to the fore: religious diversity. The heritage of Hus, Utraquists, and Bohemian Brethren was now enriched by Lutherans, Calvinists and radicals. As Ivana Cornejova points out in her survey of religion, Maximilian's Protestant inclinations (despite occasional severe decrees) became apparent on his deathbed, when he refused the Roman Church's last rites, thus leaving Rudolf with an ambiguous confessional heritage that he never dispelled. A recent study by Howard Louthan, which appeared too late to be cited here, emphasizes the strength of the irenicism at Maximilian's court, and one can readily see how this tradition encouraged the eclecticism that marked the arts and patronage of the Rudolfine age. One of the manuscript illuminations reproduced as a full page in the book seems to make the point visually: in a Catholic church, but under a prominent Habsburg coat of arms, five distinct groups gather (only two with a priest), each turning their backs to the others and singing their own songs in praise of God.

This spectrum of beliefs only widened as immigrants poured into the vibrant city. Prague's population doubled, to around 60,000, in the second half of the sixteenth century, and, as Jiří Pešek shows, the newcomers were drawn from many faiths and many lands: Germany, Italy, the Netherlands, France, and Spain.

At the same time, the Jewish community, about 1,000 people at mid-century, grew more than sixfold in fifty years, mainly as a result of the protection and tolerance of the regime, and became a powerful creative force in its own right, famous for its mysticism, its decorative arts, and its links to the broader culture. No wonder that this crossroads city in the center of Europe, with few aesthetic traditions of its own, and open to so many outside influences—pattern books by Albrecht Dürer and others, for instance, are described by Michal Šroněk as "an irreplaceable aid" for Prague's artists—channeled the aggressive patronage of the Rudolfine age into so many different and seemingly disconnected directions.

But it is clear that there were preferences. Essential to the outlook of the age was not merely an eclectic cultural appetite, but also a fondness for the offbeat, the unexpected and the hermetic. The fascination with "wonders," accompanied as it was by a serious commitment to the new studies of nature, set Prague apart from other major artistic centers. For a while, the entourages of Tycho Brahe, Johannes Kepler, and David Gans—immigrants from Denmark, Swabia, and Westphalia, respectively—came close to making the city the principal focus of Europe's latest scientific ideas. Kepler probably felt more at home here than at any of the many other stops in his peripatetic career, and his fantastic speculations have come to seem emblematic of the Rudolfine world view.

Given these predilections, it was natural for Mannerism—with its love of the curious and the artificial, its twisted bodies, and unsettling distortions—to remain the dominant style, even as the Baroque swept over other lands. This was so despite the love of things Italian that characterized the last of the great patrons of Prague's Golden Century, Albrecht von Wallenstein (who does not make it into *Rudolf II and Prague*'s index). The palace that Wallenstein built was lavishly decorated by a Florentine, Bartolomeo Bianco, whose inspirations included both Guido Reni and Guercino; yet the more public art Wallenstein commissioned, the statuary for his garden—soon to be shipped by Swedish troops to Queen Christina in Stockholm—was by the Dutch mannerist Adriaen de Vries. And the distinctiveness of Rudolfine tastes was not lost on contemporaries. If Kepler was in his element in Prague, so too was the Milanese Giuseppe Arcimboldo, one of Rudolf's favorite painters, whose strange portraits, consisting of flora and fauna, seemed capricious and bizarre even to so keen a critic of literature and the arts as Galileo. And Christina herself, despite appropriating hundreds of Rudolfine treasures in the 1640s as part of a collecting campaign that rivalled Rudolf's, had an instinct for the

mainstream—as is apparent in the catalog for another recent exhibition, Osnabrück's *Christina Koenigin von Schweden*—that Prague rarely shared. When, finally, the religious hatreds of the age overwhelmed this irenic haven—with Rudolf, in a bitter dispute with his brother, bringing troops into the city in 1611, a foretaste of the mayhem and strict Catholicization that ensued during the Thirty Years' War—and Rudolf's successors returned their capital to the more placid city of Vienna, the Golden Age came to an end. And yet its wonder lives on, as the vast array of illustration and commentary in *Rudolf II and Prague* makes clear, despite the problems that a multiplicity of original languages seems to have caused the typographers and translators (on one occasion turning Brahe, the master, into Kepler's assistant).

Although the oddities of Rudolfine culture limited the impact of its achievements on later ages, its sheer extravagance and abundance of interests have continued to fascinate subsequent generations. One cannot imagine anyone of even minimal curiosity or love of the arts being unable to find pleasure within this magnificent *omnium gatherum*, which brings the cornucopia of imperial Prague so vividly to life.

What Does his Patronage Tell Us about Philip IV of Spain?

The dangers of hindsight become acute when empires fall. The shift from dominance to decline is an appealing subject because it offers a powerful narrative, melancholy lessons appropriate for moral pronouncements, and an entrée into every aspect of society. No wonder that the greatest historians, from Thucydides to Gibbon and beyond, have taken up the theme. But even the giants tend to dwell on the looming decay long before it affects the forceful and often confident empire-builders they describe. This is especially true when the matter at hand is a precipitous collapse, and here the exemplary case is usually seventeenth-century Spain.

The depiction of heedless but long-term Spanish disintegration is so ingrained that it has become almost a cliché. In the *New York Times* last month, the economist Paul Krugman deplored the situation of "a super-power living on credit—something I don't think has happened since Philip II ruled Spain." The implication is that the Spaniards somehow knew they were heading for disaster but plunged ahead regardless. A royal bankruptcy (the first of eight) in 1557, early in Philip's reign, should have been a decisive warning.

And indeed, alarms were to be raised by a number of critics of the regime, notably the reform-minded pamphleteers known as *arbitristas*, not to mention indirect commentaries like those in *Don Quixote*. For most Spaniards, however, predictions of imminent breakdown would have seemed ludicrous before the middle of the seventeenth century—by which time, to later observers looking back, the story was essentially over. If the historian's task is to correct such hindsight, and to look at a place and time as it might have looked at itself, a perfect starting-point would be the current exhibition at the Prado in Madrid: *Paintings for the Planet King: Philip IV and the Buen Retiro Palace*.

Today, the great royal palaces of Europe are famous primarily as muse-

ums: the Louvre, Versailles, the Hermitage. Even Buckingham Palace, though still a monarch's residence, has opened its doors so that everyone can see its treasures. For centuries, however, the collection of the finest art, and its display in huge residences, was a matter of private enjoyment for princes. The buildings might assert their owners' magnificence, but the riches within were available only to members of the court and visiting dignitaries.

Although there were some classical precedents, such as Nero's Golden House in Rome, the idea that a ruler ought to have a beautiful home, and that he might be distinguished by his taste, was essentially a Renaissance notion, accelerated by the realization that gunpowder had made the traditional castle obsolete and allowed criteria other than defense to determine the design of a palace. The pioneers here, as in so many areas, were the Italians.

Whether it was Este in Ferrara, Montefeltro in Urbino, Gonzaga in Mantua, or Medici in Florence and nearby, fifteenth-century rulers came to regard a fine palace or villa, exquisitely decorated, as essential to their status. Soon, however, these relatively minor princelings were to be eclipsed by the kings of the much larger territories to the north and west: England, France, and above all, Spain.

By the early years of the sixteenth century there were indications of what was to come. In England, Hampton Court, the other palaces along the Thames, and eventually Whitehall Palace reflected the new tastes of the time. In France, it was François I who set the change in motion, first at Fontainebleau, then at Chambord and Chenonceau along the Loire, and finally by starting a reconstruction of the Louvre. But it was the Habsburg kings of Spain who set a standard for scale, style, and splendor that was rarely to be equalled.

A foretaste of the grandeur they were to achieve was a project that the Emperor Charles V placed right next door to the Alhambra in Granada. An enormous square building, some 200 feet long and nearly 50 feet high, enclosing colonnades on two storeys that formed a circular courtyard large enough to hold bull fights, the palace was not finished when the Emperor died, but remains a stunning example of Renaissance style. At the Escorial, Charles's son, Philip II, went even further. His monastery-cum-palace was the largest and most expensive building in Europe, more than eight times the size of the Granada project, enclosing thirteen court-yards, some eighty miles of hallways and corridors, and more than 2,000 windows. And he filled it, not only with thousands of sacred relics, but

also with extraordinary works of art, including sculptures by the Leonis and Cellini and paintings by Titian, El Greco, Zuccaro, and Bosch.

This is the background against which the Prado exhibition and its illuminating catalog need to be seen. For the story they tell is of a project undertaken by Philip II's grandson, Philip IV, in the 1630s. This was half a century after the Escorial was built, and in many respects it was undertaken in the shadow of that previous achievement. The new palace was not a permanent residence. Staying in one place had not been characteristic of Spanish monarchs. Madrid did not become the official capital until 1607, and even Philip II, who made the original choice of Madrid, moved his court about. Moreover, there was already a royal seat in Madrid, the medieval castle, the Alcazar. What was created at the Buen Retiro was a pleasure palace: a home outside the city to which the court could retire for a few weeks each summer for relaxation, for theatrical performances, and for walks in lavish gardens that are still recalled in the vast Buen Retiro park in the centre of Madrid.

Because most of the palace was destroyed, it was not the subject of a great deal of attention by modern scholars until 1980, when *A Palace for a King*, by Jonathan Brown and John Elliott, first appeared. The book was a revelation. With their expertise in the careers of the King's chief minister, Olivares, and his chief painter, Velázquez, the two authors were able to reconstruct, in remarkable detail, the story of the building of the palace and also to convey a vivid sense of its appearance during Philip's reign. Their book has now been revised, partly in response to further research but most strikingly so as to incorporate two revealing new sets of illustrations: charming and hitherto unpublished drawings of the Retiro grounds by the Earl of Sandwich, made during his embassy to Madrid in the 1660s; and astonishingly life-like computer simulations of the appearance of the palace by Carmen Blasco. This updated book is an essential accompaniment to the Prado exhibition and its catalog.

The palace was built at tremendous speed in just a few short years in the 1630s, under the supervision of Olivares. Although it covered a large area, with huge landscaped gardens dotted with hermitages, and with the main building, of three or four storeys, encompassing six courtyards—two of them easily large enough for bullfights and other displays—its outward appearance was simple brick and stone, free of decoration. What was opulent was the interior, which a massive acquisition campaign filled, during the 1630s, with costly furniture, tapestries, sculpture, and paintings. The last are the focus of the exhibition.

Philip was the most ambitious patron of his time. He had been deeply impressed by a visit from Rubens—an expert on the European cultural scene as well as a formidable painter himself—early in his reign, and he made the pursuit of art central to his rule. It has been estimated that he added some 2,000 paintings to the royal collection, and about 800 of these were destined for the Retiro. Most have not survived; how they were hung is often not known. Nevertheless, thanks to inventories and records of purchases (the Spanish ambassador in Rome and the Viceroy in Naples were kept constantly busy with commissions), we can see that for contemporary artists Philip was Maecenas. There is hardly a significant Italian or Spanish painter of the 1630s whose work he did not buy, and although, as Brown notes in the catalog, "the results were of decidedly mixed quality," there were enough major works to have helped make today's Prado (the principal inheritor) arguably the most important repository of seventeenth-century European art.

The exhibition, *Paintings for a Planet King*, displays some sixty works, mostly from the Retiro, in five rooms. It begins with a model, designed by Carmen Blasco, that situates the palace, three of whose buildings survive, in relation to present-day surroundings. Looming over the model are two Velázquez canvases: Philip himself in 1634, and a scene set in one of the Retiro courtyards that shows the young prince, Baltasar Carlos, during a riding lesson supervised by Olivares and watched by his parents. Like *Las Meninas*, the picture brings the time and place to life.

The next two rooms are notable, first, for a cycle of sixteen paintings (part of a much larger collection) about life in ancient Rome, commissioned in Rome and Naples in the mid-1630s; and second, for an assemblage of court figures by Velázquez—four actors/buffoons and a huge equestrian glorification of Olivares—alongside searing portrayals by Ribera of the ghastly tortures inflicted on Tityus and Ixion. The Velázquez and Ribera canvases are well known, but it is admirable to be able to see them together in this context, even though we no longer know how they were hung. Equally memorable is the glimpse we are afforded between the Riberas into the hall next to the exhibition, which has been filled with contemporary masterpieces that Velázquez painted for the King: *Las Meninas*, *Mars*, *Vulcan*, *Bacchus*, and others.

The scenes of ancient Rome are less familiar, though they include works by the leaders of Roman and Neapolitan painting at the time: a Poussin, five Lanfrancos, a Ribera, and a Domenichino. The specific purpose of some of the commissions for the Retiro is not always clear, but in

this case the wish to emphasize the analogy between the Roman and Spanish Empires is plain. The very title of the exhibition is drawn from a description of Philip IV by his courtiers, inspired by his planet-wide empire. Nothing like it had been seen since Rome, and it seemed natural to draw parallels with ancient glories. The focus is on public events and ceremonies, including processions, athletic displays (notably an unusual Ribera of battling women), gladiators, and funerals—reminders of a long-gone majesty and assurance that Spain had now revived.

Yet they represent only one strand among the palace's paintings, whose variety encompassed most subject matters of the age. There could hardly be a sharper contrast than the one between these ambitious canvases and the pictures in the final room: a sampling of the delicate landscapes Philip also commissioned, here dominated by the peaceful, slightly melancholic works of Claude Lorrain. Before one gets there, however, one comes to the centerpiece of the show: the reconstruction of the Hall of Realms that Brown and Elliott have justly called "the most significant room in the Retiro."

This was essentially the throne room, the place where the King would greet his most honored visitors. Here, his power was made visible by twelve programmatic canvases (all approximately ten feet square) which display the military triumphs of his reign. Eleven survive, and it is an awesome sight to see them hanging together, interwoven by ten small scenes from the life of Hercules by Zurbarán, the purpose of which has never been fully clarified. The meaning of the battle celebrations, however, is inescapable, and as one walks past them one can feel again what a visiting dignitary must have felt in the late 1630s.

On the end wall behind the King's throne were equestrian portraits (also about ten feet square) of his parents by Velázquez, and on the far wall Philip faced similar portraits of himself and his first wife, with a smaller equestrian Baltasar Carlos between them. Along each of the side walls were six of the victories. At the Prado (in a revision of the placement proposed by Brown and Elliott), the events of the 1620s are on the King's left, the 1630s on his right. The most famous picture is another Velázquez, *The Surrender of Breda*, but it is seen here in its intended context. Like two other surrender scenes, and Maino's deeply moving *Recapture of Bahia*, the emphasis of the *Breda* is not on the satisfaction of military success but rather on the nobler virtues—magnanimity and sympathy for loss—that war could arouse. The dignity of the generals who dominate all the pictures accentuates the confidence of Spain's rulers. There was no

need to show enemies trampled under foot; one merely displayed evidence of the empire's might and high-mindedness.

For all the criticisms prompted by the cost of the Buen Retiro, therefore, the warnings about Spain's over-extension, and the reversal of some of the Hall of Realms victories by 1640, the palace itself reflected nothing but exuberant confidence. Spain's hard times may have lain immediately ahead, and the causes of the collapse deserve analysis. But it is to misunderstand Philip, Olivares, and those who governed Spain to suggest that the Retiro was really a white elephant or a final fling taken by those who foresaw disaster. It was a demonstration by a new generation that great rulers deserved great palaces.

The reconstruction of this long-lost monument of Spanish history is a fitting symbol of the present-day flowering of Spain. As a cut-away in Blasco's model shows, we know exactly where the Hall of Realms was situated, and that building, the former Army Museum, still stands. If the current expansion of the Prado extends that far, the Hall of Realms could live again. This entire area in the city center, with the Prado, the Thyssen-Bornemisza collection (also newly enlarged), the Archaeological Museum, and the Reina Sofia Museum of modern art (now holding *Guernica*) all within easy walking distance, is on the verge of becoming one of the richest concentrations of Western art in Europe. It would be an apt reminder of the earlier time when this site was a prime focus of the arts if its centerpiece could again be the original Hall of Realms.

Does the British Royal Collection Help Us Define Flemish Art?

Published in advance of the exhibition *Bruegel to Rubens: Masters of Flemish Painting*, in the Queen's Gallery, two volumes offer a dazzling overview of the treasures of late Flemish painting that the monarchy has accumulated during the past 400 years.[1]

The first volume, Christopher White's meticulous catalog of seventeenth-century works, completes the four-volume set, begun by Oliver Millar in 1963, that surveys all the Netherlandish Old Master pictures in the Royal Collection. White examines 147 works, leaving aside only van Dyck, whom Millar had treated, and assesses the contributions made by the main collectors. The twenty pages on Charles I alone represent a major contribution to an understanding of the interests and activities of the most astute connoisseur to occupy the English throne. White also pays tribute to George II's son, Frederick Prince of Wales, and George IV, who both made substantial additions to what remained of Charles's acquisitions following the sale of royal pictures during the Commonwealth.

Two artists dominate White's book: Rubens, much beloved by Charles, and David Teniers the Younger, a favorite of Frederick and George. Nearly a third of the catalog is devoted to Rubens and his studio, providing a wealth of detail about the history, iconography, and condition of fifteen paintings and their relations to other works, though White is no less thorough when examining three copies after the master. The care and precision of the enterprise are apparent throughout, leavened by suggestive insights, such as the possibility that a lamb might serve as a symbol of both St. Francis and the Baptist. Teniers and his imitators account for a quarter of the pictures, and although White treats them more concisely, his painstaking and convincing accounts will long remain, as with Rubens, indispensable to further study of the artist.

The second volume, the catalog for the exhibition *Bruegel to Rubens*, is a different order of publication. Openly indebted to White and his predecessors, it has the luxury of being able to focus on just 51 works, ranging from the 1440s to the 1650s, to represent the distinctive features of Flemish art. In this endeavor it brilliantly succeeds, conveying an abundance of information with a light touch, and illuminating the artists and their works through analogies and references that take us far beyond Flanders. Thus the continuing presence of the elder Pieter Bruegel, through family connections as well as imitators, is vividly evoked by a startling comparison: "It is as if David Garrick (1717–1779) had made his debut in the 1740s on a stage managed by someone called William Shakespeare III."

The central theme of the catalog is the question: what is especially Flemish about these works? The answer comes in many guises. There is, for example, the fondness for a high vantage point from which one looks down on a vast landscape. Its first major exponent—not represented in the Royal Collection, but the subject of a recent exploration at the Prado—was probably Joachim Patinir, but its most influential practitioner was Pieter Bruegel the Elder. His *Massacre of the Innocents*, which provides the catalog with its cover and attracts some of its closest attention, is a famous example of such perspective. There are also types of portrait, scenes of peasant life, and a documentary inclination—typified by depictions of the rooms, or cabinets, in which collections were housed—that, again, are identified as distinctively Flemish.

All of this, moreover, is closely related by the authors to the political and social situation of the time, and in particular to the rise and fall of Antwerp, the center of Netherlandish artistic activity until it was eclipsed by Amsterdam in the seventeenth century. Politics is represented by portraits of some of the leading actors of the age. Since the Emperor Charles V, born in Ghent, dominated the sixteenth century, we see his ancestors and also a remarkably unflattering portrait of the man himself. Though his successors are not on display, politics remain central in paintings that reflect the war that broke out soon after his death. Bruegel's *Massacre of the Innocents*, bowdlerized by the Habsburgs to replace murdered babies with slaughtered farm animals, is the most powerful of the commentaries on the sufferings of Flanders (*Illustration 5*). And the yearning for peace is a persistent theme, implicit especially in Rubens' country scenes, notably the magnificent *Summer*.

What is particularly fascinating is the extraordinary variety of subject matter that inspired Flemish artists. Their affection is bestowed equally on

aristocrats and peasants, and their scrupulous treatments of the mundane details of daily life sit easily next to expressions of profound religious feeling. Rubens may have been a courtier, but he was also drawn to the humble and the ordinary. And van Dyck applied his mastery of human character to biblical themes as easily as to princely portraits. The diversity will be on lavish display in the gallery, but this is one of the few occasions when, without qualm, one can urge the exhibition's visitors to read the catalog before they sample the bounty of the Royal Collection.

8

Why Create a "Paper Museum"?

Rome has enjoyed many golden ages, but none as exuberant or exploratory as the era of the Baroque. From the 1590s to the middle of the seventeenth century, before the grandiosity of the Spaniards who dominated the city gave way to the restraint and order of their French successors, this was a place bursting with invention and ambition. Its great figures— Caravaggio, Bernini, Bruno, Campanella, Galileo—are icons of daring investigation. Except for Bernini, these pioneers got into trouble with the authorities, because what set them apart was their willingness to probe into unknown territory, whether forbidden or not. That one of the most subversive figures of the time, Orazio Morandi, collector of prohibited books, happened also to be an abbot, suggests how all-consuming was the atmosphere of open-ended inquiry.

In this world of extravagant projects, none was more remarkable or far-reaching than the so-called "Paper Museum" envisioned by a member of a distinguished north Italian family who moved to Rome in 1612, in his mid-twenties: Cassiano Dal Pozzo. Cassiano fitted easily into the city's elite, and was particularly close to a nephew of the long-reigning pope Urban VIII, Francesco Barberini, a prominent cardinal known for his diplomatic activities and patronage of intellectuals. Through Barberini and other friends, Cassiano knew everyone of consequence, and he was himself a notable patron, especially of Poussin. But it was his "Paper Museum" that was his distinctive contribution to the cultural achievements of his generation.

One of the central intellectual figures on the European scene during the decades around 1600 was the antiquary. Scourer of documentary records, of physical objects, and of relics of the classical world, he represented the quest for solid and indisputable information that was one aspect of the Scientific Revolution. His clear and irrefutable findings also stood as a

bulwark against the contradictory passions that pervaded the religious conflicts of the day. The antiquarian impulse lay behind the creation of the cabinet of curiosities (also known as the Kunstkammer), that remarkable assemblage of exotica, ranging from a rhinoceros horn to a Roman coin, which was regarded as an epitome of the universe and became a major treasure at many princely courts. The equivalent in the natural world was the botanical garden, like the one in Padua that reproduced the Earth by placing plants from each quadrant—north, south, etc.—in the appropriate section of the garden. Thus, alongside the antiquary there came to prominence the phytographer, the collector of plants, such as Carolus Clusius, who traveled through Spain and Portugal in the 1560s, discovering en route some 200 plants that had never before been described.

This was the background against which Cassiano's project unfolded. What he decided to commission were drawings of two sets of physical phenomena: antiquities and architecture in one group, and natural history in the other. Every single item had to be an accurate depiction of what the artist saw; nothing fanciful or imaginary was allowed. In both these enterprises, Cassiano was building on previous efforts, notably the record of natural phenomena assembled by Prince Federico Cesi, the founder in Rome of a pioneering scientific society, the Lincean Academy, which numbered Galileo as well as Cassiano and Cardinal Barberini among its members. Cassiano bought Cesi's library after the prince's death in 1630, and he determinedly continued the enterprise of recording natural phenomena. By the time Cassiano himself died in 1657, he owned a compilation of some 7,000 drawings, mostly by unknown artists, which filled more than sixty volumes. The result was a physical and visible collection of hard data vastly larger than any mere cabinet of curiosities: a paper museum indeed.

Cassiano bequeathed the library to his brother Carlo Antonio, who added to it, but in the early eighteenth century it was sold by Carlo Antonio's grandson to Pope Clement XI. It remained in the pope's family until the large majority was bought by George III in 1763, and subsequently dispersed to the Royal Library at Windsor (the main portion), the British Museum, Sir John Soane's Museum, and various other repositories, notably the Institut de France in Paris. For about a century or so, the drawings remained in obscurity, until German and English archaeologists realized the importance of the drawings from the antique. Research into the entire collection began to gather pace, and in the 1980s the decision was made to produce a *catalogue raisonné*.

This has required many hands, but none more capable than the editors of the three volumes devoted to the kingdom of the fungi. The drawings, reproduced in vivid color, are a splendid testimony to the skills of seventeenth-century artists; and the 1,210 catalog entries, by David Pegler, are a mine of information, both biological and curatorial. The appearance of these splendid volumes allow us to experience at first hand the spirit of inquiry that pervaded seventeenth-century Europe.

Why Collect Géricault?

By and large, collectors have sought beauty, meaning, uplift, or fame (or, more recently, profit) when purchasing works of art. Bosch's lively colors and sense of humor, for instance, often outweighed the horrors of his vision. But one major figure in the canon of Western art seems to defy most of these assumptions. Profoundly pessimistic and even grim, he nevertheless remains an unavoidable presence in any history of European painting and collecting.

Seen in the context of his own times, the interest seems understandable, because Théodore Géricault was the embodiment of French Romanticism. Dandyish, sickly, unhappy in love, and condemned to an early death in poverty, he was to the visual arts what Chopin was to music. Yet the reason his most famous painting, *The Raft of the Medusa*, has long been a star attraction in the Louvre can be attributed to other aspects of his reputation: his standing as the epitome of Liberalism, his aura of restless inquiry, and his revolt against the classical aesthetics that marked Restoration France.

Although these aspects of his reputation have long fed the interest in Géricault, they do not sit easily amidst the paradoxes of his life and career. His ardent Republicanism, for instance, contrasts strongly with his patriotic laments for the glories of the Napoleonic era. It was one thing to defend the rights of the oppressed and sympathize with the unfortunate; it was quite another to mourn the passing of a military regime that had been responsible for the deaths of at least a million men. Similarly, his determination to forge a new art, true to nature, contrasts with his lifelong study and imitation of classical models. Géricault's visit to Italy, and his many *hommages*, both to antiquity and to inheritors of its spirit like Michelangelo, underpin even his most deeply felt works. This was also a man fascinated by the scientific inquiries of his contemporaries, who at the same time was

absorbed by the limits of reason. And although he was to end his days in poverty, for most of his years he lived a life of privilege and ease.

The best detailed account of Géricault's life and the aspects of his society that affected his career is by Nina Athanassoglou-Kallmyer, in her book *Théodore Géricault*. She also takes a close look at his paintings and some of his drawings and prints, and describes the teachers, friends, and associates who surrounded him during the brief period (less than ten years) when he produced the work for which he is known. She uses the recent scholarship on her subject to excellent effect; her judgments are carefully argued; and her study has clearly become the basic introduction to the artist.

It is precisely because the book presents Géricault's life and work so clearly and thoroughly that the idiosyncrasy of his oeuvre becomes so striking. Here was a classically trained artist, deeply familiar with the Old Masters—his copy of Caravaggio's *Entombment* is a tour de force—who nevertheless departed from their subject matter in highly personal and unexpected fashion. Though there were precedents for the topics he addressed, it was their combination that was unique. Never before had there been such intense focus on essentially four themes: horses, military men, violence, and madness. Géricault also produced portraits, depictions of the downtrodden, and landscapes, but none of these aroused the level of involvement he devoted to his four themes. And although horses and portraits had long attracted collectors, violence and madness—his prime trademarks—were hardly the stuff of broad appeal.

For the first two subjects Géricault had many antecedents. He was as drawn to horses as Stubbs, and he was as ardent a nationalist and admirer of the army (in which he served) as Gros. Indeed, the horses and the military men often appeared together. But the instinct for violence and the shadow of madness achieved a prominence in his art that was unprecedented, and gives a unique quality to his stature.

Athanassoglou-Kallmyer places these aspects of his work into the context of early-nineteenth-century practices in the realms of justice and medical research. Thus the reliance on capital punishment and the mishandling of the legal consequences of the *Medusa* shipwreck offer insight into the choice of subject matter, because both were taken up by Liberals at the time. In addition, the investigation of phrenology and other means of understanding the mind and the psyche were much in the air, and in fact preoccupied doctors whom Géricault knew. Moreover, the extremes of human behavior held a particular fascination for the Romantics. Never-

theless, it was not just participation in the larger developments of his time that seems to have shaped the unique blend of Géricault's interests: his partiality for human misery even as he relished classical representations of the body, and—a further contrast—even as he depicted horses with unalloyed pleasure.

With a painter like Otto Dix it is self-evident that, haunted by his closeness to a ghastly war, he should have unleashed a torrent of grim, stomach-wrenching pictures of people at their most inhumane. But Géricault sought out such scenes. The ghastly story of the *Medusa*'s raft was well-known—the agonies of those who had been set adrift on the flimsy craft, the horrors and the deaths before the few survivors were rescued—but it took a peculiar passion to invest as much time as Géricault gave to creating and advertising the scene, not to mention the related picture of cannibalism that is also in the Louvre. And the vividly realized canvases of severed limbs and guillotined heads extended powerfully his engagement with suffering and violence.

That background has obvious implications for the moving portraits of the insane that Géricault undertook in his last years. What is notable in these five faces (the other five in the series have disappeared) is the blankness of expression. Each figure is shown at bust length, in nondescript clothes with touches of white near the face, against a dark background. All attention is riveted on the faces, which stare past the viewer without a hint of emotion. Yet their impassiveness is strangely similar to the look in the artist's other portraits. His paintings of people, in other words, leave the viewer with no sense of individual feeling, no hint of contentment. And the absence of serenity merely emphasizes the degree to which a somber outlook underlies his work. At a time when Romanticism sought to uplift, Géricault offered a vision of humankind that was forbiddingly bleak.

The notion of a grim Romantic may not accord with one's usual understanding of the elements that have shaped admiration for an artist, or that have drawn the attention of collectors. But the uniqueness of Géricault's achievement is that, despite the paradox, he was able to win both that admiration and that attention.

Part Four

Bohemian and German Art

1

Was Prague the Home of Two Golden Ages?

Most great cities get only one chance at a golden age. Rome is the chief exception, an Eternal City not least for having hosted repeated outbursts of remarkable creativity. But now Prague, thanks to a path-breaking exhibition, needs to be added to the small list of cities that enjoyed more than one shining moment of artistic and intellectual glory.

It has long been recognized that the era of Rudolf II, who made Prague briefly the capital of the Holy Roman Empire in the decades around 1600, was such a moment. A memorable exhibition in 1988, *Prag um 1600*, assembled nearly five hundred works of art that left no doubt about the brilliance of the culture over which the Habsburg emperor presided. For painters and sculptors, Prague became the embodiment of Mannerism; for those interested in the latest ideas, it became the home of magical speculation, Rudolf's famous Kunstkammer, or Cabinet of Curiosities, and the cutting edge astronomy of Brahe and Kepler. Few monuments to that time have survived—the garden of Wallenstein's palace is perhaps the most evocative—but its importance to the history of European culture is secure.

The achievement of the exhibition *Prague: The Crown of Bohemia, 1347–1437*, recently at the Metropolitan Museum, is that it establishes the decades around 1400 as no less glittering than their successors around 1600. The case is made with some 200 objects, and there are also reminders that major monuments from the period remain in the city itself: St. Vitus Cathedral, the Charles Bridge, the Bethlehem Chapel, Charles University, and the vertiginous Our Lady of the Snows. Even without visiting the Czech Republic, however, one can appreciate that the Prague of this period should be spoken of in the same breath as the more famous artistic centers of Bruges or Florence.

The star of the show is Charles IV: active in promoting the arts from the 1330s, king of Bohemia from 1342, Holy Roman Emperor from 1355,

and ruler of extensive territories in Italy and Germany until his death in 1378. Prague was his main residence, and after him both bridge and university are named, though he was also responsible for building the Cathedral and Our Lady of the Snows. Charles was the Medici of his day; none of his contemporaries came close to the extent and discernment of his patronage, and both catalog and exhibition make clear the range of his interests.

We are at one of those fascinating moments in Western art when what seem to be almost different worlds overlap. Nearly twenty years after Charles died, his son Wenceslas IV procured for a chapel in Březnice a dark-skinned Madonna, set in glowing gold, who is utterly Byzantine. Yet half a century earlier there had come to Bohemia a *Dormition of the Virgin* (a favorite subject) that seems to come straight out of post-Giotto and post-Duccio Italy. The radiant colors look Venetian; the sharp rendition of perspectival space is almost Florentine; and the distinct, emotional faces would not have been out of place in the Arena Chapel in Padua. As Fajt, one of the curators, argues in the catalog, we are witnessing the creation of a new kind of imperial style, drawing mainly on Charles' German and Bohemian subjects, but pulling into its orbit the approaches and techniques of artists throughout his far-flung territories.

It does an injustice to the richness of the display to highlight just a few of the pieces. In the very first room, however, a 30-inch-high lindenwood *Virgin and Child* of 1350, with the original soft paint, suggests the pleasures to come. This is as young a mother as one ever sees, barely able to support her enormous gilded crown, but still offering a winning smile, as does the vigorous child on her lap. There are gilded reliquaries that enhance the muted lighting of the museum's rooms, notably an entire arm and hand, studded with jewels, that held the arm of St. George, and a stunning bust of a crowned John the Baptist, over 30 inches high, sitting on four lions worthy of a Venetian goldsmith. The gilding is testimony to the wealth of this area in the late Middle Ages, and it covers monstrances and tabernacles of astounding complexity and delicacy. One in particular, an iron and gilded tabernacle of the 1370s more than six feet high, designed to hold the host in the Cathedral, looks like a microcosm of St. Vitus itself, with a grandiose (locked) portal, a decorated spire, and graceful flying buttresses. Those who made these objects were no mere craftsmen.

The worlds of paint and pen are no less accomplished. A pair of saints on panels from the 1370s, nearly four feet high, are attributed to one of

the few named artists of the period, Master Theodoric. His St. Luke listens intently as his attribute, a tiny bull, whispers inspiration into his ear. The eyes, staring into space just to the left of the viewer, blaze with startling intensity. The colors, the beautifully observed hands, the chiseled face, and even the little lock of stray hair on the forehead, bespeak the work of a master. And across the room, a small ink and wash head of a prophet or apostle from the same period displays the same power of expression and mastery of technique. This drawing; a somewhat later book of over fifty silverpoint drawings intended as models for illustrators; a moving crayon head of the Virgin; and the striking illuminations of the many books on display—all suggest the presence in Bohemia of a community of talented artists equal to the best of the age. Van Eyck himself would have been proud of some of these depictions of people, animals, and places.

It was not just the wide provenance and even wider inspirations of the art that gave fourteenth-century Prague its trans-European flavor. Like Venice, this was a multicultural city *avant la lettre*. It stood at the intersection of east-west and north-south trade routes, and even in its new university tensions ran high between Czech and German speakers (the latter soon left, to found their own university in Leipzig). Symptomatic of the international flavor was one of non-Mediterranean Europe's largest and most lively Jewish communities, represented at the exhibition by gravestones that recall their extraordinary cemetery; by ceremonial objects; and by some of the most beautiful manuscripts ever produced, notably the Prague Hebrew Bible. This last dates from the 1480s, but is an appropriate inclusion, because the skills it represents developed over the years only because Charles reversed the Jews' expulsion from Bohemia by his father, and made them welcome once more in Prague. They were to face persecution after his reign—there was a ghastly pogrom in 1389 that killed three thousand—but their survival from Charles' time onward is evidenced by the Altneuschul, the oldest synagogue in Europe.

The exhibition takes the story beyond Charles, through the reigns of his sons, Wenceslas IV and Sigismund. They were not in Charles' class as patrons, but the traditions he had set in motion led to the so-called "beautiful style" around 1400. Marked by the serenity and gentle melancholia of the holy figures it portrayed, the style is best seen at the Metropolitan in a dramatic limestone *Pietà*. The dead Christ's body, rigid and almost horizontal, flares into space from the Madonna's lap, while she looks down on him with an expression of utter sadness. The sculpture gains its power not

from the composition, but from the feeling it communicates.

The emphasis on emotion may connect with the religious and political ambitions of the Hussites, who now tore Bohemia apart. It was in 1400 that Jan Hus became a priest, and soon all of Prague echoed to his message of an inner faith and his denunciations of the Pope, all foretastes of Luther's revolt a century later. It was Sigismund who was to betray Hus, repudiating the safe-conduct to a church council at Constance that he himself had granted, and allowing Hus to be burned at the stake. During the long civil war that followed, the Hussites did win a small level of toleration, and the exhibition suggests that their emphasis on a simpler, more direct faith might have been reflected in the art of Sigismund's reign.

The jury may still be out on that claim, but there is no question that the upheaval—marked by the Bohemians' singular fondness for defenestration, a practice that was to recur when, in the 1610s and the 1940s, they again found themselves overwhelmed by outside forces—eventually brought this particular golden age to an end. Although it has long languished in relative obscurity, outshone by the brightness of Rudolf II's court, one can hope that this unexpectedly brilliant exhibition will restore it to the high place in the history of Western art that it deserves.

2

What Does Holbein Suggest about his Times?

The decoding of the symbols that abound in Renaissance and Baroque art has a long ancestry, but the enterprise has gathered momentum in recent years, to some degree because of the influence of its most famous practitioner, Erwin Panofsky. Though viewed with some suspicion by his distinguished contemporary, Gombrich, Panofsky's determination to unravel painters' intentions through the meanings they invested in gestures, attributes, and objects produced remarkable new insights. His use, for instance, of such seemingly mundane features of a painting as a raised hand, a pair of shoes, a dog, a candle, a bed, and a mirror to prove that van Eyck's double portrait of Giovanni Arnolfini and his wife celebrates their wedding is a striking demonstration of the rich possibilities of his method, and it is small wonder that so many have followed in his footsteps.

The art of Northern Europe has been particularly susceptible to this kind of analysis, for the Germans and the Dutch seem to have been especially fond of the many levels of reference we see in the Arnolfini portrait—a predilection that marks them as the inheritors of the fascination with detail that nearly a century ago Huizinga identified as essential to Burgundian civilization. Only rarely, as in Dürer's depiction of the four evangelists for his native city, Nuremberg, was the deeper purpose explained verbally—in this case through a caption provided by the artist. Usually the modern explicator has to juggle emblem books, scholarly and religious traditions, folk tales, classical learning, and a small library of texts to decipher the allusions. No wonder that sometimes the triumphant code breakers assume too easily that the messages they have uncovered were readily understood by those among the artists' contemporaries who saw them. And yet, even if that assumption, which can lead to tenuous claims about impact, audience, and propaganda, may be misplaced, the enterprise of decipherment itself cannot be faulted. It is a significant scholarly

achievement to explain, as have Panofsky and others, the moral, political, or philosophical aims that may lie behind a painting's surface subject matter. What is important is to recognize the limits of that explanation, especially when its complexities multiply, and not to assume, without further evidence, that the meanings were always clear to an artist's audience.

This is precisely the virtue of John North's painstaking examination of Hans Holbein the Younger's masterpiece of 1533, *The Ambassadors*, which hangs not too far from the Arnolfini double portrait in the National Gallery in London (*Illustration 6*). This, too, is a double portrait: of a French nobleman and diplomat, Jean de Dinteville (on the left), and his friend Georges de Selve, bishop of Lavaur. De Selve may have commissioned the picture as a gift while visiting Dinteville in London, but in any case it was painted for Dinteville, who took it home later in 1533. That some symbolic purpose is intended is readily apparent, thanks to the anamorphic skull, lying at an angle across the lower section, which is visible in proper perspective only when seen from the side of the frame, and which has long inspired a search for hidden meanings. Equally intriguing has been the table between the two figures, which is covered in instruments and books that may reflect the seven liberal arts of European university education: possibly the *trivium* of grammar, dialectic, and rhetoric, but more certainly the *quadrivium* of arithmetic, music, geometry, and astronomy (with instruments devoted to the heavens on the upper shelf, and the terrestrial sciences on the lower). As North's ample bibliography indicates, the interpretations inspired by these puzzling objects have been manifold. Already by 1900 Mary Hervey had published a book of over 250 pages on the subject; with appendices and apparatus, North exceeds her by more than 100 pages.

His conclusion, after completing analyses both arcane and exhaustive, is that the painting is meant to evoke 4 o'clock in the afternoon of Good Friday 1533, exactly a millennium and a half after Jesus was lowered from the cross after his crucifixion. Whether it also has other meanings he is not entirely sure, though he explores a whole range of possibilities, from the significance of shadows to the ambiguities of astrology and the cabbalistic mysteries of gematria (whereby divine significance was derived from the numerical value assigned to each letter of the Hebrew alphabet). Simpler interpretations, such as the view that the painting is a *memento mori* or an essay on the vanity of earthly things, or even Hervey's suggestion that it reflects Dinteville's interest in the world of learning, North regards as inadequate. Indeed, though he is respectful of Hervey's pioneering study,

in general he shows little patience with the speculations of others among his predecessors.

His own analysis rests on a complex geometric and astronomical exploration of lines, angles, and zodiacal symbols. Even the gist of the argument is impossible to convey in a brief review, and in fact, unless one is at home with such technical matters as gnomons, ecliptics, and the use of the quadrant and the cylinder sundial, it is far from easy to follow North through the many steps of his reasoning. Suffice it to say that he finds an almost bewildering series of lines, circles, and shapes that connect various items in the painting, including stars on the celestial globe, the eye of Jesus on the almost invisible crucifix at upper left, and a plumb line on one of the instruments on the upper shelf of the table. From these lines he produces a circle, a hexagram, and a horoscope chart, all hidden within the scene, not to mention a repeated one-in-two gradient, or an angle of 27 degrees—a number that represents the trinity to the third power.

It is a bravura performance, drawing not only on considerable technical skills but also on a dazzling array of references in Renaissance thought and the literature of the occult. Whether, at the end, one can match North's confidence that he has solved many of the painting's mysteries, and that all the connections he uncovers were indeed intended by Holbein, is less clear. He believes the painter's connection with Nicolaus Kratzer, a fellow German at the English court whom he portrayed in 1528, and who was expert in astronomy, astrology, and instrument-making, was the source both for some of the objects on the table and for the geometry and astronomy implicit in *The Ambassadors*. The case for Kratzer's influence seems firmly established. But whether it extended to quite so many arcana is less clear. And one's doubts are not allayed by the approximations that nestle amongst the claims of precision. On two pages alone, a particular view is accepted because it is "not out of key," a contributing event "almost certainly" happened, a combination of themes was "not out of bounds," and an important distinction "could easily have come to the notice of Holbein, his sitters, or Kratzer." One is asked to take a great deal on faith: for instance, that both sun and moon are deliberately just out of sight on the celestial globe; or that a shadow that seems to go in the wrong direction is actually a "smudge" (at this point, even North admits he is seeking acceptance for a "somewhat convoluted conclusion"); or that an apparently brown pair of gloves is in fact black. The gloves have to be black for the sake of his argument for Good Friday, which requires appropriate priestly garb; although the black may have a

"brown cast", therefore, he insists it is black, because "there is no liturgical colour brown."

What is one to make of these gymnastics? Much of North's case is, of course, an argument from silence. There is documentation for almost none of his claims, and even the repeated recurrence of some of his geometric or astrological features—the 27-degree angle, for example—may be "incontrovertible" (his word) as a phenomenon in the painting, but not necessarily incontrovertible as signifiers of meaning. Yet it would be churlish to take so negative, even nihilistic, a view. The very presence of the distorted skull suggests powerfully that Holbein and his colleagues were up to something. The remarkable collection of objects on the table, and Kratzer's documented links with the artist, only strengthen that impression. And North is very careful to emphasize that the meanings would not necessarily have been apparent to anyone except the four participants: Holbein, Dinteville, de Selve, and Kratzer. Though expansive in his interpretations, therefore, North remains modest in the importance he assigns to his decipherments, making quite clear that the painting's main claim to fame is its aesthetic appeal. That he is able to keep this perspective amidst the enormous effort of iconographic, scientific, and literary research he has undertaken is a prime reason for taking his conclusions seriously.

Equally important is his refusal to tie everything to a single scheme. One of the indications that Holbein had symbolic purposes in mind is the presence of a lute with a broken string. It does not take much detective work to find here a reference to disharmony. But what kind of disharmony (religious? political?) North cannot say. Nor can he explain with assurance a box of flutes, a Lutheran hymn book, or a mathematics text, all on the table's lower shelf. About the text he even disarmingly suggests "it is possible that the fevered brow of the original schemer would have put to shame even that of his latter-day interpreter." Thus, although North's argument sometimes seems stretched to its limit, the calculations and references give it a weight that is all the more impressive in that he acknowledges its limits.

The exposition itself is as lucid as the complexities allow, with but few slips and infelicities along the way, such as minor confusions about the Talmud and about the Christian uses of Jupiter. Increasingly, moreover, one comes to feel that the decision as to whether North is absolutely correct about the meaning of the painting is less important than the insights he offers into the cultural norms, assumptions, and traditions of Holbein's era. Precisely because he regards the symbolism as essentially a private

matter, he avoids the burden of having to demonstrate its wider comprehensibility, and he is free to wander through some of the more exotic byways of Renaissance thought. The result is a rich compendium of scientific, astrological, magical, educational, religious, artistic, and philosophical lore that, whether entirely relevant to *The Ambassadors* or not, is a splendid sweep through the culture of the age.

3

How Was Dürer Special?

To start the celebration of its 250th anniversary, the venerable British Museum has mounted a major exhibition devoted to a single artist, Albrecht Dürer. The show is rich in iconic images essential to the history of Western art and yet, remarkably enough, it offers only one small oil painting by his hand. In a culture that cherishes its Old Masters for instantly recognizable works that are nearly always paintings or sculptures—Botticelli's *Venus*, Michelangelo's *David*, Leonardo's *Last Supper*—Dürer's stature is unique. Apart from two self-portraits in oil, the images for which he is famous are drawings and prints: praying hands, a hare, a rhinoceros, St. Jerome in the desert and in his study, *Melencolia*, *Adam and Eve*, *The Four Horsemen of the Apocalypse*. If he is just the right artist to warrant the homage of an institution that is not a gallery but does have one of the world's great collections of drawings and prints, then one must say that the Museum has done him proud.

As the catalog that accompanies the exhibition observes, in the early 1500s Dürer was "Europe's most famous living artist." It may be that his younger Italian contemporaries—notably Michelangelo and Raphael—would eventually eclipse him, but the reverence for the German in the sixteenth century and beyond provides the Museum with a basic theme for the show, appropriately entitled *Albrecht Dürer and his Legacy*. A good proportion of the nearly three hundred drawings, prints, medals, porcelains, and sculptures on display are by his imitators and disciples. And they demonstrate an impact not merely on northerners like Albrecht Altdorfer or Lucas van Leyden but also on such Italians as Jacopo da Pontormo, Andrea del Sarto, the ceramicists of Faenza, and Marcantonio Raimondi, second only to Dürer as a printmaker, and a crucial popularizer of Raphael as well as Dürer.

The enthusiastic reception the artist inspired, and the way that different

generations made him their own, is the central concern of the beautifully illustrated catalog. The editor, Giulia Bartrum, emphasizes the reverence he evoked in his own day. Erasmus, for instance, was rapturous: "[Dürer] depicts what can not be depicted: fire; rays of light; thunderstorms; . . . characters and emotions." Moreover, Erasmus recognized that the effects were achieved by "lines, black lines at that, in such a manner that, were you to spread pigments, you would injure the work." Joseph Koerner then takes the story through the first century after Dürer's death in 1528. This was a time when the copying and collecting of the great man gathered momentum, but also when—as Koerner skillfully explains—the very multiplicity of the prints raised vexed issues of imitation and originality.

Dürer's reputation outside Germany succumbed thereafter to the passion for Italian art, but—as Ute Kuhlemann argues—the revival that began in the late eighteenth century has continued to this day. Kuhlemann brings the account to the present by identifying the successive waves of appreciation that have engulfed the artist: his appropriation by nationalists and Nazis, and the reinterpretations associated with the 1871 and 1971 centennial celebrations of his birth. A final essay, Günter Grass's rumination on the *Melencolia* engraving, seems out of place in a volume that is otherwise exemplary in its examination of an artist's changing fortunes over five centuries.

The themes of influence and reputation, while valiantly pursued in the exhibition itself, inevitably give way, as one looks at the works themselves, to the power of Dürer's own presence. The very first item, a self-portrait drawn at the age of thirteen, indicates how precocious was the young Albrecht. For sheer mastery in one so young it seems without peer; only van Dyck's self-portrait in oil, done when he was fourteen, is in the same league. The face was to become one of the most familiar in Western art, and the entire first section of the show is dedicated to depictions of Dürer over the centuries. By comparison with the self-portrait, however, the medals struck in his lifetime, their elaborations in woodcuts and engravings, and the nineteenth-century copy of one of the early medals, all suggest antiquarianism rather than art.

What is notable is the astonishing versatility and innovation by which Dürer made his mark. The watercolor landscapes that he painted in the mid-1490s, for example—four beautiful examples are in the show—are "the earliest pure landscape studies" in Western art, as the catalog notes. Their effect on the "wilderness" background of the St. Jerome he both engraved and painted in the same period is immediately apparent. And the

engraving offers vivid evidence of the new levels of freedom and preci-
sion that Dürer's work with burin and copper achieved following the es-
tablishment of his own workshop in Nuremberg in 1495. Nobody before
had achieved such fluidity, such complexity of detail, and such command
of perspective as well as light and shade in printmaking. And the same
was true even of the more simple and crude techniques demanded by
woodcuts.

What made him famous was in fact a series of fifteen woodcuts pub-
lished in 1498, accompanied in separate editions by German and Latin
texts. The woodcuts adorned *The Apocalypse*, which was not only the first
illustrated book issued by a major artist, but also the first to become a
bestseller. Ever aware of his audience, Dürer also sold individual sheets
on their own. The three superbly preserved examples in the exhibition,
linked to the imitations they spawned, reveal the power and originality of
his creations, and suggest why his fame spread so rapidly.

Not that he was content to let quality speak for itself. Perhaps the most
unprecedented of his innovations was his fashioning of an entirely new
career path for the artist. As the catalog emphasizes, Dürer's decision to
make his living from prints was quite deliberate, taken despite the prestige
of painting, the many offers of patronage he received, and his mastery of
oils. His hard-headed commercial instincts emerge unmistakably from a
letter he wrote to a wealthy but demanding patron:

> Only from quickly painted mediocre works can I really make a profit,
> but my painstaking care in producing excellent paintings for you, sir,
> is far too time-consuming. Therefore I will take up engraving again.
> Had I done this in the past, I would be a thousand florins richer to-
> day.

That his approach succeeded becomes evident from the extraordinary
variety of his images, and their dissemination throughout Europe precisely
because they were reproducible prints.

Dürer indeed demonstrated that an artist could make a living on his
own if he was also shrewd enough as a businessman. Rejecting the de-
pendence on wealthy patrons that bound even the greatest of his prede-
cessors and contemporaries, he built up a broad clientele which, in turn,
made him rich. He realized, for instance, that although technical limita-
tions allowed the woodcut to achieve only relatively simple pictorial ef-
fects, it was cheap to produce. Because it was widely affordable, he used it
for the devotional themes that were popular at the time, and brought it to
his public by setting up stalls at markets and fairs. It may be that his wife,

Agnes, the daughter of a hard-nosed Nuremberg craftsman, was at least equally responsible for this strategy. It is certainly true that she had little taste for the grand company that Albrecht often kept. While he was being lionized by the city fathers in Bruges, for example, she set up a stall selling prints in the main city square to make sure that the florins kept coming in.

Copper engravings, by contrast, were far more delicate and expensive to produce. But they were also capable of much subtler pictorial effects. Accordingly, Dürer adapted their subject matter to the tastes of wealthier and more sophisticated buyers. Among the many stunning examples in the exhibition, including a mysterious *Nemesis* floating above a meticulously depicted city, and an almost surreal *St. Eustace* surrounded by flora and fauna, the superb impression of *Melencolia* reminds one of the extraordinary learning that was required to decode the symbols and references in these works. But Dürer knew his customers. By the time he died he was one of the richest men in Nuremberg.

Dürer's understanding of the market was confirmed by his insistence on his proprietary rights. His printed signature, the "D" nestled inside the "A," is the most recognizable in the history of art, and he protected it fiercely. In both Nuremberg and Venice he won actions against engravers who copied it—although, as the show makes clear, forgers and imitators remained undeterred as they sought to cash in on his success. With a pension from the Emperor, and the high prices his work commanded, Dürer could have eased up. But his priorities were unshakeable, even if the humility was disingenuous: "I would rather live a modest life here, in Nuremberg, where I was born, than achieve fame and riches elsewhere."

For he was no ordinary burgher. The leading intellectual figures of his time, including Erasmus and Melanchthon, sat for him, and his engravings made their faces known throughout Europe. His fascination with the natural world—at its most remarkable in his much-copied depiction of a rhinoceros—extended the subject matter of art. His studies of the science of perspective and depiction influenced generations of artists. And when he traveled, his journeys were triumphs. It was largely because of Dürer that his favorite artistic media, prints and drawings, came to be treated as masterpieces in their own right, not merely as adjuncts to paintings.

If respect for these forms is one of his most enduring legacies, one can see it dramatically at work in two small exhibitions that the British Museum has mounted, as part of its anniversary celebration, in its prints and drawings department. To commemorate their eighteenth-century founder, Sir Hans Sloane, the curators have given us a brief glimpse of the cabinet

of wonders that he acquired and then bequeathed to the nation as a start for the Museum's collections. Among the fifty or so items on display, mainly drawings, are exquisite sheets by such notables as Jusepe de Ribera, Inigo Jones, and Stefano della Bella. A lovely Dürer study of a bird suggests the riches of Sloane's holdings. They comprise a significant segment of the main Dürer exhibition, but it was still possible to keep back this sheet to honor the collector. There are also Turkish, Persian, and Chinese works—still reflected in the Museum's worldwide reach—and a unique impression of an aerial view of what is now London's West End in 1666 by the renowned printmaker, Wenceslaus Hollar. Most striking of the show's revelations, however, is the degree to which Sloane's fascination with depictions of nature and the world, and his commitment to prints and drawings, mark him as a true disciple of Dürer.

As printmaker and depicter of the physical world, though, the most obvious descendant of Dürer was the eighteenth-century Italian, Giovanni Battista Piranesi. And here again the Museum has a treasure to offer: side by side, the extremely rare first and the more common second editions of his haunting engravings of imaginary prisons, the *Carceri*, together with some preparatory drawings. This exhibition enables one to see how the artist darkened his vision in the second rendering. Like Dürer, he was a shrewd businessman, gearing his engravings to a market that seemed insatiable: reprints of the *Carceri* continued to be issued by his heirs into the following century. These works may well have appeared too late to join Sloane's collection, but thanks to the astuteness of his successors, the two editions on display were bought by the Museum in 1910 for a mere £22.

The Sloane and Piranesi exhibitions are particularly effective demonstrations of Dürer's influence. They remind us—as does so much of the master's oeuvre—that artists seem most free when they draw, and most attuned to the widest circle of their admirers when they make prints. Such conclusions would have delighted Albrecht Dürer.

4

What Makes Dürer So Accessible?

Of all the Old Masters, none is easier to explore through his finest creations than Albrecht Dürer. A number of his paintings, notably his portraits and self-portraits, are major milestones, but his drawings and prints have been no less indicative of his achievements. Since plentiful exemplars of these works are available in the many places that house significant collections of the graphic arts, organizers are able to mount effective exhibitions without becoming absorbed by the endless difficulties of borrowing and transporting precious and fragile panels and canvases.

The result is a spate of books, shows, and catalogs that shows no sign of diminishing. Not that Dürer is incapable of sustaining such serious and constant attention. Thanks to the fecundity and variety of his imagination, not to mention the ample written record he left behind, in diaries, letters, and published works, curators and scholars enjoy abundant materials as they probe, reevaluate, and seek new perspectives on the artist's intentions and accomplishments.

The four books under consideration here exemplify the situation. Only one, the catalog of the exhibition at the Städel Museum from October 2013 to February 2014, includes paintings. This was a major display—a comprehensive look at the artist and his setting through nearly 280 works, over two-thirds of them by Dürer, and it would have been impossible to survey his oeuvre with prints and drawings alone. But this was the exception. At the Courtauld Gallery and at the National Gallery in Washington (in conjunction with the Albertina Museum), drawings and prints could generate probing explorations on their own.

What, then, seem to be the particular concerns of current scholarship? A prime focus is on the early years. Like van Dyck, Dürer was a precocious genius. His self-portrait at the age of thirteen reveals a level of attainment astonishing in one so young. Where did such skill come from,

and how did it develop in the following years? Though much is obscure about this period, the decision to leave his apprenticeship with his father as a goldsmith in 1486, at the age of fifteen, and to move to Michael Wolgemut's workshop to train as a painter and woodcut designer, is considered crucial, as are his experiences during his travel years in the early 1490s. Yet his knowledge of the goldsmith's art was vital to his skill as a printer and engraver, as Karoline Feulner's essay in the Städel catalog emphasizes. Less clear are the results of his travels, or even the places he visited, but the sparse evidence we have indicates that he was busy copying, experimenting, and learning whatever he could.

It is on these years that the Courtauld catalog concentrates. Two essays, in particular, throw new light on the ways the young artist was preparing for his future. In the first, David Freedberg argues that Dürer's study of limbs was his way of working out how to convey action and (even more important) emotion in the depiction of the human figure. From just a few drawings and prints, notably two studies of the artist's left leg, Freedberg is able to show how Dürer laid an essential stepping-stone towards his mature art. The second essay, by Michael Roth, demonstrates the importance of his early drawings for his later work. The young man was not merely learning the elements of his craft; he was assembling a treasure-house of copies and observations, together with a command of technique, that were to be an essential preparation for his subsequent career.

A recurrent theme is Dürer's engagement with Mantegna during his first visit to Venice. Starting with Aby Warburg's pioneering essay, the subject of a small Courtauld exhibition, this specific connection takes on large implications. For Warburg it was a window into his famous critique of Winckelmann's thesis that dignity and grandeur were the qualities that the Renaissance learned from antiquity. Arguing that action and passion were no less a part of that heritage, Warburg highlighted Dürer's *Death of Orpheus* as representing a very different tradition, and pointed to the impact of the Mantegna copies as the inspiration of classical models took hold. There is a growing interest in the effect the foreigner had on his Venetian hosts—surveyed in an excellent essay by Andrew Morrall in the Städel volume—but most of the scholarship concentrates, as did Warburg, on the way the German responded to his two Italian journeys.

Another major concern has been Dürer's repeated examination of the mathematics of his art—looking into the principles of perspective, the proportions of the human form, and the structuring of the world in two dimensions. Was this, as Andrew Robison claims in his essay in the Wash-

ington volume, a "search for perfection," or was it a relishing of measurement almost for its own sake, as Almut Polmer-Schmidt suggests in the Städel catalog? Could it have been the preoccupation of an instinctive experimenter obsessed with precision and an ever-more accurate understanding of the elements of his craft? Or was Dürer far too thoughtful a member of humanist circles to have eschewed larger meanings or the elaboration of subtle ideas in anything he did?

There is no question that it is hard to reach conclusions on these matters. The *Melencolia* engraving seems almost purposefully enigmatic, containing as it does brilliant exercises in perspective as well as a brooding atmosphere and references to mathematics, to traditional views of the temperaments, and to symbols both obscure and obvious. In similar vein is the puzzle of the enormous gourd that hangs from the ceiling in the engraving of *St. Jerome in his Study*. What is it doing there? Is it a reference to the gourd that shaded the biblical Jonah, and therefore intended as an indication of the book that Jerome is currently translating? Or is it a demonstration of the engraver's mastery of perspective, an exercise similar to Uccello's drawing of a chalice? Whatever one's interpretive inclinations, the extent, variety and detail of Dürer's works ensure that such debates and reinterpretations will never end.

That so much can be learned from the drawings and prints makes it all the more unfortunate that what is probably the greatest of all the collections, at the Albertina in Vienna, remains almost entirely out of sight. The display in Washington, and the splendidly illustrated catalog, make it all the harder to condone the restrictions that allow so few of Dürer's works to be on view at any one time. For he was, in many respects, the most far-reaching master of the age. There is hardly a theme of his time that he did not address, from landscapes to portraits, from nudes to drapery, from ancient myth to the mysteries of faith. He was at the very forefront of technological innovation, and he was also a pioneer in establishing the artist as an independent earner. His *Apocalypse* was one of Europe's first bestsellers, and his ability to thrive in the marketplace, aiming woodcuts and engravings at different clienteles, enabled him to make a living as a solid burgher of Nuremberg, without reliance on the patronage that was offered to him by the emperor himself. One must therefore lament the Albertina's failure to give visitors a glimpse of these achievements by the many-sided genius who is the star of their holdings.

The compensation is, of course, that the exhibitions elsewhere show no signs of abating. If these four are anything to go by, the list of inexhausti-

ble questions will continue to grow, as will the appeal of a man whose vision encompassed all of nature, every aspect of the human condition, and the deepest of ideas, feelings, and beliefs.

Part Five

Dutch and Flemish Art

1

What Distinguishes Dutch and Flemish Art?

Until the sixteenth century, the seventeen provinces that make up the Low Countries regarded themselves as autonomous areas, each with its own traditions and privileges. In one of history's great ironies, their ruler, the Emperor Charles V, decided in 1549 to declare them a single legal entity; yet within less than twenty years a revolt broke out that split them irrevocably apart. The outcome, which today is basically enshrined in the separate Dutch and Belgian nations, emphasized how different could be the components of even a very small region of Europe. The two countries encompass about 25,000 square miles, less than half the size of New York State. Yet no territory this small has had an impact on Western art to compare with these provinces. What is even more astonishing is that, even within so limited a compass, there have been profound differences in style, intent, and production. And a final astonishment is that some of the most remarkable artistic achievements emerged from these lands at the very time, the sixteenth and seventeenth centuries, when they were enduring the most profound upheavals and transformations of their history, including the wars that created the independence of the seven northern provinces, today's Republic of the Netherlands.

The contrasts between the artistic traditions and interests of these neighbors, the Dutch and the Flemish, have attracted much scholarly speculation. And the issue remains alive in the works under consideration here, a gleaning of a dozen books from the spate of publications that the two traditions continue to inspire. Seven focus on the north, four on the south, and one embraces both.

Two of the volumes, the most massive in terms of scholarly contribution, illustration, and weight, introduce us to two artists active in the first half of the sixteenth century: the age of Charles V, well before the revolt that split the region in two. Both men built on the fifteenth-century herit-

age—the glory days of the van Eycks, Memling, and van der Weyden that established the Low Countries as a center of creativity affecting artists as far as away as Italy and Spain. And both gave early indications of the divergent inclinations that were to shape the distinct features of the art of their successors during the seventeenth century.

The older of the two artists, Jan Gossart, was born in the southern province of Hainault, probably in 1478, and by 1503 was already a master of the painters' Guild of St. Luke in Antwerp, which was to inherit from Bruges the role of dominant artistic center in Flanders. The catalog for the exhibitions of his work at the National Gallery in London and the Metropolitan Museum in 2010 and 2011 is a massive enterprise. *Jan Gossart's Renaissance* has a subtitle, *The Complete Works*, and it includes discussions, by more than half a dozen scholars, of over 300 of his paintings, drawings, and engravings. In the shows themselves, which included examples from followers and contemporaries, some 170 items were on display. The result is a treatment so comprehensive that it will become definitive for generations.

What Gossart took from his predecessors was a loving attention to the details of observed reality. His elaborate panel of *Saint Luke Drawing the Virgin* in Vienna, for instance, not only has the saint's shoes removed (a standard indication of a holy place) but places them at odd angles, with one propped up against a platform, that give them a palpable presence. The knuckles and nails on the bare foot of the angel who is guiding Luke's hand are almost tangible. And the background arches and pillars, like all of Gossart's settings, are so meticulously presented, and decorated with such exhaustive precision, that one has to be grateful for Ethan Kavaler's essay on Gossart as an architect.

The minutiae in such religious and mythological works, as well as his striking portraits, place Gossart within the traditions he inherited. But his major contribution, as these essays demonstrate, was his importation to the Low Countries of the new ideas he encountered in Italy, a trip that was made possible when he came under the patronage of a cultured aristocrat, Philip of Burgundy. In the words of the editor of the catalog, Maryan Ainsworth, "His trip to Rome in the entourage of Philip of Burgundy changed the course of his career and also the direction of Netherlands painting." The change is startlingly visible in the Vienna *Saint Luke*, with an elaborately clad saint at his desk, depicted in familiar Netherlandish manner, inspired by an Italianate Madonna, child, and putti, floating in a cloud in front of him. The integration of the two styles is unmis-

takable.

What is also distinctive is Gossart's association with aristocratic courts, first with Philip and then with Margaret of Austria, the ruling Regent of the Netherlands. In this respect he was a descendant of Jan van Eyck, who had been employed by Philip the Good, the father of Philip of Burgundy. The stability of livelihood bestowed by such patronage, the refinement it encouraged, and the opportunity to visit Italy that was given to Gossart were all features of the Flemish scene that were to set it apart from its northern neighbors.

The contrast is already apparent in the work of the master who was born just sixteen years after Gossart, and only 62 miles north of Antwerp, Lucas van Leyden. He is no less comprehensively studied in *Lucas van Leyden en de Renaissance*, the catalog of an exhibition in his home town in 2011. This may have fewer pages than the Gossart volume, but it has contributions from fifteen scholars, describes over 150 items, and has, in addition, over 250 illustrations to document the eight probing essays that accompany the catalog. Lucas did meet Gossart, and he too brought the new Italian aesthetic into his work, but little else about his career was similar: he did not travel to Italy, and although he portrayed the emperor Maximilian I in a drawing and an engraving, he was never a court artist. Moreover, in his commitment to printmaking, in his realistic settings, and in the elegance of his figures, the images he created were very different.

Given the wealth of information and insight in this volume, it is invidious to single out particular contributions, yet for the purposes of this review, which explores the Flemish/Dutch divide, the long essay by Ilja Veldman is especially noteworthy. Assessing the various influences on Lucas, she emphasizes the roles of Erasmian humanism and the Lutheran Reformation, neither of which figure in assessments of Gossart. Lucas' interest in classical subjects, in the Old Testament, and in religious stories with a strong moral purpose give him a closer connection to the intellectual and confessional issues of the day than those of his main Flemish contemporaries, Gossart and Joachim Patinir. Furthermore, unlike them, he was willing to address social issues, such as the relations between men and women. In terms of religious doctrine, Veldman notes that "Lucas' lost panel of *Susannah Before the Judges, Accused of Adultery* and his *Potiphar's Wife Accusing Joseph of Assault* can be associated with the commandment against bearing false witness." Both stories, she points out, were evangelical favorites, seen as guidelines for the upright. It is in this context that Lucas' famous meeting with Dürer, another son of the Church who nev-

ertheless admired Luther, takes on new meaning.

What is clear is that the Dutchman absorbed the latest ideas of his time and made them his own. The wings of his triptych of *The Last Judgement*, with their vast landscape backgrounds, come straight out of Patinir. That triptych has Bosch-like devils, and also delicate bodies that reflect the new aesthetic coming from Italy. Yet the links with Dürer were especially strong, not only in the Italianate figures, but above all in the profound commitment to the production of engravings. Here the contrast between the court artist and the city artist becomes salient. Dürer, the city dweller who refused to attach himself to a court, had figured out that the sale of prints could provide him with the income he needed. The concentration on engravings put Lucas on the same side of the patronage divide, though in this instance it also helped that he was married to the daughter of a wealthy city patrician.

As for content, it would take a connoisseur's eyes to distinguish the two men's etchings, and in some respects Lucas is the more remarkable. His talent, for a start, appeared at a much earlier age. The mastery he displayed at the age of fourteen suggests that, as a child prodigy in the visual arts, he bears comparison with a Mendelssohn in music. The essay on his prints, by Huigen Leefland, even describes his efforts between the ages of fifteen and eighteen as "the productive years." Moreover, Lucas published more than 170 engravings, an oeuvre considerably larger than Dürer's. There is a directness here that again differentiates him from the Flemings: a powerful physicality in his settings and people, exemplified by his *Ecce Homo*, which reflects an interest in the concrete representation of buildings, clothing, and the specifics of day-to-day existence—all traits that mark him as a pioneer of Dutch art's unique vision of the world.

When we move ahead to the seventeenth century, the divide between north and south becomes social, political, and religious as well as artistic. The major figure of Bruegel had worked in the interim, influencing his successors in both camps. Yet the remaining books under consideration here indicate how the sixteenth-century glimmerings of a divide between a Catholic court culture and a Protestant urban culture were to become fully manifest.

*

The difference in the forms of artistic expression between the neighboring Flemings and Dutch became indisputable in the seventeenth century, and the contrast dominates the ten volumes under consideration here. Among the many contributors, Desmond Shawe-Taylor, in the in-

troduction to *Dutch Landscapes* (the catalog of a 2011 exhibition of 42 works owned by the Queen), makes the most concerted effort to understand the distinctiveness of the northern painters. He notes their dependence on their appeal to a locality; the importance of market forces in what was the least stratified society in Europe (recent research, not mentioned here, suggests that sales reached a million works a decade); their interest in the everyday and what some called the shabbiness of ordinary life (as opposed to more lofty themes); and their focus on the reality, rather than the idealization of nature. Thus, while Flemish artists were fond of the bird's-eye view of a landscape, the Dutch remained at ground level, so that the viewer was part of the scene.

Shawe-Taylor's ability to make such comparisons within the specialized genre of the landscape indicates both his perspicacity and the ubiquity of the distinctiveness he seeks to define. The latter is on full display in three monographs on individual painters who embody the characteristic emphases of seventeenth-century Dutch art. Each is known for his interest in a specific kind of subject, which he explored with an eye for the physical details of the setting; each was closely identified with particular places; and each has been dismissed as a "minor" master, primarily because of the narrow focus of his work.

The oldest was Hendrick Avercamp, who spent most of his life in Kampen, a Hanseatic port city in the eastern Netherlands. As the catalog for the exhibitions of 20 paintings and 30 drawings in Amsterdam and Washington in 2009 and 2010 demonstrates, his fascination with winter settings and ice skaters did not lessen the subtlety or range of subjects he addressed. There is social commentary, humor, a feel for landscape, a nuanced investigation of dress, and even a reflection of the Little Ice Age that affected Europe in his lifetime. The seven scholars who contributed to *Hendrick Avercamp: Master of the Ice Scene* make it clear that his lifetime disability as a mute had no effect on his work or on his popularity. Both paintings and drawings had a loyal following, at auction and in direct sales, and he was admired and imitated by his fellow artists. The places and people he put on panels, canvases, and paper make him one of the most easily recognizable figures of the Dutch Golden Age, and also, in his concrete elaboration of limited themes, typical of the artists of his time and place.

Forty years Avercamp's junior, Jan Steen was associated primarily with Leiden, though he also spent ten years in Haarlem. An exhibition of the fourteen paintings owned by the Mauritshuis has prompted a charming

catalog that encompasses other works as well. Here the moral purpose and the admonitory proverbs often associated with his countrymen's art come to the fore. Drunkenness, sexual laxity, and the dangers of setting a bad example are Steen's major themes, though his brooding *Moses and Pharaoh's Crown* shows what he could have accomplished as a history painter. More common are the good humor, liveliness, and affection for people and spaces that mark his work, often including a fun-loving self-portrait. Once again the aims are limited but the execution is masterful.

More ambitious, both in art and in scholarship, is *Gabriel Metsu*, the catalog of an exhibition of 41 works shown in Dublin, Amsterdam, and Washington in 2010 and 2011. Here the comparison is with Vermeer, the contemporary whom Metsu was once considered to have outshone, but who now, thanks to what Adriaan Waiboer calls "hyperbolic" commentary, has downgraded his fellow genre painters in critical esteem. The acclaim has certainly made it more difficult to appreciate Metsu in his own right, though the many similarities between the two contemporaries do raise the question of why one should be regarded as a "minor," the other as a "great," master. It is not to belittle Vermeer to suggest that Metsu belongs in the first rank—a notable exponent of fond depictions of indoor activities that recall the man from Delft and also seem emblematic of the Dutch art of the period.

Metsu worked in Leiden and Amsterdam, and had a devoted following of collectors in both cities. Like Vermeer, he was a Catholic, and produced a few expansive religious works as well as his more familiar domestic interiors. He also painted marketplaces, an imposing family portrait, and an unusual nude self-portrait during a prolific career which, although years shorter than Vermeer's, resulted in many more works. Yet it was with ordinary people and small domestic dramas, such as *The Intruder*, that he seemed most at home. The care lavished on every artifact, such as a candlestick; the deft use of light and shade; and the subtle moral implications of his subjects—all exemplify the qualities that distinguished Dutch art in his lifetime.

That the Golden Age was not to last much longer is made clear in the work of Nicolaas Verkolje, born in Amsterdam in 1673, just six years after Metsu died. He was the subject of an exhibition of 58 works in Enschede in 2011, which was accompanied by a catalog written by nine different scholars. What their learning and discernment demonstrate is that Verkolje became an echo of the French Rococo tastes that were sweeping through the Continent at the time. His painter father Johann had still em-

braced the social commentary and the evocation of daily life of earlier generations, notably in a domestic scene entitled *The Messenger*, but Nicolaas himself shifted to the soft colors, and the elegant but slightly risqué narratives that his younger contemporary Boucher was to bring to new heights. The Dutch Golden Age was clearly over.

The one figure who seems to transcend the conventions of these surroundings is Rembrandt, another Amsterdammer, but someone who commanded every subject matter and artistic medium of his age, whether in the Netherlands or elsewhere. Even the catalog for a small exhibition like the Frick's 2011 show, *Rembrandt and his School*, displaying just five paintings and 58 prints and drawings, includes portraits, landscapes, history paintings, biblical events, and the mysterious allegory of *The Polish Rider*. Rembrandt's exceptional status is demonstrated even by his career, because unlike the other Dutch artists who have appeared in this survey, local patronage failed to sustain him throughout his life.

As soon as we cross the border into Flanders, such considerations recede. The three principal figures in Antwerp in the seventeenth century were the subject of a wide-ranging and richly informative exhibition of 50 works in Hamburg and Oslo in 2010 and 2011. The catalog *Rubens, van Dyck, Jordaens: Barock aus Antwerpen* offers five analytic scholarly essays at the outset, and then, after the discussions of the objects themselves, a pair of extremely useful appendices identifying the city's principal buildings and outlining a chronology of the period. The latter is particularly helpful in that the effect on these artists of living through an age of confessional, political, and military crisis arises in the essays, as it rarely does for their Dutch equivalents. Indeed, the editor, Michael Phillipp, notes the irony of Antwerp's radiating brilliance when it was beleaguered and disrupted by conflict, yet suffering rapid decline when peace arrived in 1648.

On patrons and purchasers, however, there is little comment, because in the south we enter a culture of courts and aristocrats. City patricians did play some role, and they take up one section of the catalog. But even Jordaens, the anomaly among these three artists—openly Protestant at the end of his life; a stay-at-home who did not absorb the Italian Baroque masters at first hand; and a reluctant courtier—in his later years accepted court patronage. Jordaens also enjoyed the anecdotal and moralizing subjects of his Dutch contemporaries. But the lushness and the drama of his versions of stories like *As Sing the Old, So Pipe the Young* (not to mention his sensual renderings of mythological themes like *Amor and Psyche*) place him immediately on the Flemish side of the border.

With van Dyck and Rubens, the case is plain. These were international figures, linked to the Italian and Spanish masters of the time in style and subject matter. Like these contemporaries, they were employed by princes, and they strove for a grandeur, for dramatic effects, and for an emotional impact that among the Dutch is to be found only in Rembrandt. One cannot imagine a religious statement like Rubens' canvas, *The Intercession of St. Teresa of Avila*—a highlight of the show—being painted, even by a Catholic, north of the border. One has but to look at the one book in this collection that straddles the two cultures, *The Hohenbuchau Collection: Dutch and Flemish Paintings from the Golden Age*, to see the difference. Even the Utrecht painter Gerard van Honthorst's *The Steadfast Philosopher*, with its smiling nude and reluctant intellectual, shows a restraint that would never have held back Rubens or Jordaens. Still-lifes, too, seem to become more luxurious and inviting as one moves south.

The divides between Catholicism and Protestantism, between court and city cultures, and between the growing wealth of the north and the decline of the south may help explain the different paths the two areas followed in the generations after Bruegel, but the figure of Rubens suggests another perspective. The latest two volumes in the magnificent *Corpus Rubenianum* deal with his copies of Titian and other northern Italians. Over fifty paintings, drawings, and retouchings are meticulously described by Jeremy Wood in a survey that reminds us yet again how totally immersed Rubens was in the work of predecessors and contemporaries.

It seems almost unfair to call this European figure a Flemish artist, and that surely is the point. One can make easy connections between him, or his compatriots, and the artists of southern Europe, just as one could with Jan Gossart a century before. With Lucas van Leyden, however, the link had already been more distant, and by the seventeenth century the Dutch were following their own road in the arts, as indeed they were in political, social and economic development. By 1700, as we saw with Verkolje, they increasingly resembled their neighbors. And yet, for one long moment they had been singular in their achievements and preoccupations, determined to celebrate in pictures the special world they created as they struggled to assert their independence. The new directions they pursued with such originality in so many spheres of life, from clean streets to religious tolerance, were what made them unique, defining them well beyond their Protestantism or their city culture. The Flemings were integrated into a Continent-wide outlook. The Dutch stood determinedly and proudly apart.

Why Are Van Eyck and his Countrymen Central to Renaissance History?

It has been a standard assumption of Renaissance scholarship for well over a century that the dramatic cultural changes that swept through Europe in the fifteenth and sixteenth century began in Mediterranean lands and migrated northward. In education, scholarship, and philosophy, the pioneers were Petrarch and the Italian humanists and neoplatonists. In the visual arts the engine of change was set in motion in Tuscany under the inspiration of antiquity.

When the Dutch scholar Johan Huizinga issued a famous challenge to this view in 1924, arguing that the fifteenth century was a time of decline as well as revival, the effect was, however, to underscore the importance of the south as the source of innovation. Once one moved from Italy to the Netherlands and France, he argued, the prevailing concerns had little to do with the hopes and ambitions one associates with the Renaissance. Death, hierarchy, fascination with detail, and a morbid religious sensibility were the major features. It was misleading, he felt, to focus solely on the quest for new standards of morality and beauty that preoccupied the Italians. To do so was to misrepresent the age, which was no less embodied in northern chivalric traditions as in southern efforts to rethink values and aesthetics. To the extent that his critique struck home, though, it merely reemphasized the leadership of the Mediterranean lands in the cultural change that eventually, unmistakably, engulfed all of Europe.

Symptomatic of this approach, at least in the history of painting, was the remarkable exhibition mounted at the Palazzo Grassi in Venice in 1999: *Renaissance Venice and the North: Crosscurrents in the Time of Bellini, Dürer, and Titian*. The catalog, issued under that title, and edited by Bernard Aikema and Beverly Louise Brown, paid tribute to the admiration aroused by some of the northerners who visited the Queen of the Adriatic (notably Dürer), and identified a number of specific debts that were owed

to the example of such Flemish masters as Jan van Eyck and Rogier van der Weyden. In the end, though, there was no doubt about the principal direction in which the major influences flowed. And the time in question was not the early budding of the Renaissance, but its full flowering from the late-fifteenth through the mid-sixteenth centuries. Not only in origin, but throughout its development, in other words, Renaissance culture expanded primarily from south to north.

Because the most vivid evidence documenting and sustaining this argument has long come from the visual arts, it is particularly telling that the first major attempt to temper its conclusions is, once again, an exhibition. Mounted in Bruges in 2002, *The Age of Van Eyck: The Mediterranean World and Early Netherlandish Painting 1430–1530* neatly reverses the priorities of the Palazzo Grassi exhibition that preceded it by three years. As the catalog, edited by Till-Holger Borchert, makes clear, the innovations that arose independently in the north, and the influence they exercised, force a rethinking of the notion of a one-way street that has so long prevailed in the field. That the case is made in this fashion, through painting, not only underscores the importance of interdisciplinary research, but also throws into relief the limitations of attempts to understand an age through its written texts alone. The pioneers who gave us our picture of Renaissance Europe—Jules Michelet and Jacob Burckhardt, not to mention Huizinga—did so by drawing on a cornucopia of visual as well as written sources. And those who followed have been most successful when, as in the case of John Hale, they have drawn on an equally extensive armory. It is a lesson that other fields of study might well wish to ponder.

Given the emphasis on the visual, it is notable that only one commonplace in the history of art concerns a gift from north to south, namely, the belief that Jan van Eyck invented oil painting. Not until the last essay in the catalog, however, does the editor himself, together with Paul Huvenne, address the issue. This is a story that goes back to the sixteenth century and Giorgio Vasari's *Lives of the Artists*. For Vasari, it was a dramatic tale of secret discovery, spied out by the Sicilian painter Antonello da Messina, who brought the technique back to Italy. Although it was clear by the beginning of the nineteenth century that the story was not true—the practice of mixing pigments with oil antedated van Eyck by centuries, and Antonello never left Italy—the legend persisted. What Borchert and Huvenne demonstrate is that there is an essential and more far-reaching truth behind the traditional tale. It was not oil painting per se that so impressed the Italians, but the colors and the realism that the

northerners achieved. In the words of the authors, the "unique colourfulness" identified with van Eyck was the real breakthrough that made possible "the verisimilitude of Netherlandish art," which, in turn, was the quality "long coveted in Italy."

Even though the reader has to wait until the very end of the catalog for this explanation of the northerners' impact on the aesthetics of their day, the basic case has, by then, been firmly established. A wealth of documentation has demonstrated both the avid interest of Italian collectors in Netherlandish paintings and the influence of those paintings on those who saw them. Moreover, as Borchert makes clear in an essay on the mobility of artists, the interaction was personal as well as stylistic. The hazards of fifteenth- and sixteenth-century travel notwithstanding, visits across hundreds of miles were not uncommon. Perhaps the most famous was Rogier van der Weyden's pilgrimage to Rome in 1450, a Holy Year, but he was not alone: dozens of his compatriots headed south, passing through or settling in France, Italy, Spain, and Portugal. There is a suggestion that even van Eyck himself journeyed as far as the Holy Land.

The effects produced by these encounters with people as well as paintings are clearly recognizable. In subject matters as different as landscapes and portraits one can see the borrowings that shaped Renaissance art through a continuing process of exchange that was obviously two-sided. In the catalog essay by Manfred Sellink, for instance, a cogent case for the impact of Flemish landscapes is developed through documentary as well as pictorial evidence. He notes that both van Eyck and van der Weyden gave rich emphasis to the settings in which religious scenes took place, and then shows how this prominence came to be echoed by their southern imitators. Van Eyck's *Stigmatization of St. Francis*, for example, which places two figures in an elaborate rocky countryside, with a river and a city in the distance, was in Italy by the 1430s, and it affected the work of no less a series of masters than Sandro Botticelli, Andrea del Verrochio, Filippino Lippi, and Domenico Ghirlandaio. As for van der Weyden, one Italian commentator remarked that his landscapes seemed to have been produced "not by the artifice of human hands but by all-bearing nature herself." This was clearly a case where the south learned from the north.

Much the same seems to have been true of portraiture. As Paula Nuttall stresses in her essay on this theme, "until the last quarter of the [fifteenth] century Italian painted portraiture lagged behind that of the North in terms of sophistication and realism, as the Italians readily acknowledged." Above all, it was the fidelity to appearance that astonished the southern-

ers. Italian patrons sought out Netherlandish artists when they wanted to
have their portraits painted, and the examples they brought home began
to transform the work of their countrymen by the late fifteenth century.
Thus it is noteworthy that the three-quarters view had superseded the
profile as the favorite pose in the north by the 1430s, but some four or
five decades passed before it took hold on the other side of the Alps.
Equally influential was the use of landscape backgrounds, parapets, and
strong contrasts of light and dark—all associated with van Eyck and his
followers. Nuttall considers the *Mona Lisa* "inconceivable without the
precedent of Netherlandish models," and she extends the argument to
Italian Renaissance masters from Botticelli to Titian. The juxtaposition of
works by van Eyck, Hans Memling and Petrus Christus on the one hand,
and Antonello da Messina, Pietro Perugino, and Piero di Cosimo on the
other, demonstrates the connection beyond cavil.

Other essays in the catalog pursue the links in particular areas of Eu-
rope: France, various Italian cities and courts, Aragon, Castile, and Portu-
gal. These provide extensive details of contact and cross-fertilization, and
add overwhelming weight to the fundamental argument of the exhibition.
The biographical information, the comments by contemporaries, and the
records of travels all strengthen the case, but its heart lies in the paintings
themselves. Without the visual evidence, the texts would not carry convic-
tion to the same degree. Here art leads the way for history.

To be fair, one must acknowledge that the written word gives an argu-
ment a weight and cogency that paintings (though they may have prompt-
ed the idea in the first place) may not be able to provide. But that is not to
minimize their importance. Any light that can open up a new path in his-
tory deserves an enthusiastic welcome. The signposts offered by fifteenth-
century northern art ought therefore to be exemplary wherever cultural
change and authority are at issue, from the spread of early Christianity to
the heritage of Africa in the Americas.

If in so well-plowed a field as Renaissance history images are capable of
overturning long-held assumptions, one must assume they have similar
power elsewhere. This may be a field peculiarly focused on the im-
portance of art and its sources, but it is surely not unique, given that the
analysis of origins and influences is one of the standbys of cultural history.
What is clear is that when such research remains within the confines of
written texts, it deprives itself of the possibilities offered by the world of
images—the illuminations that are made possible when historians and art
historians interact. Considering how deeply ingrained are the views of the

Renaissance that *The Age of Van Eyck: The Mediterranean World and Early Netherlandish Painting 1430–1530* seeks to counteract, one cannot help but see how relevant to many subjects, and potentially persuasive in them all, is the interdisciplinary approach that has animated both a remarkable exhibition and its catalog.

3

Why Did Rubens Copy his Predecessors?

In his recent play "Red," John Logan has Mark Rothko say: "Courage in painting isn't facing the blank canvas, it's facing Manet, it's facing Veláz-quez." If that is indeed the basic challenge, then it is clear why Peter Paul Rubens stands so firmly at the pinnacle of Western art. For there has never been a great painter who so insistently and relentlessly studied, copied, retouched, and absorbed his forebears.

Although this aspect of Rubens' career has long been known and commented upon, it has only recently become as salient as it must have been to the artist himself. For he was not just copying and retouching (in the hundreds) the pictures that he liked, or from which he hoped to learn; he also had a formidable memory that enabled him to keep images in mind for decades. When, in his twenties, he went for a few years to Italy, the trip became a storehouse of memories on which he drew for the rest of his career. And the connections he made were not just with the great figures of the day, such as the Titians and Tintorettos he copied in Venice, or the Raphaels he sought out wherever he went. He was always filling his head, not to mention canvases and paper, with the shapes, structures, colors, ideas, and compositions that he saw.

A striking example dates from his years in Mantua in the early 1600s. We know he spent time in Giulio Romano's stunning Palazzo Te, for he retouched drawings that had been made of its military decorations. But there is no evidence that he kept a detailed record of another room, filled with risqué scenes on the theme of Amor and Psyche. One of these, which must have amused the guests who banqueted there, showed Mars chasing a barely clothed Adonis after he had caught him *in flagrante* with Venus, while the *déshabillée* goddess tries to hold on to Mars. The furious war god looks back at her, but there is no mistaking his intent, dressed in military tunic and plumed helmet, brandishing a huge sword. What is

astonishing is that over thirty years later, as Rubens engaged with an utterly different subject, *The Horrors of War*, Giulio's composition should have reappeared at the center of his epic canvas. There are Mars and Venus, in the same dynamic, in almost identical postures and clothing, but now symbolizing the struggle between peace and war, with no hint of the humorous origins of the pose. In Rubens' hands, the masters of the past were his way to the future.

One reason that awareness of his engagement with his predecessors is on the rise is because the massive survey of his work, the 29-part *Corpus Rubenianum Ludwig Burchard* has in the past year reached Part XXVI, *Copies and Adaptations from Renaissance and Later Artists*. Four of the volumes in this Part have now appeared, two on northern artists, and now two on Italians. This is a magisterial enterprise of scholarship that has been under way for decades, and must surely be the most comprehensive treatment of a single artist ever contemplated—let alone brought to completion, as is expected in a few years' time. That we now have four large and densely argued books on the copies, fully illustrated, and running to well over a thousand pages, is reason enough to think again about the importance for Rubens of confronting and understanding those who had come before.

And the new volumes are indeed revelations. We do not have here an intervention as extreme as Rubens' changing the subject of a Paul Bril work by his overpainting. But we do have dozens of drawings and retouchings, plus a few major oils that demonstrate the range of Rubens' encounters with his fellow artists. The finished copies of works as varied as Raphael's portrait of Castiglione and Caravaggio's *Entombment* suggest both an openness to others and an intensity of interest that are unique in the annals of art. During one feverish stage, Rubens made at least 22 copies after Titian in the space of seven months in Spain.

As Jeremy Wood, the author of the two new volumes in the *Corpus*, notes, there have been those, like the eighteenth-century scholar Antonio Palomino, who believed that Rubens' copies of Titian were "better than the originals." On the other hand, there have been many who have found the practice an affront or even deceitful. Yet surely that is not what makes his efforts so interesting. It may well be that, at least in part, Rubens was trying to outdo or improve what he saw before him; and in some cases he may have too blatantly appropriated figures or compositions that had been created by others. But that is not to imply—and even his fiercest critics do not go so far—that his ideas or his skills would have been any less fertile or abundant if he had ceased to copy or retouch. What sets

Rubens apart is that his need to study these images, and to set his hand to them if necessary, was so urgent and so constant.

Wood's two volumes document a central part of this enterprise with exemplary erudition. Not only is there a close analysis of dozens of works, but we soon come to realize how essential for his art was Rubens' passion as a collector of prints and drawings. And Wood makes it clear, too, how natural it was for a painter of his time to be making copies. The Renaissance had begun with visitors to Rome trying to figure out how the ancients achieved their effects, and by the seventeenth century the rising stature of artists also made modern works much sought after. Thus one of Rubens' duties, from his earliest days in the employ of the dukes of Mantua, was to copy famous paintings—Titians, Correggios—for his patron. In Wood's pages, however, we see (as in the earlier *Corpus* volumes on the northerners) that for Rubens the obligation became a lifelong commitment, indispensable to his development as an artist.

The growing awareness of this leitmotiv in Rubens' career also received a boost from the exhibition held a few months ago at Munich's Alte Pinakothek. That it had the title *Rubens im Wettstreit mit Alten Meistern* may suggest too strongly that this was some kind of duel. As we have seen, one cannot rule out the influence of Rubens' competitive instincts. But to see his copying entirely, or even largely, through this particular lens is to miss the broader significance of his need to spend so much time in the company of his predecessors. As both exhibition and catalog demonstrate, this was an artist forever seeking to learn, to expand his horizons, to master every possible technique. It is in that context, above all, that one needs to approach this aspect of his oeuvre.

Given the extent and range of Rubens' pursuit of his predecessors, the seventeen paintings in the Munich show can give only a glimpse of the enterprise. But the glimpse is revealing, and its ramifications are elegantly pursued in the catalog essays. Only three pictures in the show were Rubens' copies placed next to their originals—a Key and two Titians. In every case, however, the Fleming had made the painting his own. The flesh became fleshier, the skin pinker, the gaze more direct, the silk more luxurious, the colors and gestures more vivid. In the Key a slightly open mouth was widened to show teeth. Rubens was exploring how effects were created, but he did so in his own way. In the Titian *Adam and Eve* he muted a red flower and a small fox, but added a brilliant and startling red parrot.

Titian was the star of the Munich exhibition, as he seems to have been

for Rubens. From Stockholm came Rubens' lush copies of *The Worship of Venus* and *The Bacchanal of the Andrians*; from Madrid *The Rape of Europa*; from Brisbane the *Woman in a Fur*. And the catalog not only puts the originals next to the copies but elaborates, in the essays, the many debts that Rubens owed the Venetian, even when the subject matter was entirely different—as in the spears of his *Massacre of the Innocents* of 1638, which echo the rods of Titian's *Crowning with Thorns* of 1570. Yet the variety of Rubens' choices is not neglected. One of the highlights of the show was the copy of Parmigianino's *Cupid*, and the essays reveal how many others stood alongside Titian, from Holbein to Caravaggio. The only two cavils that can be offered against this landmark in the expansion of our understanding of Rubens are that the catalog lacks an index, and that Tintoretto does not get his due—for instance, as an inspiration for the *Allegory of Peace* (also known as *Peace and War*).

The larger insight into Rubens that emerges from this spate of research has to do with his intellectual as well as artistic distinction. What is striking is that one can now perceive, unmistakably, a basic link between his friendship with scholars known for their learned explorations of the past and his own explorations of his predecessors. It was a commonplace of the Renaissance, shared by both these enterprises, that each generation stands on the shoulders of giants. In the case of Rubens, the acknowledgement of that debt led to the fashioning of a new giant.

Is Later Western Art Conceivable without Rubens?

The word "legacy" is at the heart of any understanding of the past. Without it there can be no narratives, no consequences, no ancestry. One may consider looking forward to be perilous, but hindsight seems both easy and common—a reliable prop whenever one tells a story or explains why some assumption has taken hold. And what is true in general has a particular relevance for the arts.

Harold Bloom, in *The Anxiety of Influence,* made the connection fundamental to the creative life. Nobody works alone; always there is the awareness of, even the struggle with, those who came before. Bloom's subject was poetry, but if the argument is applied to the visual arts, the case is irrefutable. Leaving aside such obvious instances as the discovery of the *Laocoön* in Rome in 1506, and the subsequent flurry of echoes of the sculpture, it is almost a cliché to find reflections of antecedents in works of art. Originality does not exclude homage.

What this situation leads to is a double criterion for judgment in historical and critical studies. On the one hand is the assessment of achievement: by what standards, and on what grounds, should we identify the qualities that mark an artist's body of work or even a single work? On the other hand is the assessment of influence: regardless of the conclusions reached about the first set of criteria, is there a clear path from this artist to successors? Can we see the thumbprint of the master in generations to come? The first is often a matter of taste. In the history of European painting there is hardly a major figure, let alone a minor one, who has not suffered from periods of neglect or dismissal. The second, however, is a matter of research. Finding traces of a predecessor depends on documentation, close study and perception.

Few painters loom as large in the second category as Peter Paul Rubens. Almost impervious to changes in taste, he hovers over nearly every

generation since his own, admired for virtues that ranged from his use of color to his evocation of atmosphere. He was himself an avid copyist of those who preceded him—notably Raphael, Romano and Titian—and he inspired dozens who came after. It is a daunting task, therefore, to mount an exhibition and prepare a catalog entitled *Rubens and His Legacy*.

Part of the problem is the very versatility that enabled Rubens to appeal to so many different kinds of artists. He was not only prolific, but also took on all the subjects of his day, from portraiture to landscapes. Even the practitioners of a genre not obviously suited to his vigorous style, the still-life, could draw lessons from his garlands of fruits and flowers. The result is an abundance of topics that have to be reduced to graspable categories if anything like a coherent picture is to emerge.

The solution that the organizers of the recent exhibition at the Royal Academy in London and the authors of the catalog have reached is to divide Rubens' output into six basic themes: violence (history paintings of both myth and faith, together with depictions of hunts); power (celebrations of Europe's princely courts); lust (fleshy nudes, usually in myths); compassion (religious works); elegance (portraiture); and poetry (mainly landscapes). The divisions are not always clear-cut. Where, for example, should one place *Landscape with St. George and the Dragon* (1630–1635)? The central figures are clearly the king and queen of England; there are gesticulating mythological figures all around; and yet, for all the large characters in the scene, the feeling Rubens conveys is of a vast and lush landscape—the category that Tim Barringer, author of an essay in the catalog, has chosen.

It has to be said that these divisions are far more comprehensible and solidly supported in the book than they were in the exhibition. The latter was also a much weaker means of convincing the viewer that a creator of masterpieces (namely Rubens) was also able to inspire masterpieces. The book makes this second case with a wealth of illustrations, which are capable of suggesting—as a limited set of physical loans could not—the quality and range of the paintings, drawings and engravings that shaped and reflected themes and approaches across the centuries.

What makes the comparisons so fascinating is that there is no need to demonstrate an immediate encounter between past and present. Artists have long memories: when Rubens, in his *Horrors of War* (around 1638), revealed a debt to a painting by Giulio Romano, it had been some thirty years since he had seen it in Mantua. Similarly, artists such as Watteau and Delacroix are so suffused with references to their Flemish predecessor

that their visits to particular collections or their familiarity with particular works seem almost self-evident.

Nevertheless, much of the research that lies behind the essays in *Rubens and His Legacy* consists of precisely this kind of documentation—a lecture by Constable, for instance, or a letter by Falconnet offer evidence of direct contact. Far more telling, however, are the visual traces. Here the authors have to pick and choose, because few European artists have been immune to Rubens' presence during the centuries since he died. That his own students, van Dyck and Jordaens, were acolytes is no surprise. But it is also the case that many of the eighteenth-century portraitists are here: Gainsborough, Lawrence, Vigée Le Brun, Reynolds, all showing what they had learned from Rubens. Much the same is true of their contemporaries among the landscape artists—whose inspiration has been learnedly and precisely explored in Corina Kleinert's *Peter Paul Rubens (1577–1640) and his Landscapes: Ideas on Nature and Art*. Of special interest here is the universality: although it is no surprise to come across an admirer like Constable, it is less predictable to discover that a critic like Turner was sufficiently impressed, despite his reservations, to join the company.

Manet revealed that Rubens was still a force in the nineteenth century, as did Renoir and Cézanne. What is less expected is the connection to Modern artists, represented here by Lovis Corinth, Oskar Kokoschka, Wyndham Lewis, and Ivon Hitchens. No less a figure than Pablo Picasso, despite his disdain for what he considered the "courtier" painters of the seventeenth century, is shown to reflect the Fleming's influence.

If at times these essays seem almost to be overviews of Western art, that is because their subject matter is indeed all-embracing. The artists whose names crop up, whether it be Goya or Géricault, are all essential representatives of the history of European painting. The contributors to this volume may make more of Rubens the diplomat than is warranted by his peripheral role in international relations, but they do not exaggerate his importance to the generations of painters who followed him. Like just a handful of the powerful presences of the last 800 years, from Giotto to Cézanne, it is not solely his achievement that defines his importance; it is also the legacy that has kept him alive ever since his own exuberant career came to an end.

Why Does Rembrandt Continue to Appeal?

Since 1991, there have been at least nine Rembrandt exhibitions, displayed in twenty cities, from Canberra to Stockholm. The latest—*Rembrandt's Journey*, at the Boston Museum of Fine Arts—shows an artist perpetually on the move. Whether considering subject matter or medium, he was constantly shuttling back and forth among themes and techniques. He came back to the Bible, to daily life, to landscapes, to portraits again and again. What is equally noticeable is that he seemed to reach, almost randomly, for the copper plate, the pen, or the paintbrush.

For all the controversies and de-attributions prompted by the Rembrandt Research Project since the late 1960s, the fascination with the master himself, and with the endless opportunities for interpretation (social, historical, artistic) that he provides, seems insatiable. Boston has been a fertile source of scholarship and display: two of the books under review emerged from a gem-like exhibition of just nineteen works, focused on the Leiden years, 1629–1631, at the Isabella Stewart Gardner Museum in 2000, and now there is this blockbuster of more than 200 prints, drawings, and oils; its sheer ambition suggests this may be an appropriate time to take stock.

No recent show has conveyed so vividly not only the variety of Rembrandt's interests, but the importance he gave to etching as well as to drawing and painting, and the ease with which he moved from one medium to another. Someone has doubtless done the sums, but even at a guess, his nearly 300 etchings, if multiplied by their different states (each of which often creates a new work of art), would outnumber his 1,400 or so drawings. The abundance is dizzying, and through it all *Rembrandt's Journey* emphasizes the coherence of the life's work, as we follow ideas that take form with equal felicity as prints, drawings, and paintings.

The first half of the seventeenth century was the first great age of art as

print. There had been important and prolific engravers before, most famously Dürer 100 years earlier, but not until the age of Rembrandt did the form become so central a vehicle of artistic activity. Indeed, not until the rise of the photograph would there again be a similar surge of numbers, interest and achievement connected with a new means of expression in the visual arts. And the Boston Museum has highlighted this remarkable phenomenon by mounting, nearby, a handsome exhibition that showcases *Callot and his World.*

Some 150 prints, drawings and books, drawn from its own collections, and concentrating mainly on Callot and his younger contemporary Stefano della Bella, document the outpouring that began in Rembrandt's time. That the Metropolitan Museum recently celebrated the work of an artist from the previous generation, Hendrick Goltzius—the first Dutchman to become famous for his prints, and a master much admired by Rembrandt—merely confirms the impact and vitality of the medium from around 1600 onward. It is true that, for many years, the sharp, carefully modeled depictions associated with Goltzius or Callot were more widely admired than the looser, softer, sketchier style that Rembrandt preferred. One has only to compare the crisp details of Goltzius's *Circumcision* with the younger man's reinterpretation of the same scene, smokier and less distinct (though the infant now cries out with pain), to see how different were Rembrandt's intentions and his uses of the technique. But the point remains: as the print assumed new stature, it ceased to serve as mere adjunct. For Rembrandt, it was essential to his art.

The result was an oeuvre of unique breadth. The range and profusion of images that Rembrandt created are unmatched. In some cases, particularly the landscapes of his native land, one tends to think first of the prints (and drawings), though the exhibition does include the only oil of such a scene: a small panel of winter, showing a placid village corner, illuminated in just a few strokes by subdued sunlight. For the most part, though, it is the portrayal of these scenes on paper that stay in the mind—the sturdy trees, the windmills, the cottages, the flat vistas and the quiet animals and people—as they make us see the Dutch countryside through his eyes.

Much the same is true of the ordinary people who populate his work. No earlier age had so insistently found art in the mundane. That the sturdy, republican Dutch should have become the first copious exponents of the genre is no surprise (although at the time there were those who considered such subject matter demeaning—a criticism also made of the contemporary Caravaggio). Again, however, it is Rembrandt who gives the

subject a singular grace, especially through the print and the drawing, both of which lend themselves particularly well to quick sketches of heads, to street sellers, to beggars, and to children. But no medium has a monopoly: although the oils tend to be more formal, they, too (notably in the portraits of old men, and the figures in biblical stories and landscapes), echo his fascination with the everyday.

In all these cases, the juxtaposition of etchings with paintings freshens the encounter with Rembrandt's work. We see a portrait of the Portuguese doctor Ephraim Bueno in both formats, and we can see how differently the artist achieved the aura of deep contemplation which emanates from the eyes and envelops face and posture. In both versions, the arm looks oddly out of proportion, but we are drawn past it to Bueno's melancholy gaze. Less predictable, but equally telling, is the connection between a small etching from 1632, *The Holy Family*, and the huge canvas of the same subject painted thirteen years later and now in the Hermitage. For all the contrasts—Joseph reading or shaping a piece of wood, Mary suckling the child or rocking the cradle—the mood of calm domesticity remains the same. Angels may hover in the painting; Mary may kick off her slipper in the etching; but the principal impression is that these are parents enjoying a peaceful moment of reading and taking pleasure in their child. The conception was elaborated and brought to full maturity in the canvas, but it had already been formulated and given life in the etching.

Given the breadth of Rembrandt's interests, it seems invidious to single out any one leitmotiv for comment, but at the Boston exhibition one kept noticing the remarkable intensity of his depictions of old men. If perhaps an ageing viewer had reason to find these figures so sympathetic, it nevertheless remains true that, from his earliest days, Rembrandt seemed uncannily able to give bearded patriarchs starring roles in his pictures. An ancient St. Jerome, engrossed in a book, is a barely visible outline, yet he dominates the elaborate landscape and powerful lion that loom above him. Even a lustful Jupiter, hovering over a naked Antiope, exudes a dignity and calm that seem at odds with the scene. And although the somber oil of *The Visitation* and the mournful etching of *The Death of the Virgin* supposedly concentrate on Mary, it is the ailing Zacharias, standing above her in the first, and the comforting St. Peter, bending over her in the second, who seem to steal the spotlight. With their prominent balding heads and fine beards, they assert a presence that defines the mood of the picture. That this should already have been a feature of works that Rembrandt completed in his twenties—one can see what is coming in the

Flight into Egypt of 1626, and it is fully there in the *Presentation*, the *Jeremiah*, and the *Old Man in a Cap*, all of 1630, when he was twenty-four years old—may prompt one to speculate both about the models the artist saw on Dutch streets and about his relationship with his father.

But that is a temptation one ought to resist. For the books under review (a mere sampling of recent scholarship) remind us, in their strict adherence to evidence, how unwarranted have been the leaps from the meager documentary record to confident interpretations of Rembrandt's art. The extraordinary series of self-portraits, for example, has been plumbed for self-aggrandizement, bravado and despair; similarly, his religious beliefs have been deduced from Bible scenes, from illustrations of mysticism and depictions of preachers and Jews.

In recent decades, by contrast, the chief explorations (apart from the technical analyses conducted by the Research Project) have ventured into the well-documented society in which Rembrandt lived. Sales, legal documents, inventories, art world connections, and the market have been scoured to bring forth what Montias in *Rethinking Rembrandt* calls a "harvest" of passing references to the painter. Interestingly, Gary Schwartz and Svetlana Alpers published books in the 1980s that took this evidence in almost diametrically opposed directions: for Schwartz, Rembrandt was enmeshed in a circle of family members, friends, and clients, whose help was crucial to the establishment of his fame; in Alpers' view, he took control of his fate and those around him. The conclusions are in the eye of the beholder, and Montias acknowledges as much in his discussion of the surviving evidence about Rembrandt's friends and associates: he calls his contributions "two conjectural essays."

Research of this kind now alternates with close analyses of individual works, where, for instance, a curtain becomes essential to understanding Rembrandt's relationship with Gerard Dou, or the eyes of a bride give meaning to an entire painting. Yet another approach concentrates on a brief period—in the case of *Rembrandt Creates Rembrandt*, the formative Leiden years, 1629–1631—so as to see all sides of his exuberant investigations at a given time. The result of all these efforts has been an enormous accumulation of information, a detailed tracing of the connections both in Rembrandt's work and with others, and a strong sense (captured in the Boston Museum exhibition, and elaborated in its learned catalog) of the way the artist worked over the years, regardless of his personal situation, as he pursued his specific interests.

Yet a central elusiveness remains. The elements of the artist's style may

now be well established; we may be able to see how he made the most ordinary scenes seem luminous; but still, if we ask why, profit aside, he returned so often to certain distinctive themes (the Hebrew Bible, everyday life, the aged, landscapes, and Jews), the answers remain as fragmentary and subjective as ever. *Rembrandt's Jews*, the latest attempt to elucidate one of these recurrent preoccupations, seeks a middle ground between speculation and chronicle. Nadler does not hesitate to ask why Jewish themes figured so prominently, but his reply does not stray from the verifiable conditions of Rembrandt's life. Above all, he situates the artist physically in the Jewish neighborhood where he lived during the years of his high maturity, 1639–1658, and lays out his relationships with the leading members of the community, notably the famous Rabbi Menasseh ben Israel, whose Apocalyptic tract, *Piedro Gloriosa*, he illustrated. That this was fertile ground for Rembrandt is clear.

Although Amsterdam's Jews were divided between relatively prosperous Sephardim, who had come from Spain and Portugal during the century or so since their expulsion from Iberia, and the newly arrived, often destitute Ashkenazim, refugees since the 1620s from a Germany ravaged by the Thirty Years' War, it was the former who lived near Rembrandt and provided patronage and subjects for his art. Whether he was aware of the excitements that stirred these neighbors at the time—not only the Sephardi/Ashkenazi divide, but also the rivalries among rabbis and synagogues, and the famous condemnation of Spinoza—we cannot tell, but there is no doubt that he was able to forge close connections with the learned and urbane leaders of the community. What those connections meant, however, it is difficult to say. When Nadler considers the wider import of Rembrandt's devotion—unequalled among his Christian contemporaries—to the stories of the Hebrew Bible and the portrayal of the Jews of Amsterdam, he remains cautious. He sets aside the long-standing idea that this reflected a special affinity: this is a legend which implies "more than the extant documentation and even the paintings themselves will support." What he emphasizes instead is the Dutch Calvinists' inclination, first, to see analogies between their history and that of the people of Israel, and, second, to show special fondness, derived from their Biblicism, for an exotic but intriguing community.

Because of this situation, "Rembrandt was not the only artist in town taking advantage of the opportunities" provided by the presence of the Jews to create new and interesting images. He may have done so more extensively than other artists, but there were so many of these (Jacob van

Ruisdael, de Witte, Berckheyde, Steen, de Hooghe, to name only the best known) that the social and religious environment of the time is surely sufficient, Nadler suggests, to explain his choices of subject. This is perhaps too abstemious a conclusion, but it is cogently argued, and it serves as a formidable counterweight to more instinctive and personal explanations. The book thus becomes, not a quest for Rembrandt, but a kind of Baedeker to seventeenth-century Amsterdam, its remarkable Jewish community, and the artists the community attracted. Nadler proves to be a brisk and engaging guide to the context of Rembrandt's art. Except for a strange equating of Park Lane with the Lower East Side, he also offers the most reliable, and readable, introduction to the Amsterdam Jewish society of the time.

Can one go no further in explicating the fascination with particular themes that set Rembrandt apart? Possibly not. Given the scarcity of private sources, the kind of scene-setting to which Nadler resorts may bring us about as close as we can come to the wellsprings of Rembrandt's art. It is true that the archival research of recent decades enables us to see, in exhibitions like Boston's, how he worked and what his interests were. Paradoxically, however, it may be the very abundance of his creativity, mediated by a scholarship that lacks the evidence to address the larger personal questions head on, which prevents us from suggesting why he cherished the particular mix of subjects that he made his own, and thus keeps veiled the deeper commitments and ambitions that Rembrandt himself might have recognized.

6

Is There a Distinct "Late" Rembrandt?

This erudite and illuminating catalog adds insight and meaning to the powerful exhibition at the National Gallery in London: *Rembrandt: The Late Works*. The display is the first to focus solely on the artist's last two decades, and reflects a growing interest in the "late" phase of the creative life. Thus a recent show emphasized that, in Titian's final years, his painting became looser, freer, more impressionistic, and the argument has been made that this kind of distinct style may be characteristic of a master's "late" work. By contrast, the contributors to this volume, while acknowledging many influences, regard this period as essentially a time when Rembrandt pursued, with special intensity, themes and techniques that had occupied him throughout this career.

A good example is the exploration of the effects of light and dark, discussed here by Erik Hinterding. This subject absorbed Rembrandt in both his paintings and his etchings from his earliest days, but it remained central to his art, and was profoundly explored in his last years. An etching of *The Adoration of the Shepherds* of 1657 went through eleven states, each unique, and Hinterding emphasizes that the consequences of altered highlights and shadows could be produced by a change of paper as well as adjustments to the plate. Even two copies of the first state are subtly different. Similarly, though Rembrandt had used drypoint before, in his final decades he resorted only to this more fuzzy, velvety technique in his etchings.

The catalog does not address directly a singular feature of the late work—the interest in the depiction of old age. Although the authors effectively resist the inclination to link the art with the biography, suggesting that simple connections with Rembrandt's financial difficulties or family tragedies serve little purpose, in this one respect the predilection seems unmistakable. In the portraits, quite apart from his own ageing features,

the interest is clear. The *Old Woman Reading* of 1655, with its uncanny evocation of deep concentration; the representation of *Jacob Trip* (1661) in his declining months; and the venerable figures involved in what Gregor Weber, in a moving chapter, identifies as a theme of reconciliation—all testify to the artist's emotional engagement with people of advanced years.

Above all, however, it was his ability to plumb new depths, to intensify what he had undertaken throughout his career, that is the most remarkable feature of the late work, and the essays repeatedly make the point. The early biographies—now elegantly available in translation in a small, nicely illustrated paperback—made much of Rembrandt's determination to chart his own path, and the habit did not flag. Although accused of ignoring the examples of his predecessors, he was fully aware of the traditions he inherited. As this catalog makes clear, however, he adapted them to his own needs. He refused, for example, to use the bright Rubensian colors that his students, among others, embraced in order to please clients. To the end, his concern remained to penetrate the depths of human character, to show the world as it was, and to hone further the skills he had accumulated.

There is some repetitiveness in this book's essays, but their success in laying out these themes is admirable. The one cavil has to do with the cross-referencing. It has become customary in catalogs to integrate the exhibited pictures into the text. Since other illustrations are also needed, these are designated as Figures. The two sets of numbers that ensue not only are confusing (one has to check the caption to find out which is which) but also complicate the finding of a particular image. If two lists at the outset were to provide page references for each number, the difficulties would be allayed, and publishers like Yale should take this small step for the sake of those who read their books.

A final thought, prompted not so much by the writers as by the handsome plates in this volume. What set the artist apart, in his humanity and his exposure of character and feeling, is his treatment of eyes. One has but to look at the woman in *The Jewish Bride* (1665), the men in *The Syndics* (1662), Joseph in *Jacob Blessing Ephraim and Manasseh* (1649), the saint in *St. Bartholomew* (1661), or almost any other figure, to realize that, for Rembrandt, the eyes were indeed windows into the soul (*Illustration 7*).

What Can We Learn from a Painter of the Everyday?

Why do "golden ages" so often erupt in such small communities? Why do populations as relatively tiny as the Athens of Pericles, the Florence of the Medici, or the London of Elizabeth I suddenly produce astounding bursts of creativity? It is a question that seems almost inevitable when one contemplates seventeenth-century Holland. Absorbed in a life-and-death struggle with the enormous Spanish Empire and drawn into the Europe-wide Thirty Years' War, the vastly outnumbered Dutch not only held their own, won their independence, became a dominant force in world trade, and set the standard for religious toleration in the post-Reformation era, but at the same time bestowed on the West a treasury of intellectual and artistic achievement that has been cherished ever since.

Explanations of this flowering have ranged from the consequences of political struggle, urbanization, or Protestant militancy to the more prosaic effects of economic prosperity. But all beg the question of why Dutch exuberance should have taken the form it did. Why was their particular achievement to have launched the first comprehensive artistic celebration of ordinariness? Whether versatile masters like Rembrandt and Vermeer, portraitists like Hals, or explorers of genres like de Hooch, Ostade, and Avercamp, they bring their world to life like no artistic tradition before them. We look at their landscapes, their cities, and their houses through their eyes, and even the most high-minded collectors of subsequent ages have found their work irresistible. Although often suffused with symbolic references that foreign purchasers may well have missed, Dutch art of the seventeenth century came to seem the quintessence of a simplicity, a directness, and a down-to-earth realism that could be found in no other artistic tradition.

These ruminations are prompted by the latest in an ongoing series of exhibitions at the National Gallery in Washington organized by Arthur

Wheelock. They began with *Dutch Painting in the Age of Rembrandt* in 1980; continued through lavish presentations of the work of van Dyck, Vermeer, Steen, flower painters, Gerrit Dou and Aelbert Cuyp; and are now focused on 52 canvases, panels, and oils on copper by Gerard ter Borch.

How well does ter Borch do in such company? There is little doubt that, alongside the more famous artists of the seventeenth century, he seems to belong in the second echelon: capable of much fine work, but still a minor master. The portrait of his half-sister Gesina drinking wine, for instance, is easily overshadowed by Vermeer's *Glass of Wine*, painted a few years earlier, with a similar young woman holding a near-empty glass to her lips. But such comparisons are beside the point. What sets the Dutch Golden Age apart is the very variety and fecundity of its artistic achievements. And very often it is the second echelon that most clearly illuminates the society that sponsored and supported this extraordinary outpouring of talent.

Seen in this light, ter Borch is among the more appealing figures of the age. By and large, he was an indoor painter, a sought-after portraitist and the creator of small encounters fraught with implication. On occasion, the meaning of a scene is clear: a trumpeter/courier brings a paper summoning back to duty an officer who sits glumly with an arm around his even more glum young lady. But usually we are left to complete the story, as men and women look meaningfully into one another's eyes; young women confront men who may be relatives, bordello customers, or lovers; the writers and recipients of letters interact with other figures both curious and indifferent; or the courier for a letter-writer gives a sidelong glance at the viewer. The excellent catalog lays out the often contradictory interpretations of these encounters that have accumulated over the years, and convincingly advocates readings that emphasize subtlety and a minimum of moralizing.

Ter Borch happens to be one of the best-documented of the artists of his time. As Wheelock points out, we can follow his life, spent mostly in the area of the eastern Netherlands where he was born, and especially in its chief city, Deventer, almost year by year: from the age of eight, in 1625, until his death in 1681. In particular, we know his movements and can examine their consequences. Thus, a visit to Spain seems to have brought to his portraits the technique of a sharp outline against a spatially neutral background that was characteristic of Velázquez. And the two years he spent in nearby Münster, 1646–1648, as the negotiations over the Peace of Westphalia entered their final phase, gave him a singular moment in the

public eye. He managed (possibly as a result of his stay in Spain) to gain the patronage of the principal Spanish negotiator, the Count of Peñaranda, who formally granted the Dutch their independence. Ter Borch painted portraits of a number of the negotiators, including the count himself, elegantly dressed in the high, thin collar that became fashionable among the Spanish aristocracy at Philip IV's court. It is the collar that sets him apart in ter Borch's remarkable depiction of the moment when the Dutch swore the oath that ratified the treaty, a painting that is less than 18 by 24 inches, but is still crowded with well over 70 figures, most of them individually portrayed. The Spaniards fill one side, the Dutch the other, and at the far end of the Dutch delegation stands the artist himself, a Zelig-like figure at one of the most notable occasions in European history.

Historians treasure ter Borch, not only for his careful documentation of this famous public event, but also for his evocation of the ordinary life of the prosperous citizenry that was his main interest. A few of his canvases do reveal a lower stratum of society: a milkmaid, a groom, an evocative grinder's yard. But mostly we are in the company of army officers and the elegant patricians of the day. The men, and some of the older women, may have emphasized their sobriety by appearing in black, but that did not prevent them from donning effusions of ribbons, lace, and ruffles. And many of the women sported the gleaming satin that was ter Borch's trademark.

A fascinating essay in the catalog by Arie Wallert explains, through x-radiographs, large magnifications, and various modern analytic techniques, how ter Borch was able to convey the sheen and glow of satin with a brilliance that none of his contemporaries could match. In some respects, however, this was merely another way of ensuring that he was representing accurately the world he moved in: prosperous, graceful, and yet restrained. The hints of unexplained meanings give the scenes life, but they remain, above all, reflections of an existence that would have been familiar to his contemporaries. That mastery of the commonplace, often populated by members of his own family, gave him a reputation as a painter of "modernity," of the world that he knew, and endears him all the more to students of the seventeenth-century Netherlands. In the catalog, moreover, we can see some of the sketches and drawings that connect him directly to his surroundings, and one wishes that some of these could have been brought to Washington.

But one must not think of ter Borch merely as a documentarian. For

the details regularly reveal a master at work. A doctor studying urine in an untidy study has laid across a stool a shimmering white cloth that rivets the viewer's attention. Large, dark eyes give character to an elaborately dressed two-year-old girl who seems to float in space. Musical instruments, musical scores, and placid dogs seem to become part of a room's furniture. And people lost in concentration, whether spinning, removing fleas from a boy's hair or from a dog, or learning to read in a folio Bible (a particularly charming portrait of ter Borch's abundantly red-headed half-brother at the age of seven), achieve an intensity that draws one into their lives. Ter Borch may not be a Rembrandt or a Vermeer, but he offers pleasures and insights that are multiplied in the works of his many peers, all of which reminds us yet again of the special role that this country of barely one million people played in shaping Europe's future—not least when, in the seventeenth century, their painters transformed the passing, everyday world into enduring art.

What Can Artists Tell Us about Delft?

No small European town of the past 500 years, not even Wittenberg, has received anything like the scholarly attention that has been lavished on Delft. During its glory days from the late sixteenth century to the 1670s, the population of this Dutch city barely exceeded 25,000, yet we have come to know what its streets and houses looked like, the addresses of many of its citizens, the feel of its markets and taverns, and countless details about its inhabitants' civic organizations, economic fortunes, personal finances, interest in art, and daily behavior. So precise is our knowledge that it is usually possible to identify the exact location shown in a seventeenth-century painting and even to discuss the inaccuracies artists introduced into specific views.

That Delft would have a disproportionately important place in Dutch history was signaled when William the Silent made it his headquarters in the fight for independence from Spain. Unlike The Hague, on the coast nearby, Delft was protected by a well-fortified wall. Because the town could be defended, it housed not only the rebels' government but also their chief munitions store. And it was here that William was both assassinated and buried in 1584, events which only reinforced Delft's special place in the consciousness of the Dutch. None of these marks of distinction, however, would have inspired the extraordinary efforts of research that scholars have devoted to Delft. The explanation for that outpouring lies elsewhere, in the life spent in this town between 1632 and 1675 by a man who left only a handful of references in the documentary record, plus some three dozen surviving paintings: Johannes Vermeer.

What makes this intense interest especially remarkable (the exhibition at the National Gallery in London, which includes thirteen Vermeers, is the second major international show of his work in five years) is that the artist was virtually unknown until little more than a century ago. Yet, since his

"rediscovery," he has come to be regarded as one of the iconic figures of Western art, unmatched in his evocation of a particular time and place. The very scarcity of his oeuvre, moreover, and the elusiveness of information about his life, have stimulated both exhaustive research and endless speculation.

All four of the books under review reflect this double passion for minute detail and broad conjecture. Like much of the literature these days, they rely regularly, for a grounding in fact, on the archival discoveries of the economist John Michael Montias. His two books, published in the 1980s, uncovered a wealth of new information, largely statistical, about the structure and finances of the artistic community in Delft during the seventeenth century. Thanks to Montias, we know how devoted to the arts Vermeer's fellow citizens were; he was able to estimate, for instance, that two-thirds of Delft's 4,000 or so houses contained a painting, and that the total amounted to just about two paintings for each of the town's inhabitants. At the same time, however, he demonstrated the shrinkage in the market for art in the seventeenth century, as Delft, once a flourishing center of breweries, potteries, and the cloth industry—home of a sub-chamber of the Dutch East India Company because of the scale of its investments—faced increasingly hard times. Vermeer's own financial difficulties could thus be seen in the context of a general economic decline, though the unusual size of the Vermeer household, with its eleven surviving children (out of at least fifteen), certainly exacerbated the painter's burdens.

To this skeletal information may be added the name of Vermeer's chief patron, Peter van Ruijven, a wealthy brewer's son, and a few passing references in travelers' accounts and legal documents. Yet little of this knowledge can be linked to the painter's art. Even his change of religion, when he married into a Catholic family, sheds little light; as with his fellow Catholics, Leonaert Bramer and Jan Steen, who could hardly have been more different as artists, adherence to a minority faith in the staunchly Calvinist Netherlands seems to have had little impact on the forms or content of his work.

Given the slender underpinning of fact, students of Vermeer must rely on surmise and a wide range of reference and analogy. Anthony Bailey's biography, *A View of Delft*, for example, finds points of comparison with most of the well-known painters of the Dutch Golden Age, whether or not they intersected with Vermeer, let alone Delft. To flesh out his 250 pages, Bailey has to venture far from the artist himself; thus we have a

detailed account of the shattering explosion of Delft's munitions store in 1654 (an event which, for all the damage it caused, is not known to have affected Vermeer), and a history of Van Meegeren's notorious twentieth-century forgeries. Bailey also has to make the most of every fragment: two sentences in which a collector mentioned visiting the artist become three pages of explication, including a string of questions the collector might have asked Vermeer. And speculation is rife, not only in the author's interpretations of individual paintings but also in such unlikely suggestions as the possibility that Vermeer asked a printer to make more complimentary to himself a poem about Delft that was published in 1667.

One can hardly blame the harried biographer, seeking ways to dramatize the almost silent record of his subject's life. And Bailey, despite occasional lapses (like calling Descartes Kepler's pupil), does offer a lively account of the world through which Vermeer moved. If he has to hang more on wisps of evidence than they can strictly carry—the link with the Delft scientist Anthony van Leeuwenhoek, for instance, or the preponderance of women in Vermeer's household and family—he is in good company, because most studies do exactly the same, and at least he does so with wit and style.

Very different is Philip Steadman's closely reasoned argument, in *Vermeer's Camera*, that Vermeer relied on a camera obscura to help him achieve some of the effects of perspective and the play of light for which he is famous. This is not a new idea, and it has long been controversial; the organizer of the exhibition, Walter Liedtke, for instance, is skeptical. But to this non-expert in matters optical and geometrical, Steadman's case seems convincing. He offers no mere guesswork, but experimental and mathematical evidence to reconstruct the rooms and the lighting in eleven of Vermeer's paintings. Moreover, he shows that the size of the image cast by a camera obscura in a room of the right dimensions corresponds to the size of the resulting canvases. As with Galileo's proofs, so with Steadman's: one can refute him only by his own methods, not by citing opinion or authority. My guess is that this geometer and architect will add a new dimension to the literature on Vermeer—just as that other non-art-historian, Montias, did before him. And the exhibition itself reinforces this conclusion, for Steadman uses his approach to demonstrate a mistake in perspective by De Hooch that Vermeer would never have made, and that neither the catalog nor previous analyses have noticed: in the National Gallery's *A Woman Drinking with Two Men, and a Serving Woman*, there is an impossible extra row of floor tiles on the far left.

The two books that have been published to accompany the exhibition exemplify the deep learning as well as the conjecture that have been brought to bear in order to expand our understanding of artistic creativity in Delft before and during Vermeer's lifetime. The catalog is largely the work of Liedtke, a curator at the Metropolitan Museum, who provides magisterial surveys, both of the individual painters active in Delft in this period and of the genres they explored. To his account, mainly of painting, are added essays by other scholars on drawings and prints, collecting, and the mapping and topography of the city. The long and informative catalog entries are shared primarily by Liedtke and the curator at the National Gallery, Axel Ruger, who has written the brief survey which visitors may find more manageable than the seven-pound catalog. The major theme that pervades these contributions, beyond their detailed discussions of individual artists and works, influences, borrowings, genres, ownership, and technique, is the question of whether there was such a thing as a Delft School.

Those who see the exhibition will have to judge for themselves, but even Liedtke makes only a tentative case. If one can expand the normal definition to include a rich community devoted to art, with collectors who had a special interest in a sober and refined style in portraits, interiors, city scenes, and explorations of light and space—collectors who were able to attract some of the finest talents of the time, all linked by the artists' Guild of St. Luke—then Delft can be said to have sponsored a school. That many of the painters spent only a few years in the city, and also worked elsewhere, notably in Amsterdam or The Hague, may lessen the distinctiveness of the school, but does not refute the appropriateness of the term.

What is unmistakable, as one encounters the works on display at the National Gallery, is the extraordinary quality of the work produced in this small Dutch city during the seventeenth century. Apart from the Vermeers, there are masterpieces by Carel Fabritius and Pieter de Hooch, and lovely specialist scenes: animals by Paulus Potter and church interiors by Gerard Houckgeest, Hendrick van Vliet, and Emanuel de Witte. The last four may not be well-known names, but the elegance, beautifully observed detail, and dignity they share is not to be missed.

Fabritius, one of Rembrandt's star pupils, lived only four years in Delft before he was killed in the munitions store explosion. But the two self-portraits in the exhibition (worthy of his master), his haunting painting of a sleeping sentry, and his charming goldfinch indicate how tragic was his

death at the age of thirty-two. He left fewer pictures than Vermeer, but their vivid intensity, and the originality of his explorations of perspective, illusion, and space—seen here in a view of Delft intended for one of the "perspective boxes" of the time—suggest that he might well have become as admired a master as his younger contemporary.

With De Hooch, we are on more familiar ground. He, too, lived only a short time (five years) in Delft; yet his evocations of perspective in subtly lit interiors and sunny courtyards reveal interests that link him closely to Vermeer. There is more animation in his people, though it has to be said that his early *Two Soldiers and a Serving Woman with a Trumpeter* and *A Man Offering a Glass of Wine to a Woman*, where feelings are conspicuously on display, are not as successful as the later paintings, where the emotions are more understated.

This contrast has larger import. For if an absence can be said to help define a school, then the scarcity of art that is either disturbing or joyous seems characteristic of Delft. Interestingly enough, the Dutch artist of this period most closely associated with scenes of high spirits and revelry, Jan Steen, lived briefly in Delft, where he managed a brewery. His omission from the London exhibition is unfortunate, because his portrait of a patrician (displayed in the New York show) exposed a side of Delft not seen here: a pair of the beggars who, though forbidden to pursue their calling until they had been inhabitants for four years, were notable exceptions to the city's well-scrubbed image.

The local patrons clearly preferred the aura of gentility and calm that was the mark of De Hooch in his later years. Thus, although his *Soldiers Playing Cards* is more dramatic than anything Vermeer painted, it looks at first sight so much like the latter's work that the connection has long exercised art historians. To his credit, Liedtke uses the catalog entry to emphasize that such speculation "does a disservice to de Hooch," whose inventiveness and skill in painting objects, space, and light are remarkable in their own right. The same could be said of two other Vermeer-like canvases, *The Visit* and *A Woman Drinking with Two Men*, let alone the rooms with receding vistas and the courtyards that were de Hooch's trademark. Nobody was better at creating the peaceful, Delftian domesticity that differs so markedly from the exuberance and the shabbiness often emphasized by Steen.

But the supreme master of the quiet life was Vermeer. If neither the three early paintings in the exhibition—a *Diana*, a *Christ*, and a Caravaggesque *Procuress*—nor the late *Allegory of the Faith* seem as moving as the

portraits and the scenes of daily life, it may be because, for all Vermeer's mastery of representation and effect, these are not themes that set him apart from others, notably in Italy, who had made them their own. When, however, one reaches *The Glass of Wine* in the fourth room of the exhibition, and the seventh and final room, devoted solely to Vermeer, everything that has come before seems to reach its fitting climax.

The breathtaking clarity of vision in these canvases, and the assurance of the artist, are almost beyond comment. The settings, with their gleaming furniture, decorations, and carpets; the people, with their delicately painted clothes, hats, and expressions; even the mundane objects that are scattered about—all seem so complete in their perfection that we can seek no more. Light and space become mere instruments for the display of those simple gestures—a girl in a dazzling red dress putting a glass to her lips, a woman in deep blue holding both a pitcher and a window—that evoke a pervasive contentment. Where Rembrandt stirs with shifting moods and probings into human nature, or Rubens arouses with high drama and action, their fellow Low Countryman gives us peace.

The quest for larger meaning in these works is part of the torrent of conjecture and fiction that has engulfed Vermeer. And the curators have not always resisted the temptation to add to it. Does it help the viewer when the labels suggest that the two women at the virginals "may" represent higher and lower levels of moral correctness? Both women look out at us in the same way, which makes it puzzling that only one—"less morally correct"—is said to do so "openly" and to invite us to join her. Nor does it enhance appreciation of *Woman with a Lute* (indeed, it distracts) to read the claim, based on the most tenuous of reasons, that "she may be eagerly anticipating the return of an absent lover."

Similarly, both the *Glass of Wine* and the *Woman with a Balance* are given a moralistic weight that seems far less significant than their loving portrayal of people in relaxed absorption, or the way they capture transparency amid solidity—in the drinking glass, the stained glass seen through stained glass, or the glistening pearls and scale. Fortunately, the label for *The Milkmaid* focuses, not on its moral implications, as proposed in the catalog, but on its textures (the bread basket and sliver of milk are especially notable). Although flights of interpretation, erudite if not always illuminating, are grist for the scholar's mill, they do not necessarily enhance our understanding of Vermeer's achievements.

A case in point is *The Art of Painting*, which, filled with symbols, has attracted more than its fair share of elaborate explication. One recent

commentator has even called it an attack on the formal "history painting" that attracted Vermeer early in his career. Liedtke, citing the fact that the artist kept the work at home, makes the more plausible case that this is a self-portrait intended to praise the art of painting and, because it shows Clio, the muse of history, that it asserts the fame the painter can attain. (Liedtke is on shakier ground when he suggests that the map on the wall, a common subject for Vermeer, represents the inferior art of print-making; after all, the map has been colored by a painter.) In this composition, the decoding of symbolic meaning can be helpful to the viewer, but it is reassuring that the wall label also emphasizes the illusionism in the picture's depiction of light and surfaces, which encourages a delight in such details as the flecks of reflected sunlight on the chandelier or the tangibility of the creases in the map and the shirt, rather than a quest for a definitive meaning that is beyond reach. For *The Art of Painting*, despite its ambitious content, is above all an unsurpassed illustration of Vermeer's unobtrusive skill and his affection for the spaces and objects of daily life—qualities that, as always, draw us into his world and convey a sense of serenity and completeness that is unique in the annals of Western art.

Has Vermeer Been Over-Praised?

To get an inkling of the current reverence for Vermeer one need only learn that his lovely, small (18" x 16") *Milkmaid* has prompted art historians to use such adjectives as "heroic" and "monumental," and to call her "frankly" alluring as an object of male desire. In the words of one critic (Peter Schjendahl in *The New Yorker*), "everybody idolizes the elusive Dutchman. . . . Vermeer beggars analysis. . . . He intoxicates." The admiration is so overwhelming that apparently he is now "displacing Raphael as Europe's cynosure of artistic perfection." Given such appraisals, it might be time to address the implications of a far-reaching adulation that places Vermeer alongside or above the most redoubtable figures in the history of Western art. Doubts about this consensus may seem heretical, but they are only strengthened by a juxtaposition of the brief catalog for the Metropolitan Museum's show, which is centered around a loan of *The Milkmaid* by the Rijksmuseum, with a recent publication in the *Corpus Rubenianum* that links Rubens to the long traditions of Old-Master painting.

The solemn veneration accorded Vermeer had its roots in the midnineteenth century, when his relative obscurity was lifted by art historians, and reached full flower when Proust not only called the *View of Delft* the most beautiful painting in the world but had the novelist Bergotte dying in front of it, ecstatic about a (non-existent) tiny patch of yellow wall. Since Dostoevsky's far more powerful tribute to Holbein in *The Idiot* had no similar effect, what we have here is the ascendancy of a broad cultural norm rather than admiration for a great novelist's aesthetic. That Vermeer's work is often exquisite cannot be denied. It is not inappropriate to marvel at the effects he creates in the tiniest details, from a nail and its shadow on a wall to the hues he brings out in a piece of cloth. To acknowledge a number of his paintings—in addition to *The Milkmaid* and

View of Delft, *The Artist's Studio*, *The Glass of Wine* and a few others—as extraordinary achievements is no more than to give genius its due. But does he really warrant the use of words like "monumental" and a place (above even Raphael) at the top of the pantheon of Western art?

For a start, the output is not only narrowly focused but very small— fewer than forty confirmed paintings—and within the oeuvre there are more than a few works that even Vermeer's most ardent admirers do not consider first-rate. There is no doubt that some of his paintings have rightly become exemplars of the seventeenth-century Dutch preoccupations with the play of light, the celebration of daily life, and the capture of moments that tell tales with a moral purpose. Explications of the latter, however, do sometimes get out of hand, and Vermeer has his share of such analyses. In his essay on *The Milkmaid*, for instance, Liedtke makes much of two hard-to-see tiles at the foot of the wall. When enlarged, they are seen to depict Cupid and a man with a staff, which is taken to confirm that the portrait had salacious connotations. Whether one thinks that this quietly absorbed and sturdy young maid could serve as a symbol of sexual laxity is, of course, a matter of taste, but when one compares her with other female figures in Vermeer paintings, one could be forgiven for raising an eyebrow. As Veronese noted, a century before, artists often included details simply because they were pleasing. In his words: "I adorn [a subject] with figures of my own invention." As with the Inquisition's examination of Veronese, though, the quest for hidden meaning is a recurrent theme in treatments of Vermeer. Precisely because the oeuvre is so small, and the subject matter often so prosaic, the need to make large claims must seem irresistible.

When an artist bestrides the world like a colossus—as did Rubens— interpretive exuberance seems warranted. But in the case of Vermeer, it is his iconic status rather than the effects he achieves that seems to prompt the intensive investigations. These have led, it is true, to remarkable scholarly discoveries, notably those of John Michael Montias in the Dutch archives. They have also revived interest in the use of the camera obscura as an artistic technique, and they have inspired works of fiction in both prose and film. But one does wonder how an artist whose subject matter was so limited, and whose emotional range remained within such tight boundaries—attempts to portray him as heroic notwithstanding—merits superstar status.

Here the contrast with Vermeer's older contemporary Rubens becomes particularly acute. An important criterion for acclaim, after all, is the role a

painter plays in the development of art. On this score, while a few links have been suggested between Vermeer and some predecessors, contemporaries, and successors, Rubens seems to be operating in a different universe. Even if we leave aside his ability to command an enormous range of subject matter and emotion, and to astonish with technique, we are faced here with a painter whose versatile and probing studies of previous masters put him at the very center of the story of Western art.

The two volumes that make up the first half of Part XXVI of the *Corpus Rubenianum* are a revelation. They explore nearly 150 works by German and Netherlandish artists that Rubens, inimitably, made his own. Thanks to Belkin's meticulous analyses, we see how, in dozens of retouched paintings and drawings, in copies of woodcuts and engravings, and in full-blown copied oil portraits, he was able to add life, character, and movement to his models. In most cases, one can see the interest in composition, texture, and effect that persuaded Rubens to take on an existing work, though the distinctiveness of the outcome is also unmistakable—a hint of warmth and hesitancy in Holbein's cool and confident Thomas More, a softening of a hard-edged Hans Weiditz woodcut banquet. And in one notorious instance he painted a lush nude Psyche over an austere St. Jerome in a landscape by Paul Bril. Yet it is obvious that he was constantly reacting to and learning from his forebears. This was an artist participating in the many traditions of his craft. And the hundreds of prints derived from his work made him a dominant presence for generations to come.

One might add that, when the *Corpus Rubenianum* turns to artists from the south, it will be moving on to the likes of Raphael, Giulio Romano, Parmigianino, Titian, and Caravaggio, who were probably even more important to Rubens than the northerners. But the point will be the same: one cannot divorce the artist's stature from his response to, his departures from, his absorption of, and his quest to triumph over, his most powerful predecessors.

The contrast with Vermeer could hardly be more stark. Isolated masters certainly deserve a cherished place in the story of their craft. Gregor Mendel may have remained essentially unknown for decades after he published his pioneering studies of genetics, but he is now recognized as a pioneer in a major branch of science. Still, he is not likely to be placed on a par with the Galileos, Newtons, or Einsteins of his world, let alone displacing them as the cynosure of any scientific quality. For Vermeer to receive such deference is surely to make the tribute disproportionate to the

achievement.

Even more noticeable is the effect of such judgment. When this reviewer mentioned to a group of art historians his pleasure, as he taught seventeenth-century history, on coming to Rembrandt, whose greatness became quickly evident to students, they were shocked. "You say he was great?" Vermeer, however, escapes such restraint, and it is no wonder that the major 1995 Washington exhibition attracted four times as many daily visitors as the major Rubens exhibition in London in 2005.

That such deification has taken place prompts an obvious speculation: why should this be? Taste is, of course, ineffable, but two considerations may be worth pondering. The first is the steady devaluation of history in both British and American culture. People may enjoy reading about or viewing the past, but as a serious pursuit it is in steady decline, shrinking as a classroom subject and as a basis for public discourse. In that context an artist's historical importance is easily devalued. That Raphael, like Rubens, owed huge debts to his forerunners, and in turn shaped the future, gives him little credit when aesthetic judgement comes to the fore.

A second, related, consideration is that recent generations have lost the capacity to appreciate the biblical, classical, and historical references that infuse Rubens' paintings. As cultural horizons contract, the private and domestic supplant the public and the grand. It may not be irrelevant that a Vermeer is likely to be visible only to a few people at one time, whereas a Rubens can tower over a crowd. We may be living, in other words, in an age that prefers small pleasures to large. We cannot settle into dreamy contemplation of Rubens. He overwhelms. He demands soaring, energetic attention. Rather than undertake that effort, we seem to prefer quietly to contemplate, explore, and relish the limited but subtle beauties of Vermeer.

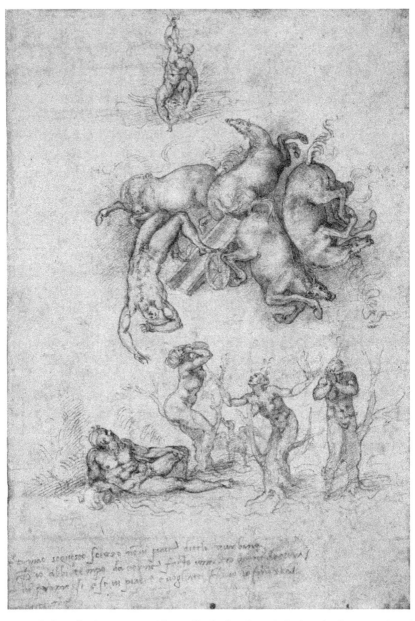

1. Michelangelo Buonarotti, *The Fall of Phaethon* (1533), ink drawing, British Museum. © The Trustees of the British Museum. All rights reserved.

2. Peter Paul Rubens, *Peace and War* (1629), oil painting, the National Gallery, London. Art Resource, NY.

3. Jan Van Eyck, *The Arnolfini Marriage* (1434), oil painting, the National Gallery, London. Art Resource, NY.

4. Otto Dix, *The Skat Players* (1920), oil painting and collage, reproduced by kind permission of Staatliche Museen zu Berlin, Nazionalgalerie: acquired by the Association of the Friends of the Nationalgalerie, with aid from Ingeborg and Günter Milich. Bpk/Jörg P. Anders.

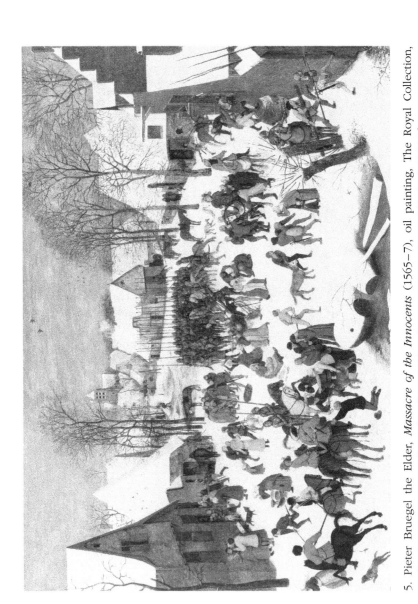

5. Pieter Bruegel the Elder, *Massacre of the Innocents* (1565–7), oil painting, The Royal Collection, England. By permission of Royal Collection Trust/© Her Majesty Queen Elizabeth II 2016.

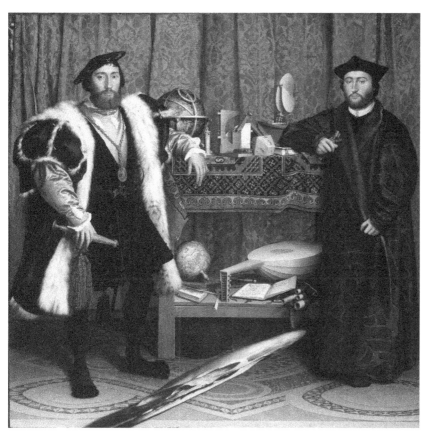

6. Hans Holbein the Younger, *The Ambassadors* (1533), oil painting, the National Gallery, London. Art Resource, NY.

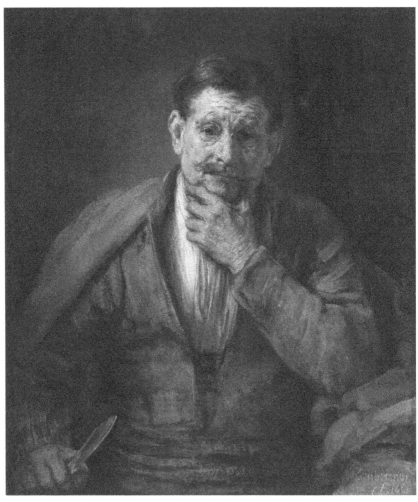

7. Rembrandt van Rijn, *St. Bartholomew* (1661), oil painting. By kind permission of the Getty Museum, Los Angeles.

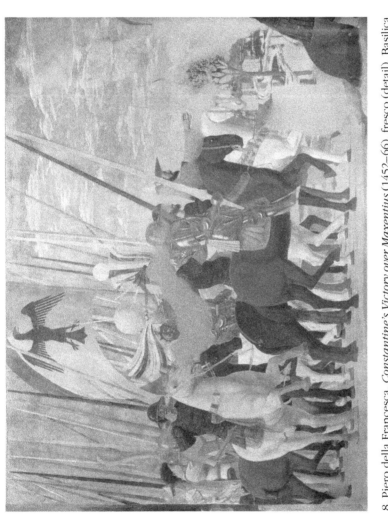

8. Piero della Francesca, *Constantine's Victory over Maxentius* (1452–66), fresco (detail), Basilica di San Francesco, Arezzo. Scala/Ministero per i Beni e le Attività culturali/Art Resource, NY.

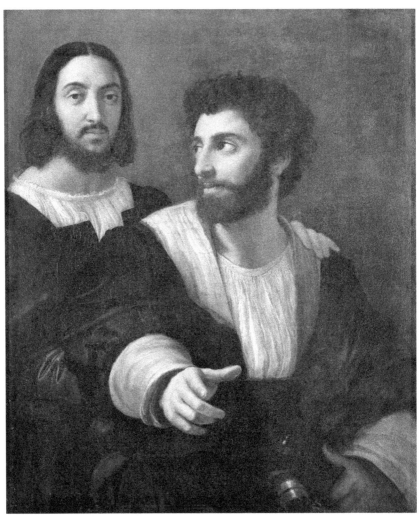

9. Raphael Sanzio, *Self-Portrait with Giulio Romano* (?) (1518–9), oil painting, Louvre, Paris. Art Resource, NY.

10. Baldassare Longhena, *Santa Maria della Salute*, photograph by Karen L. Marshall of a rare sight: snow in Venice (December 19, 2009).

Part Six

Spanish Art

1

How Did Flemings Shape Spanish Art?

The starting-point for any assessment of the role of Flemish artists in Spanish culture must be an astonishing fact: that there are some 1,100 Flemish paintings, dating from the fifteenth through the seventeenth centuries, in the Prado. And these are but a portion of the paintings, tapestries, buildings, sculptures, and other works of art throughout Spain that were either created by Flemings or strongly influenced by them during these years. How could a small area of less than 11,600 square miles, some 930 miles (and a journey of at least two weeks) away, have had so profound an effect on the much larger kingdom of Castile, and eventually on the entire Iberian Peninsula?

Before trying to answer that question, one needs to relate it to a recent scholarly discussion of what has been called the "geohistory" of art. This literature has sought to counter some of the attempts to find the roots of distinct schools of art in the effects of local conditions, whether topographic, linguistic, or socio-cultural. It has emphasized the importance of local continuities, but at the same time has emphasized the power of diffusion, which blurs boundaries and reveals cross-fertilizations through adjacent territories and even over considerable distances. To some degree this has been an approach focused on northern Europe, reflecting an effort to reduce the standard emphasis on the stimuli emanating from Italy. An exhibition at the Palazzo Grassi in Venice, for example, revealed the reciprocal effects of northerners on the art of the south. On a parallel track, the "geohistory" research has shown the Flemings alongside the Italians helping to shape artistic styles in Poland.

This is not to deny the distinctiveness of the sources of these cultural movements. The Mansard roof is unmistakably French. And the organizers of a 2008 London exhibition of the Flemish paintings owned by the Queen argued cogently for a number of elements that made this tradition

instantly recognizable: a particular kind of landscape, especially the aerial perspective first elaborated by Joachim Patinir; an interest in documentary representation; a fondness for peasant scenes; and a commitment to unadorned "reportage" portraits. Within this broader understanding of the tension between distinctiveness and diffusion, however, the Flemings in Spain constitute a special case. Nowhere else in Europe is there so profound an influence, so broad a presence, that leaps over so enormous a distance. No other repository is as indispensable as is the Prado to the study of an art that originated so far away. Can it be that this interaction offers a first glimmer, not merely of the power of artistic inspiration to seep into adjacent territories, but of something much broader: a Europe-wide culture?

If such a phenomenon is to be found anywhere as long ago as the fifteenth and sixteenth centuries, it surely would be in Spain. For this was the Continent's most obviously hybrid culture. Wherever one turns in the nation's historiography, one encounters a spirited discussion of the implications of its origins in a blend of three different but potent faiths: Christianity, Judaism, and Islam. No other European nation has had to grapple with such diverse ancestry, and it therefore seems only appropriate that, in the arts too, there should have come together a multiplicity of traditions.

For the phenomenon we are confronting goes significantly beyond the well-documented percolation that took place across immediate frontiers: from Florence or Rome to Venice and vice-versa, from Italy northward, or from Flanders eastward and northward across neighboring lands. Under that heading one would place the importance of Italy in the Spanish story: this was another Mediterranean culture, not far away, and the time spent there by such leading figures as Velázquez and Ribera is only to be expected. But the presence of the Flemings is a different matter. This far-flung connection achieved a magnitude unique in the Europe of these centuries, and if it is to be given its full significance one needs to see how it began and how it persisted.

*

The unlikely pioneer was a king who has not had a very good press in Spanish history: Juan II of Castile. He came to the throne as a baby, and died in 1454 in his late forties. Not only was he overshadowed by his daughter, Isabella, Queen of Castile, but also by his contemporary, another Juan II, often called "the Great," who ruled the neighboring kingdom of Aragon and was the father of Isabella's spouse, Ferdinand. It is not often in a scholarly paper that one quotes Wikipedia, but in this case it

sums up well the standard view: "Juan was amiable, weak, and dependent on those about him. He had no taste except for ornament and no serious interest except in amusements such as verse-making, hunting, and tournaments." Hidden in that dismissal is a feature that makes Juan central to our subject. For it was his love of ornament—particularly Flemish art—that began a tradition that remained strong for some 200 years.

The presence in the Prado of the masterpieces of the mid-fifteenth century by Roger Campin, Jan van Eyck, Roger van der Weyden, Hans Memling, and Dirck Bouts are a result of Juan's inclinations. His interest also helps explain why there are magnificent altarpieces at Miraflores and Najera by, respectively, van der Weyden and Memling. The reasons for this partiality can no longer be recovered, but one can posit that Juan's fondness for amusements could easily have extended to the arts; that he may have found the representational realism for which the Flemings were famous especially appealing; and that his known devoutness may have drawn him to the spiritual qualities of their art.

Behind these elusive possibilities, however, stands one major practicality: the fair at Medina del Campo. This was one of the principal centers of trade in fifteenth-century Europe. It took up 100 days each year, and it was the main gathering-place for those who dealt in the huge export of wool from Spain. As Castile's most important commodity, it attracted above all the Flemings who were Europe's leading finishers of cloth. Here they obtained their raw materials, and Spanish merchants in turn were quite prominent in the Netherlands. It was undoubtedly thanks to the fair that goods other than wool or cloth—namely art—found a resting-place so far from home. And the traffic had dimensions beyond these direct contacts. It is telling, for instance, that among the early owners of van Eyck's famous portrait of the Italian Giovanni Arnolfini and his wife, now in the National Gallery in London, was the Spanish humanist Felipe de Guevara.

In the reign of Juan's daughter, Isabella, the trickle became a flood. This is a much better known chapter of our story, extensively documented and studied. If the stress in the present account is on the pioneering importance of her father, one must nevertheless acknowledge how essential her patronage was in firmly implanting the connection. For Isabella was not merely drawn to the Flemings; she ensured that they would establish a formidable presence in Spain.

The basis of all else was, of course, the queen's personal enthusiasm, which is visible not only in her summoning of Flemish painters such as

Juan de Flandes to her court, but also throughout her patronage. As Rafael Dominguez Casas has put it, "Flemish tastes predominate in all of the . . . arts associated with the Catholic Monarchs, and are particularly manifest in the paintings and tapestries of the royal collection." There were, in addition, clocks and furniture, gold and silverware, a remarkable portable altarpiece, painted linens, and larger projects like the monastery of Santo Tomas in Vila, all reflecting Flemish styles. Isabella was a major client for the northerners at the Medina del Campo fair, and their hands were soon felt in all the arts: sculpture, architecture, stained glass windows, even choir stalls. All of this has prompted careful research, and it is now clear, for instance, that earlier scholars were too hasty in assuming that the appeal of the religious subjects coming from Flanders derived from the queen's sympathy for the fifteenth-century Netherlandish reform movement known as the Devotio Moderna. Isabella's was a more traditional and austere Catholicism; the attraction was the style, not some latent spiritual message.

Yet her personal preferences had much broader consequences. A major reason that Flemish artists, rather than just their art, came to Spain was that the queen made life easier for them. At home they had to observe guild rules and other regulations, none of which were allowed in Castile. They also had tax exemptions, not to mention the opportunities offered by a kingdom that was expanding as it gradually pushed back the Moors to the south. And there was also Europe's most important pilgrimage site. An index of the welcome the Flemings received is the fact that their confraternities built eleven of the nineteen hospitals on the route to Santiago de Compostella.

By the end of Isabella's reign, the centrality of their contribution to the country's culture was so evident that the style of the age has come to be known as Hispano-Flemish. This is when major foreign painters like Quentin Massys made their presence felt; when distinguished locals like Pedro Berruguete revealed their debt to Flanders; when a similar pattern became apparent in sculpture, in the work of Gil Siloe or Felipe Vigarny, both northerners who became leading figures in Spain; and when architecture was transformed by Hannequin Egas of Brussels and his family and by masters like Juan Guas, creator of such remarkable monuments as the monastery of San Juan de los Reyes in Toledo or the castle at Manzanares. The impact of Flemish styles, in other words, now extended throughout Castilian society, not merely its royal court.

*

One might have thought that Isabella's successor, her grandson Charles I (the Emperor Charles V), would have given a large boost to this tradition, since he was himself born in Flanders. But Charles' relations with his native land were far from harmonious. At the time of his quincentenary, in 2000, the city of his birth, Ghent, commemorated its famous son by emblazoning on the town walls the names of all the Ghent citizens he had executed. What is ironic is that it was in the reign of this son of Flanders that the influence of Italian art began to come to the fore. Charles' favorite painter was Titian, whom he ennobled, whom he persuaded to stay for much of 1548 at the imperial court in Augsburg, and whom he called his Apelles. The Venetian portrayed the Emperor in a variety of poses, and painted the *Gloria* that accompanied Charles to his retirement and death in the remote monastery at Yuste. Moreover, the most spectacular of the reign's building projects was the Italianate palace—unfinished but still overwhelming—that arose in the shadow of the Alhambra in Granada.

With that said, however, one cannot deny the continuing importance to the royal court, and to the Spanish scene in general, of artists either native to or inspired by Flanders. The portrait of Charles by Bernard van Orley may seem a world away from Titian's celebrations, but it has an unadorned exactitude that his subject must have admired. He certainly appreciated Bernard's designs for the tapestries that were omnipresent in his life, whether traveling his far-flung domains or briefly resident at one of his palaces. Those tapestries themselves were Flemish, notably the works of William de Pannemaker. And the influx into Spain of paintings and sculpture by a new generation of northern artists, such as Marinus van Reymerswaele, Michiel Coxcie, and Juan de Juni, makes it clear that the connection established under Juan and Isabella continued to flourish.

Both developments continued in the reign of Charles' son, Philip II. He was an even more avid patron of Titian, and during the years of his rule, the second half of the sixteenth century, the rise of the Italians accelerated. But for portraiture, for landscapes, and for devotional works, Philip still turned to Flanders.

The king's most famous images may be Titian's, but Antonis Mor was also a prominent portrayer of the court's leading figures, including Philip himself. And it is notable that Madrid is home to the single largest group (seven) among the thirty panels in the recent comprehensive exhibition of the works of Joachim Patinir, the pioneer of the aerial landscape view. Five of the seven are in the Prado and the Escorial. Patinir was active dur-

ing Charles I's reign, but it was Philip who brought him so conspicuously into the royal collection. His patronage was also responsible for the commissioning of Rodrigo de Olanda for part of the series of commemorations of victories on the walls of the Escorial. And it was above all his famous devoutness that was responsible for the continued appreciation of the Flemings' particular brand of spirituality. It is no surprise that there were two paintings by Bosch in the king's bedroom.

When we speak of the sixteenth century, however, we are dealing with an era when, as much recent scholarship has demonstrated, there began to arise in many areas of Europe a veritable mass-market for art. The social and economic elite and rich institutions like the Church may still have been the clientele for leading artists, for masterpieces, and for expensive commissions. But coming to the surface now was a demand for paintings that extended well beyond the elite and made possible an ever-rising number of purchasers and purchases. It is in this context that one needs to remember the Europe-wide importance of the Medina del Campo fairs, and also the growing importance of a new major entrepôt, Seville. What is especially significant for our subject is that the taste for Flemish work extended to these new buyers as well.

In 1553, ships traveling from Antwerp to Spain and Portugal carried four tons of paintings and 70,000 yards of tapestry. In the 1540s one third of the art exported from Antwerp went to Spain. And the Spanish New World was not neglected: as early as 1506, 85 Flemish paintings were sent across the Atlantic from Seville. It is true that, in the 1560s, Italian works began to appear in large quantities, but not until the end of the century did they match the Flemings. As late as the 25 years between 1623 and 1648, one Antwerp dealer exported over 6,000 paintings to Spain. If Flemish merchants were flocking to Medina del Campo, their Spanish counterparts were major customers of the remarkable art markets and auction houses that had sprung up in Flanders. These Pands, as they were called, even included one in Antwerp that was geared solely to customers from Spain. In other words, a phenomenon that, in the fifteenth century, might have seemed a consequence of the specialized tastes of a small, high status group had become, in the sixteenth, a commitment that extended to a broad audience in Spanish society.

*

During the early decades of the seventeenth century, the final period we are considering, the importance of Flemish art to the Spaniards remained at a high level. The connections with Italy may now have become

more central, but in the person of Rubens alone one can see the continuation of an influence that went back to the generation of van Eyck. If the most avid collector of paintings during his first visit to Madrid in 1603–1604 was Philip III's favorite, the Duke of Lerma, who was primarily a patron of Spanish artists, it nevertheless somehow seemed inevitable that the minister should have bought paintings by Rubens and that his most famous portrait should have been the enormous equestrian canvas by the Fleming (even though the Duke did not sit for it).

The last chapter of the story unfolded in the reign of Philip IV, one of the most avid collectors in history. In this seventh generation of royal fondness for Flemish art, the tradition took on new life at the very time when a distinctive Spanish influence was beginning to make itself felt elsewhere, notably in the work of Velázquez, Ribera, and their contemporaries. The continuing imports from the north included major works by Anthony van Dyck, Frans Snyders, and others, but the chief favorite, particularly after his second visit to Madrid, in 1628–1629, was Peter Paul Rubens.

By now the southern Netherlands were ruled by Spain, and the artist performed diplomatic as well as creative services for the Habsburgs. Yet it was still indicative of the regard in which he was held that he should have been knighted by Philip IV in 1624 (well before the honor was repeated by Charles I of England), and that the eight months he spent at the royal court when he returned to Madrid in 1628 should have left so profound an impact. Reflective of this final flourish of importation from Flanders is the fact that the Prado owns 115 works by Rubens. This is a staggering number, and a fitting climax to a connection whose enduring power must have been unmistakable when, in the company of Velázquez, he visited the collections at the Escorial. One would have liked to have been a fly on the wall on that occasion, to have glimpsed the ways in which their interchanges became a turning point in the Spaniard's career, and also to have witnessed the admiration for the young master that Rubens is said to have felt. In the encounter of these two artists, one senses a centuries-long influence coming to an end, but not before it had created levels of interaction that force one to rethink traditional notions of boundaries and distinctiveness in the visual arts.

For this is surely a unique instance of the difficulties inherent in attempts to define a "geohistory" of art. Developments in Spain need to be seen, not as the blurring or spread of specific commitments or of individuality, but as the mark of a culture that was ready to embrace traditions

both distant and local. One is even tempted to say that the history of the Flemings in the Iberian Peninsula reveals the first glimmering—appropriately, considering Spain's hybrid roots—of a European culture.

2

What Made El Greco Unique?

Among the Old Masters, none is more immediately recognizable than El Greco. We may *think* we can spot a Rembrandt, but Dutch scholars in recent years have been telling us we are mistaken. Michelangelo, Caravaggio, Poussin, Vermeer, Rubens—the names may conjure up vivid images, ways of painting that seem unique to each artist, yet they all had contemporaries or imitators whom only the specialist can set apart. It is true that problems of attribution can arise with respect to El Greco. Among the pictures in this exhibition, for instance, there has been uncertainty about a very early panel and an uncharacteristic portrait of a woman. What is interesting, though, is that these questions come up when a painting seems to lack his usual trademarks, *not* when someone else adopts his vision of people and the world.

That he has such a distinct vision most visitors to museums will confirm. You wander into a new gallery, and there, without doubt, is an El Greco. The elongated figures, the brilliant but smoky colors, the odd and often incomprehensible divisions of pictorial space, the serious and devout faces (nobody *ever* looks happy)—these are the instantly familiar fingerprints. And the natural question, for viewers and scholars alike, is "why?" Why the particularity (the peculiarity, in its original meaning)? Where does it come from and what does it mean? Is it merely a personal style—unmistakable, to be sure, but really only second-nature to the artist? Or can it be related to his context or to some larger purpose?

An early answer, once El Greco came to be appreciated again in the late-nineteenth century, after long neglect, was that his vision was astigmatic. That easy answer was soon exploded. If everything looked elongated to him, would he not have seen his pictures as *doubly* elongated? Could it have been, instead, the influence of the style that was much in fashion in Italy, Mannerism, a style that prized artificial effects? Especially rele-

vant, perhaps, was the elongation that marked the work of the most fa-
mous of the Mannerists, Parmigianino, whom El Greco much admired,
and who in his day was spoken of in the same breath as Raphael and Mi-
chelangelo. That suggestion still carries some weight, as does the emphasis
on the devoutness and mysticism that marked this period of Counter-
Reformation Catholicism. But are these connections enough to explain his
uniqueness, let alone the power that his imagination and his construction
of the world continue to exert? The exhibition of some 80 of his works at
the Metropolitan Museum in New York, and the elegant accompanying
catalog, give us the opportunity to try to find out.

The essayists in the catalog suggest some answers. For John Elliott, El
Greco embodies the mixture of cultures—in his case, Byzantine, Greek,
Italian, and Spanish—that was almost inevitable in someone who had re-
mained in his birthplace, Crete, until his mid-twenties, in 1567; had moved
to Italy for some ten years; and finally had settled in Spain for the last 38
years of his life. After all, the young painter of icons, deep in Byzantine
traditions, was hardly the artist we know, as is apparent from the two lu-
minous but stiff and stylized scenes of the Virgin's life which open the
show. Nor was he quite there in his "Italian" pictures, of which there are
more than a dozen in the exhibition.

In these canvases the debts to the masters he encountered are unmis-
takable: as the catalog emphasizes, the echoes of Tintoretto, Michelange-
lo, and others are omnipresent. Especially notable is the influence of a
popular new art form in Italy: eye-fooling perspective stage-designs. The
most famous theater built in this mode, Palladio's Teatro Olimpico, was
finished after El Greco left Italy, but engravings of the kind of stage set-
ting it housed were readily available, and one in particular seems to have
been used repeatedly by the newcomer from Crete. Painting a series of
scenes from the life of Christ, four of which are on display in New York,
he used receding sight-lines along a tiled floor, with a classical arch and
columns in the background, to present his protagonists (whether involved
in *Healing the Blind* or in *The Purification of the Temple*) as if they are actors on
a stage. There are odd objects strewn around, writhing bodies and dra-
matic gestures out of Michelangelo, and a precariously perched baby that
looks as though it has migrated from one of the puzzling compositions
favored by Parmigianino and the Mannerists of the day. Indeed, El Greco
made his gratitude clear by putting portraits of four of the artists he ad-
mired, including Titian and Michelangelo, in the foreground of one of the
last of these scenes that he painted before leaving Italy.

Once he was in Spain, the style that we associate with him emerged in full flower. He did return to certain themes (three versions of an absorbed boy blowing on embers to light a flame, for instance), and one can see how his art had changed when he revisited the scene of *The Purification*. Hints of theatricality remain, but perspective is no longer important, the figures (flatter and more elongated) seem to float, and blocks of color dominate the scene. Moreover, the religious references are now elaborated, with reliefs on the temple wall depicting two events that were believed to prefigure Christ's sacrifice and redemptive power: the sacrifice of Isaac and the expulsion from Eden. In a catalog essay by David Davies this shift is linked to two movements that El Greco encountered in his new homeland: the drive for spiritual reform associated with the Counter-Reformation in the Spanish Church; and the revival of Platonic idealism amongst learned circles in Spain, a philosophy that urged humanity to yearn for "a surpassing vision of beauty" that represented other-worldly perfection. There is no question that these influences, like the engagement with the different cultures of the Mediterranean, had their effect on El Greco, but his distinctiveness seems to go beyond even these contexts.

It is true that his extraordinary *Resurrection* raises a floating Christ of ethereal perfection above a disorderly earth populated by gesticulating Michelangelesque figures. But nothing out of El Greco's past—not the Byzantine background, not the Mannerist distortions, not the taste for theatricality, not even the religious intensity—prepares us for the use of gleaming color within an essentially grey-and-white scene, or for the way the eye is forced upward through this enormous canvas, over 9 feet high. Movements may be distorted, but a sense of motion and drama suffuses the scene. And lest one think that only religion could inspire such effects, one has but to look at *Laocoön*, the depiction of the episode from the siege of Troy that El Greco painted some ten years later, to see the distortions and the floating figures creating a mood that may be different but is no less compelling. Everything serves the purpose: as in El Greco's one landscape, of Toledo, the sky itself seems ominous. We are confronted by an artist whose feelings and very imagination seem so concentrated that he cannot help but transport his viewers to his own realm. He may be fully capable of making the physical world look solid, almost tangible—marvelous details of ivy, fruit, or a horse's head make that abundantly clear—but realism alone is not his goal.

Even El Greco's portraits (nearly half the show, if one includes biblical or historical figures as well as his contemporaries), while capturing their

subjects, go beyond mere reality. He may have no moving, passionate, or searing stories to convey—no entry into hell, no opening of the fifth seal in the Apocalypse—but still there is a profound plumbing of human character and emotion. The mournful eyes of a gaunt John the Baptist (standing against another tempestuous sky) expose the saint's feelings as powerfully as any of the eyes painted by Rembrandt, the master of psychological insight. A sinister Inquisitor General in dazzling red robes, a contemplative elderly man, a vigorous young friar, all come instantly to life under his brush.

In this respect, of course, El Greco's genius links him to other Old Masters. Yet his distinctiveness remains: the forceful and instantly recognizable manner that pervades this major retrospective. For one would never mistake El Greco for a Byzantine artist, for any of the Italians he admired, or for any of his contemporaries in Spain. Nor can references to pious, reform-minded, other-worldly yearnings explain the style of this hardy, tough-minded intellectual, who never married the mistress who gave him a son. The source of his uniqueness lies, I believe, elsewhere.

When El Greco came to maturity as an artist in Italy, the reaction against the calm, harmonious perfection and idealism of the great figures of the High Renaissance during the early decades of the sixteenth century—notably Leonardo and Raphael—was well under way. Even the great exponents of that perfection who lived on into the second half of the century—notably Titian and Michelangelo—embraced the twisted movements, the strong emotions, and the distortions that marked Mannerism. But they did so with a power that the younger Mannerists like Parmigianino, with their posing figures and puzzling compositions, never achieved.

When, therefore, during the last quarter of the century, Italian artists once again tried to create power and immediacy in their work, they moved toward a more highly charged, grandiose style, the Baroque. This new generation, determined to achieve the qualities that Michelangelo and Titian (both dead) had embodied, moved beyond Mannerism to emphasize dramatic contrasts of light and dark, scenes of high emotional intensity, and the other elements in the repertoire we call Baroque. During these formative years, though, El Greco was already in Spain, where he remained true to the Mannerist elongations, gesturing figures, and unsettling compositions that he had adopted in Venice and Rome. What made him unique was that he alone proved capable of infusing these characteristics with the passion and the power that his contemporaries in Italy were to find only in the Baroque. In other words, he gave Mannerism a unique

intensity, an intensity (expressed with the ravishing colors of his palette) that eventually gave his work its distinct aura. Because the Metropolitan show is arranged chronologically, we can watch, fascinated, as this vision crystallizes, and for that reason alone this lavish display of stunning masterpieces should not be missed.

Is Philip III's Reign Crucial to Spanish History?

The first two decades of the seventeenth century in Western Europe do not often get a good press from historians. They are particularly disappointing to those who seek to celebrate the larger period as an age of power and vigor that spawned the modern State and created the grandiose culture of the Baroque. In a notable essay, Hugh Trevor-Roper, echoing Voltaire, referred to these years, an interlude of relative peace amid a century of bitter conflict, as the prelude to the Enlightenment. But most national histories sag when these years arrive. For England they are the anticlimax after the death of Elizabeth I; for the Dutch, a fraught intermission in the war of independence; and for the French, a recovery cut short by Henri IV's assassination, followed by more than a decade of uncertainty. But the most striking contrast has always set the reign of Philip III of Spain (1598–1621) against those of his father and his son, Philips II and IV. If the father set his stamp on Europe and much of the known world, and the son presided over the most golden of creative ages, what happened in between seemed a sad and corrupt transition from one to the other, lacking the distinction of the first or the exuberance of the second.

There have been rumblings of scholarly dissent from this standard picture, and now a stunning exhibition and catalog finally put the myth to rest: *From El Greco to Velázquez*, a display of sixty paintings, sculptures, pieces of glassware and ceramics at the Boston Museum of Fine Arts. How can so compact a display deliver so potent a blow to a long-standing prejudice? The answer is by rehabilitating the Duke of Lerma. To the extent that the seventeenth century was the era of the Great Minister—or, more cynically, the Favorite—then Lerma usually ranks near the bottom of the pile. Compared to the stars (Richelieu and Colbert in France, Oxenstierna in Sweden, Olivares in Spain), he seems a rather feeble example of the species. His influence, whether on politics or culture, seems pale

even by comparison with lesser lights such as Mazarin or Strafford. No more. The discovery by Sarah Schroth of Lerma's household inventories, which document the creation of an extraordinary collection of art, and the researches these documents set in motion on the part of Schroth and Ronni Baer, the curators of the show, have brought to light one of the most extraordinary patrons of the arts in the era of the Renaissance and Baroque.

Lerma was Philip III's principal adviser for twenty years and bore a significant responsibility for his two major breaks with the past. First, the new king, unlike his father, welcomed the lavish display that we have come to associate with monarchs of the seventeenth century; and second, eschewing the detailed personal involvement in the running of a vast empire that had characterized the reign of Philip II, the son relied on a minister, Lerma, to oversee the enormous apparatus of government. The results were unmistakable: splendid public ceremonies, an elaborate court that fostered cronies and factions, and lavish patronage. Lerma alone, we now learn, accumulated a collection of more than 2,000 paintings. He was a founder of monasteries and religious houses; he presided over a court that promoted Lope de Vega and Góngora; and Lerma's discerning eye and patronage ranged from Veronese and El Greco to Rubens, not to mention his fondness for sculpture, for tapestries, jewelry, armor, and a unique assemblage of more than 800 pieces of pottery and glass.

This last collection, though unrecoverable, has prompted one of the delights of the exhibition: a recreation of the shelves of Lerma's *camarín*, the cabinet where he displayed ravishing examples of glass and ceramic objects from home and abroad—whether Venice, China, or the New World. Unlike the Kunstkammer, filled with unicorn horns and other peculiarities that delighted princes elsewhere in Europe, the *camarín*'s elegant linkage of domestic utility with public art was a particularly Spanish interest. Lerma's, however, was by far the most spectacular instance, and the homage in Boston, with a few dozen shimmering objects, can only hint at the beauties that must have adorned the *camarín* in the Duke's palace in Madrid.

Yet the establishment by Lerma and his master of a vibrant court is only the first step in the revaluation of their rule. More important is the role they played in the transition that gives the exhibition its name, *From El Greco to Velázquez*. These two giants of Spanish art are the bookends of the show. How, though, does one get from one to the other? The traditional view of late-period El Greco is of a painter rejected by Philip II,

who remained isolated in Toledo until his death in 1614. Remote from court patronage, El Greco stood outside the mainstream developments of Spanish art—a view reinforced by the uniqueness of his imagery and style. His achievement thus had no relevance to the appearance in Madrid, soon after his death, of the young Velázquez, another provincial artist, this time from Seville, whose interests and manner were to dominate an entirely distinct chapter in the history of the Spanish court. The achievement of this exhibition is to make that sharp division seem no longer possible.

Central to the new understanding of the period are two commitments of Philip III's regime: magnificence, and a new form of religiosity here labeled "Catholic Reformation" as opposed to "Counter-Reformation". These last terms have long been seen as alternative ways of understanding the revival of the Roman Church in the aftermath of the Council of Trent (1545–1563), the foundation of the Jesuit order in 1540, and the aggressiveness and reform that pushed back the tide of Protestantism from the second half of the sixteenth century onward. The contrast proposed here, following the lead of John O'Malley and others, is between the early phase of the revival—the Counter-Reformation—when the emphasis was on counter-attack, self-discipline, and severity (all embodied by Philip II), and the more expressive phase—the Catholic Reformation—when there was a new stress on spirituality, mysticism, inward devotion, and the inspirational symbols of faith, such as the cult of Mary. The argument is that phase one ended with the death of Philip II, and that the reign of his son launched phase two. Both Philip III and Lerma were devout, but not in the austere fashion of the king's father; for them, religion meant not only a quest for personal salvation but also an unleashing of the power of images, of ceremonial, of reverence for holiness (signaled by the successful campaign to canonize Spanish saints, including Teresa and Ignatius), and of such aids to devotion as the contemplation of Christ's suffering.

The immediate result of these new emphases was the emergence to centrality of El Greco. His work exemplified the values of the Catholic Reformation, and his sudden embrace by the court elite was marked by the installation in 1600 of his first major Madrid commission, the altarpiece for the chapel at the Seminary of the Incarnation. This consisted of six huge canvases, one of which, an *Adoration*, is the glowing centerpiece of the Boston exhibition. It is accompanied by a small reconstruction of what the whole possibly looked like: an overwhelming outburst of color and faith, uniting all the religiosity and the magnificence of Philip III's reign.

El Greco's work entered Lerma's collection, and his pious subject matter became central to the art of the time—as is made evident by the very organization of the exhibition under review. Instead of a chronological progression, there are themes. After setting the scene with six majestic canvases from El Greco's last years (including the eerie and unprecedented *View of Toledo* and *Laocoön*), and then introducing us to the figures at Philip's court, the curators move us past the *camarín* to a series of subjects particularly associated with the religiosity of Philip's reign: the Immaculate Conception and the purity of Mary; deeply contemplative moments in the life of Christ, from the Adoration to Calvary; Apostles; Spanish saints; and, especially moving, St. Francis.

El Greco is interwoven among these themes, though there are also revelations from painters of his generation who have been largely overlooked by the standard histories. There is a captivating *Holy Family* by El Greco's pupil Tristan, whose Madonna, having just finished suckling the child (who has now turned to look at us), emphasizes her domestic side by reaching for a crisp white cloth in her sewing box. There are somber bound Christs on Calvary; saints who bring the devotional and the otherworldly into the everyday; and sharply observed portraits. And then there is the young Velázquez. We first encounter him in a probing 1622 portrait of the poet Góngora, one of the chief literary ornaments of the royal court, whom the artist, in his early twenties, had come to Madrid to paint at the behest of his father-in-law, a friend of the poet. We then see Velázquez represented by an even earlier picture, the *Immaculate Conception* of the Virgin, who is shown, as always, floating on the moon, with a halo of stars. Already, however, the young man has added his own touch, giving the Madonna the face of a girl who, while exuding modesty and calm, is unmistakably a Sevillian of his own time.

The same down-to-earth simplicity is evident in the group that forms his *Adoration*, but in that exhibition room there is another surprise. Across from the Velázquez is an *Adoration* which, though richer and more complex, comes from a hand that seems no less talented than the Sevillian's. The painter is Juan Bautista Maíno. Like Velázquez, he was aware of the revolution in painting that Caravaggio had begun, and Maíno's mastery of color, character and movement ensures that he does not suffer when juxtaposed with the younger man. Maíno is best known for his commemoration of the victory at Bahia that hung in Philip IV's Hall of Realms; but, as a dedicated Dominican friar, Maíno's output was meager. Yet this *Adoration*, together with a small but penetrating portrait, is a forceful indication

of the talent that graced Philip III's reign.

That point is most vividly conveyed by the powerful evocations of St. Francis. A floating saint receiving his stigmata directly from Christ, by Vicente Carducho, and a figure embracing Christ's bleeding wounds, by Francisco Ribalta, reveal masters of devotional imagery; their canvases bear comparison with El Greco's contemplative *St. Francis* (probably owned by Lerma himself). And a series of apostles, hung nearby, demonstrate how natural is the progression from El Greco to Jose Ribera to Velázquez.

The final section of the exhibition, of which the *camarin* gave a foretaste, is given over to the distinctively Spanish forms of the still life, usually depicting food and scenes of humble activity. Here Velázquez comes to the fore, as three of his Sevillian masterpieces of ordinary life dominate the last room of the show—the famous kitchen scenes, with the Edinburgh *Old Woman Cooking Eggs* as the climax. Ribera, working in Spanish-dominated Italy at this time, created a striking gypsy eating little eels in *The Sense of Taste*, but it is in Velázquez that one sees the approaching glories of Philip IV's reign.

Among those glories was to be a famous visit to Madrid by Rubens in 1628–1629. He had been there before, in 1603–1604, and one result of that earlier trip was a large, powerful equestrian portrait of Lerma. Shown here in the Boston Museum, it echoes El Greco's St. Martin on horseback; it also represents a tradition that, for Spaniards, was made famous by Titian but remained alive in Velázquez and beyond. That sense of continuity pervades the portraits that hang nearby, as we follow the direct line from El Greco, via his student Tristan and the Toledan Maíno, to Velázquez. We see why the endpoint of Philip III's reign and Lerma's patronage cannot be separated from their beginnings; why indeed it now seems clear that Spain's Golden Age truly began long before the succession of Philip IV.

4

Why Is Velázquez So Revered?

Walk into the great hall on the second floor of the Prado that displays twenty masterpieces by Velázquez, with *Las Meninas* as their centerpiece, and you encounter a palpable hush. Surrounded by some of the most famous paintings in the world, and drawn into a veritable shrine by a critical consensus that places the artist at the very highest levels of the Western cultural pantheon, people seem to slow down; it is as if they need to catch their breath amidst such abundance.

It was not always thus. As the venerable eleventh edition of the *Encyclopedia Britannica* (1910–1911) put it, Velázquez' "European fame is of comparatively recent origin, dating from the first quarter of the nineteenth century. . . . From want of popular appreciation . . . [his pictures] to a large extent escaped the rapacity of the French marshals during the Peninsular War." The point is a little overstated, because collectors were already showing an interest in his work in the mid-eighteenth century. But it is certainly true that it was not until the nineteenth century that he became one of a handful of artists who seem beyond cavil. In the view of that *Britannica*, "his marvelous technique and strong individuality have given him a power in European art such as is exercised by no other of the Old Masters." The catalogs of two recent exhibitions offer the opportunity to test such judgments yet again.

The first, reflecting an exhibition that opened at the National Gallery in London in October 2006, surveys his entire career through 46 works. Starting with the humble scenes of ordinary Sevillian life that Velázquez started painting in his late teens, and proceeding through the early religious works and portraits, the overview moves on to his portrayal of life at the Spanish court, his remarkable mature portraits, and his large-scale depictions of classical figures and events. All of the themes that preoccupied him are here, and what is amazing is how contemporary his concerns

seem, even though his people and his subjects may be inherently alien to modern eyes.

This paradox, which lies at the heart of the artist's perennial appeal, is one of the topics addressed in the catalog essay by the curator of the exhibition, Dawson Carr. "Reality" is a word often applied to Velázquez, and Carr contrasts it with an inherent ambiguity in the oeuvre. The naturalism Velázquez cultivated, his creation of recognizable people and settings, whatever the subject, is tempered by a reserve and an artifice that allow him to keep his distance. The point is well taken. In portraits that make backgrounds disappear; in the illusion of vast space in *Las Meninas*; in the device of using a vivid foreground to overwhelm the ostensible subject of a painting, as in *Christ in the House of Martha* or *The Spinners*; or in the bold assertion of the painter himself in *Las Meninas*—Velázquez could almost be a post-modern, an artist who makes us think about what he is doing even as we engage with what he has done. As we wonder how he achieves his effects, we pay tribute to the wonders of his art.

A few months after the National Gallery show closed, the Prado celebrated the opening of a new wing of the museum by mounting a show devoted—for the first time—to just one aspect of Velázquez's work: his history paintings, wherein he depicted moments or characters from sacred or mythological texts. These "fables," as the curator, Javier Portús, calls them, enabled the artist to deploy his most dazzling skills. Moreover, by presenting him in the context of his most talented contemporaries—just over half of the 52 works on display were his; he was joined by 17 other artists, most notably by Rubens—the Prado catalog is able to highlight his special achievement. After observing the ways in which rivalries and influences helped shape Velázquez, one comes to see how crucial it was that, as Peter Cherry notes, "he prioritized the representation of the protagonists of the narrative." His models, and hence the stories they embody, come alive on his canvas to a degree one senses in none of his contemporaries. Apollo and Vulcan, like St. John and Aesop, are almost tangible as they stand alongside us.

It is his ability to draw us into his world that sets Velázquez apart. What we find there might be utterly unfamiliar. How many of us have been in a forge, let alone Vulcan's? Yet the understated shock on the smith's face as he hears of his wife's adultery, and the interruption it causes in his assistants' work, are all easily recognizable. The humble pitcher on the shelf even makes it an everyday scene. And we feel the same instinctive connection as Joseph's bloody coat is brought to Jacob. It is hard to believe that

an artist can bring home to us the stories of the Bible or pagan mythology, let alone the stiff atmosphere of the Spanish court, and persuade us to revel in the beauty of what he shows. But that is indeed what Velázquez achieves, and, as these catalogs reveal yet again, why the reverence for his art continues unabated.

How Does Spanish Art Reflect Devout Catholicism?

A massive wave of scholarly research during recent decades, illuminated by associated exhibitions, has transformed our understanding of what Gabriele Finaldi, in one of the catalogs, calls "the rich panorama of the Seicento, the great century of painting." Of the many revelations and reevaluations, none has been more far-reaching than the renewed and expanded appreciation of the art of Spain during the Golden Age. Where once El Greco, Velázquez, and Murillo stood largely alone as towering peaks in an otherwise little-known terrain, now they are surrounded by patrons, collectors, and other artists in a far more crowded landscape. The 2008 exhibition *El Greco to Velázquez*, for example, revolutionized the reputation of the Duke of Lerma, revealing him to have been possibly the greatest patron of his age, and introducing us to an array of superb artists who formed the hitherto little-known bridge between the worlds of Philip II and Philip IV. One of those artists, Juan Bautista Maíno, has now become the subject of a major exhibition and catalog that establish him as one of the luminaries of his time.

Born in 1581 to an Italian father and Portuguese mother who had moved to Spain, Maíno began to study painting, first in Madrid and then, in his twenties, in the Rome of Caravaggio, Gentileschi, the Carracci, and Guido Reni. All were to become major influences on his art, though the record is too sparse to clarify specific connections. By 1609 Maíno was working in Toledo, possibly in contact with the aged El Greco, whose portrait may be discernable in a later painting; and in 1613, while undertaking a commission from a Dominican friary, he entered the Dominican order. That his output remained small—40 or so works during his remaining 36 years—reflected his commitment to his vocation both as a friar and as a priest. He had left an illegitimate son in Italy, but he now became an exemplar of the deep piety that was central to the Spain of his day.

Religious themes were Maíno's principal commitment. An *Adoration of the Magi* that he completed in his early thirties drew the eye more forcefully than did the nearby treatment of the theme, completed by Velázquez a few years later, in the *El Greco to Velázquez* exhibition. Velázquez was only twenty when he painted his picture, and Maíno in his early thirties, but it is a testimony to the latter that the richness and drama he brought to the scene could bear favorable comparison with the future master. And they clearly knew one another. Maíno's prior, Sotomayor, became the royal confessor, and brought the painter to Madrid, where he taught drawing to the young Philip IV. For much of the remainder of his career Maíno remained a well-known figure both at court and in religious circles: a friend of Lope de Vega; an active Dominican; a judge of a competition won by Velázquez; a painter of altarpieces; and, most famously, the artist whose *Recapture of Bahia* was regarded at the time as a more prominent feature of the Buen Retiro Palace's Hall of Realms than its neighbor, Velázquez' *Surrender of Breda*. All of this and more is explored in detail in a learned and wide-ranging catalog, *Juan Bautista Maíno*, which is a worthy tribute not only to a fine artist, but also to the high production standards through which the Prado gives a remarkable figure of the Golden Age his due.

In one document Maíno listed the painting of sculptures as one of his skills. It is to reveal the importance of that trade, and to open another window into a hitherto obscure field of Spanish art, that the National Gallery in London has assembled *The Sacred Made Real*. The main purpose of the exhibition, enhanced by the sharply observed and beautifully illustrated catalog, is to connect the precise and disturbing realism of seventeenth-century religious painting and sculpture to the intense and even grim piety of the ordinary Spaniard. What is overwhelmingly clear is that the hyper-realism that Velázquez and especially Zurbarán brought to their devotional works was closely related to the aesthetic of the sculptors whose painted polychrome figures were an essential feature of churches and religious processions. Through the presentation of some three dozen of these works—often shocking to a modern sensibility in their loving depiction of gaunt, bloody, and maimed bodies—the connection becomes unmistakable.

The result is to bring to the fore a group of sculptors whose work demonstrates how widespread was the artistic brilliance of the Golden Age. The names of Montañés (portrayed by Velázquez himself), Mesa, Mena, and Fernández may be little known, but they created images of sadness, agony, and piety that stand easily alongside the masterpieces of

painting by their contemporaries. And the essays in this catalog make clear how the omnipresence of these depictions of holy figures—in contemplation, in sadness, or in pain—reflected the deepest currents of the Spaniards' Catholic beliefs. Their nation may have dominated Europe and America in these years, but the extraordinary outpourings of their artists remind us, again and again, how profoundly they were driven by the joy and the suffering of a powerful faith.

Is There a Distinctive Spanish Art?

No country has been more obsessed with the nature of its own identity than Spain. With its tripartite roots (Muslim, Christian, and Jewish) in the Middle Ages; its centuries-long "reconquista" and subsequent expulsion of minorities; its doctrine of "limpieza di sangre"; its fortuitous political origins in the marriage of Ferdinand and Isabella, which ultimately divided off Portugal within the Iberian Peninsula; and its modern anxieties, provoked by Catalans and Basques—one can hardly consider it surprising that so much energy has been expended on defining what it means to be a Spaniard. Even the Germans seem reticent by comparison.

The attempt to encapsulate "Spanishness" is the underlying purpose of the masterpiece-laden exhibition, *El Greco to Picasso*, which has been mounted at the Guggenheim Museum in New York. Nearly 140 pictures, with especially strong representation of Velázquez, Zurbarán, Ribera, Goya, Picasso, and Dali, are juxtaposed across the centuries in order to extract underlying themes and to highlight markers that are unique to Spain.

For its display of extraordinary works the exhibition is not to be missed. Quite apart from iconic works by Velázquez, Goya, and Picasso, there are profoundly moving canvases that are less well known. For example, Zurbarán's depiction of *The House in Nazareth*, which shows Jesus as a young boy, sitting near his poignant, contemplative mother, and looking at a finger he has pricked as he makes a crown of thorns, plumbs level after level of meaning. At its simplest, this is a warm domestic scene. The domestic objects, the clarifying rays of light, the intricately folded draperies, both on and off the two figures, the charming doves in the foreground, and the pensive faces of mother and son draw one into a welcoming space. But just about everything in the picture also has a symbolic resonance, from the crown of thorns to the lilies of virginal purity and the

doves that Mary sacrificed in the Temple. It captures both Rembrandtian domesticity and the omnipresent lessons of religion. Not far away, Murillo's portrayal of four utterly disparate yet ordinary people is no less riveting. A woman of striking presence looks sadly out of the scene as, with worn fingers, she plucks lice from the head of a boy in torn clothes, sprawled across the bottom of the picture. Next to them a grinning, foppish, young man and a dark, quizzical girl raising a cloth over her head look out at us. Is this merely the world of the streets? Is there an erotic subtext? Enigmatic but attention-grabbing, the painting draws one into its private world; it is hard to pull oneself away.

But what does any of this have to do with Spanishness? In a 1996 book of essays, *Picasso and the Spanish Tradition*, edited by Jonathan Brown, five scholars looked closely at the pictures through which Picasso, though living in France, regularly returned to the inspiration of the Spanish masters. The juxtapositions they explored might have prompted a trenchant investigation of the continuities and inspirations that animated Spanish artists for over 400 years. What is one to conclude when, instead, Velázquez' affectionately observed *Needlewoman* is hung next to Picasso's deeply troubling *Woman Ironing*? That women at work are a standard Spanish subject? Even when the evidence of a distinctive commitment is more persuasive—as it is in a remarkable succession of closely observed still-lifes—the crucial question remains: how does this differ from similar commitments by the artists of other countries and traditions?

Such questions might be beyond the mandate of wall labels, but they are also rarely addressed in the lavish exhibition catalog. The Velázquez and Picasso working-women, for instance, are described without reference to one another, and indeed Picasso's canvas is given context, as it should be, not with Spanish antecedents, but with his response to the French artists, notably Degas, in his new home in Paris. And the splendid group of paintings of monks hardly constitutes an especially Spanish tradition, because all but two of them come from the brush of that connoisseur of clerics, Zurbarán.

The still-lifes (known as *bodegónes* in Spanish) are a different matter, encompassing a number of artists in different periods, and sustaining the theme of the tabletop with consistent precision and a penetrating eye. The brief catalog essay, moreover, does make a case for the difference between the Spaniards and their counterparts elsewhere in Europe. There is good reason to regard the sharply focused interest in just a few objects, which pervades the genre from the time of Cotán at the beginning of the seven-

teenth century until the twentieth, as a unique thread in Spanish art. And it has echoes in paintings on other themes, such as Zurbaran's *House of Nazareth* and the early canvases of Velázquez.

But the *bodegónes* alone cannot serve to define a national culture. Even the most sophisticated treatment of the subject, the essay on still-lifes by Robert Rosenblum in the *Picasso and the Spanish Tradition* volume (a clear influence on the curators) makes no such claim. Other than the *bodegones*, a few pictures of bullfights do support the theme, as do the distinctive mien and costume of Goya's women aristocrats. Yet the vast majority of the many portraits are essentially stateless. A dazzlingly executed *Anna of Austria* by Coello, for instance, may show one of the wives of Philip II, but it is hard to see the white-costumed, fair-haired, jaunty Ana as particularly Spanish. Much the same is true of the landscapes, notwithstanding the unmistakable forms that El Greco brought to his canvases. As for the Madonnas, the saints, and the Crucifixions; the adults and the children; and the angels and the dwarfs—only occasionally does there seem a reason to place them in Spain.

If the case for a unique tradition were to be convincing, it would have to embrace a more comprehensive chronology. The exhibition is rich in the seventeenth century, in the works of Goya, and in the early twentieth century. But it comes to a halt before the Civil War that was one of the major struggles over the meaning of Spanishness, and most of the eighteenth and nineteenth centuries are totally absent.

The conclusion is unavoidable, therefore, that the case is not proven. Whether or not the theme of the enterprise really works, however, the assemblage of paintings it inspired is irresistible. Spanish distinctiveness aside, the exhibition's treasury of memorable and compelling images offers reason enough for celebration.

Part Seven

Italian Art

What Can We Learn from the Appeal of Piero della Francesca?

How is one to account for the fascination that has made Piero della Francesca, after centuries of neglect, *the* iconic figure of the early Italian Renaissance? Despite his limited surviving output, and the meager information about his life, the scholarly output he has inspired is little short of astonishing. During the past 25 years—if the collection of the Marquand Library at Princeton University, a major research center for the study of art history, can serve as a guide—he has easily outdone such masters as Brunelleschi, Masaccio, Donatello, and Botticelli in the number of books devoted to his work. Only Giotto, the pioneer who lived a century before the beginnings of the extraordinary outburst of artistic creativity in central Italy in the early 1400s, has received more attention, but even he does so by a very small margin. Not until one reaches the age of Raphael, when the documentation and the output became so much richer, does one find anyone so closely studied as Piero.

The sources of the new interest may lie in the visionary decisions of two Victorians: Sir Charles Eastlake's purchase of the Pieros now in the National Gallery in London, and Charles Blanc's commissioning of copies by Charles Loyeux of the frescoes in Arezzo for the École des Beaux-Arts in Paris, which deeply influenced Seurat, among others. In broader cultural terms, however, the argument that is regularly put forward is that, for a modern audience, the attraction is the formalism and the coolness of Piero's paintings. The precision of the mathematical calculations that inform his compositions, and the blank expressions on so many of his faces, suited the mood of a twentieth century that was ready to abandon the clear-cut stories of narrative art and the passions that still echoed from the Romantics. In a famous essay, Bernard Berenson saw him as the embodiment of "the ineloquent in art," and linked him to such modern masters as Degas and van Gogh. Piero, in other words, has a contemporary reso-

nance that sets him apart.

The artist himself would doubtless have been amazed at such a conclusion. It is clear, for example (and amply demonstrated in a number of recent monographs), that he was driven by a profoundly religious sensibility. For all his fascination with the world that surrounded him, and the inspiration he found in pagan antiquity, his drive to express religious themes in his own way, and to display a subtle but profound piety, is unmistakable. He did paint a *Hercules* as an emblem of Fortitude, and portraits of patrons that were animated by classical symbolism, but the overwhelming majority of his work was devotional. Even those patrons were shown on their knees in sacred scenes that may well have preoccupied Piero more closely than did the portraits.

Yet there is no doubt that his absorption in form, and particularly in mathematical exactitude, has been an important attraction. One would be hard put to think of an artist who has prompted so many schematic analyses of his compositions. His authorship of three tracts on arithmetic and geometry—on the abacus, on perspective, and on the five regular solids—has been the occasion for intensive and minute examinations of the proportions and spatial relationships in his paintings. And the results have always confirmed his remarkable mastery of exact measurement, which nevertheless was not allowed to intrude into the relationship between viewer and picture. Unless one is especially attuned to questions of ratios and geometrical forms, one is unlikely to be aware of the underlying structure that apparently meant so much to Piero himself, and which has been the object of broad scholarly interest.

Above all, it seems to be the omnipresence of enigma that drives the spate of research on Piero. A case in point is his *Flagellation of Christ*, a panel slightly less than two by three feet. The central event in the painting is relegated to the background, and is framed by the criss-crossing lines of a classical building that takes up 60 percent of the picture. Although the subject matter is thus downplayed, the flagellation takes place in the palace of Pontius Pilate, who himself observes the proceedings from a throne. The model for this portrait is unmistakably the Byzantine Emperor John VIII Palaiologus, who had attended a Council of the Church in Ferrara and Florence in 1438 and 1439 in the hope of healing the schism between the Greek and Roman churches, and whose profile and hat were familiar from a number of depictions, notably by Pisanello. Christ stands before him, at the foot of a classical column, which is topped by a golden figure variously interpreted as Apol-

lo, Hercules, or Glory, but undoubtedly a pagan idol. The chief object of speculation, however, are the three standing figures in the foreground of the remaining 40 percent of the panel, who dominate the scene. There is not a shred of evidence as to who these people are, why they ignore the biblical scene in the background, how they relate to the flagellation, or even why they should be there at all.

The lack of evidence, however, has not deterred eminent scholars from proposing irreconcilably different explanations of the scene. These range from references to the Greek/Roman schism, to plans for a new crusade, or to Piero's patrons (some of whom, even if implausible, have been rescued from obscurity with prodigious research), all the way to a commentary on the murder of his half-brother that enabled Federico da Montefeltro, unquestionably a patron, to become the ruler of Urbino. A perfect example of the approaches scholars have taken is in the title of Bernd Roeck's engaging 2006 volume: *Mörder, Maler und Mazene: Piero della Francesca's "Geisselung": Eine kunsthistorische Kriminalgeschichte.*

That last word echoes the preface by Peter Burke to the English translation of Carlo Ginzburg's foray into the subject, *The Enigma of Piero,* which presents his distinguished colleague, and implicitly all good historians, as a detective. Ginzburg has himself discussed the interpretation of clues as a means of understanding historical scholarship, and these analogies with police work are certainly not irrelevant to the attempt to recover an elusive past. But there is a major difference. Police seek a case for the prosecution that a judge or jury will accept as true. On the subject of the *Flagellation* nobody really expects to win conviction. The very impossibility of reaching an accepted conclusion about the painting seems to be the main reason that the scholarly engine keeps turning. Previous theories are regularly denounced as "hypothetical," which is no surprise in the absence of evidence, yet in second editions authors respond to critics as if certainty were somehow attainable.

The absence of evidence, in other words, is one of Piero's charms. His very date of birth keeps shifting: once ca. 1420, then 1415, it is now 1412. Antonio Paolucci's essay in the catalog under review even begins with a lengthy disquisition on a letter from Sigismondo Malatesta, lord of Rimini, to Giovanni de' Medici, dated April 7th 1449, which refers to a master painter who is on his way to Rimini, and seems to refer to Piero, only for Paolucci to pull out the rug: "la suggestiva ipotesi non è sostenibile." And so it goes. We do have scraps of information: Piero was working with Domenico Veneziano in Florence in 1439; he did spend time in Perugia, Rome, Ferrara, Rimini, and Urbino in addition to his years in his home

town of San Sepolcro and nearby Monterchi and Arezzo. We know that
about twenty of his works survive, though their dates are disputed, and we
also know that at least another dozen, including frescoes in Rome, have
vanished. Toward the end of his life, back in San Sepolcro, he went blind,
and he died in 1492. It is clear, too, that he knew the work of a number of
contemporaries, and that he particularly admired Leon Battista Alberti,
with whom he shared a passion for classical architecture that is visible in
many of his paintings. His fresco of Malatesta with St. Sigismund—
another painting whose structure, classical columns, and black and white
greyhounds have encouraged much speculation—is located in the very
structure in Rimini that Alberti had transformed into one of the emblem-
atic Renaissance buildings, the Tempio Malatestiano.

At times it is Piero's very meticulousness that not only distinguishes
him but also leads to fertile research. Because of the care with which he
presents banners, we know more about banner painting in the Renais-
sance. Because of his commitments, our information about the mathemat-
ics, the architecture, and the interest in classical forms of his day has been
greatly expanded. And because his *Dream of Constantine*, the first night
painting in Western art, shows the stars in recognizable patterns, an essay
by Vladimiro Valerio in the exhibition catalog can suggest that it shows
the night sky of summer 1463, that it displays familiarity with astronomi-
cal texts, and that Piero may have met the Byzantine Cardinal Bessarion
and the German astronomer Regiomontanus in 1463.

Can we know more? The search shows no sign of diminishing, and this
sprawling exhibition, *Piero della Francesca e le corti Italiane*, which encom-
passes unmovable works in Arezzo, San Sepolcro, and Monterchi, plus
some 100 items—paintings, sculpture, medals, manuscripts—in local mu-
seums, seeks to add yet another dimension to our understanding of Piero.
The very title of the exhibition points the way, for the principal effort is to
illuminate the settings in which he worked. This has long been one of the
fruits of the research stimulated by the passion for Piero. The essay in the
catalog about Piero's books, for example, is by James Banker, whose *The
Culture of San Sepolcro* brought to light in 2003 more information about the
culture and society of this small town during the first four decades of the
fifteenth century than is available for any place of equivalent size in Eu-
rope at this time. And the exhibition openly seeks, not merely to present
the master's own paintings and writings, but to make us aware of the con-
temporary art scene at the courts where he worked. We may learn little
new about Piero's own ideas or relations with others; the quality of the

works may vary widely; we may see almost as much of Pisanello as of Piero; but there is no doubt that we are led to confront the nature of the patronage, mainly at princely courts, that made his achievements possible.

What is immediately striking is the refinement of the world that Piero inhabited. The calm dignity that was almost second nature to court artists in these years is everywhere to be seen. One can hardly imagine a more restrained battle scene than *Constantine's Victory over Maxentius* in Arezzo (*Illustration 8*). The clarity, strength, and precision of Piero's figures and scenes may be unique, but one quickly sees how he fitted into this context. Even such obscure figures as Bono da Ferrara or Lorenzo da Viterbo convey the easy elegance that is the mark of the times. The bodies and drapery are carefully modeled, the classical touches are apparent, and the expressions remain opaque and unmoved. Only very rarely did Piero himself allow drama or emotion to tinge the glacial composure of his protagonists. In a *Crucifixion* and in *The Death of Adam* and *The Battle of Heraclios and Chosroes*—two episodes in his most ambitious surviving masterpiece, the frescoes narrating *The Legend of the True Cross* in San Francesco in Arezzo—the calm surface is broken by rather stiff, open-mouthed expressions. Mourners grieve over Christ and Adam and, in the battle, the blood flows and there is a suggestion of anguish. But these are rare exceptions amidst the dignity and the impassive faces of his figures.

Which again, inevitably, raises an unanswerable question. How did artists and writers of such sensitivity and delicacy feel about serving princes whose ruthlessness, brutality, and treachery define their era? Jacob Burckhardt, speaking of the despotisms of the fifteenth century, said that "the greatest crimes are most frequent in the smallest states," and used the Baglioni of Perugia, whom Piero probably served, as his prime example. One Baglioni was said to have bitten the still-beating heart of one of his enemies. Sigismondo Malatesta and Federico da Montefeltro may not have descended to such levels, but their easy inclination toward viciousness, betrayal and murder stands in stark contrast to the exquisite refinement of the buildings and paintings they commissioned. One must wonder if the hallmarks of Piero's art—minute attention to detail, mathematical precision, and utterly calm demeanor—were not, in part, a defense against such surroundings.

2

Why Is Leonardo Worth Studying?

In the popular mind, Leonardo da Vinci stands—and deservedly so—as the archetype of the many-sided genius. Starting life as the illegitimate son of a notary, he came to be fervently sought by some of the most powerful and discerning patrons of Renaissance Italy and France. They wanted him at their courts, moreover, not just as an artist and theorist of art, but also as an engineer, an inventor, and an expert in fortifications and armaments. His *Mona Lisa* and *Last Supper* may be the two most famous paintings ever created, and his *Proportions of the Human Body* the most famous drawing. Yet the significance of his work within the larger story of Western culture and thought remains elusive.

The consequences that flowed from the innovations of, say, Michelangelo, Machiavelli, Luther, Columbus, or Copernicus, are highly visible. But Leonardo left a subtler legacy. He may have been more versatile than any of these contemporaries, more far-sighted, more inquiring, and no less gifted. For Vasari, he represented not just humanity, but divinity itself. His achievements, however, often seem *sui generis*, leaving on those who followed an imprint that has to be carefully uncovered.

Art historians have given this issue considerable attention. Rona Goffen's recent *Renaissance Rivals: Michelangelo, Leonardo, Raphael, Titian*, for example, devotes an entire chapter to the love-hate relationship (not unlike Picasso's with Matisse) between Michelangelo and Leonardo. Here the influence of the older man (Leonardo) on the younger is unmistakable. But the connection is rarely this clear. Leonardo's writings on aesthetics, and his investigations of human and animal proportions, the mathematics of perspective and design, and the technicalities of painting in various media, did make him an essential point of reference for other artists. The breadth and cogency of his contributions in these areas gave him a stature that no other Renaissance artist, except perhaps Dürer, attained.

But in Dürer's case there was also an accessible body of work that was avidly and widely copied. Leonardo, by contrast, was not a printmaker, and his paintings—few, far between, and occasionally undone by his experiments—did not amount to the readily available source of inspiration that flowed from other stars of Renaissance Italy. Images by Raphael, Michelangelo, and Titian flooded Europe; Leonardo's did not.

It is true that his geological fantasies; his ability to capture movement and emotion; the tension that connects his figures and his landscapes; and his riveting explorations of facial types, both beautiful and misshapen; have continued to echo through Western art. Yet the echoes are sporadic, and often mediated through the contemporaries who responded to him directly. Rubens did rework a drawing copied from a scene in *The Battle of Anghiari*, but this is only a tiny part of the Flemish artist's voracious assimilation of Italian masters. The variety of Leonardo's images is so rich that one feels there *must* be major connections, and the inclination is to make leaps on the flimsiest of pretexts. If only one could show that Rembrandt knew the elegant Fitzwilliam drawing *Rider on a Rearing Horse*, for instance, could it not have been a source for the pose of the horseman in the Frick *Polish Rider?* After all, the drawing was once owned by Peter Lely, who was trained in Haarlem. Can one not draw the line more tightly? Sadly, one cannot. The possibilities are immense, but the reality is that the disciples were rare.

Nor can one trace direct effects from the many astonishing things Leonardo did besides painting, from observing a foetus to designing a helicopter. Many historians of technology, while full of admiration for his ingenuity, his conceptual insights, and his uncanny instinct for important problems, find it hard to link his work to the practical conquests by which engineering has advanced. Thus, although he figured out the principles behind the construction of a parachute (and even drew one that would probably work), it is difficult to connect his comments on the subject with the invention of the modern parachute. His machines and devices, for all their brilliance, had little direct impact on the progress of technology. Many have been reconstructed in recent years, and they are marvelous to behold, but they cannot be seen as the starting-points for further discovery, let alone changes in practice. They are like the Atlantic voyages of the Vikings, not of Columbus.

Studies of technology therefore tend to give Leonardo respectful mention more because of his fame as an artist than because of his legacy as an inventor. As a result, in histories of anatomy, hydraulics, ornithology, a

dozen other subjects, and sometimes even the history of art, his unique distinction as an innovator and explorer may be recognized, but scholars rarely give him a central role in an unfolding narrative.

To some degree, he himself caused the difficulty. He was, first, so easily distracted by new projects that he brought few of them to the kind of completion that would have attracted a steady stream of disciples. He was also so private that much of his creativity is in notebooks of often baffling, sometimes deliberate, obscurity. In addition, he was so reluctant to commit himself that he was the despair of patrons (disappointing even the relentless Isabella d'Este). If he was regarded by many as a shining exemplar of human ingenuity (and, by his contemporaries, as a courtly, elegant, and approachable figure, unlike his bitter rival, Michelangelo), the disappointments were nevertheless obstacles for those who sought to learn from him. Many, of course, did. In 1500, Leonardo was probably the most celebrated artist in Florence, and there is plenty of evidence of the debts he was owed by immediate contemporaries and successors, such as Michelangelo and Raphael. Yet his main call on the attention of posterity has derived not so much from the ways he shaped the many disciplines he touched, but rather from the fascination that is aroused by an individual whose versatility, skill, and insight make him the embodiment of human abilities at their very best.

The special virtue of the exhibition at the Metropolitan Museum, *Leonardo da Vinci, Master Draftsman*, is that it brings out these latter qualities so effectively. There may be fewer than 120 sheets of drawings and writing by the master on display (together with some 30 works by teachers, students, and copiers), but their chronological arrangement allows one to see an extraordinary mind grapple, successively and simultaneously, with subjects of breathtaking variety. We start in the studio of Verrocchio, where we encounter at once the aesthetic sensibility and the love of experimentation that were to mark his pupil Leonardo's work. Verrocchio's ravishing drawings of young women and a young boy; his sketches of infants and adults, overlapping and viewed from different angles on both sides of a sheet; and his measurements of the proportions of a horse; all point unmistakably toward the preoccupations of his student. We then follow Leonardo's career through five distinct periods, each with its own gallery, until we reach a final gallery devoted to the interests of his last years as well as the work of a few of his pupils in Milan.

From the elegant drapery studies of the young artist, through the remarkable Leicester Codex (with its examination of water, siphons, and the

light of the moon), and on to the late explorations of storms, cats, and horses, this is a beautifully designed display. Every item can be studied at such close quarters that one almost wishes one could swivel the double-sided sheets so as to do justice to the many images which, inevitably, are upside down. It is an exhibition for the limber of neck. And the abundance of stunning details is almost too diverse to absorb. Three small sheets of preliminary sketches for the lost *Battle of Anghiari*, for example—two of them less than six inches square, the third slightly more—have room for some three dozen horsemen and soldiers in violent combat, a bridge, the smoke and dust of battle, and (on the reverse) notes and drawings about the raising of weights. These sketches were clearly done at speed, laying out the essentials for a large artistic project. But Leonardo could also slow down, coming back again and again to a dog's paw, with every hair showing, until he had it mastered from every side.

Here, as in the horses that were one of his passions (long before he embarked on the massive equestrian sculpture for the Sforza in Milan that, had it been completed, would have outdone even his teacher Verrocchio's bronze tour de force, the statue of Colleoni), Leonardo combined his experimental and aesthetic instincts with an obsessive curiosity about the natural world. What draws us to him, though, is the grace that he brings so effortlessly to everything he touches. Thus, when he displays the pattern of fire that besieging mortars need to rain down upon defenders behind a wall, the beauty of the perfect, parallel curves he drew transcends his analytic purpose. Uniquely among the great masters, however, he did not confine himself to the pleasing or the attractive. Although he created exquisite Madonnas, delightful infants, and striking male figures, his name is also associated with depictions of faces that were ugly, eccentric, and deformed. The exhibition gives a good showing to this aspect of his interests; when seen in context, moreover, it connects directly with his analytic studies of skulls, arteries, machines, and ghastly weapons of war. A sheet from Venice, for instance, is full of calmly—almost prosaically—observed blades, axes, and spikes of fearsome design, together with a gruesome barbed club. These are rendered with the same cool, unflinching appraisal that marks the grotesques. And yet, on the edge of this same sheet, the artist takes over from the note-taker. A tiny scene of a horseman charging two defenders with ingenious conical shields comes vibrantly to life, and Leonardo's artistic instincts suddenly overwhelm the page.

Yet when he imagined or saw bizarre features on a human face there was no relief. Distorted noses, ape-like foreheads, and massive upper lips

appear in harsh profile. Leonardo's focus was so intense, so devoid of mitigation or evasion, that he helped create a genre—the grotesque — that, if not in the mainstream of Western art, nevertheless forms a tradition whose continuity we *can* trace from Leonardo's work: an undercurrent that fed the meticulous dissections, anatomies, and physiological studies of scientists, and, more distantly, the embrace of shock and terror in twentieth-century aesthetics.

Most of the exhibition consists of sketches and the contents of notebooks, as its title promises. Even the one painting in the show, the Vatican *St. Jerome*, is an unfinished work that offers special insights into technique. Close examination has revealed, for instance, how Leonardo formed the outline of the face by dropping charcoal dust through perforations in a cartoon; used the tip of his paintbrush to draw the outlines of the composition; and softened the focus by pressing his fingers into the wet paint. Yet the supplicant demeanor of the emaciated saint, and in particular the emotion Leonardo evokes in his eyes—a feature of the human face through which he conveyed character and feeling whenever he went beyond a sketch—is yet another moment when (as with the charging horseman) the artist supplants the draftsman.

Not surprisingly, however, the massive catalog (nearly 9 pounds of it) focuses on the building blocks with which the art was constructed. Accordingly, the ten introductory essays are more concerned with new discoveries and specific aspects of the drawings than with broader assessments. Two are more general: a lucid overview of the show by the editor (and curator), Carmen Bambach, and a magisterial history of the reception of the drawings by the Leonardo scholar Carlo Pedretti, both of which suggest a broader horizon. The rest are close, extensively documented analyses of particular questions—not unlike the drawings themselves.

These scholarly contributions offer a rich diet of insights into Leonardo's life, career, and art. Erudite and suggestive in all cases, they nevertheless divide between the more and the less ambitious. The editor herself uses Leonardo's left-handedness as the starting-point for an illuminating examination not only of its effects on his art (especially his natural tendency to draw lines from right to left, and his interest in mirrors) but also of attitudes toward the left-handed among contemporaries and later commentators: she notes the consistency of discrimination against the left-handed, and she calls for further work on such other exemplars as Michelangelo, Holbein, Munch, Klee, and Picasso. Alessandro Cecchi probes the archives of Florence to uncover important new information

about Leonardo's father Ser Piero and the network of friends, patrons, and contacts into which the young artist was born. And Martin Kemp takes off from the mere dozen or so drawings with border frames to show us Leonardo filling an empty sheet: his dynamic first thoughts, his exuberance in overlapping images, his mastery of compression, and his dexterity as he "orchestrated" poses "with apparently boundless fertility."

On the whole, the authors are content to limit their discussions of Leonardo's wider influence to his immediate contemporaries. Kemp notes his impact on Raphael's drawing, and Pietro Marani documents his reception among such Milanese as Boltraffio, Solario, and Melzi (the devoted aristocrat who became Leonardo's heir). These artists formed the only group one can consider a "Leonardo school," perhaps because Milan was the city where he spent the longest time as a mature artist, and where he was the dominant figure. Finally, Varena Forcione discusses the ownership and influence of the "grotesque" drawings in the Devonshire Collection.

It is only when claims take flight that the arguments become stretched. Thus, when Claire Farago, at the end of an excellent discussion of the Leicester Codex (now owned by Bill Gates), endorses recent speculation about links between Leonardo's innovative analyses of reflected sunlight on the moon and Galileo's *Starry Messenger*, one becomes aware of a decline in the standards of evidence. The speculation is suggestive about connections between art and science in the Renaissance, but the further step—implying that Leonardo influenced the history of astronomy because his drawings of light bouncing from the earth to create a bluish tinge within the horns of the crescent moon might have been known to the Venetian friar Paolo Sarpi and thus to Galileo—seems as superfluous as it is undocumented: on a par with the link to Rembrandt's *Polish Rider*.

For the exhibition makes it overwhelmingly clear that the loneliness of Leonardo's eminence in no way lessens the admiration he inspires. To move through the galleries, and see ideas and conjectures exfoliate even as they first occurred to Leonardo—which is what the spontaneity of the drawings makes possible—is a rare privilege. Those who experience it can feel that they are accompanying a uniquely inventive and talented man as he journeys through a life of multifaceted discovery and achievement without peer.

3

Why Is Raphael So Central to Western Art?

It takes an informed layman—in this case Spain's minister of culture, José Ignacio Wert—to highlight a major paradox in the history of Western art that is often ignored. As he puts it in the opening sentence of the catalog to the exhibition *Late Raphael*, now at the Prado: "Of the three great High Renaissance artists—Leonardo, Michelangelo and Raphael—the latter is the least known to the general public, even though he probably influenced the future of western painting more decisively than the others." Those visiting the show or taking a serious look at the catalog may be surprised by the degree to which the second half of that sentence seems to be confirmed. What is less clear is that the paradox in the first half of the sentence might be allayed—even by a display of some 80 works as potent and as revealing as those here on show.

The organizers have focused on the last seven years of the artist's life, 1513–1520, spent in Rome. Thanks to the favor of the Medici pope Leo X, he became the city's dominant artistic figure at a time of conspicuous commissions that were to influence the outlook and style of painters, sculptors, and architects for generations to come. Remarkably enough, even though this was when Raphael set his stamp on the aesthetics of his contemporaries and successors, there has been no previous exhibition devoted to the moveable paintings he completed in these years or to their impact. By taking a close look at the period and its immediate aftermath, therefore, the curators seek to reassert Raphael's centrality in the development of European art.

One has but to enter the exhibition to see their point. The very first space presents three huge altarpieces whose colors and composition, gestures and expressions, overwhelm the viewer. Scholars remain divided over the attribution of specific sections of these enormous panels (now transferred to canvas), and precise dating remains a major problem, but

there is no doubting the power of their impact. In the St. Cecilia altarpiece, for example, the massive figure of a contemplative St. Paul (unmistakably by the master himself) amply documents what Vasari called Raphael's "rarest gifts."

The difficulty in identifying individual hands, whether of Raphael himself or of his students, is a leitmotiv of the catalog, as is the thorny question of chronology. Yet these two problems merely underline the ascendancy Raphael enjoyed in the Rome of his day. Not only was he heavily overcommitted, but so too was his workshop. Vasari estimated that he may have had fifty assistants at any one time, and John Shearman, in a pioneering article on the organization of the workshop, suggested that it was an institution of unprecedented size and responsibilities, with participants added and removed according to demand. Although, as a result, Raphael was able to play an important role in a multitude of architectural and sculptural as well as painting projects throughout Rome, the sheer volume of production has caused almost insuperable problems of attribution and chronology. One of the striking accomplishments of the exhibition's organizers, however, is to turn these technical problems to their advantage. They do not shirk the difficulties of dating or identification, but instead use them to drive home two of the features of Raphael's Roman years that they seek to emphasize.

First is his frantic busyness, which required so much delegation to the workshop—not just of final paintings, but also of preliminary drawings and *modellos*. The evidence suggests that, at times, Raphael was doing no more than providing the outline that his acolytes filled in and executed. To an age like ours, which so strongly emphasizes individual creativity, such cavalier treatment may seem unacceptable, but for Renaissance and Baroque patrons it was no surprise. Even Raphael's last painting, *The Transfiguration* (which could not leave the Vatican for this exhibition), shows signs of workshop interventions, despite the fact that it was a test of his reputation, produced in direct competition with a commission given to his rivals in Rome. For Henry and Joannides, the productivity, and the reliance on assistants, was above all a token of Raphael's dominance of the Roman scene. Not until Rubens did an artist again reach so formidable and influential a presence in Western art.

The second emphasis is on the heritage of Raphael, particularly in the four years after his death and in the work of his most talented follower, Giulio Romano. Precisely because the workshop was so busy, and specific hands and dates are so elusive, much attention is given to the identity of

the various artists involved and the possible timing of their work. Yet the absence of documentation means that conclusions can be reached only through connoisseurship. To that end, the recognition of individual styles and the ability to make connections with other work being done at the same time is crucial. Henry and Joannides, like many Raphael scholars, are adepts at the kind of seeing and comparing that is called for, and it occupies much of their analyses. Again, however, they turn the problems to their advantage by stressing the extent to which Raphael's vision shaped his immediate disciples and generations of his successors. Indeed, there was a separate room at the Prado (not included in the catalog) which explored the continuing force of his example not merely through direct copies, such as Giulio Romano's version of *The Transfiguration*, but through the Mannerists and other painters all the way to another son of Urbino, Federico Barocci, who lived into the seventeenth century. The fascination could easily have been extended to Rubens, to Delacroix, and beyond.

Because of the emphasis on collaboration, and on the importance of the workshop, the exhibition pays special tribute to Raphael's star pupil, Giulio Romano. He had joined the workshop around 1515, probably in his early twenties, and we watch his talent flourish (especially by comparison with his pedestrian colleague, Gianfrancesco Penni). Before he left Rome in 1524 for Mantua, where he was to earn Europe-wide fame, Giulio had already demonstrated his distinctive command of complexity, both in the crowded scene of his *Circumcision* and in his *Woman in a Mirror* of 1523–1524, the date at which the show ends. This heritage makes all the more remarkable the last painting by Raphael in the exhibition. Finished in 1519–1520, it is a double portrait of the artist with Gulio. In an almost fatherly gesture, the older man puts his hand on the shoulder of the younger, who looks back with a warm expression even as he points ahead. It is to that forward sight that Raphael looks, and the whole picture becomes a moving evocation of a torch being passed from one generation to another—a meaning that becomes all the more poignant when one realizes that within a few months the master, already looking careworn, was to be dead at the age of 37 (*Illustration 9*).

What was it that gave Raphael his extraordinary stature in the history of art? In the past, it was the serenity and delicacy of his Madonnas, or the classical elegance of his frescoes, that set him apart. Never a tortured genius, he was as distinctive in his ability to win the affection and admiration of his contemporaries as he was in the grace and perfection of his work. Henry and Joannides emphasize the sweetness of character, but for them

it is the enormous range of his achievements that is especially notable. Above all, it was his ability to change his approach according to the needs of a particular commission, they argue, that marked Raphael as a protean figure. Limited in the exhibition to moveable pictures, they make the case in the catalog also by reference to frescoes, tapestries, and architecture. The diversity, subtlety, and precision of the effects Raphael created are noted repeatedly, and it is when they are absent that it becomes possible to spot the assistants on whom he relied to implement his designs.

A compact example of the versatility of styles that Hall and Joannides emphasize occurs in a double portrait included in the catalog but not in the show. The subjects are two Venetian scholars visiting Rome, Agostino Beazzano and Andrea Navagero, whom Raphael distinguishes not just by clothing and posture. Beazzano is in full light, revealing even his need for a shave, captured with a clarity that comes straight out of the Florentine tradition. Navagero, by contrast, has half his face in shadow—a moodier depiction, more characteristic of the Venetians, and bearing a striking resemblance to Titian's *Barbarigo* in the National Gallery in London. It is as if Raphael is trying out two different techniques in one canvas.

If such adaptations mark even the relatively straightforward realm of portraiture—where Raphael's virtuosity, like Titian's, was still dazzling Rubens more than a century later—they are all the more visible in more ambitious works. Two of the exhibition's paintings, in particular, seem to take us from the High Renaissance far into the future. The first is the Uffizi's *St. John in the Wilderness* which, despite recent attribution disputes, remains one of Raphael's most famous images. Yet one would be forgiven in seeing the link to a successor whose very lack of sweetness may have helped give him greater appeal to modern viewers, namely, Caravaggio. The latter's *St. John the Baptist* (now in Kansas City), another nude set against a dark background, covered with a casually draped cloth, and with a long pole topped by a cross on his right, seems almost a homage to his Renaissance predecessor. The other picture that suggests such a link across the decades is Giulio Romano's powerful *Flagellation* in Santa Prassede, which Henry and Joannides themselves discuss in terms of the lines that connect the early sixteenth century with the seventeenth.

That such thoughts can arise is yet another indication of Raphael's fundamental importance in the story of Western art. If today, as José Ignacio Wert claims, his appeal does not match those of his contemporaries (and rivals), Leonardo and Michelangelo, that is a comment on the taste of our times, not on the man whom Vasari summed up as a "mortal god."

4

How Did Parmigianino Capture His Age?

It is 500 years since the birth of Parmigianino, the Renaissance artist who was once likened to Raphael and Michelangelo. He did not remain in that pantheon long, and though his talents are now widely recognized, one may wonder how he could have borne the comparison. The question is raised, in particular, by the major exhibition mounted in honor of the anniversary by his native city, Parma—an exhibition that is now in Vienna's Kunsthistorisches Museum.

Consisting of nearly 250 paintings, drawings, prints, sculptures, and decorative objects produced by masters from Raphael to Tintoretto, this is not merely a showcase for Parmigianino himself, but an overview of his origins as well as his influence during the course of the sixteenth century. More than half of the contents are from his hand—35 paintings and some 130 drawings and prints—but the purpose seems as much to place him in context as to relish his art. What is reconstituted, to some degree, and strongly argued in the catalog, is the evidence for his fame in his own day.

There is no question that Parmigianino was an exceptionally skillful draftsman. It takes no special pleading to regard his drawings as bearing comparison with those of Leonardo and Dürer. And he was almost as prolific as Leonardo. Although his life was much shorter—he died at the age of 37—we have some 1,000 of his drawings; a significant further number have been lost. Using a broad range of techniques and instruments, he had an uncanny ability to create a mood and capture a passing moment. Two sharply observed seated figures in pen and ink, a philosopher and an astronomer; a charming chalk head of the Christ child; and beautifully observed and finished pencil sketches of a dog, a young girl, and the head of the newly excavated *Laocoön*—all show an artist, even when working at speed, in command of his medium.

That his drawings were admired and imitated the exhibition makes

abundantly clear. But his reputation came from his paintings, which helped shape a new style in Rome and Venice, and in princely courts from Italy to France and Bohemia. Here is where the divide lies between his contemporaries and his successors. For after the sixteenth century, his reputation faded rapidly, and not until the publication in 1921 of Lili Fröhlich-Bume's *Parmigianino und der Manierismus* did he again begin to oc-cupy an important place in the history of his times. Neither exhibition nor catalog addresses the long hiatus, but the paintings themselves suggest an explanation, particularly if they are considered in the light of two other major shows devoted to the sixteenth century that are now on view in Europe's museums.

The first is also at the Kunsthistorisches Museum: *Kaiser Ferdinand I, 1503–1564,* a stunning collection of nearly 500 paintings, prints, coins, tapestries, manuscripts, and beautiful objects that document the life and rule of the lesser-known brother of, and successor to, the Habsburg Em-peror Charles V. The second is the display of Titian's works in an exhibi-tion, currently at the Prado, that is a spacious and luminous expansion of the version presented earlier this year by the National Gallery in London. From these two shows one gains a rich sense of the commitments and achievements of a tumultuous yet creative age, even though the northern and Mediterranean worlds that they represent often seem to have pro-foundly different interests. One can overdraw the contrasts, but there is no avoiding the sense of discipline, correctness, and orderliness in the Habsburg portraits and possessions, as distinct from the lush sensuality of Titian's art. A stately dog owned by Ferdinand's son, for example, seems almost to be posing for a formal portrait, stiff and magnificently sturdy. Titian's dogs, by contrast, cavort. They are hardly ever still: they wag their tails, they reach out, they seem to move even when just looking around.

If the sixteenth century helped shape the sensibility of succeeding ages, it is not hard to see why. The sense of organized grandeur developed by the great aristocrats of the Renaissance, and the psychological insight and power that artists began to communicate, make it clear that European society and culture had turned a corner towards modern times. But what about Parmigianino? Why, as someone so lavishly admired in his own day, does he not give the same impression of a magisterial foretaste of the fu-ture? To some extent the answer lies in the very title of Fröhlich-Bume's pioneering monograph—in the word *"Manierismus,"* Mannerism. It is by no means easy to characterize this often elusive style, though most schol-ars would agree that it was embodied by Parmigianino, that it gathered

force in the 1520s, and that its central features—a taste for elegance, achieved through delicate, slightly artificial and occasionally puzzling ways of painting—held sway at some of Europe's more refined courts for nearly seventy years, until its predilections were swept aside by the exuberance and drama of the Baroque. Parmigianino's canvases teem with Mannerism's special qualities. Surrounded by them, one can ponder both their appeal and the reasons why they seem so closely linked to just one particular moment in Western history.

The beauty of the paintings is unmistakable. Already at the age of eighteen, in 1521, Parmigianino had produced a "mystic marriage" of St. Catherine with St. John the Evangelist, with St. John the Baptist and a Madonna and child, that must have become a star attraction at the church in Mantua for which it was painted. A spectrum of colors glows from the robes and from a massive marble plinth; a segment of the wheel on which Catherine was martyred, entwined by her palm frond, catches the eye in the foreground; and the flawless faces of the holy figures form an arch that reflects the columned apse into which they are placed. We are in the presence of a masterpiece, but one which already reflects a new set of aesthetic purposes. Instead of the untroubled serenity, the symmetry, and the easy comprehensibility that marked such scenes in previous decades, we have oddities that signal a retreat from the depiction of a recognizable world that had been the achievement of the Renaissance hitherto. Catherine and an almost feminine Evangelist are crammed into one side; it is impossible to tell how the Madonna and child are supported; long fingers extend in odd gestures; one has to look closely to realize that Catherine is holding up a goblet containing her heart; and the wheel and palm are more of a distraction than an example of reverent iconography.

As Parmigianino's career progressed, this combination of painterly prowess, of radiant figures and scenes, on the one hand, with disturbing compositions and details on the other, became ever more intense. When he moved to Rome, he produced a *Circumcision* that sets exquisite colors and faces in an over-crammed panel, full of figures whose gestures and positions are difficult to decipher, leaving the viewer as much puzzled as uplifted. And these almost contradictory impulses continued after his departure from Rome, fleeing the notorious sack of 1527, until the end of his life thirteen years later. Even his portraits managed to combine the vivid with the unsettling. Parmigianino brings his sitters to life, yet at the same time he bathes them in an introspective moodiness that only occasionally (for instance, in the painting of two finely garbed young women

that is on display in Vienna) leaves room for the assertiveness or the cele-
bration that are the usual marks of Renaissance portraiture.

It is this contrast between the exquisite and the troubling that one can
regard as the hallmark of Mannerism. Parmigianino may have been one of
its most sustained exponents, but he was by no means alone, as works in
the Vienna exhibition by contemporaries such as Beccafumi, Giulio Ro-
mano, Anselmi, and Rosso Fiorentino demonstrate. Even the dominant
figure of the previous generation in Parma, Correggio, who is represented
by seven resplendent paintings, was headed in this direction in his last
years. The grace and elegance in all these works are unmistakable, but so
too is the inclination to leave the observer slightly disconcerted. Although
Parmigianino's most famous work, *Madonna with the Long Neck*, with its
indicative title, could not be brought from Florence, the issue is no less
starkly before us in his *Madonna with St. Zacharias*, also from the Uffizi.
Three figures are stuffed into one side of the picture; the saint, in exagger-
atedly larger scale, is on his own in the foreground on the other side; there
are odd gestures; the composition overfills the panel; and so forth.

There have been many explanations for this combination of elegance
and distortion. Perhaps it was a reaction against the perfection and ideal-
ism of the High Renaissance, as exemplified by Raphael, which it was
clear nobody could again equal, let alone surpass. Perhaps it attracted pat-
ronage because it served so well a highly refined court culture that was
seeking consciously to set itself apart from the rest of society. The days of
the illiterate noble, famous only for military prowess, were over; aristo-
cratic circles now sought to demonstrate their superiority through culti-
vated connoisseurship, and they were much taken by the esoteric, from
astrology to Hermeticism. In that setting, a self-evidently sophisticated
work of art, particularly if ingenious, unusual, or slightly mysterious,
found a ready audience. And finally, these were bewildering, destructive,
and revolutionary decades: the aftermath of the Reformation, which
spawned unprecedented civil violence; the disorientation caused by the
discovery of new lands overseas; the challenge of major political change,
associated with newly powerful monarchies and the name of Machiavelli;
and the outburst of new ideas from Copernicus, Erasmus, and Thomas
More. In a century when radical philosophical skepticism flourished, the
undermining of reality and calm that was the legacy of the Mannerists be-
comes quite understandable.

All of these pressures were at work simultaneously. There is no single
or simple explanation for the style, and yet every artist felt its force. Both

Michelangelo and Titian, who outlived Parmigianino, moved on from High Renaissance ideals, though they did so with a power that their young contemporary from Parma never achieved. Titian's *Marsyas*, now at the Prado, is as devastating a portrayal of indifference, agony and horror—going far beyond mere unease—as has ever been put on canvas. Without the power, however, the style remained time-bound, and one can see why, when court culture became more settled and assured, when religious warfare seemed to die down after 1600, and when the Baroque injected new qualities of grandeur and drama into the painter's vocabulary, the fastidious grace of the Mannerists was left behind.

Given the unique opportunity (probably never repeatable) that the Vienna exhibition offers, the catalog is more concerned to bring together what is known about the main periods of the artist's brief life, and to document both his oeuvre and his influences. It is a handsome publication, which will be a landmark in the study of sixteenth-century culture. Although it does not pose the question with which this review has been largely occupied, it is invaluable—especially if seen in conjunction with the other major shows of the summer—as a window onto the eternal contest between the lasting and the temporary in Western art.

5

Has History Been Unfair to Bologna?

"Italian art" is an easy shorthand that brings to mind familiar and distinctive images. Yet it masks a basic anachronism, because until the mid-nineteenth century what we now call Italy was a collection of long-independent principalities, kingdoms, dukedoms, and republics. Though united to some degree by language, thanks to the reverence for Dante and his Tuscan tongue, the inhabitants of the peninsula identified themselves with their regions, not the larger entity, and they were divided from neighbors even by the way they spoke. To this day, speakers of Piedmontese, Venetian, or Sicilian cannot understand one another. Easier for an outsider to miss, but no less proudly sustained, have been local traditions in the arts. Here the contrasting contributions of Florence and Venice may be relatively well known, but there are many other cities—Naples, Milan, Siena, Urbino, and Parma, to name but a few—which can claim a unique role within the overall story of Italian art.

A notable case in point is Bologna. Set apart by a history that went back to the Etruscans, by a prominence in trade that began under the Romans, and by a university that was one of the oldest in Europe, the city fostered a distinguished artistic tradition that eventually, around 1600, became central to the development of the Baroque throughout Italy. By comparison with Florence, Venice, Rome, and Naples, however, the Bolognese story is little known. To a large degree the disparity is the result of a paucity of famous names. Only a handful of Bologna's artists, active in the half-century starting in the 1590s, gained major international standing and exerted a broad influence on contemporaries or successors. Yet there may also have been another reason, which the volumes under review, and the series they launch, seek to redress: the relative absence of the powerful propaganda that, in the case of the Florentines, and to a lesser extent the Venetians, was embodied in the work of Giorgio Vasari.

The Bolognese equivalent was Carlo Cesare Malvasia. Malvasia was a scholarly aristocrat who took degrees in law and theology and also had a brief career as a soldier. He was devoted to his native city and found his metier when he decided to establish the importance of its artists. Unlike Vasari, he was not himself a painter or an architect, but he had an understanding of the arts, a talent for research (using witnesses as well as documents), and a critical eye that suited him to his task. His trouble was that he did not write well and—most important—Vasari had preceded him by more than a century.

It was as a riposte to Vasari's claim that Cimabue "shed the first light on the art of painting" that Malvasia began his magnum opus, *Felsina Pittrice*, with the assertion that "Bologna probably had painters and painting from its very origin." The same purpose doubtless led him to use the city's Etruscan name, Felsina, in his very title. Yet his attitude toward the Florentine veered between criticism and admiration. For all his resentment of the primacy Vasari gave to Tuscany, Malvasia did pay homage to the wealth of information, the eye for artistic excellence, and the creation of a new field of study that were his predecessor's major achievements.

Nor should the relative importance of the two men be forgotten. This new version of *Felsina Pittrice* starts by suggesting that the very different fates of Florence and Bologna in 1944 (Florence spared, but Bologna bombed) reflect the attention paid to Vasari versus the neglect of Malvasia. The editor emphasizes the disparity by citing Roberto Longhi's lament for the raids that destroyed so much Bolognese art. All such devastations are of course grievous, but one has to be grateful if indeed it was the unique stature of the Florentines, and of Vasari himself, that protected their city. That said, one can still cite Malvasia's own qualities to justify his revival.

The magnificent edition that these two volumes launch makes the case beyond cavil. Elizabeth Cropper's magisterial introductory essays not only validate the enterprise but guide us through the intricacies of Malvasia's account. The first volume, dedicated to "early Bolognese painting," starts with ancient beginnings that resemble the mythical "origins" stories that were being put forward by patriotic historians like François Hotman. Once he gets past what he considers this necessary first chapter, though, Malvasia can point to surviving twelfth-century frescoes that give the lie to the notion of an artistic vacuum before Cimabue. Even so, it is only with works of the fourteenth century that he can begin to argue for the quality of Bologna's art. And here his first exemplar, Franco Bolognese, is

cited not for specific works (none of which had survived) but for a mention in Dante's *Purgatorio* and his role in founding the first of the many art schools for which the city would be famous. It was one of his pupils, Vitale di Bologna, on whom Malvasia could at last lavish full praise. "He gave movement and life to the figures" is a judgment borne out by the excellent illustrations. Since the works could be seen, the author could also display his critical eye, which he did by linking a motif in a Vitale fresco to one in a Ludovico Carracci fresco.

Seeing for himself was crucial for Malvasia, as was any reference by other writers to his artists. Proceeding through works of the fifteenth century, he tells us exactly where each that he mentions is located, and quotes at length from sources that refer to Bolognese artists, even if the result is yet another frustrating gap. Thus he learns about a man named Severo, "mentioned exclusively in written sources," but in the end has to admit that "I have seen nothing with his name on it." Given the lack of information, this first part of the book hardly fulfils the promise of offering "lives" of painters. Even the final protagonist, Marco Zoppo, whom Malvasia proudly notes as appearing in Vasari and acknowledged as an influence by Mantegna, is little more than a shadowy figure, though his *Madonna and Child* (after 1450) makes one understand why his work could have been mistaken for Dürer's. Rather than offering us "lives," in other words, these opening pages seem intended mainly to demonstrate the existence of the arts (without much claim for their greatness) in Bologna before 1500.

The full text of *Felsina Pittrice* will take up sixteen volumes, but the second to be published (and reviewed here) is number thirteen, the life of Domenichino (accompanied by a briefer account of one of his pupils, Francesco Gessi, and Gessi's students). Dealing with a contemporary, Malvasia was on more solid ground, though he never met him, and the artist's reclusiveness meant that even in this case information was not easy to uncover. Nevertheless, Malvasia was able to give a picture of the man, quote his letters, and assess his work. He paid particular attention to what he considered masterpieces, such as *The Madonna of the Rosary* (1617–1625), but he also set the scene by recounting Domenichino's background and telling us about such matters as his fondness for arithmetic, architecture, and music; his patrons; his funeral; and his bequest to his daughter.

When it came to describing temperament and character, however, Malvasia had problems. His chief idols may have been the Carracci, but next in line was Guido Reni, six years older than Domenichino. One significant

difference was that Reni was gregarious and the epitome of easy mastery, whereas Domenichino was distant and painstaking. Malvasia did note his subject's envy of "quickness and fecundity" in others (accompanied by dislike for the impatience it engendered), and did defend his erudition and his habit of meticulous preparation. What tipped the scale against Domenichino, however, were his seclusion and the absence of disciples. The judgment was mitigated slightly by the assertion that the artist was so inimitable that no one could follow him, but it was clear that, for Malvasia, who treasured Bologna's commitment to academies and the development of traditions, Domenichino fell short because he founded no school.

Cropper's introduction to this volume explores this ambivalence in detail, and as in the first volume, provides an essential set of guidelines for reading Malvasia. Hers is an exemplary part of a truly magnificent publication. Even Vasari has not been treated this lavishly. Thanks to CASVA at the National Gallery in Washington, and above all to the production values of the publisher, Harvey Miller, these are volumes of the very highest quality, featuring large type, illustrations of all pictures, profound and extensive scholarship in notes and bibliographies, and a translation on facing pages that makes Malvasia a pleasure to read. Harvey Miller has already set the bar high with its many volumes of the *Corpus Rubenianum*. Malvasia's *Felsina Pittrice* is even more lavish, and one can only hope that next on the list will be Carlo Ridolfi's *Vite degli Illustri Pittori Veneti*.

6

Why Was Rome a Center of Innovation around 1600?

Unlike Europe's political history, which is dotted by milestones attached to seemingly random years—1648, 1789, 1914, and so forth—the history of its art seems to organize itself more neatly, by century. Quite distinct images are evoked by references to the quattrocento or to the eighteenth century. It is equally remarkable that the basic round numbers are often associated with a particular place—1500 with Florence, 1900 with Paris—and it is in this spirit that Clare Robertson has produced a deeply learned volume, *Rome 1600*.

Her opening sentence justifies the enterprise without hesitation: "Rome in 1600 was the centre of the artistic world." Over the next 400 lavishly illustrated pages, she makes the case—first by discussing the city's chief patrons, the Aldobrandini Pope Clement VIII and his Cardinal nephew Pietro, and then by laying before us the dazzling array of artists and projects that brought a new style, the Baroque, into being. This is not a matter of a single year, of course, but Robertson does not wander too far from 1600, especially since the jubilee celebration was one of the pope's chief preoccupations.

One of her conclusions is that spending the largest sums on art did not invariably make the Aldobrandini discerning patrons. An altarpiece that Pietro commissioned, for instance, is in her view "a thoroughly mediocre painting." The pope was a harsh, rapacious, and conservative figure, old-fashioned in his tastes. The nephew was more open to new ideas, more urbane, and in his architectural projects—notably the villa at Frascati—the sponsor of superb achievements. But where painting was concerned the leadership in vision lay elsewhere.

If one identifies the artists working in Rome in the late-sixteenth and early-seventeenth centuries who brought about a basic shift in artistic styles, the chief names would probably include Caravaggio, Carracci, Ru-

bens, and Reni. None was a native Roman, but all were drawn to the city by the relics of its ancient past and by its recent artistic efflorescence. They came, however, not just to study and emulate the examples of antiquity or of Raphael and Michelangelo, but to seek the abundant patronage that their predecessors had enjoyed. Here the Aldobrandini played a lesser role than the Farnese, the Giustiniani, the Mattei, and individuals like Cardinal del Monte. Pietro did commission works by Carracci and Reni, but neither he nor his uncle had an interest in Caravaggio. The major marks they left on the city were architectural rather than painterly.

Robertson deals with both branches of the arts, but she devotes most of her study to painting. Though we learn about the many palaces, villas, churches, and chapels that were built and decorated, it is the latter that prompts the fullest introduction to the commissions and masterpieces that helped transform the city. The stories are often complex or incompletely documented, but one can always rely on Robertson to offer plausible judgments of the evidence. Her account of the creation of the Contarelli chapel in San Luigi dei Francesi, for instance, is exemplary, making clear what is not known, but giving good grounds for her conclusions. There is no better introduction to the site or its famous Caravaggios. Nor is there a more perceptive guide to the way Rome looked before the age of Bernini, despite the destruction that ensued. And a few pages on censorship and rejection carve a clear path through another fraught subject.

In a final chapter, Robertson examines the lives that some of the leading artists of the time led in Rome. Here she is able to give attention to the Zuccaros, Elsheimer, and other figures who have appeared only briefly in earlier pages. Taken together with Patrizia Cavazzini's *Painting as Business in Early Seventeenth-Century Rome*, this chapter offers a comprehensive and vivid insight into the interests, the pressures, the advisors, and the structures with which these artists had to contend. If their workshops and an institution like the Accademia di San Luca gave some degree of order to their daily existence, their numbers, and the alternatives they faced, ensured that they seemed always to be scrambling for their next opportunity. And the vignettes of relatively unknown painters like Cigoli bring the atmosphere of the period to life.

<p style="text-align:center">*</p>

What all this contextualization makes clear is that Rome around 1600 was ripe for the revolution that, in these decades and this city, swept through the arts. Just thirty years before, one would have had no doubt

that the style known as Mannerism ruled the world of European painting. Indeed, the volume published in 1988 under the title *Prag um 1600* made the case that, in the last years of the sixteenth century, the Emperor Rudolf II, ruling from Prague, was the greatest patron of the time. In sculpture, moreover, the Dutchman Adriaen de Vries, working largely in the Bohemian capital, was the Michelangelo of his day. But that was not where the future lay.

The extraordinary concatenation of circumstances that vaulted Rome to its primacy in the seventeenth century was already visible by the early 1600s. Neither Caravaggio nor the Carracii were Romans, but they came to the city not only to see its antiquities and the exemplary works of recent masters like Michelangelo and Raphael, but also because its powerful families and its ostentatious cardinals offered a level of patronage not available elsewhere. No less attractive was, first, a Church whose lavish outlays were making Rome worthy of the 1600 jubilee (one need but recall Caravaggio's many altarpieces); and, second, the dominance of the city by the richest power of the day, Spain. And the particular visions of these artists—Caravaggio with his vivid lighting, his immediacy, and his drama; Annibale Carracci with his elegance, his sense of color, and his elaboration of classical themes—created a new style, the Baroque.

The grandeur, power, and drama we associate with the Baroque were very much a product of those who lived in Rome in the decades around 1600. That point was made beyond demurral by the 2001 exhibition at the Royal Academy in London: *The Genius of Rome: 1592–1623*. Yet the change also reflected a Europe-wide effort to overwhelm, with magnificence, grandeur, and theatricality, the discord and disruptions of the age of Reformation and Counter-Reformation. It is not surprising that these years also saw the birth of a new art form, opera. In the visual arts, however, it was Rome that set the pace. That is why so many foreigners came here, not merely to study and learn, but also to bring the innovations back to their homelands: Rubens, van Dyck, Velázquez, Poussin. Even the major figures who remained in Rome—Guido Reni, Gianlorenzo Bernini, Guercino, Domenichino—came from elsewhere in Italy. Like Florence in 1500, this was the hub, the home of inspiration.

If we add the criterion of innovation to her judgment, then Robertson's opening sentence becomes impossible to deny. By setting the scene, and documenting the taste of the city's chief power, the papacy, she has established the foundation which enabled Rome in 1600 to join the galaxy of centers that have shaped the history of European art.

What Happened to the Followers of Caravaggio?

As one might have predicted, 2010, the 400th anniversary of his death, has been a bumper year for Caravaggio. Exhibitions, books, and press attention have confirmed the reputation of the one-time outcast as a popular favorite. One could hardly have predicted such lionization on the 350th anniversary, because as recently as 1952 the Nelson-Atkins Museum in Kansas City was able to secure (for a not inordinate sum) a luminous *John the Baptist* that had been turned down by the National Gallery in Washington. More scholarship is now being devoted to Caravaggio than to Michelangelo—predictably, perhaps, since there is so much more to find out, such as the recent discovery of where he was born—and the major anniversary retrospective in Rome, despite its location in the gloomy, cavernous stables of the Quirinal Palace, drew bumper crowds.

The reasons are not far to seek. That Caravaggio was an artist of the first rank is undeniable. His output may have been uneven (as the Rome show demonstrated), but his standing as a true original, whose masterpieces helped change the way artists perceived and depicted the world, is beyond question. Yet this alone cannot explain why, after some 300 years of neglect, he has come into his own. For that one must look to the culture of our times. An age that likes to have its local television news programs filled with murders, fires, robberies, and assorted mayhem, and is more interested in the private lives of "celebrities" than in their accomplishments, is naturally drawn to the most notorious reprobate among the Old Masters: the habitué of the seedier quarters of Rome, the murderer, the fugitive.

It may be instructive, therefore, to look back to the first period of Caravaggio's fame, which arose from the substance of his art alone—a time when his imitators and admirers, indifferent to his life style, made him a force to be reckoned with. What is of particular interest is that his promi-

nence lasted for only a few decades, and the contrast between the forces that made for the brief flurry in the seventeenth century, and those that sustain our own interest, can suggest why the attention is now likely to remain.

The two volumes under review are the best guide to that first burst of glory. Exhaustively researched, and drawing on the scholarship of more than sixty contributors, *I Caravaggeschi* is so detailed and comprehensive an account of its subject that it is unlikely to be surpassed for many years to come. The widening interest in the epigone of Caravaggio prompted recent exhibitions in Rome and Florence, but this monumental publication has become the basic point of reference.

It takes over 1,100 three-column pages, more than 700 illustrations, and a weight of over 13 pounds to cover the chief artists as well as the main centers of activity in Italy and most of Western and Central Europe (Scandinavia, as often happens, is absent). Though the book is not always easy to use, forcing the reader to go back and forth between the first volume, devoted to artistic centers, and the second, which consists of biographies of nearly fifty of the leading protagonists, it is worth the effort in order to plumb the work of a remarkable international coterie of often obscure figures. A few of them, such as the Gentileschi and Vouet, are well known, but the majority will not be familiar, and the spectrum extends to a number of anonymous painters. Among the latter, the artist known only as Saraceni's Lodger, probably a Frenchman, is a striking reminder of the rich array of talent that Caravaggio inspired. As the Lodger's biographer notes, his work is of "high quality," and the illustrations confirm her assessment.

What is particularly suggestive is that *I Caravaggeschi* restricts itself to just the first three decades of the seventeenth century. A few latecomers, such as the English, are allowed to stretch those limits, but the boundary-setting allows the authors to make a basic distinction. Until around 1630 there were artists who tried to paint like Caravaggio: scenes, compositions, lighting, and subjects that he himself might have undertaken. Indeed, there is probably no other period in the history of Western art that produced so many depictions of the story of Judith and Holofernes. But this phenomenon was fading by the 1630s. On the other hand, there were many who, while not imitators, revealed the influence of Caravaggio, and among them the echoes resounded well beyond 1630.

It is only on the first group that this book concentrates. Although Rubens was in Rome, made a copy of the *Deposition*, and revealed his debts to

Caravaggio in a number of ways, he is not the authors' concern. Among Flemings, pride of place is given, not to Rubens, but to Caravaggists like Abraham Janssens. Similarly, the many seventeenth-century artists who did not see the work at first hand but, like Rembrandt, took ideas from Caravaggio, are specifically excluded. Yet this divide is not observed with absolute consistency, for alongside the treatment of the Spaniards Maíno, Tristán, and Ribalta we find the work of Velázquez, who in this regard seems more like Rubens (as a visitor to Rome, but hardly a Caravaggist). Nevertheless, the distinction between the early followers and those who reflected the influence less directly not only makes sense but also helps focus the book's coverage.

The result is a treasure-trove of information and insight. Very early on, for instance, the attention given to Orazio Gentileschi is justified by the comment that he "moved not only from Mannerism to the style of Caravaggio, but from mediocrity to the very highest level as a painter." Gentileschi's many places of residence, moreover, made him a pivotal figure in a number of different settings. The one exception is France, where he lived for a number of years, but where Arnauld de Lavergnée prefers to emphasize the Frenchmen who took up Caravaggism.

What is not sufficiently investigated is the meaning of that term. The authors repeatedly refer to the new "naturalism" that Caravaggio brought to art, but its elements are not explored. The editor, Alessandro Zuccari, speaking more generally, suggests that Caravaggio brought "an unusual and 'dramatic' innovative force into painting." Again, however, the components of that force receive no extended discussion. Artists are designated as Caravaggists with little further ado. This is not to say that the identification is misplaced; only that the reasoning behind it deserves elaboration.

For the record, therefore, it may be worth noting the aesthetic commitments that seem to unite the dozens of artists who are discussed in *I Caravaggeschi*. Zuccari's "drama," for instance, is apparent in the common choice of theatrical subjects, such as moments of tension or active engagement. The "naturalness" is visible in the figures, who, as in Caravaggio's works, regularly seem to be ordinary, rather than idealized, people. And throughout there is a sharpness in the depictions, emphasized by the strong contrasts between light and shade and the distinctive colors that mark both the master and his disciples. These traits make it clear that the Caravaggeschi were indeed a distinct group.

It is the editor, Zuccari, who addresses the big question: why did the

burst of enthusiasm die away? In a long essay, he traces the progression at the home base, Rome, where he defines different stages, including a "splendid decline" in 1624–1630. Zuccari emphasizes the international character of Rome, with artists constantly coming and going; turnovers in patrons; and the arrival in the city, during the mid- and late-1620s, of the rather different styles of a new generation of masters: Nicolas Poussin, Claude Lorrain, and Diego Velázquez. Suddenly, Caravaggism was no longer "modern" or revolutionary. If, as we glimpse in a later essay in the book, the devotion seemed to last somewhat longer in Naples, that was probably because of the presence of Ribera, one of the movement's chief disciples. On the other hand, the work of Artemisia Gentileschi, who arrived in Naples in 1630, is seen by Judith Mann as reflecting a "growing distance" from Caravaggio.

In other words, the inclination to embrace the new, and to leave behind what seemed "modern" to a previous generation, is by no means restricted to our own times. Fashions have natural life-spans. And where the Caravaggists are concerned, one can see the effects of a cultural shift from the upheavals and confrontations of the first half of the seventeenth century to the calmer and more restrained tastes of patrons and artists after the 1650s. Yet the current cult of Caravaggio may well last much longer, thanks to the new adherents it has found in the world of scholarship. Art historians and curators have become, in some respects, the modern patrons. And their commitments, unlike the original enthusiasms, are likely to enjoy a long life, sustained as they are by research, exhibitions, catalogs, and media attention. It is not only artists who are Caravaggeschi now.

8

Can One Explain the Shift in Rome's Values in the Mid-1600s?

Rome's abiding presence in the Western imagination derives as much from a role in the arts as from imperial prowess. And no period was more remarkable than the one that followed the reassertion of the papacy's power at the end of the Great Schism in the mid-fifteenth century. For this was a time when foreign armies dominated the city and heretics destroyed the unity of the Roman Church. Yet the relics of antiquity and the patronage of the papal court continued to inspire much of the most important artistic creativity in Europe throughout the sixteenth and seventeenth centuries. Neither the Renaissance nor the Baroque is conceivable without Rome, and although it is but one chapter in the city's unrivaled legacy, the era stands out because its glory was sustained even amid the political decline caused by the Reformation and the consolidation of Europe's territorial states.

In this long outpouring of energy and creativity, the sixteenth century has tended to take pride of place, which is understandable. Raphael, Bramante, Titian, and Michelangelo bestrode the world, and their many acolytes—from Giulio Romano to Bronzino, from Sansovino to Vignola, from Giambologna to della Porta—helped make their work essential to Western painting, architecture, and sculpture thereafter. But in recent decades the seventeenth century has attracted growing attention and enthusiasm. If its leading lights regularly paid homage to the mighty authority of their predecessors, their own achievements and influence have come to be seen as scarcely less impressive.

When they described their aims, however, they again had to grapple with the past, because no theorist loomed as large as Giorgio Vasari, whose *Lives* celebrated the very artists against whom they were measured. Vasari had documented his subjects' ability to imitate nature, to ravish with color, to compose figures and spaces, and to arrive at perfect harmo-

ny, and there seemed no reason to expect a better understanding of the nature of artistic genius. It is true that in 1607 Federico Zuccaro, the founder of Rome's principal art academy, the Accademia di San Luca, published a widely read treatise which shifted the focus from individual artists to their larger philosophy, as his title made clear: *L'Idea de' Pittori Scultori e Architetti*. Yet his emphasis on *disegno*—the skill in drawing, composition and design that had set Michelangelo apart, and which Zuccaro punningly called the sign of God—merely reinforced an aesthetic ideal that was already associated with Vasari. A new direction had to wait for more than half a century, until the publication in 1664 of Giovan Pietro Bellori's similarly titled *L'Idea del Pittore, della Sculture e dell 'Architetto*.

Unlike Zuccaro, Bellori was determined to live up to his title. For him, it was the idea of beauty that counted; it was the intellect and the imagination that created great art, not the inspiration of God or nature. Taking a Platonic and Cartesian view of beauty to its logical conclusion, he described what he thought his exemplars, the ancients and, more recently, Raphael, had achieved: the triumph of mind and artifice over nature. Beauty as conceived by the artist always outdid its representation in nature, even in the form of Helen of Troy.

As he emphasized in the long continuation of the title of his treatise, he regarded "bellezze naturale superiore alla Natura." Eight years later, Bellori published his own *Lives* of contemporary artists, prefaced by his *Idea*, and now a massive exhibition is attempting not merely to re-create the artistic world in which he lived, but to document the change in style which he championed. Entitled *L'Idea del Bello*, and described as a journey through Bellori's Rome, this enormous display of more than 700 items takes up almost two floors of the huge Palazzo delle Esposizioni. As the more than 900 multi-columned pages of the catalog, with contributions by some 40 scholars, make clear, the purpose is to present not only Bellori's own fascination with antiquity but also fifteen Baroque artists whom he promoted in his *Lives*. The array of ancient sculpture, paintings, and artifacts and seventeenth-century drawings, etchings, plans, paintings, and sculptures fill some two dozen rooms and corridors in a breathtaking onslaught of color, gesture and sheer extravagance.

How is one to make sense of it all, and what does it tell us about a decisive moment in the history of Western art? The most striking immediate impression is how partial, in both senses of the word, was Bellori's view of his age. Looking back a generation, he admired the Carracci and Caravaggio, and gave two foreigners, Rubens and van Dyck, a place in his pan-

theon. Modern art historians would agree that these artists, at work from the 1590s to the 1630s, were the founding fathers and first major exponents of the style that has come to be called the Baroque. But the qualities they fostered were not necessarily those that appealed to Bellori, as becomes obvious when one encounters the splendid examples of their work in the exhibition—shown together with some of the antique statues, gems, and medals that inspired them.

Bellori described at length Annibale Carracci's decorations in the Farnese Palace, and regarded them, appropriately, as the artist's principal Roman achievement. Yet the intellectualization of Carracci sits uneasily with the works themselves. The magnificent Annibale scene of *Hercules at the Crossroads* for example, commissioned by the Farnese but now in Naples, is not merely a cerebral accounting of the Greek hero's choice between a didactic Virtue, pointing to the mountain he has to climb to reach his worthy steed, Pegasus, and a diaphanously clad Vice, offering distractions of sensuality, music, and theatre. It is also a painting filled with tension, as a troubled Hercules, looking distractedly between the two personifications, anxiously ponders his future. Even a lush Annibale etching of *Susannah and the Elders*, also owned by the Farnese, prompted Bellori to analyze the disposition of the figures rather than to recognize the intensity of the gazes of the three protagonists.

With Caravaggio, Bellori had more difficulty, praising the use of color and trying to justify the practice of painting from nature by arguing that the artist went beyond nature to create archetypes. But he could not disguise his distaste for the vulgarity of Caravaggio's models, and he could do no better than cite "le sue inquiete inclinazioni" when faced with the qualities that are so striking in the exhibition: the passionate engagement of the artist's *Abraham and Isaac* and the dark concentration of his *Madonna of the Palafrenieri*. Nor could Bellori disguise his evasion of the strong emotions aroused by Caravaggio's disciples, as represented here by Manfredi's and Valentin's renditions, full of action and anger, of Christ sweeping the moneylenders from the Temple, or Ribera's moving *St. Matthew*.

As for Rubens and van Dyck, the learned contributors to the catalog are themselves at a loss to explain Bellori's choices. Nicole Dacos regards Rubens as the artist whose work least corresponds with Bellori's *Idea*, and Luciano Arcangeli describes the inclusion of van Dyck as the most difficult of all to understand. One can see, for instance, that Bellori was delighted that Rubens made copies of ancient marbles and of Raphael, but one cannot imagine that he would have been able to find his *Idea* in the

swirling, agonizing *Hero and Leander.*

With his remaining exemplars, Bellori had a simpler task. The sweetness, the vivid color, and the studied compositions that had made Barocci beloved by Rudolf II also endeared him to Bellori. A contemporary of the Carracci and of Caravaggio, Barocci had hardly been a pioneer of the new style, but his *Escape of Aeneas from Troy* was an almost perfect example of a constructed classical beauty that had little to do with nature. And much the same was true of the trio from the next generation whom Bellori singled out for praise: Reni, Domenichino, and Lanfranco. Here, the idealizations and the artificiality are inescapable, notably in Reni's exquisite depictions of the Magdalene and the *Massacre of the Innocents*; a marvelously gesticulating Domenichino guardian angel, standing near a classical plinth that the exhibition echoes to telling effect with a Roman funeral altar from the Vatican; and an *Ascension of the Magdalene*, by Lanfranco, that looks like a precursor of Magritte and Dali.

Similarly, the presence of Bellori's contemporaries and friends, Sacchi and Maratti, is not hard to explain; devoted to the antique, they conveyed none of the power, the fervor, or the relish of nature that was so evident among the pioneers of the Baroque. And a slightly comic allegorical portrait of the castrato Pasqualini, by Sacchi, showing the demure singer crowned by a naked Apollo, is almost the embodiment of Beauty as Idea rather than Nature. In sculpture, the case may seem less clear, because Bellori's two favorites, Algardi and Du Quesnoy, were known for their unidealized, realistic portraits, of which superb examples are on display in Rome. But both men were distinguished by a calm and by a determined emulation of the antique that won them their honored place in Bellori's canon.

Above all, it was in Nicolas Poussin that Bellori found his soulmate. There are nearly fifty examples of the Frenchman's oeuvre in the exhibition, and they are incarnations in pencil and paint of the theorist's views. There has never been a more cerebral artist, rooted in antiquity, than Poussin, and his formal, carefully posed scenes made the case for the superiority of his controlled compositions, inspired by ancient models, over the unruly world of nature. His work has plenty of movement, and a fondness for strong gestures, but all is studied and meticulously arranged.

Gone is the raw emotion of Caravaggio, the sheer luxuriousness of Rubens. Yet the inspiration of imperial Rome is omnipresent. Poussin's *Capture of Jerusalem* is juxtaposed in the exhibition with Roman sculptures of dead or dying warriors; alongside his *Triumph of Venus* stands an ancient

sculpture of Aphrodite with both goddesses partly reclining and each one raising a curved arm. Repeatedly we see how the reverence for antiquity infused everything Poussin did.

Yet the central questions remain. How could Bellori, the major theorist of the Roman Baroque, have taken so partial a view of the age he tried to define? How could he have ignored the theatricality, the fondness for the shocking, and the pervasive passion that marked so much of the art he admired? Put in more personal terms, how could a survey of Roman art in the seventeenth century omit Bernini and Velázquez, Borromini and Cortona? Might *L'Idea* have offered advance warning of the embarrassment Bernini was to suffer when he visited Paris? Questions like these force one to consider a larger context.

Bellori's life crossed one of the great divides in Roman (and indeed European) cultural history. When he was born in 1613, Spain dominated the Western world, and in particular Rome itself; by the time he died in 1696, that century-and-a-half-long hegemony had ended, and the Spaniards had been replaced by the French, both across the Continent and in his native city. The site of the Carracci decorations which Bellori so admired, the Farnese Palace, was the residence of the French Ambassador, and Bellori was closely associated with the Palace's famous guest, Christina of Sweden. Moreover, by the time Bellori received his most important appointment, as papal commissioner of antiquities in 1672, the papacy too had thrown off the Habsburg yoke. It was thus almost inevitable that he should have shared the values that were to be the hallmark of Rome's new conquerors: restraint, decorum, and a classicism that required strict adherence to formal rules. Grounded in studies of antiquity, he naturally found the archetype of those values in Poussin.

By taking on the role of apologist for the newly regulated and decorous style, Bellori became the presiding theorist of an intellectualized, Cartesian classicism: a controlled and elegant expressiveness, visible especially in France, that was to hold sway over much of Western art until the rise of Romanticism. It was no mean feat to give this style its credo, and one can see at the Palazzo delle Esposizioni how Bellori's particular predilections shaped the way he viewed the Roman Baroque.

When one comes face to face with their work, however, one finds it impossible to put the likes of Caravaggio and Rubens into the straitjacket of Beauty as an Idea. Their exuberance and fire, their resistance to constraint, pour forth from their canvases. They make tangible the élan that was to be lost as the Baroque came to an end. Another recent exhibition

devoted to Rome (*The Splendor of Eighteenth Century Rome*, at the Philadelphia Museum of Art) demonstrated how fundamentally the city was transformed as it turned its back on the striving, the ambition to overwhelm, and the high drama of the Baroque. We can admire Bellori as the theorist of a new age of order and of calm, but we must not allow his perspective to rob the previous decades of the unique power and vigor that they injected into the traditions of European art.

How Did One Buy Art in Early Modern Italy?

The interaction among art historians, economists, and historians during recent decades has added an important new dimension to our understanding of the world of the artist in Renaissance and early modern Europe. To the traditional focus on content, style, inspiration, and influence (with considerations of biography usually secondary) has now been added a huge body of information about prices, income, markets, sales techniques, and, in general, the financial and social setting in which artistic productivity functioned. Whether this new information has led to a more nuanced understanding of the ways by which aesthetic standards are shaped and defined is not clear, but it has certainly expended enormously what we know about the lives of the artists and the audiences that they served.

The most extensive work in this area has concerned the Low Countries, though there has also been substantial research into the workings of the art market in England and Italy.[1] Spear and Sohm, however, have gathered a volume of material on seventeenth-century Italy that can rival the detailed findings about the Netherlands to which scholars have become accustomed. *Painting for Profit* is a vast, unrivaled compendium of facts and figures about the daily existence of painters in five cities (Rome, Naples, Bologna, Florence, and Venice) during a period billed as a hundred years, though it stretches at times from the fifteenth to the eighteenth centuries.

Because of the book's perspective, it is full of characters and elusive details that would never, in more traditional studies, gain much attention. Sohm, for instance, tells of Lionello Spada, a fresco painter in Bologna, who had to be fed while on the job, and whose hobby was to construct, on the floor of the room where he was working, a pyramid of the bones from the animals that he had eaten. On top of this pile he placed a sign— "Funeral of the Death Feast." In another instance, the far more famous Salvator Rosa accepted Parmesan cheese instead of cash as payment for

his efforts. But food is just one of hundreds of such sidelights in the book. A number of charts show the decline of artists' income in old age; others offer analyses of the relative prices paid for various subject matters (history paintings were the most expensive and still-lifes the least); statistics also demonstrate the criteria—such as prestige, the overall size of a work, or the total count of individual figures that it contained—that helped to determine monetary value; and page after page compares the life styles, earnings, expenses, and sales techniques of artists both famous and obscure.

The one figure who rises above all others is Guido Reni, who reappears in almost every chapter as being able to demand the highest prices, which were matched only by his extravagance. At the other end of the scale were the day-laborers, who could barely make ends meet. In between were the hundreds of men and women in these five cities (a tiny percentage of the workforce serving an ever-rising demand) who turned out the canvases, frescoes, and other decorations that made the Baroque style ubiquitous throughout Italy. The best prices were paid in Naples (where Caravaggio did much better than he had in Rome), but famous artists, such as Nicolas Poussin, were not always the highest earners. A shrewd operator like Pietro Liberi could do well enough to have a palazzo built on the Grand Canal in Venice, even though he was hardly one of the great talents of the age.

Fascinating as this material is, its presentation, in dense double columns of text, makes the book seem more like an encyclopedia than a sustained narrative. The one exception is a remarkable summary chapter by Richard Goldthwaite, which pulls the threads together in a penetrating assessment of painting as an industry. Goldthwaite locates painting within the overall economy—the reasons for its growth, the innovations in method that changed its appeal throughout the centuries, the development of its markets, its inherent economic limitations, and a comparison of its value between Italy and other European countries—with a coherence and analytical bite not apparent elsewhere in this volume. The other chapters are mines of information, but for an argument that has relevance well beyond the confines of *Painting for Profit*'s subject-matter, the reader is advised to turn to this final essay.

In general, this is not a book that tells us much about the sources of creativity, the criteria for artistic excellence, or even the political context of patronage (for example, the shift from Spanish to French dominance in seventeenth-century Rome). In Goldthwaite's analysis, however, we gain a

clear picture of the forces that determined the economic conditions under which Italian painters functioned during the Renaissance and early modern times.

Was Eighteenth-Century Rome Living on Its Past?

By 1700, Rome had been the principal city of western European civilization for some 2,000 years. Other places may have had their moments of glory, but the enduring heart, first of a great military empire, then of an all-conquering church, had been Rome. For most of the previous three centuries, moreover, the city had also been the chief inspiration for the artistic revolutions that we associate with the Renaissance and the Baroque.

But that centrality was at last fading away. When Innocent X's denunciation of the 1648 Treaties of Westphalia was universally ignored, the papacy for the first time came to be regarded as marginal to the Continent's international relations, a fall in status that was never to be reversed. And the rise of Amsterdam, London, and Paris signaled the end of the Mediterranean's hegemony over the economic, religious, and cultural life of Europe. The engine of change, of new ideas, and of artistic innovation was moving northward.

The most telling shift came in the aims and interests of visitors to Italy. Half a century before, the encounter with Rome's past and present had shaped the art of Poussin and Velázquez; it had been a place of self-evident stimulation. Now, although it still offered a connection with a vital past, and remained an essential stop for the cultivated traveler, it was no longer a unique fount of artistic change. Painters learned as much in its academies as from its relics, and its patrons did not set the pace they once did for a Raphael or a Caravaggio.

Indicative of the change is the famous transformation that affected one visitor to eighteenth-century Rome: the conviction that struck Edward Gibbon, as he surveyed the ruined Forum, that he should seek the reasons the glory had passed. Thomas Jefferson, for all of his devotion to classical forms, did not even venture south when he came to northern Italy from

France. Tobias Smollett, who did make the trip, regarded the inspection of ancient relics as the main purpose of his sojourn, though he dismissed the Pantheon as a cockpit with a hole in the roof. And that other well-known traveler, Laurence Sterne, did not even take his readers to Rome, despite his knowledge of the city, in his *Sentimental Journey*.

Why, then, devote a gigantic exhibition of over 400 works—the largest show the Philadelphia Museum of Art has ever mounted—not to mention a sumptuous and learned catalog, to eighteenth-century Rome? For the same reason that one would welcome such an exhibition about eighteenth-century Venice, another city that had lost both power and artistic influence, yet still shone in the canvases of Ricci, Canaletto, Guardi, Magnasco, and the Tiepolos. The Eternal City may have become not so much the sire as the embracer of talent, but there was plenty of it to celebrate: Rome's own Venetians, Piranesi and Canova; its Luccese Batoni and its Piacenzan Panini; and its galaxy of non-Italian residents, including Fragonard, Robert, Houdon, and David from France; Wilson and Adam from England; and Kauffman and Mengs from Switzerland and Bohemia. Clearly, the city remained an important setting for artists, who could benefit from its patrons, its academies, its ancient monuments, and its thriving market for the arts, let alone the centrality of its physical features in the imagination of Europe.

Those features, never more ravishingly portrayed than by Panini, overwhelm the visitor entering the Philadelphia exhibition. In the entry hall and the first room are eight enormous Paninis, accompanied by a Locatelli, which sweep the eye across the dazzling buildings and spaces that epitomize modern Rome. The panoramas, the maps, and the designs for new public works, from the Piazza del Popolo to St. John Lateran and the Trevi Fountain, set the scene, and they remind us how much of modern Rome was shaped in the seventeenth and eighteenth centuries. Indeed, it is astonishing to see how compact the city still was: in one Panini, open country stretches right up to the Tiber and the Castel Sant'Angelo from the north, across a district that now bustles with teeming streets.

Once the stage is set, we enter the world of religious devotion, elegant visitors, graceful furnishings, and the decorous taste that epitomized the eighteenth century. In a few instances, notably the works of the young David, one feels the power, the quest for grandeur, that had pervaded Rome's art in previous generations. But these are exceptions. In the vast majority of the paintings commissioned by and for the leaders of Roman society are depictions of holy scenes, of miracles, and of pious figures

who replaced the strivers of the Baroque with a restraint, a sweetness, and a dignity that give religion very different qualities.

It is not surprising that the culture of the times was summed up by Sterne as sentimental—in its non-pejorative meaning of tender emotion and what Sterne called "fine feelings." He himself, captured in a gleaming marble bust by Nollekens that was to make the sculptor famous (and apparently helped identify the skull when Sterne's remains were transferred to his Yorkshire home in 1969), looks out on a room filled with portraits of the famous denizens of Rome, many of whom echo his characterization of the age. Distinguished aristocrats, dedicated artists, and the father of the modern study of ancient art, Winckelman, are just a few of the figures whom Sterne surveys. A delicate self-portrait by Angelica Kauffman suggests the choice of careers she faced at a young age. She stands between two allegorical figures, representing music and painting, who tug her in different directions; only the picture itself reveals which of her talents she decided to pursue.

Yet amidst this gentility and refinement there is also a wall adorned with pungent caricatures by an artist, Pier Leone Ghezzi, who is more famous today for his wicked lampoons than for the colorful scenes of saintliness that gave him his reputation in his time. The hilarious drawing of the noted castrato Farinelli, for example, in costume for one of his roles, is a foretaste, decades earlier, of Gillray and Cruikshank. Amidst the proprieties of the Roman world, these caricatures are rare indicators of the taste for satire that was a notable feature of eighteenth-century culture. Perhaps Ghezzi, as a native of the city rather than a visitor or guest, felt free to cast a skeptical eye on the genteel figures who otherwise parade before us in splendid and unruffled finery.

Another distinctive eye was that of Piranesi. Trained as an architect and printmaker in Venice, he found his metier in the drawings and engravings that he produced after he moved south. These works, scattered throughout the exhibition, are a late echo of the centuries-long admiration for the classical past, but they also form an extended love poem to the buildings, spaces, and very fabric of Piranesi's adopted home. Yet he was no mere dreamer. Another splendid Nollekens bust makes him look like a cross between an ancient emperor and Winston Churchill. Seeing this resolute figure, we can easily appreciate Piranesi as the master of a thriving workshop, and one of the most successful entrepreneurs in Rome's burgeoning art market.

In an accompanying exhibition, drawn from the Philadelphia Museum's

extensive print collection, which surveys the heritage of antiquity as it was spread through Europe by three centuries of engravers, Piranesi is represented by one of two prints he made of a magnificent Roman vase that had recently been unearthed at Tivoli. But this was no mere homage to a beautiful object from the past; it was also a means of finding a customer for the vase, which in fact was bought by George Grenville, and has since migrated, via William Randolph Hearst, to the Los Angeles County Museum. Yet in the end it is not his commercial acumen but the power of his art, the immensities that he is able to suggest—whether in fantastic prisons, in city scenes, in monuments, in stonework, or even in inscriptions—that sets Piranesi apart from his less arresting contemporaries. A pen and ink drawing in which he reconstructed what was assumed to be a prison room for gladiators, recently excavated at Pompeii, puts him in a league with Goya. The manacled figures sit despondently on the floor, below a shelf of the helmets they will have to wear, the entire scene suffused with oppression and despair.

In his very different style, Panini, too, summed up the engagement with the physical city and its past that dominated eighteenth-century Rome. A pair of huge paintings, reunited here from their separate homes in Boston and Stuttgart, take a theme made familiar in the previous century by David Teniers—the gallery of works of art—and evoke on a huge scale the masterpieces that defined the public image of both the ancient and the modern city. Its most famous buildings (shown in paintings within the painting) and sculptures adorn the walls and floor of an immense arched interior, looking out to a garden beyond. In the ancient scene we see Panini himself, palette in hand; in the modern the central figure is Choiseul, the French ambassador who commissioned the works. They pose in settings that seem to be the very embodiment of Rome, its different periods of greatness distinguished by the presence of Michelangelo's *Moses* or the *Laocoön*, St. Peter's or the Pantheon. Tiny figures within the interior paintings—in front of Bernini's Four Rivers Fountain or on the Capitoline Hill—only reinforce the *trompe l'oeil* that has the viewer imagining that the city has somehow been compressed into canvases just seven or eight feet wide. For all their scale, these pictures were so successful that Panini was twice more commissioned to create such pairs of *Roma antica* and *Roma moderna*. Like Piranesi's engravings or Canaletto's canvases, though, they were magnificent tourist mementos rather than sources of inspiration for Europe's artists, as the Roman past once had been.

It is this transition that one senses amidst the Philadelphia show's rich

and lavish detail. The exhibition is a treat for the senses, a perfect reflection of a society that was living in elegant reminiscence of a heroic past. There have been few cities as welcoming to people of style and cultivation as eighteenth-century Rome, and it is indeed splendid to have it brought back to such vivid life. But over this grace and display there looms the realization that the future lay, not here, but in the tough-minded questions coming out of Enlightenment Edinburgh and the fervor surging through revolutionary Paris.

Part Eight

Venetian Art and Architecture

1

What Triggered the Creativity of Venetian Art?

The appeal of Venice is inexhaustible. Except for a handful of curmudg-eons like Dudley Carleton, the seventeenth-century English ambassador who found the city dark, rank, and corrupt, and a generation or two of the revolutionary-inclined around 1800—notably Jefferson and Napoleon—who disdained the city's pretensions to good government, the standard response to the long-lived republic and its concentration of wealth and artistry has combined affection and awe. Naturally, therefore, our leading museums mount exhibitions connected with Venice with steady frequen-cy. There have been six major shows devoted to Titian since 1990, and others on Giorgione, Lotto, and more general subjects such as Venice and the north. The problem increasingly (as with the Impressionists) is to find a new angle. But that is exactly what the National Gallery in Washington and the Kunsthistorisches Museum in Vienna have now achieved.

As was apparent in the recent *Bellini and the East* exhibition, Venetian painting did not come into its own until the decades around 1500. For centuries the port had been a wealthy naval power, and also a magnet for tourists and for Crusaders and pilgrims on their way to the Holy Land. It may have been famous for its luxury goods and for the pleasures it of-fered its visitors, but its leadership, a hard-nosed military/merchant oli-garchy, patronized extensively only the traditional and eastward-looking arts of stone: architecture and mosaics. In the decades around 1500 that situation changed dramatically, and the Washington exhibition under re-view—*Bellini, Giorgione, Titian, and the Renaissance of Venetian Painting*—explores this crucial phase of the transformation, between 1500 and 1530, when a few brilliant figures forged new ways of treating both old and new subject matter and shaped a style that reverberated far beyond their city.

There are 52 paintings on display in Washington; with a few changes, they will move on to Vienna. For its wealth of glorious masterpieces, this is an exhibition not to be missed. Yet its aim is to disclose patterns of in-

novation, and that is what sets it apart. The argument, visible in the show, and strongly (though repetitively) put forward in the sumptuous catalog, is that in these thirty years a series of new directions was taken that made Venice a new center of original ideas and inspiration for Western art.

The opening three rooms lay out the first case: that, by shifting the structure of a devotional picture from vertical to horizontal, as Giovanni Bellini in his *Madonna with Blessing Child*, and Titian in his *Gypsy Madonna* memorably showed, space opened up for the pastoral landscapes and the interacting figures that became hallmarks of Venetian religious art. Other examples from the early years of the century by Lotto, Palma Vecchio, and Pordenone—the first also showing unmistakable influence from Dürer, who visited Venice in 1505 or 1506—emphasize the dynamism of these scenes, with squirming babies and gesturing saints, and the lushness of the countryside that often served as their background.

Four pictures, in particular, demonstrate how far artists had moved from the stately holiness of just a few years before. A Giovanni Bellini *Jerome Reading* and a Giorgione *Adoration of the Shepherds* push the main subject to the right, leaving the eye to occupy itself with peaceful yet busy distant vistas on the left. The attention to rocks, to foliage, to countryside and sky reflects a new atmosphere, and an interest in asymmetrical composition, in religious art. But it was Titian who brought landscape and dynamic theatricality together in his *Noli Me Tangere*, where a turning Jesus pulls away from the forward movement of a kneeling Mary Magdalene. Behind them, an angled tree balances Christ's twisting body, while a huge panorama, with a small town, farm animals, and woods and fields turning to blue towards the horizon, surrounds the drama with a sense of ultimate peace. And then, finally, there is a marvelous Savoldo of St. Anthony in flight from his torments (a notable departure from his usual endurance). Here the landscape on the right is Boschian, with flames, monsters, and even Bosch's touches of humor, visible in a tiny scholar reading a book, but with huge clawed feet. Anthony, arms raised and toes splayed, races towards the calm of a countryside on the left that could have served as the setting for a *Madonna and Child*.

From religion, which was by far the favorite subject of the age, we move to new kinds of portraiture. Although pictures of individual women were rare in this period, the striking fondness of this "dolce vita" city for sensuousness and flirtatiousness was soon evident. Venice was to be famous for her nudes, but even Giorgione's relatively demure *Laura* exposed tantalizing décolletage. Scholars have for some time assumed that

the ladies in déshabille were courtesans, which makes sense, though the catalog comment that "there were more than ten thousand prostitutes in sixteenth-century Venice, not including the procurers, servants and others who depended on the commerce" suggests—for a city of some 100,000 inhabitants—the need for a historian amidst the art historians. At any event, the startling contrast, in this exhibition room, with Giorgione's *Vecchia*, the sad, disheveled, and open-mouthed old woman pointing to herself and holding the phrase "col tempo" ("with time"), demonstrates the strong moralizing streak amidst the celebration of beauty.

The portraits of men reflected a different quest for novelty. Here it was character and interaction that came to dominate. Sebastiano del Piombo's *Ferry Carondelet and his Secretary*, for example, not only presented a lifelike imperial ambassador, but placed him in a scene alive with interchange. With his secretary looking up at him expectantly, Carondelet has a look of contemplation as he composes the reply to a letter he holds. The messenger, dimly visible behind him, looks straight at the viewer. And the lively background—a classical marble temple with a carving of the ambassador's motto ("Recognize opportunity") on one side, and a pastoral landscape on the other—merely adds to the interest of the three gazes, though the dominance of the richly clothed central figure is never challenged. And the end of the exhibition, Titian's *Man with a Glove* infuses life into a portrait by depicting a young man as a Castiglionean courtier, a cynosure of elegance, relaxation, and grace. Creating a new ideal, drained of the stiffness and formality that was the norm, Titian establishes a model for aristocratic portraiture that was to last for centuries.

Before this final room, however, are two rooms devoted to allegory and myth, where one sees the flowering of Venice's belated interest in antiquity, which had captured Florence and a number of Italian princely courts decades earlier. Dominant in the first room is Giorgione's *Three Philosophers*, a rumination on age and on the different objects of philosophic inquiry, including darkness and light, nature, geometry, and astronomy. The new fascination with landscape and human character gives the picture both its immediacy and its mystery. Hung alongside it is the most famous of Venetian classical allegories, the *Concert Champêtre* from the Louvre. Its dull and grainy surface contrasts sharply with the many pictures specially cleaned for this exhibition, and until its surface is revealed in full glory the long debate between Giorgione and Titian attributions will be hard to resolve.

Next door, re-framed in order to be adjacent to one another, as origi-

nally intended, are two paintings that are the climax of the show: Bellini's *Feast of the Gods* and Titian's *Bacchanal of the Andrians*, commissioned by Alfonso d'Este for his Alabaster Room in Ferrara. We have known for some time of the competitiveness among the Venetian masters of these years, and in particular of Titian's determination, in this picture, to outdo his master. His lush, fully displayed nude raises the temperature of Bellini's semi-clad sleeping nymph; his bird is grander than Bellini's; he adds a suggestion of the three ages of man; and so forth. But what the juxtaposition of the two pictures demonstrates beyond argument is that Titian's repainting of Bellini's background, replacing a grove of trees with a mountain descending to a sunlit glade, was meant to link with the sunlit glade in his own painting. Seen together, the pair of masterpieces, for all their differences, transports the viewer to the Arcadian landscape of the classical gods.

A final question remains. Why now? What was it that prompted this outburst of experimentation and creativity? This is not an issue the writers of the catalog spend much time addressing. Instead, they repeatedly emphasize how sparse is the surviving documentation and how tricky a number of attributions. When they do dwell on the larger history, they point to the various crises of the age—the losses in the Mediterranean, plague, fire, and the disastrous war of the League of Cambrai, when Venice was driven out of her possessions in the *terra firma*, the mainland—and either marvel that such exuberance was possible amidst the mayhem, or see various aspects of the new style (for instance, its peaceful landscapes) as escapes from the turmoil. But might not the answer be found by reversing the connection? Could it be that the military failures on land and at sea, and the waning resilience in the face of disaster, were themselves the result of a subtle but unmistakable shift in the priorities of Venice's patricians? Perhaps the hard-boiled warrior/mercantile elite was softening as it responded to the new values of Renaissance refinement and aristocratic behavior that were springing up around it. Machiavelli sneered that Venice's rulers were not true gentlemen, but maybe that is what they were becoming at this very time. Felix Gilbert many years ago identified this period as the time when members of the Venetian upper class shifted their attention from commerce and war to the good life that soon was to be embodied in Palladio's villas. If he was right, then this splendid exhibition documents the birth of this new body of patrons, renowned for their taste and for the artists whom they supported, and at the same time underlines the enduring debt we all owe to those who proved willing not

merely to beat their swords into plowshares but also to exchange their armor for the garb of the connoisseur.

2

Why Is Titian a Special Presence in Western Art?

Only one Old Master in the history of Western art has never fallen out of fashion. However much we may admire them today, Michelangelo, Raphael, Rubens, Vermeer, Rembrandt, and Caravaggio have all suffered periods of neglect and indifference. That was never true of Titian, the long-lived Venetian who has influenced other artists and commanded the highest prices in every generation since his death in 1576.

Why has he held this unique position? Why is it that so many who followed, such as the Spaniard Velázquez, regarded him as the ideal they sought to emulate? Two exhibitions in Europe this summer—at the National Gallery in London and at the Prado—take the reverence for their subject for granted. But the questions remain, and one must be grateful for the opportunity to seek answers amid these riches.

The London show, displayed in the subdued lighting of the underground area that is now the gallery's major exhibition site, had a hard time making the case. The best the catalog could do was the comment that "his greatest contribution was to extend the expressive range of oil-based pigment." But the paintings did manage to convey the ravishing colors, the noble figures, and the persuasiveness of composition that indicated why Titian's influence persisted over the centuries.

The Madrid show, larger, more spacious, and bathed in natural light, allowed the impressions to flower. The Prado has 35 Titians of its own, thanks to the Habsburgs' passion for his work. Five more are in and around Madrid, and 25 foreign loans made this one of the most comprehensive assemblages of his art one is ever likely to see. Although the Madrid catalog does little more than its British counterpart to suggest why Titian has been so widely appreciated for so long, it is certainly more expansive. Above all, though, the Prado exhibition was the best place to ponder the reasons for Titian's enduring appeal.

A fundamental source of his popularity—his use of color—is apparent at once. It is fitting that no other artist's name is also that of a color: the glowing red that is one of Titian's trademarks and lights up room after room. And he used it not merely to give richness to a scene but also to focus the viewer's attention. In a desolate *Entombment of Christ*, for instance, he extends the arm of Joseph of Arimathea, who is holding the body, well beyond its possible actual length in order to create a splash of red from Joseph's sleeve right at the heart of the scene: next to the dead white hand, with its own splash of red, the blood from the crucifixion nail. Titian regularly distorts physical reality for effect; here the distortion enables color to tie the composition together.

And it is not just the reds that dazzle. There are radiant blues (often the Virgin's robe, notably in that *Entombment*), greens and browns, and luminous whites. Even Michelangelo, who haughtily complained "that these Venetians . . . do not apply themselves better," admired Titian's use of color. And it is especially notable in the creamy flesh of his nudes, one of the specialties that made Titian a continuing inspiration for later artists.

The first lush example at both exhibitions is in a *Bacchanal* commissioned by the Duke of Ferrara for a room that, in its original form (reconstituted in London), must have felt like an act of homage to the human body. Even among the dozens of nudes, however, the provocative sleeping nymph in the *Bacchanal* proclaims a sensuality that has rarely been matched (though much imitated) in Western art. The painting hangs, as it did in Ferrara, next to *The Feast of the Gods* by his teacher, Giovanni Bellini (on which Titian also worked), and it makes the semi-clothed sleeping nymph in the latter seem tame—a comparison that Titian may well have expected viewers to make.

A room in the Prado elaborates on this mastery, with two versions of a naked Danäe reclining on her bed as Zeus visits her in the form of a shower of coins; a ravishing *Venus and Adonis*; two versions of a reclining Venus with an organ player; and (most famous and influential of all) the *Urbino Venus*, presented to the viewer in all her glory. So many of these nudes were bought by Philip II of Spain that Erwin Panofsky used to refer to that austere king as one of the great connoisseurs of the female form in Europe.

Yet eye-catching beauty was only the start. What is notable in Titian's portraits and religious art is the psychological insight. With the possible exception of Holbein in England, Titian was the most sought-after portraitist in the Europe of his day. And in creating character he was without

peer. The masterpiece of the genre, which was included in both exhibitions, is his portrait of Pope Paul III. One is almost inclined to wonder how the pontiff allowed himself to be shown thus: as a shrewd and suspicious old man, one hand clutching the purse from which he distributed bounty—an ambiguous accessory that may hint at his notorious nepotism. Even more devastating is Titian's portrait of the old man with his two grandsons (which hangs next to it in Naples but, sadly, was not on view), a painting that bristles with so much tension that Titian may not have been allowed to finish it. Paul was a Farnese, a family famous for its military skills, and it was largely as a result of his astute policies that the church's Counter-Reformation proved so successful in the fight against Protestantism. After seeing Titian's portrait, one begins to understand why this pope was so formidable an opponent.

Not all the portraits are this effective. A depiction of a recently deceased empress is flat and unconvincing, perhaps because Titian had not had a chance to study her in person. But a two-year-old girl from the affluent Strozzi family with her dog is an extraordinary evocation of charm and innocence, almost the complete antithesis of Paul III. Nearby, the aristocrats and patricians of the day proclaim their untroubled superiority, and even the self-portraits, though more muted (the example in Madrid reminds one of Rembrandt decades before his time), still emphasize the wealth and standing the artist himself had achieved. Again and again, one feels one has come to know Titian's subjects, whether a thoughtful clockmaker or two angry young bravos about to come to blows. The emotion spills out of the latter painting despite the distraction of an astonishing red ruffled sleeve that dominates the canvas.

With royalty Titian seemed more discreet. There was no mistaking the authority and the riches that kings conveyed, but there is little plumbing of character. Instead there is the creation of the standard of grandeur by which royalty and power could be judged. The enormous equestrian portrait of Emperor Charles V, in particular, became the model for kings, ministers, and warriors for centuries. To make the point, in Madrid (from which it cannot travel) the picture is placed so that one can see at the same time, in the Velázquez room alongside the exhibition, the Spaniard's variation on the theme in his portrayal of the royal minister Olivares.

All of these skills came together in Titian's religious works. To the elegance, strength, and color of the saints, Madonnas, and other biblical figures he depicted throughout his career, there was added, as he grew older, a somber mood, a sense of drama, that foreshadows Caravaggio. A vigor-

ous, confident John the Baptist becomes, 30 years later, though in similar pose, darker and self-absorbed. We see unmitigated horror, too, as St. Lawrence is martyred on a burning grill or as, a few years later, the mythic figure of Marsyas is flayed alive. St. Jerome, yearning for salvation and close to despair, holds the stone with which he beats himself in contrition. And Christ's sorrows become ever more intense, even when he is fully lighted in brilliant blue and red at one corner of an otherwise dim, dark brown *Agony in the Garden.*

The evocation of deep human emotion sets these works apart, and it may be that the absence of real feeling is what makes Titian's allegories (which he rarely painted, possibly for this reason) seem so tame by comparison. But one aspect of his art remains consistently remarkable, whatever the ostensible theme: his landscapes. Here Titian set a standard that none of his imitators—even the Impressionists, for whom it was a central concern—exceeded.

Whenever you go outdoors in Titian, you can tell, as had never before been the case in Western art, exactly what the weather is like, and usually also the time of day. Unlike Raphael's idealized scenery and skies, here you are unmistakably in a real setting: The clouds are scudding past, and there may even be a wind blowing. Shafts of sunlight illuminate the very air, and foliage rustles in the trees. Just as Titian was able to suggest that a dog was wagging its tail or make painted fabric (as his friend Pietro Aretino put it) seem more real than the fabric itself, so he could make nature come alive. One suspects that this ability alone would have endeared him to every generation that followed.

Yet there was still one more quality that inspired his successors. Unlike any previous artist, Titian was accepted by his society not merely as a highly skilled craftsman but as a member of the aristocracy. Emperor Charles V gave him a title of nobility, which made it official; what was more telling was that in his native Venice he lived like a patrician, in a splendid palazzo with a lovely garden. For a village boy from the mountains near Venice, apprenticed in the workshop that cut mosaics for St. Mark's Basilica and then taken on as a student by the leading Venetian painters of the early sixteenth century, the heady ascent into noble circles demonstrated the new status of art in the Renaissance. That Rubens, van Dyck, and Velázquez should have been similarly elevated a century later merely confirmed the example Titian had set. It is true that wealth and status did not come unsought: Titian was ambitious and knew how to advance his own interests. But there is no denying that the eminence he

achieved helped transform the status of the artist and inspired all who followed. It is a major reason Titian remains one of the central icons of Western civilization.

3

Did Competitiveness Help Shape Venetian Art?

One is easily fooled by Venice's nickname, "La Serenissima." Soothed by the waters lapping gently against the swaying gondolas, ravished by the mist-shrouded views of exquisite towers and domes, and made content by a never-ending supply of Prosecco, one readily concedes that here is the most serene of republics. But nothing could be further from the truth. There is no place on earth whose fate and achievements owe more to fierce hostilities, to bitter competition, to ruthless struggles for survival and supremacy. Venice is the ultimate Darwinian city.

This was true not only of her internal conflicts but of her very place in history. Sharp elbows were second nature to the patricians, and through-out the society animosities and feuds were endemic. Even a distinguished man of letters and a cardinal, Pietro Bembo, lost the use of a finger in a street fight over a lawsuit. Lower on the social scale, two factions regularly scheduled violent encounters on the city's bridges. The dark vision of James Fenimore Cooper's *Bravo* is no travesty of a quarrelsome, intrigue-ridden society. And the competitive instinct served her well as she swept rivals aside to establish her wealth, her dominance of the Aegean, her rule of northern Italy, and her presence throughout the eastern Mediterranean.

But what about the arts? Here, surely, the nickname is earned as we contemplate the rich colors, the calm figures, the charming pets, and the sunny landscapes that fill Venetian canvases. Yet that, too, is an illusion. It is true that, for the practitioners of some kinds of art history, there are no exemplars of high achievement more worthy of close attention than the Bellinis, Giorgione, Titian, or Veronese. Their work yields endless insights into aesthetic standards, mastery of conception and technique, originality, and the elements of creativity, prompting discernments both revealing and instructive. That, however, is to respond to paintings, not to painters. As soon as one tries to understand personalities—how they went about their

tasks, what they were aiming to do, how they earned their living, and why they behaved as they did—an entirely different set of questions arises, and the connections with the other inhabitants of their city rush to the fore.

The purpose of Boston's remarkable exhibition is to elucidate precisely this context: the competitiveness that drove even the greatest artists to some of their supreme achievements. Through an adroitly positioned display of 54 canvases, we are convinced that, in this respect, Titian, Tintoretto, and Veronese were unmistakably Venetian. What is astonishing is that this is the first exhibition to approach them in this way. We know about the protean Picasso, and his uneasy connections with Braque, Matisse, and others. But the Old Masters?

That they succumbed to such impulses is suggested by a few well-known stories, in Vasari and elsewhere. But it was not until Rona Goffen's *Renaissance Rivals* (which Frederick Ilchman, the curator, appropriately honors in the catalog) that the theme of competitiveness assumed major importance. And it is still often relegated to the sidelines. It was not much in evidence, for example, at the splendid Palladio exhibition at the Royal Academy this year, despite Tracy Cooper's exhaustive recent demonstration of the centrality of competition for patronage in Palladio's life. If, therefore, the Boston exhibition can help temper the usual reverence, it will have done much to advance our understanding of the Old Masters and their works.

The emblematic story in the relationship of these three artists, mentioned more than once in the catalog, took place in early June 1564. One of the rich and powerful charities of Venice, the Scuola san Rocco, was determined to make a splash in the world of charitable institutions by commissioning the finest decorations for their magnificent headquarters. Accordingly, they announced a competition for the oval canvas at the center of the ceiling of the *albergo*, the room where the Board met. As was customary, the finalists (Tintoretto, Salviati, Zuccaro, and Veronese—not a shabby group) were asked to come to the *albergo* with drawings of their proposed entries, which the assembled Board would judge. The four competitors appeared with their drawings, except for Tintoretto, who, when asked for his design, had the cardboard covering the ceiling removed, to reveal his finished painting, *St. Roch in Glory*. Thanks to an accomplice on the Board, he had been able to install it secretly a few days earlier. To complete his triumph, he offered the picture to the confraternity as a donation, which they were bound to accept (though 20 of 51 Board members still voted against it—another reflection of the factions that

swirled through the city). The consequences of this episode dazzle to this day: the vast array of Tintorettos throughout the Scuola (of which he became a member), and particularly the enormous *Crucifixion* in the *albergo*, which Ruskin and others have considered the finest painting ever made.

Where the exhibition is concerned, however, this is merely one of many dramatic instances of the aggressiveness that underlay the interactions of this artistic community. One might have thought that Titian, by far the oldest of the trio on display in Boston, and famous throughout Europe by the time the others entered the scene in the late 1540s, would have been immune. But no. The exhibition begins with his training in the studio of Giovanni Bellini (two Bellinian panels are the only works not by the three protagonists), to show how, from the start, he injected movement and emotion into his heritage. We then jump to the period of nearly four decades when he overlapped with Tintoretto and Veronese. By then, however, his competitive instincts were well honed. A perfect example is the altarpiece he painted for San Giovanni Elimosinario, a small church near the Rialto. This was newly built, and while Titian was out of the city in the 1530s one of his contemporaries, Pordenone, began to decorate the interior, notably with a large portrait of three saints that is there to this day. Titian's intervention, a portrait of San Giovanni in his trademark posture of giving alms, was intended, so Vasari tells us, not merely as a pious gesture but also as a deliberate attempt to outshine Pordenone. It hardly seems surprising that, many years later, he could not resist intruding into Veronese's church, San Sebastiano, with a *St. Nicholas* that still is the first painting that greets the visitor.

It was no wonder, therefore, that Titian should have kept out a sharp eye as Tintoretto and Veronese began to compete for commissions. Their talent was obvious, and in Tintoretto's case it was married to a naked ambition and an ability to work at furious speed that clearly alarmed the older man. Veronese was a much gentler figure, and so it was not surprising that, when tenders went out for the decoration of the ceiling in the new Marciana Library, Titian made sure that Tintoretto was excluded and that Veronese got the prize for the best contribution.

This story, too, appears more than once in the catalog, and it is interesting to see how differently the contributors view Tintoretto's aggressiveness in driving the tripartite rivalry. For Ilchman, an expert on Tintoretto, adjectives such as "assured," "bold," "defiant," even "brazen," bespeak a profound admiration. Patricia Brown, by contrast, drily notes that, after installing some paintings for the Duke of Mantua—his first trip outside

Venice—Tintoretto "characteristically . . . sought (without success) to replace the court artist . . . with himself." And Linda Borean appropriately refers to him as the "enfant terrible" of the trio. Love him or hate him, though, there was no escaping Tintoretto's driving and almost overabundant creative presence. Mark Twain spoke of being taken aback by the "acres of Tintorettos" in Venice, but recognition of his genius was unavoidable.

A major merit of the Boston exhibition is that, in effect, it tames this hyperactivity in order to show its effects. Thus the installation of a ceiling canvas once owned by Aretino in the ceiling, where it belongs, gives one a sense of Tintoretto's range, but serves also as a reminder of how the artist could rub people the wrong way. Aretino bought the painting while Titian was away from Venice, but did not repeat the mistake after experiencing his friend's fury when he returned to the city. One can also imagine what Titian must have said when he saw how Tintoretto had refashioned one of his own most famous works, an expansive *Presentation of the Virgin*, now in the Accademia, which showed the little girl climbing a long stairway. The younger man's version, in the church of Madonna dell'Orto, was tight, angled, and dramatic, dominated by the staircase, and with an entirely different feel. Tintoretto may have been a difficult colleague, in other words, but the results of the rivalries he relished were paintings of grace, elegance, power, and profound insight.

It seems almost invidious to pick out just a few of the juxtapositions that the show uses to illuminate its central themes, but one cannot do equal justice to some two dozen revelatory pairings. Perhaps the most striking is what Ilchman calls the nude and the mirror. The Titian prototype, Washington's *Venus with a Mirror*, provides the catalog cover and the emblem of the entire show. Hung next to it is Veronese's extraordinary response, also *Venus with a Mirror*, from Nebraska. Where Titian has the half-nude goddess seen from the front, Veronese has her in almost the same pose, but seen from the rear. The result is an awkwardness in the twist of her head that seems almost painful, yet it is clear that Veronese's aim was to demonstrate his comparable mastery of lush flesh and crimson drapery. Tintoretto's nude with a mirror is Susannah, and we do not see her reflection, but we do see the full body, drapery, and a creamy, shadowed skin that proclaims itself the equal of anything Titian or Veronese could produce.

Nearby, alongside one another, are three versions of *The Supper at Emmaus*. Titian's was famous, amongst much else, for the exactitude of the

objects on the table—almost Dutch in their precision—and for its shimmering tablecloth. In much of its history, the painting was in fact called *The Tablecloth*. When Tintoretto took the subject on, he kept the column behind Christ's head to emphasize his central position, but he realized he could not match the mastery of the objects on the table, and instead of a dog on the floor he put a cat. To make his mark, though, he put the figures into almost violent motion. Gone was the stunned surprise as Christ was recognized; instead there was movement, action, and far-flung arms. Veronese, ever gentler and more approachable, left the column in place, but now focused all attention on a heaven-gazing Christ. There was more of an effort to render the tablecloth, but the stamp he put on the subject was an adorable little girl, looking out at the viewer and embracing the inevitable dog.

Similar competitive dialogues pervade the exhibition. There are three St. Jeromes in the wilderness. Three women with just a touch of drapery face grave peril: two Lucretias and an Andromeda facing a remarkable Veronese monster that would do a horror-movie proud. In every case there are echoes of predecessors' compositions and conceptions. The same is true of depictions of children with large dogs; of portraits; of figures in armor; of floating saints and divinities; and of goddesses as symbols of love and fertility. The show has both Titian's *Venus and Adonis* and Veronese's *Venus and Mars*, embodiments of the female form clinging to a lover, though not the third in the trio, Tintoretto's *Origins of the Milky Way*, where a nude Juno arises from the same red drapery as Jupiter approaches with the baby Hercules. The rivalry that helped propel the creativity of these masters is unmistakable.

What is interesting is that, in one respect, the competition did not end with the deaths of the artists. Alongside the magisterial catalog essays by Ilchman on the rivalry itself and by Brown on the forms of their patronage is an essay by Borean on the collectors who bought the trio's works in the sixteenth and seventeenth centuries. This is a story that, again, shows how patrons' preferences, cross-connections, and reputation affected the fate of the paintings over the decades that followed. The story is brought up to date by Nicholas Penny's meticulous and comprehensive catalog of the Venetian paintings of 1540–1600 in the National Gallery in London. Our three artists and their imitators take up nearly 300 pages in a 440-page publication, a massive compilation that is in many ways a testimony to their continuing appeal.

There are other major figures in the Gallery's collection, notably the

Bassanos, Paris Bordone, and Palma Giovane. Yet Palma's *Mars and Venus*, seen in the wake of the Boston exhibition, looks like a mere extension of the themes laid out there. One cannot deny that the National Gallery paintings offer a sumptuous window into Venice's Golden Age. And the catalog's exemplary erudition adds depth to the overview of the Boston show. Thus the 30 pages on Titian's *Vendramin Family* are so rich in information about the identities of the subjects, their clothes, the significance of the cross, the different hands that worked on the canvas, the nature of the composition and its details, the meaning of the work in the family's history, and the fate of the painting in subsequent centuries, that they transform one's understanding of the picture. It is to this kind of analysis that the Boston exhibition adds a new and fascinating dimension.

At the end of this immersion in the art of Venice's Golden Age, a pair of images remains insistently in mind. Both are in the Boston show, but their subject matter is unique, they are hung far apart, and only indirectly do they throw light on the rivalry theme: two self-portraits by Tintoretto. The first, done in his late twenties, when his fame was beginning to take off, shows the burning, piercing intensity that carried him through confrontations, triumphs, and the irresistible urge to outdo all his contemporaries. The second, which closes the show, is of the old man, around seventy, who had outlived both Titian and Veronese. There is only sadness in the eyes, a sadness that seems to suggest how impossible it was for an artist of such drive and ambition ever to achieve satisfaction or serenity.

That may not be an upbeat ending, but it does reinforce the conclusion pointed to by the Boston exhibition: for all the grief and anger it caused, the competitive urge was essential to the artistic creativity of sixteenth-century Venice.

4

How Did Living in Venice Affect Veronese?

One of the many ways in which Venice is unique is her relationship with her artists. A few masters tend to be associated with specific cities—Dürer with Nuremberg, Masaccio with Florence, Bernini with Rome—but there is nothing in Western history to compare with the long succession of stars across nearly 400 years whose very names evoke just one place, Venice. From the Bellinis and Carpaccio in the 1400s through Titian, Tintoretto, the Palmas, and on to Canaletto, Guardi, and Tiepolo in the 1700s, the identification between painter and city is inescapable. The result is that, per square inch, there may be more major works of art and architecture on the mudflats of the lagoon than anywhere else in the world.

One reason for the abundance is that for a good part of this period Venice happened to be the wealthy, proud, and powerful center of an empire, though in the last two centuries of its independence it was in noticeable decline and the patronage that fueled the outpouring of beauty increasingly came from foreign visitors. Still, there were other rich urban centers, and none inspired the long-term devotion of so many great artists. Was there something beyond patronage that fostered the bond with the Serenissima? The career and interests of Paolo Veronese, one of the luminaries of this story and the subject of an evocative exhibition at the Museo Correr, may offer some answers.

There are just 42 paintings and drawings on display—though within a mile of the Correr one has access to dozens more of the artist's works, and it makes sense, in particular, to compare his treatment of patrons, myths, and biblical scenes at the church he made his own, San Sebastiano, with these subjects as represented in the show. This is especially instructive in that all but one of the items on display come from outside Venice (in some cases, because of the depredations of Napoleon, who seemed particularly fond of looting the Venetians), and also because both church

and exhibition include distinct decades of the artist's career, from the 1550s to the 1580s.

The title of the Correr exhibition is *Veronese: Gods, Heroes, and Allegories*, and the equal attention paid to these subjects gives one a clue to the attraction of Venice for Veronese (not to mention its implications for the city's artistic traditions). There were so many patrons available, with such a variety of interests, that a market existed for every conceivable topic of Renaissance art. Venice also happened to be the most popular tourist destination of the age, famous for shops and luxury goods on the one hand, and sensuous delights and courtesans on the other. The consequences for the artists hardly need emphasis.

From Carpaccio onward, and perhaps most notably in Titian's sumptuous nudes, the attractions of the city's female beauties were carried on canvas throughout Europe. A remarkable Veronese, once in nearby Mantua but thanks to Napoleon now in Caen, is on display here: a *Temptation of St. Anthony* unforgettable for its raw emotion. A lush temptress, her breast exposed, holds back with clawed fingers a hand raised in self-defense by the aged saint who, impervious as usual to all distraction, is about to be smashed in the face by a powerfully muscled devil with his arm raised. The jewels on the temptress, the sheer exuberance of the flesh on both devils and on the poor saint's outstretched leg, make this unmistakably a Venetian picture.

By comparison, the female figures of *Justice* and *The Liberal Arts*, completed before Veronese moved to Venice, are demureness itself. Yet when, just a few years later, he paints portraits of young patrician ladies, their swelling bosoms and rich adornments proclaim a boldness that is unmistakably Venetian. A lushly naked Venus, perched on Jupiter's lap, and a huntress Diana showing off an ample leg, merely confirm the particular qualities of the arts in Veronese's new home.

Equally apparent was the cult of magnificence. This was an immensely rich city, and Veronese was the artist *par excellence* of the wealthy household. There is no room at the Correr for his gigantic banquet scenes, the most famous of which are in the nearby Accademia and (once again thanks to Napoleon) in the Louvre. The teeming setting of an intended *Last Supper* famously got Veronese in trouble with the Inquisition, despite his defense of the artistic bravura that decorated his huge canvas with a multitude of figures swirling around the central feast. He had to admit that putting drunkards and dwarfs into a *Last Supper* might hint at the heretical notions engulfing Germany at the time, but his response was a typ-

ically no-nonsense example of Venetian practicality. He changed the title of the painting to *The Feast in the House of Levi*, and it is as such that one can admire it in the Accademia to this day.

The relaxed, undemanding Catholicism, overshadowed by ornate displays of wealth, was only to be expected in this multicultural trading city that was home to a cornucopia of faiths unique in Europe. The seat the Venetians gave their patriarch, San Pietro in Castello, was about as far away from the center of town as possible, and their many quarrels with the papacy finally led to an Interdict not long after Veronese died. In this respect he may even have been more typical of Venice than Titian, who was capable of an intensity of piety that one does not often find in the more theatrical religious paintings of his younger contemporary. It is suggestive that the ceiling of Veronese's church of San Sebastiano is devoted to Queen Esther. The story of this Old Testament heroine, rarely found in such prominence, offered fine opportunities for scenes of courtly splendor, and that may well be what drew him to the subject.

There are scenes from the lives of Mary and Christ in Veronese's oeuvre, but they often seem placed on a stage, and it is telling that they do not figure at the Correr. Instead, the religious subjects here, such as the *St. Anthony* or an enormous rendition of *Susannah and the Elders*, seem designed mainly to convey drama, sensuality, or power. The *Susannah* seems to be the occasion for another of Veronese's theatrical settings. She does move away from her richly clothed observers, but there is little emotion. Once again, we are in a genteel aristocratic world.

The same is true of the portraits, one of the chief features of the Correr exhibition. Here we see a patriciate utterly at ease. Whether they are warriors (the naval commander Agostino Barbarigo, who died of wounds he received at Lepanto) or scholars (the erudite Daniele Barbaro, editor of Vitruvius), it is their relaxed contemplation of the viewer or a distant horizon that strikes the eye. These are exemplars of the very serenity that gave their city its nickname.

If one seeks the sensuality that was Veronese's trademark, then, the Correr show suggests, one must look to mythology and allegory. Veronese loved the subject of Venus and Mars, and there is a wonderful example here from Turin. The amorous couple are of course caught *in flagrante*, but not by anyone who will disapprove. Coming down some steps is a little Cupid, leading a horse whose head—all one sees—peers around at Mars, reminding him of his other duties. Intended solely to give delight are a Cupid from Munich holding on to two large hunting dogs, and a very

contented bull carrying off a Europa who is surrounded by her buxom helpers but who eventually rides off with him to sea. A *Youth between Vice and Virtue* from Madrid seems more reserved—though again laid out like a scene from a play—until one looks more closely at Vice, who seems understandably surprised by what is happening; given her charms, we too can appreciate how difficult it must be for Virtue to haul the unfortunate lad away from the scene.

That mythological and allegorical scenes seem primarily the occasion for a spirited demonstration of Veronese's mastery of color, elegance, and the beauty of the human form comes as no surprise. Living in Venice must almost have seemed like living on a theatrical stage. Very soon the great set pieces that entertained the citizenry in the Piazetta were to be transformed into a new art form, opera, performed in specially-built houses that were a Venetian invention. If Veronese seems the perfect precursor to the drama and the assault on the senses of the opera stage, he was but one of a line of great painters who responded to Venice's visual stimulation and its freewheeling society by identifying his art so closely with his home.

5

Is There a Palladian Aesthetic?

The 500th anniversary of the birth of Palladio in 1508 prompted a flurry of exhibitions, books, and catalogs. As the scholarly outpouring settles, it has become clear that the Centro di Studi di Architectura Anrea Palladio in Vicenza has become a major force, not only in exploring the works of the master himself, but in advancing our understanding of the sixteenth-century enthusiasm for classical antiquity to which he made so central a contribution. The Centro's two successive directors, Howard Burns and Guido Beltramini, have been at the forefront of this enterprise, and the volumes under review are a tribute to the discoveries they have made and the new appreciation of Palladio and his contemporaries that they have brought about.

The principal exhibition and catalog that the two directors oversaw was simply called *Palladio*, and traveled to four sites between 2008 and 2010. With over 200 drawings, paintings, and engravings that documented both his oeuvre and his influence—exquisite models that brought the designs to life, and a handsome and learned catalog whose crisp photographs put one in the presence of the buildings themselves—this was a superb intro-duction to a rich and varied life's work.

Yet it is not so much the set pieces or even the most famous achieve-ments—the Teatro Olimpico, the Redentore, the Villa Barbaro—that catch the eye. Rather, it is the unexpected vignette. In just a few pages, focusing on two drawings, the editors and Mario Piana draw attention to an interest of Palladio's that is not often remarked: his plans for low-cost housing in Venice. This never-realized project, which addressed a need that is felt to this day, puts a very different light on an architect who is usually thought of as the creator of elegance and grandiosity. Here we have the avid and erudite student of antiquity, deeply committed to such ideals as spaciousness, proportion, and harmony in patrician and public

buildings, turning his talents to the design of modest city homes.

Equally revealing is a canvas painted by El Greco, once owned by Rubens, which Lionello Puppi here identifies as a portrait of Palladio. As Puppi points out, it shows the austere, thoughtful sitter with his hand on a book, not the traditional compass and square. What we see, in other words (and appropriately so) is a man who is as much scholar as architect.

It is these excursuses from the main story of the stone-carver turned architect, the protégé of humanists, and the meticulous drawer, engraver, student, and author, that add an enlivening dimension to the basic account of a powerful creative mind at work. Yet in the end it is the close attention to the details through which Palladio imposed grace on symmetry and rendered structures harmonious and balanced that make this catalog an essential introduction to Palladio's working methods as he set his stamp on the Veneto and thereafter across Europe and America.

The catalog for the much smaller exhibition at the Morgan Library is notable for Beltramini's essays, and for magisterial opening essays by James Ackerman, the dean of Palladio scholars, and Burns. This more modest enterprise gives only a glimpse of the treasures displayed in the larger volume, but it does provide a closer look at Palladio's American legacy. Thanks to the publication of his *Four Books on Architecture*, he was able to exert a profound influence on his successors, even across the Atlantic. That the impact came from the writings and illustrations, not direct experience, was made clear by Thomas Jefferson, the greatest of American Palladians, who, when traveling in northern Italy, made no effort to get to the Veneto. Jefferson called Palladio his "bible," and that was literally true. It was the text alone that made the architect a worldwide figure.

Amidst all the celebrations of 2008–2010, however, one volume issued by the Centro stands out for originality of theme and revelation of a hitherto little-known side of Palladio. Edited by Beltramini, it explores a fascination with warfare that seems completely out of keeping with the architect's other interests. Yet it was precisely his embrace of antiquity that led him in this direction. Encouraged by patrons to use his talents to illustrate works by Caesar and Polybius on warfare that, without images, were not easy to follow, Palladio produced an astonishing series of bird's-eye-view engravings that are here reproduced in full. And the link with the architecture soon becomes apparent, for what fascinated him was pattern: the layout of troops in battle formation, the shapes into which attackers and defenders arranged themselves in a siege, the symmetries in a fleet or a detachment of cavalry. The topography of a battlefield may be necessary to

complete a picture, but it is the geometry of the soldiers' lines that gives his illustrations structure and purpose. In one extraordinary instance, the design of a Palladian villa echoes the design of a defensive formation of pikemen. It was the aesthetic, not the subject matter, which created the connection.

Anniversaries may not always bring out the best in the celebrants, but Palladio's quincentenary has in fact been splendidly served by the very undertakings he himself cherished: dedicated scholarship and the publication of elegant books.

How Do Artists Shape Our View of Cities?

We often visualize places through artists' eyes. Can one imagine a lily pond without Monet, the Dutch landscape without Ruisdael or Hobbema, or Suffolk without Constable? No place, however, has been so fixed in the imagination by painters as Venice.

Why the effect has been so powerful is hard to tell. It may be that, because there is so little natural topography to distract the eye, one focuses entirely on what is man-made between sea and sky. Unlike cities defined by rivers or hills, this one consists of structures that rise out of the water against a clear background. Nowhere else—and this, as we will see, is no accident—so vividly resembles a theatrical mise-en-scène. It may also be that the center of attention is usually an ensemble, a small world full of people, rather than an individual structure, as is often the case in Rome and other cities. Those central scenes, moreover, have been so often depicted that they have become uniquely familiar. In no other place are there so many settings that a multitude of paintings have made immediately recognizable: the Piazza San Marco, the Piazzetta and Campanile, the Bacino of San Marco with the Doge's Palace or San Giorgio, the Salute church and the entrance to the Grand Canal, the Grand Canal itself, and the Rialto Bridge. Or could it be the quality of the art these sights have attracted?

Attempts to depict Europe's cities, not as generic clusters of buildings, but as distinctive configurations, began around 1500. Already in these early portraits it was clear that Venice was unique. Hartmann Schedel in his *Nuremberg Chronicle* of 1493 shows a recognizable city (based on an earlier woodcut by Erhard Reuwich) that is unlike any other in the collection, though the foreshortened perspective brings a fantastic rendering of the Dolomites close into the background. Even amidst the pictures and maps in the more carefully observed survey that was published by Georg Braun

and Franz Hogenberg in the 1570s, by far the most dramatic print is a double view of Venice: on one side, the familiar Piazza San Marco, on the other the fire that engulfed the Doge's Palace in 1577. A number of other surveys and maps, not to mention paintings by Carpaccio and Bellini, evoked the Venetian cityscape, but it took some two centuries before the rise of the genre known as '*vedute*'—views—gave painters the medium through which representations of Europe's urban features became major works of art in their own right.

It is to that genre, and its most renowned exemplars, paintings of Venice, that an exhibition at the National Gallery in London is devoted. Following a growing trend in art history to show artists working in competition with one another (Michelangelo versus Leonardo, Tintoretto versus Titian), the exhibition's title *Canaletto and His Rivals* suggests struggle, though in the event the overlaps and contentions have as much to do with imitation, variation, and elaboration as with rivalry. What we see is a remarkable succession of artists, across more than a century, who pursued a basic theme. If one of their number, Canaletto, became more famous than the rest, and there was the occasional contest for patronage, they nevertheless resembled brethren more than competitors.

How did it all begin? As the magisterial introduction to the exhibition catalog by Charles Beddington makes clear, the first impulse came from northern Europe. Nor should this have been unexpected. After all, the collections of city views of the previous 200 years, and even the huge Barbari map of 1500, owed their origins to northerners, mainly in the Netherlands and Germany. Moreover, the patronage that kept the genre alive for over a century was also largely foreign, especially English, and Beddington notes repeatedly how few of the results remained in Venice. They appealed as reminders of places no longer easily seen.

The pioneer was a Dutchman, Gaspar van Wittel, known in Italy as Vanvitelli. Trained by an artist interested in landscapes and city views, Vanvitelli came to Italy in his mid-twenties and never left. Starting in the 1680s, he found eager patrons in Rome, and in the following decade turned his attention to other cities. It was in the mid-1690s that he apparently stayed for a while in Venice, making the drawings from which he created some 40 paintings over the next 30 years. These canvases, of which only one is in the exhibition, may have been seen by Canaletto in Rome, but they tend to encompass a far broader vista and offer less of a sense of inhabited space than the work of his younger contemporary. Still, he did get the genre under way.

Vanvitelli's most immediate successor, the Udine native Lucas Carlevaris, set his mark with a remarkable set of 103 engravings of Venetian views, including such rarely portrayed landmarks as the Miracoli church. But it was as a *vedute* painter that he paved the way for Canaletto. His canvases are more crowded and less luminous than his successor's, and his subjects remained close to San Marco. What is notable is that he set in motion two traditions: the depiction of gala events, such as regattas, and the dependence on foreign patrons. Whether the two artists felt competitive or not (and there is no evidence that they did), it was the shift of the patrons to a new star, Canaletto, that provides the exhibition with the first of its "rivalries."

That came early in the younger man's career, in the 1720s. The only other real competition came later, in the 1730s, when Bellotto, Canaletto's nephew who was to go on to a successful career in northern Europe, caught the eye of English patrons who previously had looked only to his uncle—among his commissions were at least fifteen canvases for Castle Howard. And in the 1740s, Marieschi's published engravings of *vedute* bore comparison with the engravings of Canaletto's work that had broadcast his fame in the mid-1730s.

These few are the only occasions when it seems fair to speak of a rivalry in which the success of one artist may have had an impact on the fortunes of another. For most of the time there was plenty of room for many flowers to bloom, and the exhibition pays due respect to the half-dozen lesser artists who were contemporaries of the masters. It also celebrates the final flourishing of the genre, during the second half of the eighteenth century, in the work of Francesco Guardi, once again a particular favorite of the English, and renowned for his evocations of the grand ceremonies of Venice.

The stars of the exhibition are Canaletto, Bellotto, and Guardi, as indeed they should be. These three created a sense of atmosphere, of immediacy, and of elegance that none of their contemporaries could match. And each had particular strengths. In Canaletto it was the unique crispness of his scenes, linked to his ability to shift a mood—from a splendid occasion on the Grand Canal to a quiet Campo, always set against the impassive dignity of the local architecture. Beddington rightly rejects the traditional view that the figures in his canvases are of no importance. As he notes, the people, and even the dogs, always enliven the scenes, each figure conveying "its own character and individuality."

With Bellotto the chief impression is of immensity. Though he was

often imitating his uncle, albeit with less sunny weather, the scale some-how seems enlarged. There may not be more sky per square inch, yet Bellotto manages to suggest a grandeur of vista that was to become his trademark. This may be partly because his figures, more stolid, do not catch the eye like Canaletto's, or because he smartens up his subjects. As the juxtapositions of the two men's work in the show reveal, his *Torre de Malghera* is less cluttered, his *Campo Santa Maria Formosa* less moody, his *Entrance to the Grand Canal* much neater.

With Guardi we return to the everyday. Boats criss-crossing the Bacino, spectators scattered about at public occasions, the Campanile soaring higher than in any Canaletto, grainy but glistening buildings, and the little flecks of white highlights—all combine to create a shimmering space that is distinctive in both color and feel. Though his subjects may be the same, Guardi does not try to emulate Canaletto. Instead, he changes the light, the sky, and the mood to shape his own, less dramatic but more intangible vision of Venice.

Two other features of these paintings deserve comment. The first is their theatricality. It was no coincidence that Canaletto, Marieschi, and Joli were experienced set designers. The city itself served as a stage for its spectacles—such as the outdoor performances in the Piazzetta, where the balconies in the Marciana became models for the opera houses that were first built in Venice. Its sixteenth-century architects, Palladio and Serlio, had designed for the theatre, and the *capricci*, the imaginary scenes, which most of the *vedute* artists painted, were also closely related to set designs. Even the adaptations of reality in the *vedute* themselves, such as reducing the number of bays in a building, or changing angles, perspective, or the structures themselves to enhance an effect, were a concession to the re-quirements of drama. There is no question that the theatricality of these works, inherent in Venice itself, was essential to their appeal.

The second feature was the astonishing level of foreign patronage they inspired. The English, in particular, bought with a lavishness that may be unique in the history of art. There can be few analogs in the annals of pat-ronage to the Duke of Bedford's purchase, within just a few years in the 1730's, of 24 Canaletto canvases, all of which remain at Woburn to this day. As the user-friendly exhibition catalog (with its excellent brief biog-raphies and its glossary of Venetian names) points out, very few of the *vedute* were bought by locals. What was made in Venice manifestly did not remain in Venice, because these were paintings which, above all, recreate a sense of place that visitors relished more than did natives. And it was the

foreigners who picked up the theme from the *vedutisti*, as the city came to be a favorite subject for Europe's artists: Turner, Monet, Sargent, Whistler, and the scores of painters and engravers who have etched Byron's "tiara of proud towers" ever more deeply into the imagination.

7

Why Is Venice Beautiful?

The aesthetic qualities that make Venice so remarkable a testimony to human ingenuity and taste have long been debated. Four books reviewed here continue the debate—not as sparring partners, but as works which, though animated by the question "What is special about Venice?", approach the answer along very different paths.

For Daniel Savoy, the uniqueness of the city derives from its relationship to water. Adapting the techniques of spatiovisual analysis that have been elaborated by his teacher, Marvin Trachtenberg, he has brought to the study of Venetian architecture a perspective that puts its distinctive vistas in a new light. What he emphasizes is the need to view palazzi, churches, and ensembles from the water. That is how they were seen by citizens and visitors, traversing canals and waterways as they moved about during the centuries when the buildings were being raised. And it was precisely their awareness of this viewpoint that shaped the decisions of architects and patrons alike.

Two detailed analyses make the case compelling. When the Giudecca was extended to the east in the fourteenth century, a narrow channel was created between its point and the island of San Giorgio. To this day, anyone heading toward the center of town from the Cipriani Hotel experiences the sudden unveiling, as one rounds the tip of the Giudecca, of the whole of the Bacino, with the Doge's Palace and the Piazzetta as backdrop. Many have commented on the theatricality of Venice's sights, but Savoy here demonstrates how deliberate was the effect. There is a similar analysis, involving a close examination of geometrical relations, that explains the positioning of the facade of Palladio's San Giorgio Maggiore. Hidden from sight, the facade comes suddenly and stupendously into view as one exits from the Grand Canal into the Bacino.

These are particularly dramatic instances of the way that a traveler's

slow progress on the water has helped determine the city's visual impact. But there are many others. Savoy also traces the routes by which notable visitors were brought across the lagoon, getting varied glimpses of towers and landmarks as they peered through mists or shaded their eyes against a dazzling sun. Maybe because pollution has now made it a rarity, he does not mention the panorama of the Dolomites which must have been a spectacular background as one approached from the south.

Within Venice itself, the rippling waters, the changing play of light, the unexpected discoveries as one rounds a bend in a narrow canal, and the means that were used to make a building seem to float on the water, all had a powerful impact. And Savoy emphasizes that the effects were intended. With carefully chosen illustrations, and a handsome layout, his book makes the case elegantly and effectively. It is true that at times Savoy's intricate arguments can be difficult to follow, and some of the terminology, notably the frequent recourse to "urbanistic," can make for heavy going, but he has added a valuable dimension to our understanding of Venice's special qualities.

Margaret Muther D'Evelyn could hardly be more different. In her book, she mentions some of the same features of the cityscape as Savoy: the sudden glimpse of San Giorgio as one exits the Grand Canal, or the proposal by Alvise Cornaro to put a theatre in the middle of the Bacino. But her goal is less to explain the unique impact of the city on its viewers. Rather, she seeks to enter into the mind of one of its most important theorists of architecture, Daniele Barbaro, the patrician who translated Vitruvius' *Ten Books on Architecture* into Italian (1556) and then prepared an edition of the Latin original (1567), illustrated by his protegé, Andrea Palladio. D'Evelyn's route into Barbaro's mind is his work on Vitruvius, which she has studied in minute detail, and which she uses as a means of understanding the structures, the building methods, and the appearance of the city as he saw it.

Much of her analysis derives from a close reading of Barbaro's copious writings, together with earlier commentaries on ancient architecture that he knew by Leon Battista Alberti, Sebastiano Serlio, Cesare Cesariano, and Giovanni Battista Caporali. But much rests on speculation. Unprovable assumptions are frequent, as in the notion that "it is hard to imagine" certain documents not being "of keen interest" to Barbaro. The conclusions are often plausible, but one is not always sure, when D'Evelyn takes one around Venice, whether what she sees is always what her protagonists saw. Did they stand in the "shady campo" to ponder the symmetries of

San Francesco della Vigna, or stroll towards part of the Doge's Palace to pay attention to its "invisible foundations"? Her aim is not so much to explain the impact of what she sees as to link Venice's buildings to the theoretical constructs of Vitruvius and his commentators, especially Barbaro. The more than 140 illustrations are devoted, not to the visible echoes of Vitruvius' or Barbaro's ideas, but to the drawings and engravings that embody their theories.

This is a long book, not always easy to follow, that addresses only indirectly the nature of Venice's uniqueness. But its subject is crucial to the theme. For what D'Evelyn explores in such detail is the underpinning of the fundamental transformation in the city's appearance when her architects embraced "Roman," classicizing ambitions, leaving behind the medieval and Moorish styles of the previous centuries. This reorientation, associated primarily with Sansovino and Palladio, transformed palaces, public buildings, and churches. Since the purpose was to emulate the ancients, as Renaissance humanists demanded, Vitruvius became the guiding light. By suggesting how his ideas inspired his successors, and how their theories shaped physical structures, D'Evelyn has shown what lay behind the new look that overtook Venice in the sixteenth century.

Yet the city changed yet again in the eighteenth century, and the architect who dominated the transformation, Baldassare Longhena, has found his definitive biographer in Andrew Hopkins, whose book was also published in 2012. Moreover, thanks to nearly 350 superb illustrations, the architect's ideas and buildings lie visibly before us. Hopkins' theme is versatility. Unlike Palladio, always seeking perfection, Longhena adapted his ideas to the needs of his patrons. Across a career of some sixty years, he took on bookcases, facades, tombs, altars, staircases, elements of synagogues, and humble rental houses, as well as monasteries, churches, and palaces. His masterpiece, Santa Maria della Salute, remains to this day a hallmark of the Venetian scene, as central to our image of the city as the Doge's Palace or the Campanile (*Illustration 10*). Hopkins calls it "a theatre of the world floating in the water," and thus emphasizes those aspects of Venice's fabric that Savoy and D'Evelyn also celebrate. He reaches that conclusion, moreover, through a combination of the former's searching gaze and the latter's profound scholarship.

One may think of travelers to Venice, rather than natives, as creating its image: the early pilgrims and merchants; the participants in the Grand Tour, who emptied the city of its Canalettos; and the famous visitors like Byron, Ruskin, and Twain. But among artists the reverse is true. It is the

local painters of *vedute* who have set the city firmly in our minds: primarily Canaletto, but also his contemporaries Carlevaris, Longhi, and others. None of these *vedutisti*, though, was as successful in capturing the shimmering, ethereal quality of the cityscape, and even its interiors, as Francesco Guardi. He is the subject of a major bicentennial celebration at the Correr Museum, and the exhibition catalog allows those who cannot be there to glimpse the effects that set him apart.

One of the catalog essays, "Venice through Guardi's Eyes," calls attention to the originality of his vision, which was "antithetical to the orientation of Venetian painting." Casting aside any inclination to evoke sunny, decorative scenes, Guardi relied on muted colors, bustling people, almost evanescent buildings and transparent water to suggest the city he inhabited. Cloudy skies, sudden gleams of light, and cloaked figures absorbed in a daily round come together to evoke what many a commentator has called the magic of the place.

It may be that all these investigations and analyses resemble nothing so much as the attempt to capture a sunbeam. But the effort remains unflagging, driven, as always, by the quest to comprehend the combination of elusive qualities that shape the uniqueness of Venice.

Afterword

Where the use of art in the study of history is concerned, much has changed in the past half-century. The "cultural turn" in historical scholarship has led to an interest in a period's artifacts and other visible relics that has transformed our understanding of past eras. The analysis of material goods as well as works of art has offered important new insights into the attitudes, assumptions, and mind-set of our ancestors. There is no denying the major advances that have taken place since the 1970s.

But it would be foolish to predict that images will ever become as essential as texts in the historian's armory. The basic problem is a lack of training in the analysis of visual materials. To be taken seriously as a specialist in any age before modern times, one must be able to read the handwriting of a period and master the languages its people spoke. Those are basic requirements in any graduate school. But there is no equivalent demand for proficiency in deciphering images. It was sheer luck that, while I was in graduate school, Erwin Panofsky, then at the Institute for Advanced Study, gave a rare seminar that explored how images could be interpreted. How often can such subject matter be studied by young historians?

The problem of inadequate training is compounded by two other features of the contemporary academy. The first is a precipitous decline in the acquisition of the basic knowledge of cultural history that used to be taken for granted. Expectations have had to be radically lowered when it comes to familiarity with the Bible or even a basic acquaintance with the main monuments, writings, and characters of our heritage. This is not the place to seek reasons for the decline; but the consequences are unavoidable.

The second problematic feature of the contemporary academy is that the divide between those who have this fundamental knowledge and those

who do not is reflected within both history and art history. David Ekserdjian has recently lamented the split between experts in contemporary art and those who study the Old Masters, and a similar division has arisen between those for whom "theory" is central to historical research and those who disagree.[1] Related to this internal division is an unfortunate divergence in the purpose of research, which means that each discipline goes its own way. Thus most art historians study a subject in order to understand the art; most historians, on the other hand, focus on broader issues, ignoring the art.

Given these obstacles, the best response is to marvel at the progress in cross-fertilization that has already occurred. A body of literature—some of it discussed in the essays in this book—now exists; techniques and approaches have been explored in this literature; and although major achievements, such as those of Jacob Burckhardt, will continue to depend on individual talent, one can predict that the analysis of the past through the images it produced will continue to remain a vital means of advancing historical research.

References

References

References indicate each essay's original publication, though most essays have been revised for this book. Also provided are some of the footnotes that accompanied each essay.

A number of these essays first appeared in British publications, but every attempt has been made to adjust their spelling and punctuation to American usage, given that this book is being published in the United States.

Readers will note that Pieter Bruegel the Elder's name is spelled without an "h," because that is how he signed his pictures in his last years; it was his descendants who usually spelled it "Brueghel."

Abbreviations

JIH — Journal of Interdisciplinary History
LAT — Los Angeles Times
NYT — New York Times
TAN — The Art Newspaper
TLS — Times Literary Supplement

A First Question: Why Does Michelangelo Matter?

Commentary, vol. 122 (September 2006), 56–59.
A review of the British Museum exhibition, *Michelangelo Drawings: Closer to the Master* (2006).
 [1] Lene Ostermark-Johansen, *Sweetness and Strength: The Image of Michelangelo in Victorian Britain* (Farnham: Ashgate, 1998).

Part One: 1. What Links Historians and Art Historians?

JIH, vol. 4, no. 1 (Summer, 1973), 107–117.
A review of the following books: Bruce Allsopp, *The Study of Architectural History* (New York: Praeger, 1970); Erwin Panofsky, *Problems in Titian, Mostly Iconographic* (New York: New York University Press, 1969); Christopher White, *Rembrandt and His World* (New York: Viking, 1964); Christopher White, *Rubens and His World* (New York: Viking, 1968); Jóse López-Rey, *Velázquez' Work and World* (Greenwich, CT: New York Graphic Society, 1968); Arthur S. Weinsinger and W. B. Coley, trans. and ed., *Hogarth on High Life*. The Marriage

à la Mode *Series from Georg Christoph Lichtenberg's Commentaries* (Middletown, CT: Wesleyan University Press, 1970); and Ronald Paulson, *Hogarth: His Life, Art, and Times*, 2 vols. (New Haven: Yale University Press, 1971).

[1] John Hale, "What Help From Art?" *TLS* (April 7, 1966), 292–293.

[2] William S. Heckscher, *Rembrandt's Anatomy of Dr. Nicolaas Tulp* (New York: New York University Press, 1958).

[3] The works of Panofsky referred to above can be found in *Studies in Iconology* (New York: Oxford University Press, 1939); *Meaning in the Visual Arts* (Garden City: Doubleday, 1955); *The Life and Art of Albrecht Dürer* (Princeton: Princeton University Press, 1943). For the quotation, see *Problems in Titian*, 108: "'All art is one, remember that, Biddie dear,' says Henry James' Nick Dormer when his charming but not very bright young sister insists that 'the subject does not matter.'"

Part One: 2. What Role for Art in the History of the Sugar Trade?

JIH, vol. 45, no. 3 (Winter 2015), 407–12.

A review of Daniel Strum, *The Sugar Trade: Brazil, Portugal, and the Netherlands (1595–1630)* (Redwood City: Stanford University Press, 2013).

[1] Jonathan Brown and John H. Elliott, *A Palace for a King: The Buen Retiro and the Court of Philip IV* (New Haven: Yale University Press, 1980).

Part One: 3. Can an Exhibition Illuminate Peace as Well as War?

NYT (December 13, 1998), 10 & 39.

This is a much-revised version of a review of an exhibition and its associated catalog: Klaus Bussmann and Heinz Schilling, eds., *1648: War and Peace in Europe* (Munich: Bruckmann, 1998), 3 vols.

Part One: 4. Can a Single Painting Open Windows into History?

TLS, no. 5665 (October 28, 2011), 10–11.

A review of Carola Hicks, *Girl in a Green Gown: The History and Mystery of the Arnolfini Portrait* (London: Chatto and Windus, 2011).

Part One: 5. How Should Historians Use Images?

JIH, vol. 33, no. 1 (Summer 2002), 87–93.

A review of Peter Burke, *Eyewitnessing: The Uses of Images as Historical Evidence* (London: Reaktion Books, 2001).

[1] The salutary contrast between Burke's vigilance and less stringent approaches to visual materials is unmistakable. Thus Alberto Manguel, in his recent *Reading Pictures: A History of Love and Hate* (New York: Random House, 2001), posits that viewers construct narratives when they encounter images: with respect to "images of any kind, whether painted, sculpted, photographed, built, or performed—we bring to them the temporal quality of nar-

rative" (cited in *TLS*, no. 5144, November 2, 2001, 8). Against such generalizations Burke's caveats ring loud and clear. The distinguished lineage of iconographic studies that Burke outlines, however, should have included the mentor whom Panofsky always credited as the ultimate pioneer, Julius von Schlosser. Interestingly enough, E. H. Gombrich, whose scepticism about iconography stands at the head of a tradition of art history less useful to the historian, was also a pupil of Schlosser.

[2] Compare my "Politics and the Arts in the Age of Christina," in *Politics and Culture in the Age of Christina*, ed. Marie-Louise Rodén: *Suecoromania. Studia Artis Historiae Instituti Romani Regni Succiae*, vol. 4 (Stockholm, 1997), 9–22, with Kevin Sharpe, "Representations and Negotiations: Texts, Images, and Authority in Early Modern England", *The Historical Journal*, vol. 42 (1999), 853–81, esp. 879–881.

Part One: 6. Who Understood Renaissance Art?

TLS, no. 4832 (November 10, 1995), 18–20.
This is a reduced version of a fully footnoted essay: "Politics and the Arts in the Age of Christina," in *Politics and Culture in the Age of Christina*, ed. Marie-Louise Rodén: *Suecoromania. Studia Artis Historiae Instituti Romani Regni Succiae*, vol. 4 (Stockholm, 1997), 9–22.

Part Two: 1. Why Are Portraits Important?

TAN, vol. 17, no. 197 (December 2008), 43.
A review of the following catalogs and their associated exhibitions: Miguel Falomir, ed., *El Retrato del Renacimiento*(Madrid: Prado, 2008); Lorne Campbell et al., eds., *Renaissance Faces: Van Eyck to Titian* (New Haven: Yale University Press, in association with the London National Gallery, 2008); Andrea Bacchi, Catherine Hess, and Jennifer Montagu, eds., *Bernini and the Birth of Baroque Portrait Sculpture* (Los Angeles: Paul Getty Museum, 2008).

Part Two: 2. What Do Portraits Accomplish?

TAN, vol. 21, no. 238 (September 2012), 51.
Catalogs and associated exhibitions discussed in this review include: Lorne Campbell et al., eds., *Renaissance Faces: Van Eyck to Titian* (New Haven: Yale University Press, in association with the London National Gallery, 2008); Keith Christiansen and Stefan Weppelmann, eds., *The Renaissance Portrait: From Donatello to Bellini* (New Haven: Yale University Press, in association with the Metropolitan Museum, 2011); Sabine Haag et al., eds., *Dürer, Cranach, Holbein: die Entdeckung des Menschen: das deutsche Porträt um 1500* (Munich: Hirmer, 2011); Jane Shoaf Turner, *Rembrandt's World: Dutch Drawings from the Clement C. Moore Collection* (New York: The Morgan Library, 2012); Gregory Martin, *Rubens in London: Art and Diplomacy* (London: Harvey Miller, 2011).

Part Two: 3. How Do Van Dyck and Other Portraitists Reveal Changing Values?
TLS, no. 5033 (September 17, 1999), 18–19.
A review of the following books and their associated exhibitions: Christopher Brown et al., *Anthony Van Dyck, 1599–1641* (London: Royal Academy, 1999); Martin Royalton-Kisch, *The Light of Nature: Landscape Drawings and Watercolours by Van Dyck and his Contemporaries* (London: British Museum, 1999); Carl Depauw et al., *Anthony Van Dyck as a Printmaker* (Amsterdam: Rijksmuseum, 1999); Robin Blake, *Anthony Van Dyck: A Life, 1599–1641* (Chicago: Ivan R. Dee, 2000).

Part Two: 4. What Do German Portraits of the 1920s Tell Us?
TLS, no. 5418 (February 2, 2007), 20.
A review of a catalog and its associated exhibition: Sabine Rewald, ed., *Glitter and Doom: German Portraits from the 1920s* (New York: Metropolitan Museum, 2006).

Part Three: 1. What Was the Audience for Prints?
NYT (March 2, 2000), 44.
This is a much-revised version of the review of the exhibition *Revivals, Reveries and Reconstructions: Images of Antiquity in Prints from 1500 to 1800* at the Philadelphia Museum of Art.

Part Three: 2. Why the Interest in Piero della Francesca?
TAN, vol. 22, no. 247 (June 2013), 80.
A review of Nathaniel Silver, *Piero della Francesca in America* (New York: Frick Collection, 2013) and its associated exhibition.

Part Three: 3. What Can Drawings Tell Us?
TAN, vol. 18, no. 213 (May 2010), 55.
A review of the following books and their associated exhibitions: Stephanie Buck, ed., *Michelangelo's Dream* (London: Paul Holberton, in association with the Courtauld Gallery, 2010); Hugo Chapman and Marzia Faietti, *Fra Angelico to Leonardo: Italian Renaissance Drawings* (Burlington, VT: Lund Humphries, 2010); Carmen C. Bambach et al., *The Drawings of Bronzino* (New Haven: Yale University Press, in association with the Metropolitan Museum, 2010).

Part Three: 4. How Is the Emperor Charles V to Be Assessed?
TLS, no. 5049 (January 7, 2000), 17.
A review of Hugo Soly and Johan van der Wiele, eds., *Carolus: Charles Quint, 1500–1558* (Ghent: St. Peter's Abbey, 1999) and its associated exhibition.

Part Three: 5. What Can We Learn from a Kunstkammer Collector?
TLS, no. 4948 (February 13, 1998), 18–19.
A review of Eliška Fučíková et al., eds., *Rudolf II and Prague: The Court and the City* (New York: Thames and Hudson, 1997) and its associated exhibitions.

Part Three: 6. What Does his Patronage Tell Us about Philip IV of Spain?
TLS, no. 5342–43 (August 19, 2005), 20–21.
A review of: Andrés Ubeda de los Cobos, *Paintings for the Planet King: Philip IV and the Buen Retiro Palace* (London: Paul Holberton, in association with the Prado, Madrid, 2005) and its associated exhibition; and Jonathan Brown and John Elliott, *A Palace for a King: The Buen Retiro and the Court of Philip IV*, 2nd ed. (New Haven: Yale University Press, 2003).

Part Three: 7. Does the British Royal Collection Help Us Define Flemish Art?
TAN, vol. 17, no. 195 (October 2008), 51.
A review of: Christopher White and Desmond Shawe-Taylor, *The Later Flemish Pictures in the Collection of Her Majesty the Queen* (London: Royal Collection Publications, 2007); Desmond Shawe-Taylor and Jennifer Scott, *Bruegel to Rubens: Masters of Flemish Painting* (London: Royal Collection Publications, 2007) and the latter's associated exhibition.

Part Three: 8. Why Create a "Paper Museum"?
TAN, vol. 15, no. 172 (September 2006), 39.
A review of David Pegler and David Freedberg, *The Paper Museum of Cassiano Dal Pozzo: A Catalogue Raisonné. Series B: Natural History, Part II: Fungi,* 3 vols. (London: Harvey Miller, in association with the Royal Collection, 2006).

Part Three: 9. Why Collect Géricault?
TLS, no. 5672 (December 16, 2011), 25.
This is an extensively revised version of a review of Nina Athanassoglou-Kallmyer, *Théodore Géricault* (London: Phaidon, 2010).

Part Four: 1. Was Prague the Home of Two Golden Ages?
TLS, no. 5351 (October 21, 2005), 20–21.
A review of Barbara Drake Boehm and Jiří Fajt, *Prague: The Crown of Bohemia, 1347–1437* (New Haven: Yale University Press, in association with the Metropolitan Museum, 2005) and its associated exhibition.

Part Four: 2. What Does Holbein Suggest about his Times?
TLS, no. 5201 (December 6, 2002), 27.
A review of John North, *The Ambassadors' Secret: Holbein and the World of the Renaissance* (London: Hambledon and London, 2002).

Part Four: 3. How Was Dürer Special?

TLS, no. 5207 (January 17, 2003), 16–17.

A review of Giulia Bartrum, *Albrecht Dürer and his Legacy: The Graphic Work of a Renaissance Artist* (London: British Museum, 2002) and the associated exhibition.

Part Four: 4. What Makes Dürer So Accessible?

TAN, vol. 23, no. 255 (March 2014), 67 & 73.

A review of the following books and their associated exhibitions: Jochen Sander, ed., *Albrecht Dürer: His Art in Context* (New York: Prestel, 2013); Stephanie Buck and Stephanie Porras, eds., *The Young Dürer: Drawing the Figure* (London: Paul Holberton Publishing, in association with the Courtauld Gallery, 2013); Andrew Robison and Klaus Albrecht Schröder, eds., *Albrecht Dürer: Master Drawings, Watercolors, and Prints from the Albertina* (New York: Prestel, in association with the Washington National Gallery, 2013); Marcus Andrew Hurttig, *Antiquity Unleashed: Aby Warburg, Dürer and Mantegna* (London: Paul Holberton, 2013).

Part Five: 1. What Distinguishes Dutch and Flemish Art?

TAN, vol. 21, no. 228 (October 2011), 65–66, & no. 229 (November 2011), 78 & 83.

A review of the following books and their associated exhibitions: Maryan W. Ainsworth et al., *Man, Myth, and Sensual Pleasures: Jan Gossart's Renaissance* (New Haven: Yale University Press, in association with the Metropolitan Museum, 2010); Christiaan Vogelaar et al., *Lucas van Leyden en de Renaissance* (Antwerp: Ludion, 2011); Desmond Shawe-Taylor with Jennifer Scott, *Dutch Landscapes* (London: Royal Collection, 2010); Pieter Roelofs et al., *Hendrick Avercamp: Master of the Ice Scene* (New Haven: Yale University Press, in association with the Rijksmuseum and the Washington National Gallery, 2010); Ariane van Suchtelen, *Jan Steen in the Mauritshuis* (Zwolle: W Books, 2011); Adrianne E. Waiboer, *Gabriel Metsu: Life and Work* (New Haven: Yale University Press, in association with the National Gallery of Ireland, the Rijksmuseum and the Washington National Gallery, 2012); P. Knolle and E. Korthals-Altes, eds., *Nicolaas Verkolje 1673–1746* (Enschede: Rijksmuseum Twenthe, 2011); Colin B. Bailey et al., *Rembrandt and His School: Masterworks from the Frick and Lugt Collections* (New York: The Frick Collection, 2011); Ortrud Westheider and Michael Philip, *Rubens, van Dyck, Jordaens: Barock aus Antwerpen* (Münich: Hirmer, 2010); Peter Sutton, *The Hohenbuchau Collection: Dutch and Flemish Paintings from the Golden Age* (Vienna: Liechtenstein Museum, 2011); Jeremy Wood, *Corpus Rubenianum Ludwig Burchard Part XXVI. Copies and Adaptations from Renaissance and Later Artists: Italian Artists. II. Titian and North Italian Artists*, 2 vols. (Chicago: Harvey Miller, 2011).

Part Five: 2. Why Are Van Eyck and his Countrymen Central to Renaissance History?
JIH, vol. 33, no. 4 (Spring 2003), 569–575.
A review of Till-Holder Borchert, *The Age of Van Eyck: The Mediterranean World and Early Netherlandish Painting 1430–1530* (New York: Thames and Hudson, 2002) and its associated exhibition.

Part Five: 3. Why Did Rubens Copy his Predecessors?
TAN, vol. 19, no. 216 (September 2010), 43.
A review of: Jeremy Wood, *Corpus Rubenianum Ludwig Burchard Part XXVI. Copies and Adaptations from Renaissance and Later Artists: Italian Artists. I. Raphael and his School*, 2 vols. (Turnhout: Harvey Miller, 2010); Reinhold Baumstark, Kristen Lohse Belkin et al., *Rubens im Wettstreit mit Alten Meistern: Vorbild und Neuerfindung* (Berlin: Hatje/Cantz, 2009) and the latter's associated exhibition.

Part Five: 4. Is Later Western Art Conceivable without Rubens?
TAN, vol. 24, no. 269 (June 2015), 93 & 100.
A review of: Nico van Hout and Alexis Merle du Bourg, eds., *Rubens and His Legacy* (London: Royal Academy of Arts, 2014) and its associated exhibition; Corina Kleinert, *Peter Paul Rubens (1577–1640) and his Landscapes: Ideas on Nature and Art* (Turnhout: Brepols Publishers, 2014).

Part Five: 5. Why Does Rembrandt Continue to Appeal?
TLS, no. 5257 (January 2, 2004), 16–17.
A review of: Clifford S. Ackley et al., *Rembrandt's Journey: Painter, Draftsman, Etcher* (Boston: Museum of Fine Arts, 2004) and its associated exhibition; Alan Chong and Michael Zell, eds., *Rethinking Rembrandt* (Boston: Isabella Stewart Gardner Museum, 2002); Steven Nadler, *Rembrandt's Jews* (Chicago: University of Chicago Press, 2003).

Part Five: 6. Is There a Distinct "Late" Rembrandt?
TAN, vol. 24, no. 265 (February 2015), 58.
A review of Gregor J.M. Weber et al., eds., *Rembrandt: The Late Works* (New Haven: Yale University Press, in association with the Rijksmuseum and the London National Gallery, 2014) and the associated exhibition. Also relevant is Filippo Baldinucci, Arnold Houbraken and Joachim von Sandrart, *Lives of Rembrandt* (London: Pallas Athene, 2007).

Part Five: 7. What Can We Learn from a Painter of the Everyday?
TLS, no. 5307/8 (December 24/31, 2004), 23.
A review of a catalog and its associated exhibition: Arthur K. Wheelock, ed., *Gerhard Ter Borch* (New Haven: Yale University Press, in association with the Washington National Gallery, 2004).

Part Five: 8. What Can Artists Tell Us about Delft?
TLS, no. 5166 (June 29, 2001), 18–19.
A review of the following books and their associated exhibitions: *Vermeer and the Delft School* (London: National Gallery, 2001); Anthony Bailey, *A View of Delft: Vermeer Then and Now* (New York: Holt, 2001); Philip Steadman, *Vermeer's Camera: Uncovering the Truth behind the Masterpieces* (New York: Oxford University Press, 2002); Alex Ruger and Walter Liedtke et al., *Vermeer and Painting in Delft* (New Haven: Yale University Press, in association with the Metropolitan Museum, 2001).

Part Five: 9. Has Vermeer Been Over-Praised?
TAN, vol. 18, no. 208 (December 2009), 39–40.
A review of: Walter Liedtke, *"The Milkmaid" by Johannes Vermeer* (New York: Metropolitan Museum of Art, 2009) and its associated exhibition; and Kristin Lohse Belkin, *Corpus Rubenianum Ludwig Burchard, Part XXVI: Copies and Adaptations from Renaissance and Later Artists: German and Netherlandish Artists*, (Turnhout: Harvey Miller, 2009).

Part Six: 1. How Did Flemings Shape Spanish Art?
This is the original essay, in English, that was given as a lecture at the Prado in 2008 and then translated into Spanish and published as "'Predominan Los Gustos Flamencos': Reflexiones sobre el patrimonio artístico en España" in Fundación Amigos Museo del Prado, ed., *La senda española de los artistas flamencos* (Barcelona: Galaxia Gutenberg, 2009), 83–92.

I must also record here my enduring debt to Jonathan Brown, who over many years has been extraordinarily generous in sharing his unrivalled understanding of Spanish art, and in particular for the suggestions and comments that helped shape this essay.

Rather than burden this brief survey with extensive notes, what follows is a listing of some of the most important works that were consulted in preparation for the lecture at the Prado.

Bernard Aikema and Beverly Louise Brown, eds., *Renaissance Venice and the North: Crosscurrents in the Time of Bellini, Dürer, and Titian* (New York: Rizzoli, 2000)

Mari-Tere Alvarez, "Artistic Enterprise and Spanish Patronage: The Art Market during the Reign of Isabel of Castile (1474–1504)", in M. North and D. Ormrod, eds., *Art Markets in Europe, 1400–1600* (Aldershot: Ashgate, 1998), 45–59

Ars Hispaniae; historia universal del arte hispánico, 22 vols. (Madrid: Editorial Plus-Ultra, 1947–1977), *passim*

J. V. L. Brans, *Isabel La Catolica y el arte Hispano-Flamenco* (Madrid: Ediciones Cultura Hispanica, 1952)

Neil De Marchi and Hans J. Van Migroet, eds., *Mapping Markets for Painting in Europe 1450–1750* (Turnhout: Brepols, 2006), esp. the essay by Miguel Falomir, "Artists' Responses to the Emergence of Markets for Paintings in Spain, c. 1600", 135–161

Dan Ewing, "Marketing Art in Antwerp, 1460–1560: Our Lady's Pand," *The Art Bulletin*, 72 (1990), 558–84

Elizabeth A. Honig, *Painting and the Market in Early Modern Antwerp* (New Haven: Yale University Press, 1998)

Chiyo Ishikawa, *The Retablo de Isabel la Católica* (Turnhout: Brepols, 2004)

Chiyo Ishikawa, ed., *Spain in the Age of Exploration, 1492–1819* (Lincoln: Nebraska University Press, in association with the Seattle Art Museum, 2004), esp. the essay by J. Y. Luacas, "Art in the Time of the Catholic Monarchs and the Early Overseas Enterprises," 91–101

Ronda Kasl, "Long-Distance Relations: Castilian Patrons, Flemish Artists, and Expatriate Agents in the Fifteenth Century," *Jaarboek van het Koninklijk Museum voor Schone Kunsten Antwerpen* (2001), 87–93

Thomas DaCosta Kaufmann, *Toward a Geography of Art* (Chicago, 2004)

Thomas DaCosta Kaufmann and Elizabeth Pilliod, eds., *Time and Place: The Geohistory of Art* (Aldershot: Ashgate, 2005)

P.S. Maroto, *La Crucifixion de Juan de Flandes* (Madrid: Prado, 2006); and *Pintura flamenca de los siglos XV y XVI* (Madrid: Prado, 2001)

Netherlands Yearbook for History of Art, 50 (1999): *Art for the Market, 1500–1700*, esp. two essays: Neil De Marchi and Hans J. Van Migroet, "Exploring Markets for Netherlandish Painting in Spain and Nueva Espana," 81–111; and Filip Vermeylen, "Exporting Art across the Globe: The Antwerp Art Market in the Sixteenth Century," 13–29

Erwin Panofsky, *Early Netherlandish Painting: Its Orgins and Character* (Cambridge, MA: Harvard University Press, 1958)

Desmond Shawe-Taylor and Jennifer Scott, *Bruegel to Rubens: Masterpieces of Flemish Painting* (London: Royal Collection Publications, 2007)

Ignace Vandevivere, *Juan de Flandes* (Bruges: Crédit Communal, 1985)

Barbara F. Weissberger, ed., *Queen Isabel I of Castile: Power, Patronage, Persona* (Woodbridge, Suffolk: Tamesis, 2008), esp. two essays: Rafael Dominguez Casas, "The Artistic Patronage of Isabel the Catholic: Medieval or Modern?," 123–48 (note the quotation on 137); and Chiyo Ishikawa, "Hernando de Talavera and Isabelline Imagery," 71–82.

Part Six: 2. What Made El Greco Unique?

LAT (November 30, 2003), R8–R9.
A review of a catalog and its associated exhibition: David Davies, ed., *El Greco* (New Haven: Yale University Press, in association with the Metropolitan Museum and the London National Gallery, 2003).

Part Six: 3. Is Philip III's Reign Crucial to Spanish History?
TLS, no. 5487 (May 30, 2008), 24–25.
A review of Laura Bass et al., *El Greco to Velázquez: Art during the Reign of Philip III* (Boston: Museum of Fine Arts, 2008) and its associated exhibition.

Part Six: 4. Why Is Velázquez So Revered?
TAN, vol. 17, no. 192 (June 2008), 52.
A review of two catalogs and their associated exhibitions: Dawson Carr et al., *Velázquez* (New Haven: Yale University Press, in association with the London National Gallery, 2006); Javier Portis et al., *Velázquez's Fables: Mythology and Sacred History in the Golden Age* (Madrid: Prado, 2007).

Part Six: 5. How Does Spanish Art Reflect Devout Catholicism?
TAN, vol. 18, no. 210 (February 2010), 40.
A review of two catalogs and their associated exhibitions: Leticia Ruiz, ed., *Juan Bautista Maíno* (Madrid: Prado, 2009); Xavier Bray, Alfonso Rodríguez et al., eds., *The Sacred Made Real: Spanish Painting and Sculpture 1600–1700* (New Haven: Yale University Press, in association with the London National Gallery, 2009).

Part Six: 6. Is There a Distinctive Spanish Art?
TLS, no. 5416 (January 19, 2007), 17.
A review of a catalog and its associated exhibition: Carmen Gimenez and Francisco Calvo Serraller, eds., *Spanish Painting From El Greco to Picasso: Time, Truth, and History* (New York: Guggenheim Museum, 2007).

Part Seven: 1. What Can We Learn from the Appeal of Piero della Francesca?
TLS, no. 5438 (June 22, 2007), 9–10.
A review of a catalog and its associated exhibition: Carlo Bertelli and Antonio Paolucci, *Piero della Francesca e le corti Italiane* (Milan: Skira, 2007).

Part Seven: 2. Why Is Leonardo Worth Studying?
TLS, no. 5212 (February 21, 2003), 18–19.
A review of a catalog and its associated exhibition: Carmen C. Bambach, ed., *Leonardo da Vinci: Master Draftsman* (New York: Metropolitan Museum, 2003).

Part Seven: 3. Why Is Raphael So Central to Western Art?
TLS, no. 5701 (July 6, 2012), 17.
A review of a catalog and its associated exhibition: Tom Henry and Paul Joannides, eds., *The Late Raphael* (Madrid: Prado, 2012).

Part Seven: 4. How Did Parmigianino Capture his Age?
TLS, no. 5235 (August 1, 2003), 16–17.
A review of a catalog and its associated exhibition: Sylvia Ferino-Pagden and Lucia Fornari Schianchi, eds., *Parmigianino Und Der Europäische Manierismus* (Berkeley: Gingko Press, in association with the Kunsthistorisches Museum of Vienna, 2003).

Part Seven: 5. Has History Been Unfair to Bologna?
TAN, vol. 24, no. 262 (November 2014), 77 & 91.
A review of Elizabeth Cropper and Lorenzo Pericolo, eds., Carlo Caesare Malvasia's *Felsina Pittrice: Lives of the Bolognese Painters*: vol. I, *Early Bolognese Painting* (Turnhout: Harvey Miller, 2013), and vol. XIII, *Lives of Domenichino and Francesco Gessi* (Turnhout: Harvey Miller, 2013).

Part Seven: 6. Why Was Rome a Center of Innovation around 1600?
Although the second section of this essay was written for this book, the first section appeared in *TAN*, vol. 25, no. 279 (May 2016), 59.
Review of Clare Robertson, *Rome 1600: The City and the Visual Arts under Clement VII* (New Haven: Yale University Press, 2015).

Part Seven: 7. What Happened to the Followers of Caravaggio?
TAN, vol. 20, no. 220 (January 2011), 51.
A review of Alessandro Zuccari, *I Caravaggeschi: The Caravaggesque Painters, a Catalogue of the Artists and Works*, 2 vols. (Milan: Skira, 2011).

Part Seven: 8. Can One Explain the Shift in Rome's Values in the Mid-1600s?
TLS, no. 5073 (June 23, 2000), 20–21.
A review of a catalog and its associated exhibition: Evelina Borea and Carlo Gasparri, eds., *L'idea del Bello: Viaggio per Roma nel seicento con Giovan Pietro Bellori* (Rome: Edizioni de Luca, in association with Palazzo delle Esposizioni, 1999).

Part Seven: 9. How Did One Buy Art in Early Modern Italy?
TAN, vol. 18, no. 203 (June 2009), 50.
A review of Richard E. Spear and Philip Sohm, eds., *Painting for Profit: The Economic Lives of Seventeenth-Century Italian Painters* (New Haven: Yale University Press, 2010).
[1] Of special interest in this regard is Patrizia Cavazzini, *Painting as Business in Early Seventeenth-Century Rome* (University Park: Penn State University Press, 2008).

Part Seven: 10. Was Eighteenth-Century Rome Living on Its Past?
TLS, no. 5063 (April 14, 2000), 22–23.
A review of Edgar Peters Bowron and Joseph J. Rishel, eds., *Art in Rome in the Eighteenth Century* (London: Merrell, 2000), in association with the Philadelphia Museum of Art's exhibition, *The Splendor of Eighteenth-Century Rome.*

Part Eight: 1. What Triggered the Creativity of Venetian Art?
TLS, no. 5391 (July 28, 2006), 18–19
A review of a catalog and its associated exhibition: David Alan Brown and Sylvia Ferino-Pagden, *Bellini, Giorgione, Titian, and the Renaissance of Venetian Painting* (New Haven: Yale University Press, in association with the Washington National Gallery, 2006).

Part Eight: 2. Why Is Titian a Special Presence in Western Art?
LAT (August 17, 2003), R8–R9.
A review of two catalogs and their associated exhibitions: Charles Hope and Jennifer Fletcher, *Titian* (New Haven: Yale University Press, in association with the London National Gallery, 2003); Miguel Falomir, *Tiziano* (Madrid: Prado, 2003).

Part Eight: 3. Did Competitiveness Help Shape Venetian Art?
TLS, no. 5539 (May 29, 2009), 22–23.
A review of: Frederick Ilchman et al., *Titian Tintoretto, Veronese: Rivals in Renaissance Venice* (Boston: Museum of Fine Arts; and London: Lund Humphries, 2009) and its associated exhibition; and Nicholas Penny, *The Sixteenth-Century Italian Paintings*, vol. II, *Venice 1540–1600* (London: National Gallery, 2008).

Part Eight: 4. How Did Living in Venice Affect Veronese?
TLS, no. 5331 (June 3, 2005), 16–17.
A review of *Veronese: Gods, Heroes, and Allegories* (Milan: Skira, 2004), the catalog for an exhibition at the Musée du Luxembourg in Paris and at the Correr Museum in Venice.

Part Eight: 5. Is There a Palladian Aesthetic?
TAN, vol. 20, no. 218 (November 2010), 66.
A review of: Guido Beltramini and Howard Burns, *Palladio* (London: Royal Academy, 2008) and its associated exhibition; Irena Murray and Charles Hind, eds., *Palladio and His Legacy: A Transatlantic Journey* (New York: Rizzoli, 2010); Guido Beltramini, *Andrea Palladio and the Architecture of Battle: With the Unpublished Edition of Polybius' Histories* (New York: Marsilio, 2010).

Part Eight: 6. How Do Artists Shape Our View of Cities?
TLS, no. 5620 (December 17, 2010), 19.
A review of Charles Beddington, *Venice: Canaletto and his Rivals* (New Haven: Yale University Press, in association with the London National Gallery, 2010) and its associated exhibition.

Part Eight: 7. Why Is Venice Beautiful?
TAN, vol. 22, no. 242 (February 2013), 49–50.
A review of the following books: Daniel Savoy, *Venice from the Water: Architecture and Myth in an Early Modern City-State* (New Haven: Yale University Press, 2012); Margaret Muther D'Evelyn, *Venice and Vitruvius: Reading Venice with Daniele Barbaro and Andrea Palladio* (New Haven: Yale University Press, 2012); Andrew Hopkins, *Baldassare Longhena and Venetian Baroque Architecture* (New Haven: Yale University Press, 2012); Albert Craievich and Filippo Pedrocco eds., *Francesco Guardi 1712–1793* (Milan: Skira, in association with Venice's Fondazione Musei Civici, 2012); Guido Beltramini, *The Private Palladio* (New York: Prestel, 2012).

Afterword
[1] David Ekserdjian, "The Shock to the Old," *TAN*, vol. 25, no. 280 (June 2016).

List of Additional Essays by the Author

The following, listed in chronological order under the heading of the Part where they would be relevant, are other essays on the arts, not included in this book.

Part One

JIH, vol. 14, no. 3 (Winter 1984), 647–55
JIH, vol. 20, no. 3 (Winter 1990), 437–44
JIH, vol. 27, no. 1 (Summer 1996), 87–94
NYT (December 13, 1998), 10 & 39
TLS, no. 5330 (May 27, 2005), 25

Part Three

NYT (May 12, 2002), 25–26
TAN, vol. 22, no. 247 (June 2013), 81

Part Four

TAN, vol. 16, no. 183 (September 2007), 51
TAN, vol. 19, no. 214 (June 2010), 64

Part Five

NYT, (October 31, 1999), 41–43
TLS, no. 5284 (July 9, 2004), 16–17
TLS, no. 5370 (March 3, 2006), 18–19
TLS, no. 5453 (October 5, 2007), 28
TAN, vol. 17, no. 189 (March 2008), 57
TAN, vol. 22, no. 249 (September 2013), 57–58

TAN, vol. 23, no. 254 (February 2014), 62
TAN, vol. 26, no. 288 (March 2017), *Review*, 32

Part Six

TLS, no. 5605 (September 3, 2010), 13
TAN, vol. 20, no. 225 (June 2011), 70
TLS, no. 5889 (February 12, 2016), 9

Part Seven

TLS, no. 4729 (November 19, 1993), 4
NYT, (April 1, 2001), 39 & 41
TLS, no. 5166 (April 5, 2002), 15–16
TLS, no. 5212 (February 21, 2003), 18–19
TLS, no. 5338 (July 22, 2005), 17
TAN, vol. 18, no. 203 (June 2009), 50
TAN, vol. 20, no. 221 (February 2011), 50
TAN, vol. 21, no. 231 (January 2012), 48
TLS, no. 5700 (June 29, 2012), 9
TAN, vol. 24, no. 263 (December 2014), 68
TAN, vol. 26, no. 287 (January 2017), *Review*, 16

Part Eight

TAN, vol. 16, no. 180 (March 2007), 57
TAN, vol. 21, no. 234 (April 2012), 64
TAN, vol. 25, no. 280 (June 2016), 63

Beyond my essays in the list above and in the present book, my own main effort to link art and history is in: "Artists and Warfare: A Study of Changing Values in Seventeenth-Century Europe," *Transactions of the American Philosophical Society* (1985), 79–106; *A Sixteenth-Century Book of Trades: Das Ständebuch* (Palo Alto: The Society for the Promotion of Science and Scholarship, Inc., 2009); and *The Artist and the Warrior: Military History through the Eyes of the Masters* (New Haven and London: Yale University Press, 2011).

Acknowledgments

My thanks to James Carnes, whose sharp eye and tireless efforts were invaluable as these essays were assembled; to Quentin Skinner, for first suggesting this collection; to four superb editors—David Horspool, Will Eaves, Donald Lee, and Janet Gardiner; and to the dedicatee. All errors are of course my own.

Index

CPSIA information can be obtained
at www.ICGtesting.com
Printed in the USA
LVHW111713100219
607037LV00001B/181/P